The Temple of Fame and Friendship

The Temple of Fame and Friendship

Portraits, Music, and History in the C. P. E. Bach Circle

ANNETTE RICHARDS

The University of Chicago Press CHICAGO AND LONDON

The University of Chicago Press, Chicago 60637
The University of Chicago Press, Ltd., London
© 2022 by The University of Chicago
Published 2022
Printed in the United States of America

31 30 29 28 27 26 25 24 23 22 1 2 3 4 5

ISBN-13: 978-0-226-80626-6 (cloth)
ISBN-13: 978-0-226-81677-7 (e-book)
DOI: https://doi.org/10.7208/chicago/9780226816777.001.0001

Library of Congress Cataloging-in-Publication Data

Names: Richards, Annette, author.
Title: The temple of fame and friendship : portraits, music, and history in the C. P. E. Bach
 circle / Annette Richards.
Description: Chicago : University of Chicago Press, 2022. | Includes bibliographical
 references and index.
Identifiers: LCCN 2021043225 | ISBN 9780226806266 (cloth) | ISBN 9780226816777 (e-book)
Subjects: LCSH: Bach, Carl Philipp Emanuel, 1714–1788—Art collections. | Art and music. |
 Musicians—Portraits. | Composers—Portraits.
Classification: LCC ML410.B16 R53 2022 | DDC 780/.07—dc23
LC record available at https://lccn.loc.gov/2021043225

♾ This paper meets the requirements of ANSI/NISO Z39.48-1992 (Permanence of Paper).

Contents

Introduction

To sit for one's Picture is to have an Abstract of one's Life written and published, and ourselves thus consigned over to Honour or Infamy.

JONATHAN RICHARDSON, *An Essay on the Theory of Painting* (1715)

Imagine, as a music lover, walking into a room densely hung with the faces of your music heroes and heroines: the divas who inspired you, composers who moved you, poets and writers on music who taught you how to listen to and think about music. As a connoisseur of music, you'll recognize many figures from the past, both famous and obscure; as an eager participant in contemporary music culture, you'll know, or at least know of, many of the living musicians pictured there. You might reflect on the expression on a particular face or compare the way personalities are projected through the various images; you might muse on whether the representations of individual figures contain clues to musical style, artistic imagination, or creative character. You might wonder about the friend whose room you find yourself in, as you begin to sense the depth and scope of ideas about the art of music and its meanings presented there. In the faces collected around you, you can trace your friend's understanding of, and identification with, musical lineage and legacy; but there is also a vision of the future, represented by the vibrant new talents depicted in the latest artistic styles, recently added to the already crammed walls. As your eyes range across the portraits lined up many rows deep, your inward ear perhaps calling to mind the sounds associated with individual faces, you find yourself immersed in extended musical, artistic, intellectual, and social networks, circles of friends and forebears, colleagues and acquaintances, that together deepen and enrich your understanding not only of your friend the collector, but of the whole art of music.

When the English musician, traveler, and music historian Charles Burney visited Carl Philipp Emanuel Bach in Hamburg in 1772, he recorded an experience something like this in his travel diary. On entering the Bach household, the first

order of business was portraits: before he could hear for himself the famous skill of the "German Orpheus" at his Silbermann clavichord, or engage him in conversation about his own music and his family legacy, Burney was given the opportunity to admire a collection of portraits, then numbering about 150, in which Bach took great pride. He was shown the oil painting of Johann Sebastian Bach by Elias Gottlob Haussmann and the portrait, also in oils, of his host's grandfather, Johann Ambrosius Bach. His attention was caught in particular by the numerous representatives of his own nation pictured in Bach's gallery, but he saw composers and performers, living and long dead, of every era and nationality. The report he published the following year provides us with a vivid sense of the experience:

> When I went to his house, I found with him three or four rational, and well-bred persons, his friends, besides his own family, consisting of Mrs. Bach, his eldest son, who practices the law, and his daughter. The instant I entered, he conducted me up stairs, into a large and elegant music room, furnished with pictures, drawings and prints of more than a hundred and fifty eminent musicians: among them, there are many Englishmen, and original portraits, in oil, of his father and grandfather. After I had looked at these, M. Bach was so obliging as to sit down to his *Silbermann clavichord*, and favorite instrument, upon which he played three or four of his choicest and most difficult compositions, with the delicacy, precision, and spirit, for which he is so justly celebrated among his countrymen. In the pathetic and slow movements, whenever he had a long note to express, he absolutely contrived to produce, from his instrument, a cry of sorrow and complaint, such as can only be effected upon the clavichord, and perhaps by himself.[1]

In the Bach collection there were portraits of family members and friends, of admired colleagues and long-dead predecessors, of sources of inspiration and authority. Encyclopedic in its scope, and containing nearly four hundred objects by the time of Bach's death in 1788, the collection extended to literary, philosophical, mathematical, mythical, and political figures closely or loosely related to music. In its final form, along with C. P. E. Bach's father and grandfather, the collection included his brothers Wilhelm Friedemann, Johann Christian, and Johann Christoph Friedrich and his stepmother Anna Magdalena. Contemporary musicians from across Europe represented there included composers Joseph Haydn, Christian Gottlob Neefe, Johann Adam Hiller, Christoph Willibald Gluck, and Jean-Jacques Rousseau; Leopold Mozart in the famous group portrait with his children Wolfgang and Nannerl; the Viennese actor and painter Joseph Lange with his second wife, the singer Aloysia Weber; and German star singer-actors Franziska Koch, Carolina Müller, and Marie Sophie Niklas. From an earlier generation there were George Frideric Handel and Louis Marchand, Arcangelo Corelli and Antonio Vivaldi.

Bach's collection encompassed kings, emperors, and other musical patrons as well as writers, thinkers, and philosophers who had turned their attention to

music. Erasmus was there, in the company of Charlemagne, Gregory the Great, and Robert Fludd; Aristotle and Epicurus; John Milton and Gottfried Leibniz. In the collection too were the contemporary German poets and men of letters Christoph Daniel Ebeling, Friedrich Gottlieb Klopstock, Gotthold Ephraim Lessing, Moses Mendelssohn, and Johann Georg Sulzer. Even in a period when portrait collecting was passionately pursued by members of the intellectual classes across Europe, and when a collection of portraits was an important demonstration of education, social status, and means, Bach's collection was unprecedented: it was the first portrait collection to focus on the art of music on anything like this scale and in such a broad sense, and its scope and quality were unmatched. It was widely known during Bach's lifetime, especially in German-speaking Europe, and it continued to be important long after his death.

When word of it began to circulate in the 1770s, Bach's was not the only collection of musician portraits known to his contemporaries, but it was by far the largest and the most significant. In England there was a collection of portraits in the Music School at Oxford, which Philip Hayes expanded from its seventeenth-century core of eighteen paintings to about forty during his tenure as Heather Professor of Music from 1777 to 1797. Far smaller than Bach's and narrower in scope, the Oxford collection focused largely on musicians (most of them English) who were associated with the university.[2] More nearly comparable to the Bach collection in size and scale was that of Padre Giambattista Martini in Bologna, which numbered about four hundred items by the time of his death (and is still intact today). But that collection was not begun in earnest until the early 1770s, by which time C. P. E. Bach had already assembled the more than 150 portraits that he showed to Burney and was rapidly expanding his holdings.[3]

Quickly translated and widely circulated, Burney's description of C. P. E. Bach's collection piqued the interest of Bach's German followers, contributing to a craze for collecting musician portraits among a group of admirers that included the Sondershausen organist and son of a former J. S. Bach student Ernst Ludwig Gerber; the Göttingen professor and biographer of J. S. Bach Johann Nikolaus Forkel; the young lawyer and musician Hans Adolph Friedrich von Eschstruth; the J. S. Bach student in Dresden Christoph Transchel; the C. P. E. Bach student in Copenhagen Niels Schiørring; and the physicist and musician Ernst Florens Friedrich Chladni.

Their collections paralleled those of famous and obscure contemporary collectors (many of them known to Bach) of portraits in other areas, from the literary "Friendship Temples" of the poet Johann Wilhelm Ludwig Gleim in Halberstadt and the publisher Philipp Erasmus Reich in Leipzig—both of them devoted to paintings of writers and poets—to the extensive portrait print collection, also of literary figures, belonging to the publisher and writer Friedrich Nicolai in Berlin; from the vast collection of about 3,300 portrait prints of fellow members of the medical profession assembled by the Berlin doctor Johann Carl Wilhelm Moehsen, to the ten thousand or so sheets of portraits of people of all sorts assembled by the Swiss physiognomist Johann Caspar Lavater.[4] Collections like these had their

well-known precursors in the earlier eighteenth-century Temples of Worthies and Temples of Friendship that were a prominent feature of the most famous English landscape gardens, described in detail for aspiring German readers in influential books such as Christian Cay Lorenz Hirschfeld's *Theorie der Gartenkunst* (1779–85)[5] and inspiring lavish imitations such as the park at Wörlitz, where the library of the Gartenhaus was specifically designed to incorporate a wide-ranging program of portraits of great cultural figures, ancient and modern.

In Germany as in England, the period saw a huge increase in the appetite for portraits, peaking in the 1780s, as portraiture increasingly became the dominant representational genre thanks to its role in staging character, identity, and the shifting relations between the self and the world.[6] The craze for portraiture was rampant, transforming the genre from its lowly position near the bottom of the hierarchy of the visual arts to a place near history painting at the top.[7] Detractors might still consider portraitists mere "face painters," at the mercy of commissions, their work empty of moral purpose and baldly imitative. To quote the Earl of Shaftesbury, portraiture might be understood "not so much as a liberal art nor to be so esteemed; as requiring no liberal knowledge, genius, education, converse, manners, moral-science, mathematics, optics, but merely practical and vulgar."[8] Yet as was made clear by the wealth and success of Sir Joshua Reynolds, who would become director of the Royal Academy in London, by the second half of the century portraiture was lucrative, splendid, and representative,[9] dominating the annual exhibitions at the Royal Academy, drawing the most attentive and responsive viewers at the Royal Gallery in Dresden, and generating extended critical writing (fig. I.1).

Not surprisingly, perhaps, Charles Burney's experience of listening among C. P. E. Bach's portraits produced one of the age's most vivid verbal portraits of a musician:

> After dinner, which was elegantly served, and cheerfully eaten, I prevailed upon him to sit down again to a clavichord, and he played, with little intermission, till near eleven o'clock at night. During this time, he grew so animated and *possessed* that he not only played, but looked like one inspired. His eyes were fixed, his under lip fell, and drops of effervescence distilled from his countenance. He said, if he were to be set to work frequently, in this manner, he should grow young again. He is now fifty-nine, rather short in stature, with black hair and eyes, and brown complexion, has a very animated countenance, and is of a cheerful and lively disposition.[10]

Taken as a whole, Burney's report of his evening with C. P. E. Bach slips among registers, literary genres, and writerly personae, from the diarist recounting a good evening to the music critic marveling at an extraordinary performance, from the connoisseur of the visual arts inspecting a portrait collection to a music lover losing himself in the pathos of Bach's clavichord art, from the anecdotist ventriloquizing Bach's own dryly humorous voice to the informative reporter recording Bach's age and physical appearance. Burney's account is striking for

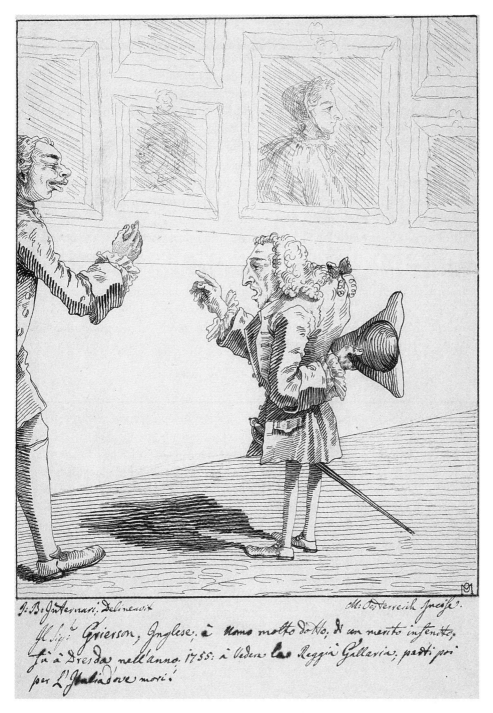

J: B: Internari. delineavit M: Oesterreich Incise.

Il Sig:e Grierson, Inglese: à Uomo molto dotto, d un merito infenito.
fù à Dresda nell'anno. 1755: à vedere la Reggia Gallaria; parti poi
per L'Italia d'ove mori:

FIGURE I.1. Engraving by Matthias Oesterreich after a drawing by Giovanni Battista Internari. The caricature shows Oesterreich himself in animated conversation with an English visitor, Mr. Grierson, over portraits in the Royal Gallery at Dresden. The caption, written in ink below, runs: "Mr. Grierson, English, a very learned man of infinite merit, was in Dresden in the year 1755 to see the Royal Gallery. He then departed for Italy, where he died." (Il Sig:e Grierson, Inglese, un' Uomo molto dotto, di un merito infenito [sic], fù à Dresda nell'anno 1755: à vedere la Reggia Gallaria [sic]; parti poi per L'Italia dove mori.) Image courtesy of the Herzog Anton Ulrich Museum, Braunschweig.

the way it so easily shifts attention from anecdotal details (who was at dinner, the quality of the hospitality, what Bach said) to portraits and on to musical performance, elucidating the distinctive musical character of a composer famous for his command of the sensitive, or pathetic, mode (and of the clavichord as the vehicle for its expression) and creating, in its turn, a portrait of the musician— a portrait remarkable for its absorption in the moment and its penchant for painterly detail, from the "drops of effervescence distilled on the countenance" to Bach's "fixed eyes," which Burney notes were black like his hair. Burney's sketch, as much portrait as anecdote, encapsulates an unforgettable evening, one that had begun with a tour of Bach's portrait collection and that finished with Bach playing at length for Burney on his Silbermann clavichord in that very same portrait-filled room.

Burney's "portraitive" mode is typical for the critical discourses of the period, a mode as widespread in writing on music (as I will argue in this book) as in the other arts, one focused on the legibility of the self, of character and identity, performed through reading faces, interpreting bodies, cataloging features.[11] Central to my story here will be those heterogeneous, generically mixed modes, like Burney's, that intermingle portraiture and biography, drawing attention to new ways of thinking about the musical individual in the present and in the past.

<p style="text-align:center">* * *</p>

C. P. E. Bach's portrait collection is a remarkable work of eighteenth-century music culture. Dispersed after his death, the collection was long assumed to have been lost, but in fact among the extensive holdings of musician portraits in the Berlin State Library, a significant portion of it survives intact. Reassembled, it constitutes a multifaceted source of information not just on musicians and music, but on the place of both in the arts, literature, and society of the later eighteenth century. Encyclopedic in its scope, Bach's renowned collection extended well beyond its concentric circles of practicing musicians into the realms of literature, philosophy, aesthetic theory, politics, and myth; the makers of the images, both originals and engraved prints, included some of the most distinguished of the time as well as the best of their predecessors, along with numerous more workaday printmakers and draftsmen. These sprawling yet interconnected holdings are important not just because they were amassed by J. S. Bach's second son, in his time far more famous than his father before him, but because they provide a vivid panorama of music history and culture, and illumine the ways this leading German figure and his celebrated circle of colleagues and admirers thought of both.

This book explores the ways the Bach collection was built, its position at the intersection of collecting culture, portrait culture, and music culture in the second half of the eighteenth century, and its significance for Bach's contemporaries and successors—and for our own engagement with the musical past and present. Embodying a multidisciplinary discourse where music meets physiognomy, character sketch, anecdote, and history, the Bach portrait collection reframes

the musical and intellectual reach of C. P. E. Bach and his circle, opening up new perspectives on music's changing claims to artistic status, cultural cachet, and scholarly heft in the later eighteenth century—music's claims, in short, to being an art with a history.

The C. P. E. Bach portrait collection constructs and deconstructs professional and personal networks; it makes and remakes a visual reality of historical figures, deeds, and webs of connection; it presents and represents the collector's interests and obsessions; and it unequivocally establishes music as an object of aesthetic, philosophical, and historiographical value. At the same time, the resonant images gathered together speak to us about concepts of feeling and sensibility, of physiognomy and character, of criticism and history, of storytelling and jokes. Their registers shift from the deeply serious to the funny, from the sincere to the ironical. In its multiplicity and heterogeneity, the Bach portrait collection alerts us to the shifting, expressive modes of meaning in late eighteenth-century music culture and in C. P. E. Bach's music—to its investments in the human face and feeling, in character and ethos, in both sociality and individual experience and expression.

* * *

The collection was dispersed in the decades after Bach's death, disappearing into the collections of other portrait enthusiasts and, by the beginning of the twentieth century, lost.[12] What remained was not a densely hung set of framed faces, peopling the walls as they were arranged by their collector (as, for example, at the house of Bach's contemporary and friend Johann Wilhelm Ludwig Gleim in Halberstadt, whose "Friendship Temple" can still be visited today). Rather, the Bach portrait collection survived only in the two-dimensional form of an inventory drawn up by Bach himself, a ghostly remnant of a complex visual panoply reduced to names, numbers, and snippets of descriptive prose, running from page 92 to page 126 in the catalog of Bach's musical estate.[13] For Bach and his heirs, the estate catalog functioned not only as a practical list of music and music books that could be bought from Bach's widow (or, more often, from which she would have copies made at the request of purchasers), but also as an encapsulation of, and monument to, the achievements and lifework of the deceased composer. The portraits were an integral part of that work.

For me, the portrait inventory was an invitation to search for and bring back together the paintings, drawings, and prints that had held such importance for Bach and his contemporaries. A few of the more precious items, including plaster and wax reliefs and some paintings and drawings, are still lost. But with Bach's catalog as my guide I was able to substantially reassemble his holdings (or as accurate as possible a version of them) from portrait collections in Europe and the United States, with the Berlin items as a crucial core. The work of reconstruction, decoding inventory entries, and hunting for the precise images they refer to involved painstaking research but also a stretch of the critical imagination—even

a willingness to speculate. Many of the portraits I discuss in this book, especially the drawings and paintings, were certainly those Bach owned, perhaps even commissioned. Most of the prints are, I believe, exact duplicates of those that hung on his walls. Some are guesses—but informed guesswork, as I shall show here, was integral to the process of assembling the collection in the first place.

"Portrait Collection, of Composers, Musicians, Musical Writers, Lyrical Poets, and some Prominent Musical Connoisseurs" (Bildniß-Sammlung von Componisten, Musikern, musikalischen Schriftstellern, lyrischen Dichtern und einigen erhabenen Musik-Kennern) runs Bach's subheading for the collection of 378 portraits. The list that follows is a connoisseur's inventory for fellow collectors, and the information it gives is precise, detailed, and economical even while it represents the barest remnant of the physical, visual presence of this great assemblage of pictures. The inventory gives the name of each portrait subject, with the format of the image (folio, quarto, octavo, etc.), the name (when known) of an artist or artists (often in abbreviated form), and usually an indication of the medium (woodcut, drawing, mezzotint, etc.). It is a shorthand that the portrait collector can use to identify a particular image of a subject where multiple images, or versions of images, are in circulation (as was often the case with engraved portraits, especially of well-known subjects), but it also describes the unique items in the collection—the pencil, ink, and pastel drawings, the paintings, the plaster reliefs. Reading the inventory, one can gather much important information, observing the wide chronological span and broad cultural reach of the portrait subjects and seeing that the collection contained many drawings and paintings alongside the work of many of the leading printmakers of the seventeenth and eighteenth centuries. Additionally, the inventory details whether items were framed, thus distinguishing those that hung on Bach's walls from those stored in folders. Last, for almost all its entries, the inventory contains a short annotation describing the professional identity or major accomplishment of the portrait subject, annotations that very likely stem from Bach's own pen and offer clues to the extent of his knowledge, his sources of information, and the significance of the portraits for the collector himself (fig. I.2).

In a portrait gallery some faces hang individually, some are framed in pairs or perhaps juxtaposed in clever thematic ways, and connections are made from one to another in the spaces between them. The portrait collection relies on the notion that the face is legible, but the visage itself is amplified by names, dates, and professions—often inscribed on the portrait—that record achievement, historical significance, and contribution. As I describe here, C. P. E. Bach's inventory annotations suggest the stories (the biographies, the histories) that would be told about each item as the collector introduced friends and acquaintances to the pictures displayed on his walls, these oral sketches bolstered by information from contemporary handbooks, essays, and biographical commentaries.

Portraits go hand in hand with character studies, anecdotes, and narratives. The Bach collection was a visual miscellany, a vibrant mixture of media, styles, and techniques of representation, from the simple outlines of the face in a wood-

92

händig für Porporino aufgesetzt. Ein rares Original.

Folgende des Seligen Instrumente sind ebenfalls bey dessen Frau Wittwe zu verkaufen.

Ein fünf Octäviger Flügel von Nußbaum-Holz, schön und stark von Ton.

Ein Fortepiano oder Clavecin Roial vom alten Friederici, von Eichenholz und schönem Ton.

Ein fünf Octäviges Clavier von Jungcurt, von Eichenholz und schönem Ton.

Ein fünf Octäviges Clavier vom alten Friederici, von Eichenholz, der Deckel von Feuern-holz, schön von Ton. An diesem Claviere sind fast alle in Hamburg verfertigte Compositionen componirt worden.

Ein Helfenbeinerner Zinken, der aus einem einzigen Elephanten-Zahn gedrehet ist, und deßwegen in eine Kunstkammer aufgenommen zu werden verdient.

Bildniß-Sammlung
von Componisten, Musikern, musikalischen Schriftstellern, lyrischen Dichtern und einigen erhabenen Musik-Kennern.

Abel, (Leopold August) Violinist in Ludwigs-lust. Von ihm selbst gezeichnet. Gr. 4. In schwarzen

93

schwarzen Rahmen mit goldenem Stäbchen unter Glas.

Abel, (Carl Fried.) Violdigambist in London. In Oel gemahlt von Joh. Sebast. Bach, 1774. 20 Zoll hoch, 16 Zoll breit. In goldenen Rahmen.

Derselbe gezeichnet von E. H. Abel, 1786. Gr. 4. In schwarzen Rahmen mit goldenem Stäbchen, unter Glas.

Accursius, (Marinus Angelus) Musikus und Poet. Holzschnitt. 8.

Agrell, (Joh.) Nürnbergischer Kapellmeister. In schwarzer Kunst von Preisler. Fol. In schwarzen Rahmen, unter Glas.

Agricola, (Rudolphus) Theol. Philos. und Musikus. Gezeichnet von Joh. Seb. Bach. 8. In schwarzen Rahmen, unter Glas.

Agrippa, (Henr. Cornel.) Schriftsteller. 4.

Alardus, Schriftsteller. Holzschnitt. 8.

Albertus, Magnus, Schriftsteller. Holzschnitt. 8.

Albertus, (Leo Baptista) Musicæ &c. summe peritus. Holzschnitt. 8.

Alcæus. lyrischer Dichter, Musices scientissi-mus. 12.

Alciatus, (Andreas) Schriftsteller. Holzschnitt. 8.

Alembert, (Jean le Rond d') Schriftsteller in Frankreich. 4. In schwarzen Rahmen, unter Glas.

Alex-

FIGURE I.2. Beginning of the inventory of the portrait collection, from the catalog of C. P. E. Bach's estate. *Verzeichniss des musikalischen Nachlasses des verstorbenen Capellmeisters Carl Philipp Emanuel Bach* (Hamburg: G. F. Schneibes, 1790). Library of Congress, Music Division.

cut to the black profile of a silhouette; from the delicate shading of a pastel drawing to the suggestive comic flourish of a caricature. In this collection the all-important communication of character conveyed by the face pointed in turn to musical works and performance styles—and to the projection of emotion so crucial to C. P. E. Bach's stated understanding of music's mission. Arranged in space, experienced in time, the portrait collection transcends the conditions of its creation to invite new readings—and perhaps hearings—of its individual subjects and their art, alongside those of the collector himself.

This book asks what it was like not only to view the portraits in the company of the collector, but to experience music in a room whose walls were packed with visual, verbal, affective, authoritative, personal, and public information

about musicians and musical thinkers past and present. How might seeing those crowds of faces, in print, drawing, or painting, inflect the sense projected by the collection's inventory of the multiply intersecting networks represented on Bach's walls? How does the physical reality of the objects of a late eighteenth-century music collector's obsession speak about the way that culture framed and conceived of itself? How might C. P. E. Bach's portraits, as a reassembled collection of images, reanimate our understanding of Bach's music room, with its visitors' chatter, its host's conversation—and the music resonating there? To what extent does this exercise in imaginative historical reenactment demand that we rethink the role of speculation and imagination in our own encounters with the musical past?

<p style="text-align:center">* * *</p>

This book is organized into seven chapters, loosely alternating studies of the collection and its contents with essays that consider C. P. E. Bach's music in the portraitive mode.

In chapter 1, "Exhibiting: The Bach Gallery and the Art of Self-Fashioning," I invite you to join me on a tour of Bach's gallery, paying special attention to the engraved prints and following the organizational categories laid out in Bach's inventory. The degree to which these categories reveal a personal view of the music culture of past and present, crafting and publicly presenting an idiosyncratic image of C. P. E. Bach even as they gesture to the Bach family lineage deeply stamped on his own achievements, is a question I explore there. The collection's items may be organized to delineate the arc of history, yet the collection erases time in making the long dead and the living simultaneously present. Other principles of organization may inform the groups of composers, performers, writers, poets, patrons, family members, and friends. Any and all are possible, depending on the route taken through space, the passage around the room, the collector's willingness to reveal what is hidden and explain what is displayed. My own selection of portraits to discuss together is informed by contemporary writing on portraiture, on Bach and his collection, and on the culture (visual, musical, literary, scholarly, social) in which Bach was embedded. As I hope to show, portraits, and especially portrait prints, were informative in multiple ways, offering models for how posthumous reputation might be secured and preserved. Their paratexts conveyed information about the portrait subjects that Bach could have imparted to his guests, assuming the role of docent and historian, even eliciting vignettes from his own memory and Bach family lore (like that published in the J. S. Bach obituary). The collection, then, might be seen to amount to a complex representation of the collector himself, establishing beyond any doubt his own place in history.

Chapter 2, "Collecting: C. P. E. Bach and Portrait Mania," takes us into the archives to glean what we can about Bach's collecting from the historical record. Reading the surviving correspondence between Bach and his colleagues

and collaborators in the 1770s and 1780s against eighteenth-century collecting manuals, I piece together a picture of Bach as an exacting yet sometimes excitable collector. Leaking out from the margins and postscripts of letters largely devoted to business are numerous indications of how the collection was put together; what sort of collector Bach was; what he knew about portraits and the subjects those images represented; and whether every item was carefully chosen. The act of organizing, arranging, and displaying the pictures presupposes choice and discrimination. Moreover, collecting in the later eighteenth century was a public hobby with a rich culture of expectations, one in which C. P. E. Bach was an enthusiastic and, I argue, knowledgeable participant. A collector of discernment and occasionally also of enthusiastic acquisitiveness, Bach was surely conversant with the discourse and literature of collecting—not simply an amateur but a connoisseur, according to the categories laid out in his late, great *Kenner und Liebhaber* keyboard collections. In the realm of music, a discipline rapidly gaining in status with respect to the other arts, Bach's portrait collection set the standard—a reference work for exacting yet fanatical collectors who followed in his footsteps.

Though silent, the Bach portrait collection resonates with implied sound; but the pictures in the music room are also witnesses to the actual creation and re-creation of musical performances. Returning to Burney's visit to C. P. E. Bach in chapter 3, "Speculating: Likeness, Resemblance, and Error," I imagine how the convergence of portrait and music in that encounter might have sounded. Speculating on what music might have been heard in that gallery space, I explore the problematic questions of identity, likeness, and biographical accuracy raised by this collection and Bach's annotated catalog of it. There is the pressing question of family likeness. How do we know if a likeness is "accurate," or even if its putative connection to a historical figure is correct? In several of the most telling cases, Bach's ascriptions of identity seem to be plain wrong. As I suggest here, Bach's error is an invitation to the latter-day scholar to speculate creatively about both the proven and the not quite knowable while reflecting on the knotty problems of likeness in the musical productions of the Bach family.

How portraits were read and what they were seen to say is a central question for any exploration of cultures of portrait collecting and portraitive modes of looking, listening, and writing. In chapter 4, "Character: Faces, Physiognomy, and Time," we encounter eighteenth-century visual and theoretical texts on faces, portraiture, and music, focusing on the theories of the Swiss physiognomist Johann Caspar Lavater, whose work Bach knew. Considering the way Lavater based his physiognomic readings on portraits, collapsing the "real" face or head with its representation, I suggest that we hear Bach's own experiments in musical characterization, the "Character Pieces" from the 1750s, as parallel explorations played out in time: Bach's games with temporality and eccentric detail come into relief against the theories of facial expression, sentience, and meaning that absorbed contemporary portrait makers.

From characters and characteristics in the Berlin friendship circle of the

1750s, we move to the friends and acquaintances of Bach's Hamburg years in the 1770s and 1780s and to the idea of the portrait collection as a mode of cultivating and preserving friendship. As I discuss in chapter 5, "Friendship: Portrait Drawings and the Trace of Modern Life," Bach's investment in portrait drawings during his last decade and a half, requested specifically from his friends, suggests that his portrait collection functioned as a shrine to his musical friendships, like the *Freundschaftstempel* of specially commissioned portraits assembled by Johann Wilhelm Ludwig Gleim, whom the composer commemorated in his own touching musical portrait. The drawings in the Bach portrait collection reveal ties of affection and admiration with old colleagues and new acquaintances alike and conjure an image of C. P. E. Bach as a man in close touch with contemporary music culture, even as, in old age, he had begun to withdraw from it.

The portrait collection as Friendship Temple reflects a widespread move away from the regularized collection of historical models toward a more emotive understanding of portraiture's effects. Here we are embedded in the culture of remembrance, friendship, and loss that resonates in C. P. E. Bach's domestic music, with its tearful farewells, its humorous critiques of sentimentality, and its gestures of distant recollection. In chapter 6, "Feeling: Objects of Sensibility and the 'Portrait of Myself,'" tears, portraiture, and friendship converge and conspire to focus on the portrait as the object of sensibility. Taking the late keyboard music of C. P. E. Bach's *Kenner und Liebhaber* series, focusing especially on the rondos, I invite you to listen to the ways these works present feeling at the keyboard as unstable and troubled, grief and laughter ambiguously combined in what might be heard as profound portraits, or self-portraits, darkly humorous in the sentimental mode.

Finally, chapter 7, "Memorializing: Portraits and the Invention of Music History," moves outward to think about the larger implications of the Bach portrait collection and to argue for the foundational significance of this collection to music historiography. Here we will meet the vast collections of musician portraits that Bach's contemporaries and later admirers assembled, expressly following his example. Drawing information from the remnants of these collections in Berlin and Vienna, as well as from practical guides and philosophical tracts on collecting, I show not only how these collections were created, but also what they signified and how they were used. I trace the Bach collection's central role in the formation of Ernst Ludwig Gerber's influential biographical dictionary of music, but I also show how parallel exercises in music historiography in the later eighteenth century were themselves rooted in practices of portrait collecting. Far from being unreliable by-products of the music-historiographical project, the anecdote, the annotation, and the physiognomical analysis that prevail in these histories reveal an aesthetic and intellectual approach grounded in the visual discipline of portraiture. My final chapter argues that the new music historiography of the late eighteenth century, rich in anecdote, memoir, and verbal portrait, was deeply indebted to portrait collecting and its simultaneous—and often paradoxical—negotiation between presence and detachment, fact and feeling.

In the pages that follow I hope to demonstrate that the little-known Bach portrait collection offers a new picture of European music culture toward the end of the eighteenth century, and especially of the ways that culture positioned itself with respect to the past. My aim is to provide fresh insights into late eighteenth-century cultures of sensibility and cults of character (central to concepts of musical meaning in the period), to offer new perspectives on the formation and self-fashioning of C. P. E. Bach as a cultural icon in his time and a figure who staged his own posthumous reputation, and to suggest new ways of hearing some of his idiosyncratic music. Bach's collecting amounted to a music-historiographical project no less ambitious than the groundbreaking work of his contemporary pioneers in the discipline of music history, Martini (*Storia della musica*), Hawkins (*General History of Music*), Burney (*History of Music*), and Forkel (*Allgemeine Geschichte der Musik*). In that respect the Bach portrait collection has an enduring, if unrecognized, resonance today.

Exhibiting: The Bach Gallery and the Art of Self-Fashioning

In the end it was our old servant who claimed the greatest attention. He could be called the deputy-custodian of our collection, for he takes people round it when my uncle is prevented from doing so or when we know that they are only coming out of curiosity. He has thought up amusing stories for certain of the pictures, and always comes out with them. He knows how to astonish visitors with the high prices of the paintings, takes them to see the puzzle pictures, shows a number of remarkable relics, and especially delights his audience with the automata.

GOETHE, "The Collector and His Circle"[1]

In a collection, hoarding and hiding must be balanced by discrimination and display. On the one hand a collection is a tool for private study and a source of solitary satisfaction. On the other, it is caught in and dependent on a web of sociability, created thanks to a network of friends and fellow collectors, elaborated through information shared and circulated, displayed to diverse admiring guests. As Charles Burney's visit to C. P. E. Bach made clear, Bach's collection was exhibited and elucidated to friends and colleagues who came to the house; it was the job and pleasure of the collector to speak about individual items and their collective meanings.

For the collector of musical portraits, there was much to know and much to tell: where an individual portrait came from, who had made it, who those depicted were and what they did, the course of their lives, careers, and contributions to music. As Bach showed Burney around his gallery in 1772, they viewed a collection of what he described as "more than a hundred and fifty eminent musicians." By the time Bach died in 1788 the collection had grown to 378 portraits that embodied a far richer and deeper approach to music culture than implied by Burney's simple category "musician." Roughly two-thirds of the portraits were of musicians practicing in various capacities, carefully classified in ways I'll detail below. Almost all these pictures, except those arriving in the collection very late, were framed and hung. The remaining third were not on view but were kept in portfolios: this large group consisted of subjects whose primary medium was not so much music as the written word—theorists, philosophers, and poets, as well as some distinguished patrons, most of whom had touched on music at least tangentially in their work or had written texts that had been set to music (in many cases

by composers who were also in the collection). The assembled faces could be interpreted physiognomically, inferring the character of both the musicians and their work from their facial features. But the portraits, especially the engravings, presented other kinds of information too. The attentive spectator strolling through Bach's music room would have noted birth and death dates, career outlines, positions and places of work. Verbal and musical fragments attached to the faces connected stories of personal achievement across a literary, visual, and musical terrain stretching into the distant past. Together they provided a commentary and supplement to the principal music-biographical reference works of the age (leather-bound copies of which were in C. P. E. Bach's library): J. G. Walther's *Musicalisches Lexikon* (1732) and Johann Mattheson's *Grundlage einer Ehrenpforte* (1740). These books were essential tools for portrait collectors even at the end of the century, still being recommended by Ernst Ludwig Gerber in 1790–92.[2]

Many engraved portraits were accompanied by laudatory poems and biographical summaries, ranging from a single line noting the subject's most important position or publication to extended eulogies sketching out a complete career. In the latter case especially, portraits announced subjects' exemplary standing in their own era and their transcendence of it as they are inscribed into the long arc of history. On Bach's portrait of the seventeenth-century Nuremberg organist Paul Hainlein (1626–86), for example, a quatrain advertised the way Hainlein would continue to be celebrated long after his death:

> Herr Heinlein [*sic*] ist zwar todt, doch wird sein frommes Leben
> und edle Music-Kunst so lang die Noris steht,
> stets durch der [*sic*] Tugend Lob = und Fama Rhum = Trompet
> auf frommer Christenzung und in den Lüfften schweben.[3]

> ([Even] though Mr. Heinlein is dead, his pious life and noble musical art will, as long as Noris [Nuremberg] stands, always float on a Christian's tongue and in the air, owing to Virtue's glorious trumpet of praise and fame.)

Likewise, on the woodcut of the sixteenth-century composer and cantor Jacob Handl (1550–91) fully half the page was filled with a eulogy describing the posthumous fame that might accrue to the gifted and successful musician, advertising the beauty and power of Handl's art in a way that would surely have appealed to ambitious successors like C. P. E. Bach:

> Iacobus Handl ein Musicus
> Sonst Gallus genandt Carniolus,
> Der hat in wenig Jahren viel,
> Zum Singen und zum Seytenspiel;
> Gar nützlich Ding verrichtet baldt,
> Dann gleich wie in eim grünen Waldt,
> Die Vöglein untereinander singen,
> Daß eim das Hertz im Leib möcht springn,
> Für großer Frewd und Liebligkeit,

So hat er viel *Motetn* bereit,
Wem solt nu seine *Music* gut,
Erweichen nicht beid Hertz und Muth,
Er müst fürwar ganz steinern sein,
Das sich nicht ließ bewegen sein.
Drumb dancken wir und loben Gott,
Der uns erfrewt in mancher not,
Mit solcher schönen *Harmoney*,
Zu singen, spielen mancherley.
 [Henricus Goetting. W. Anno 1593]

Iacobus Handl, a musician, otherwise called Gallus of Carniola, he carried out much in few years, in [the realm of] singing and string playing, that is quite useful. Then, just as in the green forest the birds sing among themselves [so] that one's heart jumps in one's body for great joy and loveliness, so he wrote many motets; anyone whose heart and spirit is not softened by his good music, their heart must be truly of stone that it cannot be moved; therefore we thank and praise God, who gladdens us in times of sadness with such beautiful harmonies to variously sing and play.[4]

The charming description of Handl's music, its joyfulness and loveliness like birdsong in the forest that would move the heart of anyone not made of stone, speaks for itself: the music is memorialized, made permanent, along with the image of its creator. The eulogy praises Handl's music not only floridly, but specifically, with the distinction between vocal and instrumental genres that would eventually figure in the epitaph written for C. P. E. Bach himself by his friend the great Hamburg poet Friedrich Gottlieb Klopstock: "Do not quietly stand here, Imitator, / For if you stay, you will blush. Carl Philipp Emanuel Bach, the profound harmonist, / united novelty with beauty, / was great / in music accompanied by words, / greater/ in bold, wordless [music]. . . ."[5] That Bach looked closely at his pictures and studied their inscriptions is evident from his inventory entry for Handl: "*Handel, (Jacobus,* sonst *Gallus* genannt) Kapellmeister in Olmütz," which mirrors the first two lines of Goetting's poem rather than borrowing from Walther's *Lexikon* entry, where Handl is classified under the letter *G*: "Gallus (Jacobus) sonsten auch Händl . . . genannt."[6]

 In similar vein, the copperplate engraving of Thomas Selle (1599–1603), Bach's forerunner as director of music for the Hamburg city churches, beautifully rendered by Dirk Diricks (fig. 1.1),[7] presented, in addition to a fine image of Selle's face, basic biographical information (inscribed into the interior oval frame) and a quatrain that sang Selle's praises:

Sellius Aonidum Decus, haud postremus eorum
Musica qui tractant, exhibit hanc faciem.
Si pietas, candor, Genius, si scripta probata
Spectentur, celebrem FAMA per astra vehet.

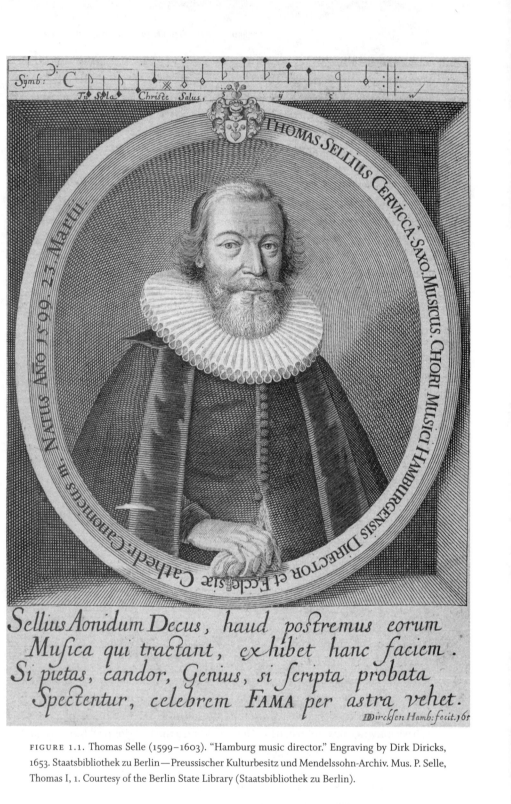

FIGURE 1.1. Thomas Selle (1599–1603). "Hamburg music director." Engraving by Dirk Diricks, 1653. Staatsbibliothek zu Berlin—Preussischer Kulturbesitz und Mendelssohn-Archiv. Mus. P. Selle, Thomas I, 1. Courtesy of the Berlin State Library (Staatsbibliothek zu Berlin).

Sellius, Pride of the Muses, hardly the least of those who practice music, shows this face. If [his] piety, candor, genius, if his proven writings should be considered, Fame will bear his celebrity to the stars.

Lasting fame could be achieved through music, especially the elevated musical learning signaled by the canon on the text "Tu sola Christe Salus" that decorates the portrait's inner frame.[8] Learned counterpoint was a visual code common to many of the portraits of the most distinguished figures in the collection, not least Samuel Scheidt (1587–1654), "Kapellmeister and organist in Halle,"[9] in whose portrait engraving a sheet of music inscribed with a canon on the text "In te Domine speravi," lying on a stone window ledge, marks the threshold between the composer's face and the laudatory poem presented in the cartouche below (fig. 1.2). As the entry on Scheidt in Walther's *Lexikon* confirmed, great achievement in the art and science of music (and especially learned counterpoint) made for a posthumous reputation that would be shored up in portraiture: Walther explains that Scheidt had made himself so famous "with his art [*Kunst*], and with his musical writings, printed in Hamburg, Leipzig and Halle" that his portrait hung beneath the great painting of the crucifixion in the library at the Liebfrauenkirche in Halle, where Scheidt had been organist (a post later occupied by C. P. E. Bach's brother Wilhelm Friedemann), and that another was to be found at the organ, funded in part by donations from Scheidt himself, in the St. Moritz Church, where it was accompanied by a laudatory verse (printed in full by Walther).[10] The portrait engraving in Bach's collection had been published as the frontispiece to Scheidt's *Tabulatura Nova* (1624), where it was accompanied by another celebratory poem:

> In effigiem SAMVELIS SCHEITI Musicoru[m] principis
> Hic ille est SAMVEL cuius vultu[m] aenea cernis.
> SCHEITIVS organici Gloria prima chori
> O numeris natam liceat quoque sculpere mentem
> Pegaseas liceat sculpere posse manus?
> Nil tibi laudo virum sat eum tibi publica laudant
> Scripta: sat artificem nobile laudat opus.

> [This is] in effigy of Samuel Scheidt, the prince of musicians.
> This here is Samuel Scheidt, whose face you see in copper,
> the first glory of instrumental music.
> Oh, can one engrave in meter his natural intellect,
> is one able to engrave his Pegasean hands?
> I praise this man to you not[,] enough do public writings praise him to you:
> noble work praises the artist sufficiently.

To look at the engraved portrait was to read of great deeds, to be reminded that reputation was the path to immortality. Portraits of these musicians brought their

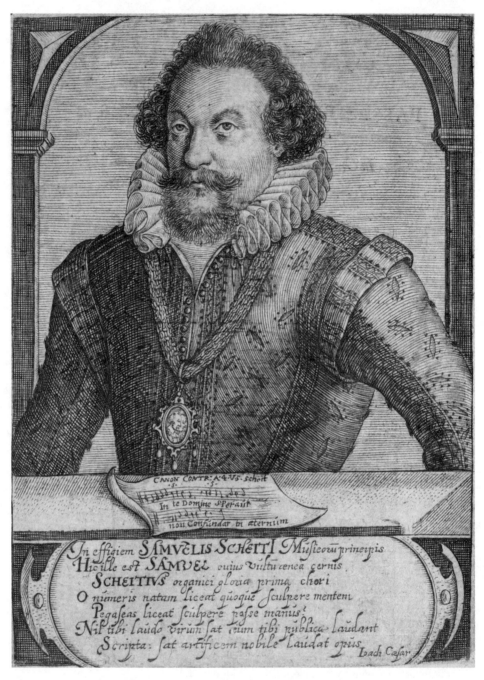

FIGURE 1.2. Samuel Scheidt (1587–1654). "Kapellmeister and organist in Halle." Engraving. Frontispiece to *Tabulatura nova* (1624). Courtesy of the New York Public Library.

work into the living presence of all who cared to look, simultaneously inscribing their achievements into the historical record.

On the largest scale, the portraits might be said to define the very notion of what music culture was for C. P. E. Bach and his circle: the myriad connections that encompassed learned composers and famous virtuosi, theorists, and organologists, instrument makers and distinguished patrons, set into a broad humanistic context with deep ties to literature, philosophy, aesthetics, and even cosmology. Further, this was a music culture rooted in a strong sense of the Bach family legacy—a legacy that the portrait collection brought vividly to life. Many of the portraits represented subjects C. P. E. Bach (also known as Emanuel Bach) would have heard spoken of, whose works he would have been familiar with, or whom he would have met in person in his father's household. In this sense the collection embodied an artistic and intellectual genealogy for C. P. E. Bach himself, suggesting a kaleidoscopic Bachian perspective on the music culture of his age and earlier ages.

At the same time, the collection conjured a vision of the musical future: the ways its individual subjects were represented offered models for how C. P. E. Bach—and perhaps his father and his brothers before him—might have understood the meanings of posthumous reputation, and methods of shoring it up. In portraits, reputations and their musical accomplishments were recorded and celebrated, put on permanent display in a way that the music itself—reliant on performance, evanescent, of the moment—could not. It is surely not a coincidence that C. P. E. Bach was himself deeply concerned with the ways his own achievements would be remembered, continually cataloging, reworking, and purging his works as well as consciously creating a monument to his own art with his series of large-scale choral works in the 1770s and 1780s.[11]

INFORMATION FOR AN INVENTORY

Collecting, as many commentators have noted, is a matter of cultivating and presenting an identity, an art of self-fashioning: the collection speaks of the collector's passions, priorities, and sense of self. A collection hints, too, at how the collector may wish to be viewed by others. As Susan Stewart writes,

> To ask which principles of organization are used in articulating the collection is to begin to discern what the collection is about. It is not sufficient to say that the collection is organized according to time, space, or internal qualities of the objects themselves, for each of these parameters is divided in a dialectic of inside and outside, public and private, meaning and exchange value. To arrange the objects according to time is to juxtapose personal time with social time, autobiography with history, and thus to create a fiction of the individual life, a time of the individual subject both transcendent to and parallel to historical

time. Similarly the spatial organization of the collection, left to right, front to back, behind and before, depends on the creation of an individual perceiving and apprehending the collection with eye and hand.[12]

Although we cannot know exactly how the Bach collection was displayed, we do have information on certain aspects of its organization, or more precisely the classification of its contents. Bach's portrait collection was the product of selection, classification, and ordering; as such, it has much to tell us about how Bach might have viewed his own position within the music culture in which he was deeply embedded, one that, especially as the eighteenth century wore on, could perhaps have been seen to culminate with him.

C. P. E. Bach prepared the inventory of the portrait collection himself, working on it over a long period. Carl Friedrich Cramer, editor of Hamburg's *Magazin der Musik*, mentioned in print in 1783 that a catalog was forthcoming.[13] Bach himself told his fellow collector J. J. H. Westphal in 1787 that it was almost ready to be printed; and in March 1789, just months after Bach's death, his widow noted in a letter to her late husband's long-standing business associate and friend, the printer Johann Gottlob Immanuel Breitkopf, that work was proceeding on the catalog of her late husband's estate, but that the inventory of the portrait collection was already done, having been "completely prepared" by him before his death.[14] As we have seen, the inventory provides an alphabetical list of sitters' names along with basic details of format, medium, and artist for the portraits. But more than this, it labels the portrait subjects by categories of professional identity, and for many it provides fragments of biographical information that offer clues to Bach's priorities in including subjects in his pantheon.

The inventory is organized alphabetically, but it identifies the portrait subjects according to professional rank and duty. The main classifications are Kapellmeister and director of music, followed by the prestigious, if generic, designation composer. Organists form another substantial group, as do singers. Bach classifies virtuosi according to their instruments, with violinists in the majority though others, especially lutenists, are also present in significant numbers. There are numerous "musical writers" (*Schriftsteller*) and "lyrical poets" (*lyrische Dichter*). Instrument makers, musical patrons, and mythical musicians are sprinkled across the ranks. The classifications are straightforward, but Bach's brief annotations add color and inflection with information on place of employment (especially for those with prestigious appointments), one-line summaries of a life, or an indication of a far from obvious connection to music.

Just as his letters to Breitkopf, Forkel, and Westphal reveal a collector evaluating his collection and identifying its lacunae, so the inventory annotations offer glimpses of Bach studying his holdings, organizing and arranging them, and deciding which information about the subjects is most relevant: Alexander the Great (356–323 BCE), he notes, "played the cyther" (94);[15] Saint Ambrose, bishop of Milan (340–94), "wrote many hymns" (94); Guido of Arezzo (c. 991 to

after 1033) "was a Benedictine monk and inventor of solmization" (94); Antonio Bernacchi (1685–1756), (principal) singer from Bologna, "served at the Bavarian and Austrian courts" (97); Heinrich Biber (1644–1704) was vice Kapellmeister at Salzburg and, Bach adds in a fine piece of understatement, "a good violinist" (97); Conrad Schott (1562–1630) was a "blind organ builder and mechanic in Augsburg" (120); Antonio Vivaldi (1678–1741), we are told, was "violinist and Kapellmeister in Venice at the Ospedale della Pietà" (124).

For some, more than one stage of a career needed to be outlined: Nikolaus Selnecker (1530–92) was first a musician, Bach notes, and thereafter a cleric, occupying the prestigious and powerful post of superintendent in Leipzig (121). For others, contributions to music culture were either too obvious to need detailing or seriously in need of explanation: Pietro Metastasio (1698–1782) is identified simply as a "lyrical poet" (113); such was his enormous fame that nothing more was needed. But Michael Richey (1678–1761) is described as a professor in Hamburg and secretary of the Patriotische Gesellschaft as well as a lyrical poet (118); Martin Luther (1483–1546) is summed up as the composer of many fine songs (111); Johann Friedrich Mayer (1650–1712), the pastor at St. Jacobi in Hamburg, as the author of a pamphlet on his objections to opera (112). Moving further afield, Lorenzo di Medici (1449–92) appears as a Florentine grand duke and a "good musician and patron" (112), Jupiter as "father of the Graces and teacher of music to his son Amphion" (109), Juno as Jupiter's wife and protector of the Graces (108), Mercury as the inventor of the lyre (113). And surely significant too is the complete absence, in a handful of cases, of any biographical information at all. For the two figures of perhaps the greatest stature in the collection, Friedrich Gottlieb Klopstock (1724–1803) and George Frideric Handel (1658–1759), nothing need be said: to look at the portrait of Handel (fig. 1.3), a mezzotint by John Faber of the magnificent 1749 Thomas Hudson portrait, was to see genius in all its portly glory, the master's great girth seeming to embody the vigor of his music, threatening to burst out of not only the tightly buttoned coat, but the portrait frame itself.[16]

Sometimes the inventory entries were lifted directly from the inscriptions on the engravings themselves (a useful clue for those trying to locate the pictures): the inventory follows the portrait engravings in designating the French artist and singer Elisabeth Chéron (1648–1711) as "célèbre dans la Musique, Poes[ie] & Peint[ure]" (99) and J. F. Lallouette (1651–1728) as "Maître de Musique de notre Dame à Paris" (110). There are hints, too, of Bach's acquaintance with the art collections of the age—his portrait of the singer Caterina Mingotti (1722–1808), he notes in the inventory entry, is a drawing by his son, Johann Sebastian Bach the Younger, after the original by Anton Mengs in the royal collection in Dresden (113), and that of the Dutch organist Hendrik Liberti (c. 1610–69) is an engraving after the Van Dyck portrait in Potsdam (94). Finally, there are glimpses of the famous Emanuelian sense of humor: Bacchus, we are told, is the god of wine and the sponsor of music schools (94).

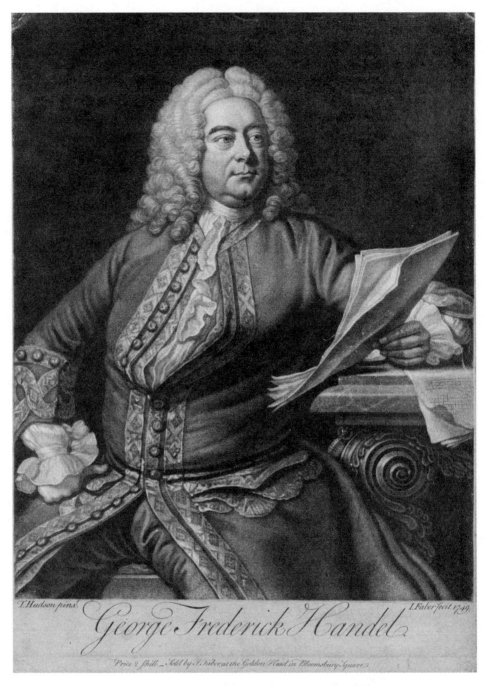

FIGURE 1.3. George Frideric Handel (1685–1759). Mezzotint by John Faber after Thomas Hudson, 1749. Staatsbibliothek zu Berlin—Preussischer Kulturbesitz und Mendelssohn-Archiv. Mus. P. Handel, G. Fr. II, 1a. Courtesy of the Berlin State Library (Staatsbibliothek zu Berlin).

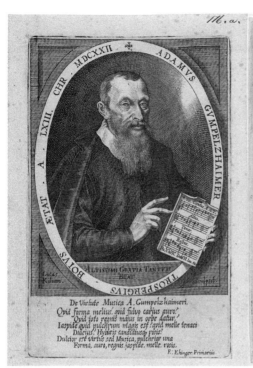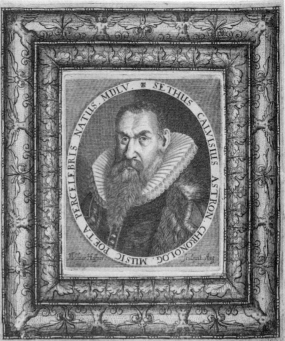

FIGURE 1.4 (A, left) Adam Gumpelzhaimer (1559–1625). "Music director in Augsburg." Engraving by Lucas Kilian, 1622. From Gumpelzhaimer, *Compendium musicae* (Augsburg, 1625). (B, right) Sethus Calvisius (1556–1615). "Music-director in Leipzig." Engraving by Melchior Haffner. Staatsbibliothek zu Berlin—Preussischer Kulturbesitz und Mendelssohn-Archiv. Mus. P. Gumpelzhaimer, Adam I, 1 and Mus. P. Calvisius I, 4. Courtesy of the Berlin State Library (Staatsbibliothek zu Berlin).

KAPELLMEISTERS AND MUSIC DIRECTORS

The numerous Kapellmeisters and music directors hanging in C. P. E. Bach's portrait gallery testified to the legacy of the men who had held those important positions before Emanuel himself in Hamburg and his father in Leipzig. Many of these figures had ties to the Bach family and to the musical world of Emanuel's youth, elements in a mosaic of interlocking and overlapping figures connected by personal contact, artistic reputation, professional succession, and humanistic tradition.[17]

Figures of the distant past whose music was still sung in the Leipzig churches during C. P. E. Bach's childhood there included Jacob Meiland (1542–77) in Ansbach and Jacobus Handl (1550–91) in Olmütz, both represented in the collection by woodcuts, and Adam Gumpelzhaimer (1559–1625) in Augsburg, whose portrait, an engraving by the Nuremberg master Lucas Kilian (fig. 1.4a), showed him holding in his left hand, while pointing to it with his right, a fragment of four-part counterpoint that alerted the knowledgeable viewer to Gumpelzhaimer's magisterial pedagogical collection filled with canons and learned counterpoint, the *Compen-*

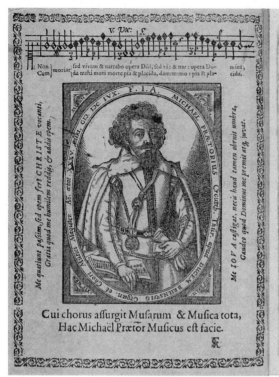
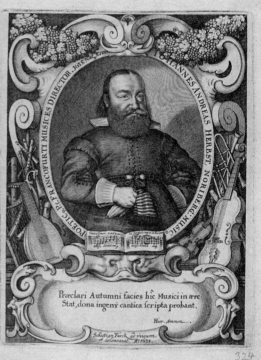

FIGURE 1.5. (A, left) Michael Praetorius (1571–1621). "Kapellmeister in Braunschweig." Woodcut from Praetorius, *Musae Sioniae* (Helmstedt, 1607). Courtesy of Harvard University, Harvard College Library. (B, right) Johann Andreas Herbst (1588–1666). "Kapellmeister in Frankfurt." Engraving by Sebastian Fürck, 1635. Staatsbibliothek zu Berlin—Preussischer Kulturbesitz und Mendelssohn-Archiv, Mus. P. Herbst I, 1. Courtesy of the Berlin State Library (Staatsbibliothek zu Berlin).

dium musicae latino-germanicum (1595–1605). Sethus Calvisius (1556–1615), too, would have been a familiar figure, J. S. Bach's seventeenth-century predecessor at the Thomaskirche, whose portrait engraving in quarto by Melchior Haffner, with its magnificent trompe l'oeil carved frame, advertised Calvisius's skills as both musical poet and astronomer (fig. 1.4b). Other key figures of seventeenth-century German music in this category included Michael Praetorius (1571–1621), Kapellmeister in Braunschweig-Wolfenbüttel (fig. 1.5a), in a portrait from his *Musae Sioniae IV* (1607) that was "extremely rare" according to Gerber,[18] its upper margin filled with a four-voice canon signaling Praetorius's accomplishments as a learned musician (his three-volume *Syntagma musicum* was in C. P. E. Bach's library);[19] there was also the Frankfurt Kapellmeister Johann Andreas Herbst (1588–1666), whose portrait engraving by Sebastian Fürck (fig. 1.5b) showed not only lavish representations of musical instruments but also, centrally placed on the lower rim of the inner oval framing the composer's image, an open book displaying a piece of learned counterpoint on the text "Music bleibet ewig" (Music remains forever).

More recent Kapellmeisters or music directors included the Ansbach Ka-

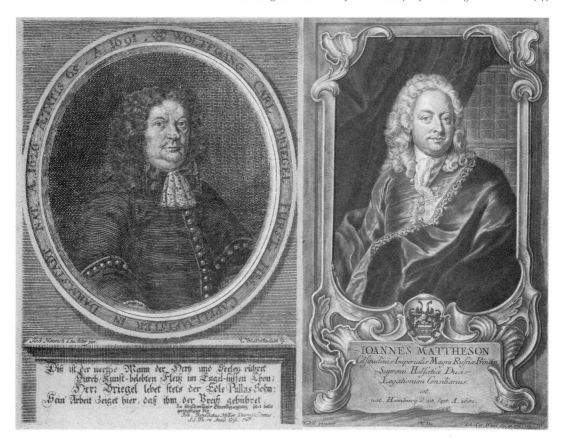

FIGURE 1.6. (A, left) Wolfgang Carl Briegel (1626–1712). "Darmstadt Kapellmeister." Engraving by Elias Nessenthaler after Johann Heinrich Leuchter. (B, right) Johann Mattheson (1681–1764). "Kapellmeister and Legations-Rath in Hamburg." Mezzotint by Johann Jakob Haid after Johann Salomon Wahl. Staatsbibliothek zu Berlin—Preussischer Kulturbesitz und Mendelssohn-Archiv, Mus. P. Briegel, W. K. I, 1, and Mus. P. Mattheson, II, 1. Courtesy of the Berlin State Library (Staatsbibliothek zu Berlin)

pellmeister Georg Heinrich Bümler (1669–1745), who was a founding member in 1738 of the Correspondierende Societät der musicalischen Wissenschaften (Corresponding Society of the Musical Sciences), the exclusive association established by the Leipzig music publisher and polymath Lorenz Christoph Mizler, J. S. Bach's student, which J. S. Bach joined in 1747 as its fourteenth member.[20] Others with connections to J. S. Bach included Wolfgang Carl Briegel (1626–1712), Kapellmeister at Gotha and then Darmstadt (fig. 1.6a), whose works J. S. Bach could have encountered in the choral library at St. Michael's, Lüneburg, and most likely also at Eisenach and Ohrdruf,[21] and Johann Mattheson (1681–1764), "Kapellmeister and Legations-Rath in Hamburg," in an imposing folio mezzotint by J. J. Haid after J. S. Wahl (fig. 1.6b).[22] An oil painting of Mattheson hung above the tallest pipe of the towering organ of sixty-five stops that Mattheson had (rather ostentatiously) donated to Hamburg's Michaeliskirche; C. P. E. Bach would have seen the portrait regularly when he made music in the church as part of his duties

as director of music in Hamburg, and when in 1772 he accompanied visitors such as Charles Burney to the balcony to see the organ.

Portrait engravings replete with paratexts present to the viewer not just a face, but also a career and a life. Consider the engraving by Georg Strauch of the Eisenach Kapellmeister Daniel Eberlin (1647 to between 1713 and 1715), showing the composer elegantly dressed in the gallery of a great church (fig. 1.7), with his big-cat mane and his extended index finger, the portrait supplemented by a ten-voice canon on the text "Ex ungue Leonem" (from its claw [we can know] the lion). There was also a dedicatory poem whose mention of Minerva referred to the swashbuckling Eberlin's soldiering in the Turkish wars during his study visit to Rome in the late 1670s. Here was a musician C. P. E. Bach could have heard much spoken of during his youth, for Eberlin would have worked closely with members of the Bach family in Eisenach, including the town musician Johann Ambrosius (C. P. E. Bach's grandfather) and the organist Johann Christoph Bach, who composed fifteen variations for keyboard on Eberlin's aria "Pro dormente Camillo." C. P. E. Bach's own godfather Georg Philipp Telemann was Eberlin's son-in-law. In his autobiography he told of Eberlin's many adventures and varied professional postings and described him as an accomplished contrapuntist and a fine violinist.[23] Exotic or not, the scholarly musical adventures of counterpoint were literally engraved into the images of these leading musicians, a visual shorthand for mastery of the learned art of music, and one of particular importance to those in the circle of the greatest contrapuntist of them all, J. S. Bach—whose portrait, too, followed this iconographical tradition and showed the composer holding a puzzle canon out to the viewer. The inscription of learned counterpoint into the portrait stamped the image with an incontrovertible testament to professional status, and many of these were impossible to miss in the proliferation of images on C. P. E. Bach's walls.

The Kapellmeisters and music directors whose portraits formed the dense heart of the collection ranged well beyond German-speaking lands and reached deep into the past: from a woodcut of Guido of Arezzo (c. 991 to after 1033) to a magnificent engraving by Lucas Vorsterman of the Jan Lievens portrait (commissioned by the composer himself) of the seventeenth-century "music director and painter in England"[24] Nicholas Lanier (1588–1666) (fig. 1.8); from engravings of the Flemish master Orlando di Lasso (1532–92) to his fellow Netherlander the Hapsburg court composer Philippe de Monte (1521–1603). And then there was Giovanni Pierluigi da Palestrina (c. 1525–94), held in high regard by J. S. Bach, who performed his music in Leipzig. His status in the family music culture was perhaps reflected in that his portrait was not a print but a drawing by an unnamed Italian artist (now lost).[25]

To eminent figures of the distant and recent past, many of whom his father had admired, learned from, and integrated into present musical practice, C. P. E. Bach added those who flourished during his own lifetime. One could turn from Johann Adolf Hasse (1699–1783), "Ober-Kapellmeister in Dresden," in an engraving by Lorenzo Zucchi after the Dresden court painter Pietro Rotari, to Friedrich

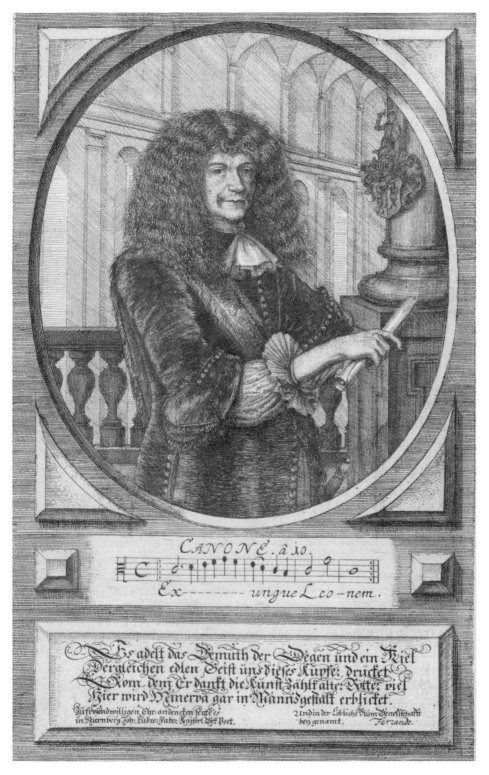

FIGURE 1.7. Daniel Eberlin (1647 to between 1713 and 1715). "Eisenach Kapellmeister." Engraving by Georg Strauch. Staatsbibliothek zu Berlin—Preussischer Kulturbesitz und Mendelssohn-Archiv, Mus. P. Eberlin, Daniel II, 1. Courtesy of the Berlin State Library (Staatsbibliothek zu Berlin).

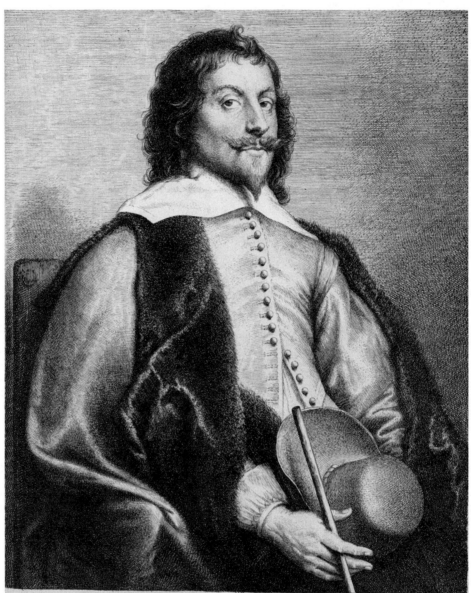

Nicolåo L'anier. In aula Sereniſsimi Caroli Magnæ Britanniæ Regis Muſicæ Artis
Directori, admodum Inſigni Pictori, Cæterarumque Artium Liberalium maximè
Antiquitatum Italiæ Admiratori et Amatori Summo, Mœcenati ſuo Vnicè
Colendo.

Ioannes Ievvius pinxit. *Franciscus vander Wyngaerde excudit.* *Lucas Vosterman sculpsit.*

FIGURE 1.8. Nicholas Lanier (1588–1666). "Music director and painter in England." Engraving by
Lucas Vorsterman after Jan Lievens. Rijksmuseum, Amsterdam.

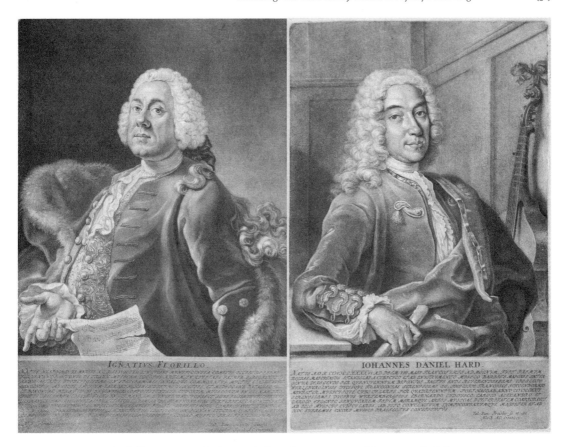

FIGURE 1.9. (A, left) Ignazio Fiorillo (1715–87). "Kapellmeister in Kassel." Mezzotint by Valentin Daniel Preisler after N. N. Colomba, 1750. (B, right) Johann Daniel Hardt (1696–1763). "Württemberg Kapellmeister." Mezzotint by Valentin Daniel Preisler, 1750. Staatsbibliothek zu Berlin—Preussischer Kulturbesitz und Mendelssohn-Archiv, Mus. P. Fiorillo, II, 1, and Mus. P. Hard, Joh. D III, 1. Courtesy of the Berlin State Library (Staatsbibliothek zu Berlin).

Hartmann Graf (1727–95), "music-director in Augsburg," in an oil portrait by his son Christian Ernst Graf (1723–1804), the court Kapellmeister in The Hague, and then to a self-portrait, also in oils, by Christian Ernst himself (both Graf paintings are now lost).[26] A set of splendid mezzotints made in the early 1750s by Valentin Daniel Preisler provided for the collection the Nuremberg Kapellmeister Johann Joachim Agrell (1701–65); the Italian Ignazio Fiorillo (1715–87) who was court Kapellmeister at Braunschweig-Wolfenbüttel and then at Kassel (fig. 1.9a); Carl Heinrich Graun (1703/4–59) who was a friend of both J. S. Bach and C. P. E. Bach, a fellow member with Johann Sebastian of Mizler's Sozietät and, from 1747, C. P. E. Bach's colleague as Kapellmeister at the Prussian court in Berlin; Johann Daniel Hardt (1696–1763), Kapellmeister at Württemberg and virtuoso on the viola da gamba, as shown by the instrument conspicuously hanging on the wall in his portrait (fig. 1.9b); and the Kapellmeister at Hanover, Johann Balthasar Lutter (1698–1757). By the time Bach's inventory was completed, figures in the

"Kapellmeister" and "music director" category crisscrossed Europe and stretched well into the present, to Joseph Haydn (1732–1809) at Esterházy, Davide Perez (1711–78) in Portugal, Anton Schweizer (1735–87) at Gotha, Johann Friedrich Reichardt (1752–1814) and Johann André (1741–99) in Berlin, Johann Adam Hiller (1728–1804) in Leipzig, Johann Heinrich Rolle (1716–85) in Magdeburg, Christian Friedrich Daniel Schubart (1739–91) in Stuttgart, Georg Joseph Vogler (1749–1814) in Mannheim in a life-size plaster bust (lost), Carl August Friedrich Westenholz (1736–89) at Ludwigslust in a gold-framed miniature painting (lost), and Ernst Wilhelm Wolf (1735–92) at Weimar.

THE STATUS OF ORGANISTS

J. S. Bach's obituary writers C. P. E. Bach and Johann Friedrich Agricola dubbed him "the world-famous organist."[27] C. P. E. Bach himself was trained as an organist and, in the 1750s, applied for organist positions, but by the 1770s he had played so little that he had, famously, "lost the use of the pedals," as Burney reported.[28] Not surprisingly, organists populated the portrait collection in large numbers, reflecting their status as learned musicians in Germany reaching back to the sixteenth century. Organists, more than other instrumentalists, could expect to have their portraits made, often to be included in the front matter of publications that continued to be known well into the eighteenth century.[29] C. P. E. Bach's collection included the portrait of the sixteenth-century Swabian organist Jacob Paix (1556–1623), a page of whose *Orgel Tabulaturbuch* (1583) Forkel would reprint in the second volume of the *Allgemeine Geschichte der Musik* (1802).[30] His woodcut of the Strasbourg organist Bernhard Schmid the Elder (1535–92) was in another important collection of intabulations of sacred and secular music, Schmid's *Zwey Bücher einer neuen kunstlichen Tabulatur . . . allen Organisten und angehenden Instrumentisten zu nutz* (1577). As I mentioned above, another important organ tablature book, the *Tabulatura Nova* (1624), provided the collection's portrait of Samuel Scheidt.

The interconnected circles of German organ culture could be traced vividly in C. P. E. Bach's gallery. The celebrated Hamburg organists Heinrich Scheidemann (c. 1595–1663) and Johann Adam Reincken (1623–1722) (see figs. 7.8a and 7.8b below) shared the walls with the Scheidt student Adam Krieger (1634–66), organist at the Nicolaikirche in Leipzig from 1655 to 1657 and court organist at Dresden from 1657 to his death, whose engraved portrait in folio by Johann Caspar Höckner and Christian Romstedt was glossed by another adulatory poem (fig. 1.10a). Likewise, Krieger's successor, the Leipzig organist Werner Fabricius (1633–79) (fig. 1.10b), who had studied with Scheidemann and, in addition to his work as organist and composer, was much in demand (like J. S. Bach) as an organ expert (his treatise on the proper inspection of organs, *Unterricht, wie man ein neu Orgelwerk . . . probiren soll*, was published posthumously in Leipzig in 1756). Fabricius was certainly part of the Bach family music culture, and a copy

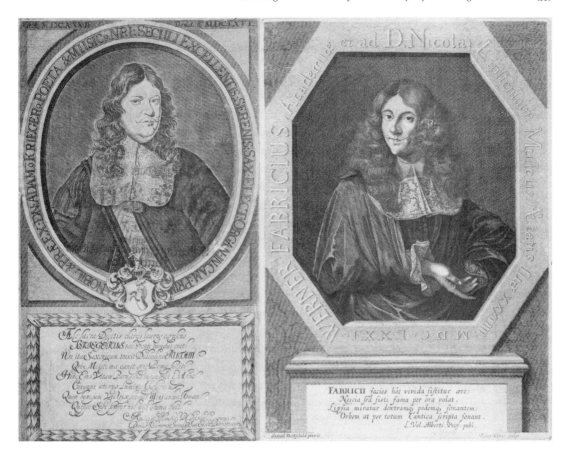

FIGURE 1.10. (A, left) Adam Krieger (1634–66). "Court organist in Dresden." Engraving by Christian Romstet after Johann Caspar Höckner. (B, right) Werner Fabricius (1633–79). "Organist in Leipzig." Engraving by Philip Kilian after Samuel Bottschild. Staatsbibliothek zu Berlin—Preussischer Kultur-besitz und Mendelssohn-Archiv, Mus. P. Krieger, Adam I, 1, and Mus. P. Fabricius, W I, 1. Courtesy of the Berlin State Library (Staatsbibliothek zu Berlin).

of Johann Thilo's funeral eulogy for him was in C. P. E. Bach's library, very likely inherited from Johann Sebastian Bach.[31] Also in the portrait gallery was the Leipzig organist Daniel Vetter (1657/58–1721), whose two-volume publication of organ chorales, the *Musicalische Kirch- und Hauss-Ergötzlichkeit* (1709–13) (see below, fig. 2.17b) was a fixture in the early eighteenth-century Leipzig chorale tradition, and especially the practice of amateur musical devotions in the home. The circle of Leipzig organists was filled out with a portrait of J. S. Bach's immediate prede-cessor Johann Kuhnau (1660–1722),[32] a man considered by eighteenth-century commentators to be one of the leading German musicians of the age.

The organists of the city of Nuremberg formed another group in the collection, from the Pachelbel student Maximilian Zeidler (1680–1745) in a magnificent folio print (see fig. 2.11 below), to an older generation that included, along with Paul Hainlein, Hainlein's successor at the church of St. Sebaldus, Johann Erasmus Kindermann (1616–55) and Kindermann's teacher, Johann Staden (1581–1634),

"Musicus Religiosus, Symphonista, et Organista" as the engraving by Johann Pfann the Younger (1640) announced. Organist at St. Sebaldus in Nuremberg and a composer of German songs, as well as sacred concertos in the Venetian style with Latin texts (*Harmoniae sacrae*, 1616) and German ones (beginning with the *Kirchen-Music*, 1625–26), Staden was credited by his later eighteenth-century biographers both with having absorbed the Italian style and with having asserted his independence from it as a German musician: What, one wonders, did Bach father or son think of Walther's claim that his motto was "Italians do not know everything, Germans are also capable of something" (Italiäner nicht alles wissen, Teutsche auch etwas können).[33] Portraiture played an important role in confirming Staden's status and assuring his posthumous reputation: a medal stamped with his portrait was made on his death in 1634, and the portrait in the Bach collection was engraved six years later. C. P. E. Bach's gallery provided literal confirmation of Bach's public statement, made in Friedrich Nicolai's *Allgemeine deutsche Bibliothek* in 1788, that "Good organists have from time immemorial been at home in Germany."[34]

Moving beyond German borders, a wider European organ culture was represented by portraits of Claudio Merulo (1533–1604), Girolamo Frescobaldi (1583–1643) (fig. 7.10b), whose *Fiori musicali* J. S. Bach had copied as a young man, Jean-Henry D'Anglebert (1629–91), Louis-Claude Daquin (1694–1772), Jean-Philippe Rameau (1683–1764), and Louis Marchand (1669–1732)—the last another organist whose direct connection to J. S. Bach was highlighted in C. P. E. Bach's obituary for his father. Finally, if a reminder of the power of the organist's art were needed, the two portraits of Dutch organists Sybrand van Noordt (1659–1705) and Hendrik Liberti (1610–69) offered plentiful confirmation.[35] The mezzotint by Pieter Schenck of Van Noordt (fig. 1.11), organist and carillonneur at the Oude Kerk in Amsterdam and then in Haarlem, celebrated the skill of this "Master in the art of music" and "outstanding organist," as the title inscription calls him, in a poem that drew attention to the memorializing medium, the print itself:

> Schenks snykunst maalt van Noord de Roem der Kunstenaaren,
> Wiens doorgeleerd Musyk de Kunstekenners streelt,
> Als hy, door Lust genoopt, op't Orgel gaad' loos speelt,
> En toont, hoe zyn vernuft voor and'ren is ervaaren.
> Doch deze Prent verbeeld slegs d'ommetrek en leest
> Des grooten Meesters, wydbefaamt door kunst en geest.
> Men moet's mans gaaven in zyn Orgelspeelkunst hooren,
> Of Clavicimbelklank, of Klokspel op den Tooren" [A:Alewyn, 1702]

> Schenk's engraving depicts van Noord the famous artist,
> Whose learned music delights the connoisseurs
> When he, incited by joy, plays the organ without equal,
> And shows how his ingenuity is experienced by others.
> Yet this image only shows the contours and shape

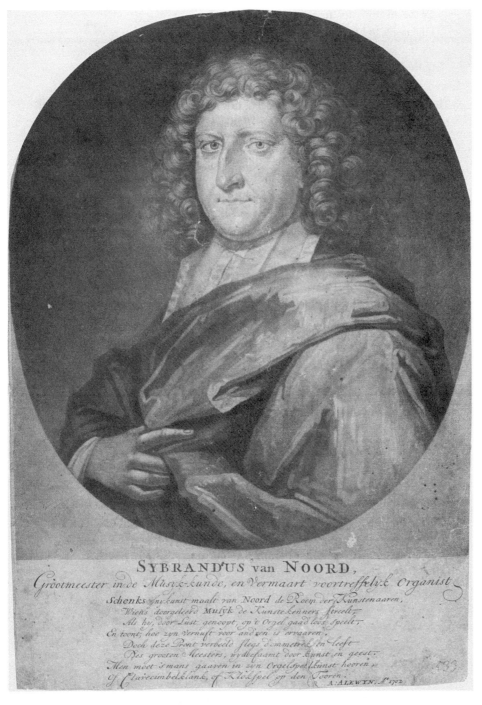

SYBRAND·US van NOORD,

Grootmeester in de Musyk-kunde, en Vermaart voortreffelyk Organist,

Schenks ynekunst maalt van Noord de Roem der Kunstenaaren,
Wiens doorgeleerd Musyk de Kunste kenners streelt
Als hy, door Lust genoopt, op 't Orgel gaad loos speelt,
En toont, hoe zyn vernuft voor and'ren is ervaaren,
Doch deze Prent verbeeld slegs d'immetrek, en leeft
Des grooten Meesters, vydbefaamt door Kunst en geest,
Men moet 's mans gaaven in zyn Orgelspel kunst hooren
Of Clavecimbelklank, of Klokspel op den Tooren.

A: ALEWYN. N° 1702.

FIGURE 1.11. Sybrand van Noordt (1659–1705). "Organist and carillonneur in Holland." Mezzotint by Pieter Schenk, 1702. Staatsbibliothek zu Berlin — Preussischer Kulturbesitz und Mendelssohn-Archiv. Mus. P. Noordt, Sybr. Van. I, 1. Courtesy of the Berlin State Library (Staatsbibliothek zu Berlin).

Of the great master, renowned for art and spirit
One needs to hear his (this man's) gifts in his organ-playing,
Or in the sound of (his) harpsichord-playing, or his playing
of the bells in the tower.

The inscription hints at the paradox of musician portraiture, the organist commemorated in a visual image that, for all the artist's skill, cannot evoke the sounds the subject's reputation is founded on and that he will be remembered for.

Yet the skill of the artist in preserving (or reinforcing) a reputation for eternity was on full display in Pieter de Jode's engraving of Anthony van Dyck's magnificent portrait of Liberti, John Bull's successor at the Antwerp Cathedral (fig. 1.12). The young man is depicted in the throes of inspiration, eyes upturned, hair billowing, wearing a double chain of honor, and holding a piece of music on which is written a canon with the text "Ars longa vita brevis." This portrait was well known, and one of its at least eight copies hung in the royal gallery at Potsdam, as C. P. E. Bach, who had likely seen it there, noted in his inventory entry. Little information about the work of either musician seems to have circulated; Walther could come up with only a very short entry on Van Noordt, and nothing on Liberti, while Gerber only copied Walther on the former and, on the latter, wrote mostly about the portrait. Yet the imposing mezzotint of Van Noordt, with its effusive eulogy, and the sheer artistic brilliance of the Van Dyck portrait of Liberti, speak volumes about importance, legacy, and artistic presence—and about the status of organists. A third Dutch organist in the collection, Dirk Scholl (1640/41–1727), confirms this; he is represented, like Liberti and Van Noordt, in fashionable mezzotint (by T. van der Wilt, 1699), with the clock tower of the Arnhem Cathedral in the distance behind the elegantly dressed musician (fig. 1.13)—a reminder that, as the verse on Schenck's portrait had made explicit, the duties of Dutch organists extended to the carillon. That these three organists, about whom relatively little was known beyond the compelling presence conveyed by their portraits, should have made it into C. P. E. Bach's collection affirms the status of organists in the edifice of German, and Bachian, music culture, but it is also testament to the collector's sensitivity to the quality of the visual image.[36]

COMPOSERS AND INSTRUMENTALISTS

Perhaps the most up-to-date and expansive category in C. P. E. Bach's portrait inventory, and the one that included many distinguished colleagues of his own generation as well as younger ones, was the more general designation "composer" (*Componist*). Earlier *Componisten* in the collection included the eleventh-century theorist Hermanus Contractus (1013–54); the Italian philosopher and humanist Giovanni Pico della Mirandola (1463–94); the French Huguenot composer Claude LeJeune (1528/30–1600); the Portuguese humanist and composer Damianus à Goes (1502–74); the theologian and composer of liturgical music and Protestant

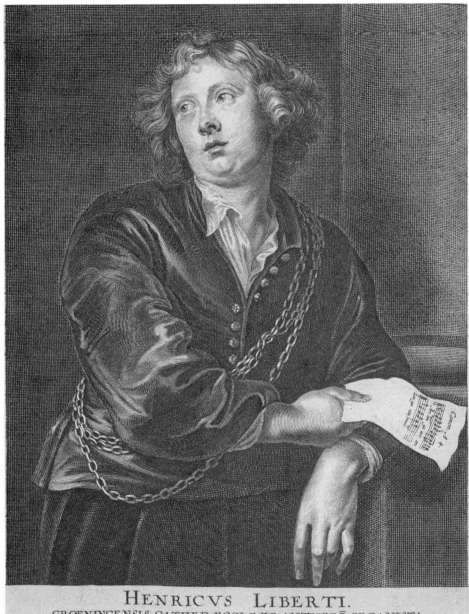

HENRICVS LIBERTI.

GROENINGENSIS CATHED. ECCLESIÆ ANTVERP. ORGANISTA.

Anton. van Dyck pinxit. Petrus de Iode sculpsit.

FIGURE 1.12. Hendrik Liberti (1610–69). "Organist in Antwerp." Engraving by Pieter de Jode II after Anthony van Dyck. Staatsbibliothek zu Berlin—Preussischer Kulturbesitz und Mendelssohn-Archiv. Mus. P. Liberti, Hendrik I, 1. Courtesy of the Berlin State Library (Staatsbibliothek zu Berlin).

DIRK SCHOLL.

Organist en klokkenist, voor defen tot Arnhem, en nu zedert den Jare 1665, tot Delft.

Dit beeld dien phénix uijt. die Orgels, klokken, fnaaren,
Bezield met Hemel galm. Sijn vrugtbre Geest en vlijt,
Verbeeld zig zelf alom, door grooff Mufijk te baaren:
Dies fal fijn Naam en Loff verduuren nijd en tijd.

Anno 1699. *T. van der Wilt pinx. et fec.*

FIGURE 1.13. Dirk Scholl (1640/41–1727). "Organist and carillonneur in Holland." Mezzotint by Thomas van der Wilt, 1699. Staatsbibliothek zu Berlin — Preussischer Kulturbesitz und Mendelssohn-Archiv Mus. P. Scholl, Dirk. Courtesy of the Berlin State Library (Staatsbibliothek zu Berlin).

hymns Leonhard Paminger (1495–1567); and Luther himself, hanging in a particularly opulent frame with a gilded inner rim. Here too were the Braunschweig organist and composer of hymns Johannes Jeep (1581/82–1644) and the Strasbourg composer Christoph Thomas Walliser (1568–1648).

Moving far beyond the realm of Lutheran church music, though, the collection's portraits of "composers" of the seventeenth and eighteenth centuries constituted an international roster of famous men and included many outstanding examples of the engraver's art as well as originals in pencil and in oil: they ranged from the imposing English folio mezzotints of Arcangelo Corelli (1653–1713), Francesco Geminiani (1687–1762), and Jean-Jacques Rousseau (1712–78) to John Frederick Lampe (1702/3–51) composing at the organ (fig. 1.14) and Richard Leveridge (1670–1758), with his fleshy chin and warty face countered by the bright hooded eyes and the elegantly raised conducting hand (fig. 1.15). (The Lampe and Leveridge mezzotints were two of the most expensive prints in the collection when it went up for sale in 1797.) Others varied from the vivid image of Willem de Fesch (1687–1761), caught with pen in hand, to the spectacular engraving of Antoine Watteau's portrait of Jean-Féry Rebel (1666–1747) (fig. 4.8 below); and from Miger's engraving of Duplessis's famous painting of Christoph Willibald Gluck (1714–87), the pockmarked visage lit up as if by inspiration (fig. 1.16), framed in a classical stone oval above an architectural mantel (suitably adorned with a eulogy), to the classically inflected prints of Jean-Baptiste Lully (1632–87), François-André Danican Philidor (1726–95), and Niccolò Piccinni (1728–1800). Likewise listed as composers were Bach's Berlin friends and colleagues Johann Joachim Quantz (1697–1773), in both a drawing by J. H. C. Franke and an engraving of that drawing by Johann David Schleuen (fig. 7.13 below) and Johann Philipp Kirnberger (1721–83), in an oil portrait, along with the contemporary Dresden composers Joseph Schuster (1748–1812) and Franz Seydelmann (1748–1806). In the portrait collection, individual attainment is celebrated, but so too are the intersections, commonalities, and threads of influence that weave the individuals together into a vivid tapestry, illustrating the cultural legacy of the educated German musician from the sixteenth century to the eighteenth.

If we want to follow still further the ways the professional associations, and indeed the skills, of C. P. E. Bach, his brothers, and especially his father, were reflected in the portrait collection, we could turn to the largest group of instrumentalists represented there: violinists. Many of these were classified under the rubric *Konzertmeister*, and they included Emanuel's brother Johann Christoph Friedrich Bach (1732–95) in Bückeburg (an oil painting)[37]; the seventeenth-century violinist Johann Beer (1655–1700) at Weissenfels (another mezzotint by Pieter Schenck); Emanuel's colleagues in Berlin Franz Benda (1709–86) in a mezzotint by J. M. Schuster; Johann Gottlieb Graun (1702/3–71) in an oil painting by an unnamed artist (lost); the Dresden violinist Johann Georg Pisendel (1687–1755), whom Emanuel Bach knew from his youth (in a drawing that Bach designated in the inventory entry as "a very good likeness" [*sehr ähnlich*]; fig. 1.17); and Georg Bernhard Leopold Zeller (1728–1803) at Mecklenburg-Strelitz, in an oil painting by Samuel Cogho (lost).[38]

FIGURE 1.14. John Frederick Lampe (1702/3–51). "English church composer." Mezzotint by James McArdell after S. Andrea. Staatsbibliothek zu Berlin — Preussischer Kulturbesitz und Mendelssohn-Archiv. Mus. P. Lampe, J. Frd. II, 1. Courtesy of the Berlin State Library (Staatsbibliothek zu Berlin).

FIGURE 1.15. Richard Leveridge (1670–1758). "English composer." Mezzotint by William Pether after Thomas Frye. Courtesy of the New York Public Library.

FIGURE 1.16. Christoph Wilibald Gluck (1714–87). "Knight, composer." Engraving by Simon Charles Miger after Joseph Siffred. Staatsbibliothek zu Berlin—Preussischer Kulturbesitz und Mendelssohn-Archiv. Mus. P. Gluck, Ch. I, 9. Courtesy of the Berlin State Library (Staatsbibliothek zu Berlin).

FIGURE 1.17. Johann Georg Pisendel (1687–1755). "Concertmaster in Dresden." Drawing by Johann Heinrich Christian Franke. Black chalk and india ink with white highlights and wash on cream paper. 25 × 18.5 cm. Staatsbibliothek zu Berlin—Preussischer Kulturbesitz und Mendelssohn-Archiv. Mus. P. Pisendel, Joh. Georg. I, 1. Courtesy of the Berlin State Library (Staatsbibliothek zu Berlin).

FIGURE 1.18. Nicola Cosimi (1660–1717). "Roman violinist." Mezzotint by John Smith after Sir Godfrey Kneller, 1706. Staatsbibliothek zu Berlin—Preussischer Kulturbesitz und Mendelssohn-Archiv. Mus P. Cosimi, Nic, II, 1. Courtesy of the Berlin State Library (Staatsbibliothek zu Berlin).

But it was famous Italian virtuosi who dominated the gallery under the more general designation violinist: Corelli and Geminiani (classified both as composers and as violinists); the young Nicola Cosimi (1660–1717), in a superb mezzotint by John Smith, whose chiaroscuro effects seem to emphasize the violinist's enormous wig (fig. 1.18); Bach's contemporaries Antonio Lolli (c. 1725–1802), in a drawing

in pastels specially made for the collection (see fig. 5.9a below),[39] Pietro Nardini (1722–93), and Giuseppe Tartini (1692–1770), both in copperplate engravings; Gaetano Pugnani (1713–98) in a caricature drawing (lost); Regina Strinasacchi (1759–1839) in what was likely a specially commissioned drawing (lost), and the aged Carlo Tessarini (1690 to after 1766) in a wonderfully expressive mezzotint by William Pether (fig. 1.19). There was also a miniature of the English violinist John Abraham Fisher (1744–1806) (lost).

Of an earlier generation of violinists there was the essential Antonio Vivaldi (1678–1741) as well as Francesco Montanari (1676–1737) and Tommaso Antonio Vitali (1663–1745), the last described in the inventory as "violin teacher to Padre Martini" and depicted in profile in a beautiful pencil drawing (fig. 1.20). The legendary Hamburg violinist Johann Schop (c. 1590–1667) was there, in a portrait printed on the title page of his *Geistlicher Concerten* (1644); so too was Heinrich Biber (1644–1704), in the engraved portrait published on the title page of his *Sonatae violine solo* (1681). Among French violinists, there were elegant engravings of Jean-Marie Leclair (1697–1764) (fig. 1.21a), Joseph Legros (1739–93), Charles Ernest baron de Bagge (1722–91) (fig. 1.21b), and Jean-Pierre Guignon (1702–74). The Austrian violinist Johann Heinrich Schmelzer (1620–80) was represented in a mezzotint showing him holding not a violin, but the medallion and chain that marked his ennoblement (fig. 1.22). Eighteenth-century German biographers including Walther and Gerber were careful to note that Schmelzer was the first native musician to become Kapellmeister at the Viennese court—thus earning an important position in the history of German music. And indeed, C. P. E. Bach's categories were hierarchical: Schmelzer was classified with the Kapellmeisters, not the violinists, just as Kuhnau was listed among the music directors, not the organists. At this stage of our tour through the gallery it is perhaps important not to overstate how much choice was involved in the acquisition of this great volume and variety of portraits; as is abundantly clear, while Bach was a discriminating collector, availability and accident surely played a role in the what he acquired. Nevertheless, once portraits were in the collection, connections, hierarchies, and systems of meaning accrued among them.

As with organists, the wealth of lutenists in the collection reflected the long-standing status of the court lutenist, but perhaps here too we catch a glimpse of a musical worldview C. P. E. Bach inherited from his father. The engraving of J. S. Bach's friend and contemporary Sylvius Leopold Weiss (c. 1687–1750), by Bartolomeo Folin after the portrait by Balthasar Denner (fig. 1.23), besides giving places and dates of birth and death, laconically states, "Only Sylvius should play the lute" (Es soll nur Sylvius die Laute spielen).[40] This inscription was belied by the many other lutenists that hung on Bach's walls, from Weiss's contemporary Ernst Gottlieb Baron (1696–1760) whose superb engraved portrait seems to invite the viewer to listen in (see fig. 2.4 below), to the English beauty Arabella Hunt (1662–1705) in a mezzotint by John Smith after the full-length portrait by Sir Godfrey Kneller, in which Hunt dreamily plays her lute in a woodland glade (fig. 7.6 below). An earlier generation of lutenists was represented by the old

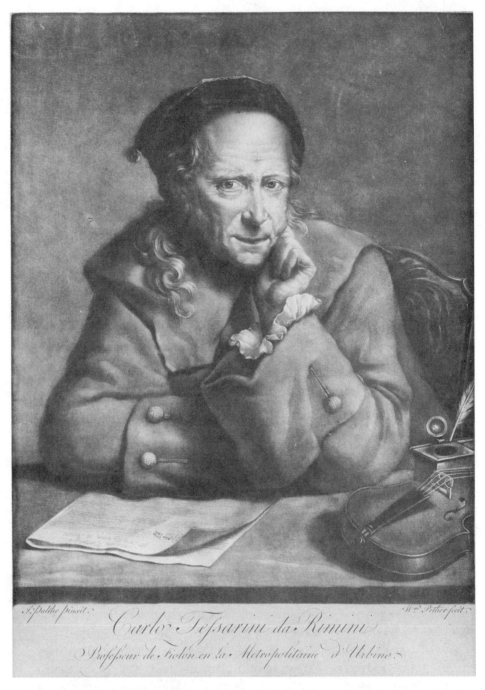

Carlo Teſsarini da Rimini
Profeſseur de Violon en la Metropolitaine d'Urbino

FIGURE 1.19. Carlo Tessarini (1690 to after 1766). "Professor, *musicus*, and violinist." Mezzotint by William Pether after Jan Palthe. Staatsbibliothek zu Berlin—Preussischer Kulturbesitz und Mendelssohn-Archiv. Tessarini, Carlo II, 1. Courtesy of the Berlin State Library (Staatsbibliothek zu Berlin).

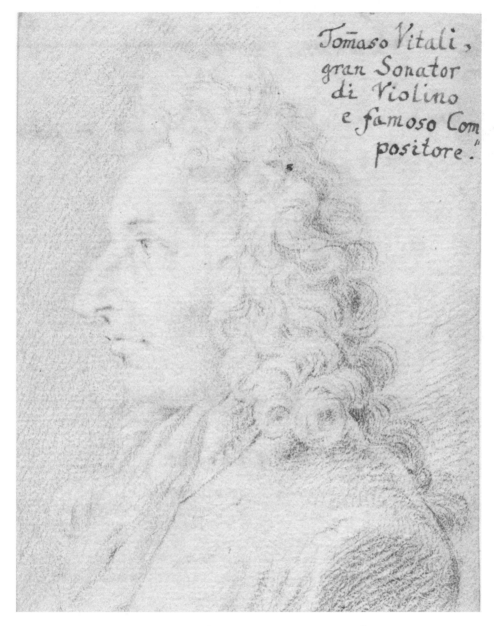

Tomaso Vitali,
gran Sonator
di Violino
e famoso Com
positore."

FIGURE 1.20. Tommaso Antonio Vitali (1663–1745). "Violinist, teacher of Padre Martini on the violin." Drawing by unnamed Italian artist. Black chalk on white paper. 12.5 × 9 cm. Staatsbibliothek zu Berlin—Preussischer Kulturbesitz und Mendelssohn-Archiv [small] Mus. P. Vitali, Tommaso I, 1. Courtesy of the Berlin State Library (Staatsbibliothek zu Berlin).

Burgundian Jean-Baptiste Besard (c. 1567 to after 1616), and a trio of sixteenth- and seventeenth-century Nuremberg lutenists, Melchior Schmidt (1608-?), Sebastian Ochsenkuhn (1521–74), and Johann Wellter (1614–66). Some of these figures were quite obscure by the later eighteenth century: Wellter, who appears to have been something of an insider tip for those in the know about the lute and its players,

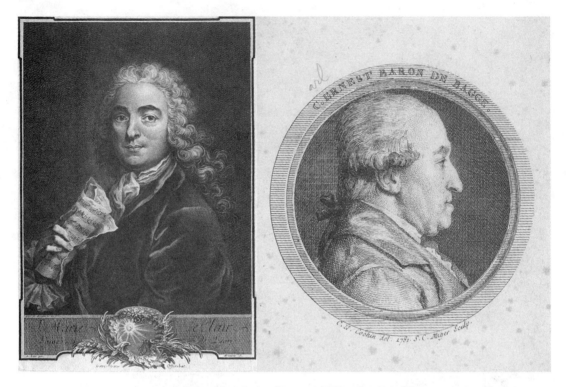

FIGURE 1.21. (A, left) Jean-Marie Leclair (1697–1764). "French violinist." Engraving by Jean Charles François after Alexis Loir, 1741. ÖNB Vienna PORT 00155787_01. (B, right) Charles Ernest, Baron de Bagge (1722–91), "in Paris." Engraving by Simon Charles Miger after Charles Nicolas Cochin the Younger, 1781. Yale University Art Gallery.

merits only a very small entry in Walther, and Gerber had little to say beyond what he saw on this portrait and in Bach's inventory entry: "He appears to have been a particular master on the lute, since he was engraved in quarto in 1668 with a lute under his arm."[41] Bach could have read about Wellter's accomplishments, and those of the others represented in his collection, in his copy of Baron's *Historische, theoretische, und praktische Untersuchung des Instruments der Lauten* (Nuremberg, 1727), where Wellter is praised as one of the foremost lutenists of his time. While some portraits presented a simple head (Besard), others set the scene with a full domestic interior; still others were particularly lavish masterpieces of the engraver's art, such as the portrait of the French-born lutenist Nicolas Vallet (1583–1642), incorporated into the frontispiece to his *Paradisus musicus testudinis* (1618), with its mythical musicians, garlands, and musical instruments (fig. 2.17a below). Equally impressive is the striking etching by Jan Lievens of the seventeenth-century French lutenist Jacques Gaultier (c. 1600 to before 1660), the rich fabric of his robe as splendidly vivid as his unruly dark hair and eyebrows, his musical art signified simply by the neck of the theorbo sharply profiled against the distant grove in the background (fig. 1.24).

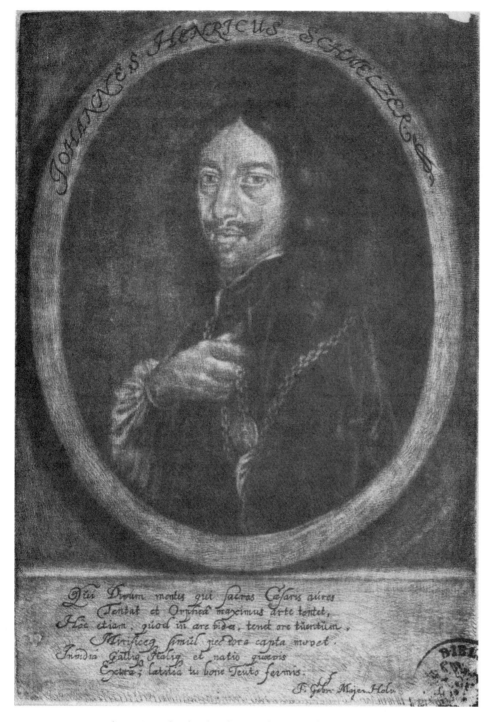

FIGURE 1.22. Johann Heinrich Schmelzer (1620–80). "Imperial vice-Kapellmeister." Mezzotint.
ÖNB Vienna PORT 00015480_01.

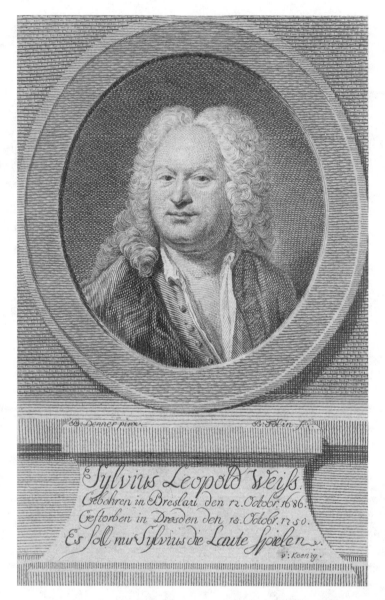

FIGURE 1.23. Sylvius Leopold Weiss (c. 1687–1750). "Royal Polish and electoral Saxon lutenist in Dresden." Engraving by Bartolomeo Folin after Balthasar Denner. Staatsbibliothek zu Berlin—Preussischer Kulturbesitz und Mendelssohn-Archiv. Mus. P. Weiß I, 1. Courtesy of the Berlin State Library (Staatsbibliothek zu Berlin).

The instrument that produced some of the liveliest images in the collection, however, most redolent of musical reverberation and performative energy, was the cello: from the lavish setting and elegant poise of Franceso Alborea, also known as "Franciscello" (1691–1739) in the mezzotint by Haid after Martin Meytens (fig. 1.25), in which the fabrics of the cellist's chair and livery coat are palpable, his clothing loosened and billowing from the physical activity, the wig slightly askew and ear cocked as if to draw the viewer's attention to the sound emanating from Franciscello's instrument; to the mezzotint of John Hebden (c. 1705–65)

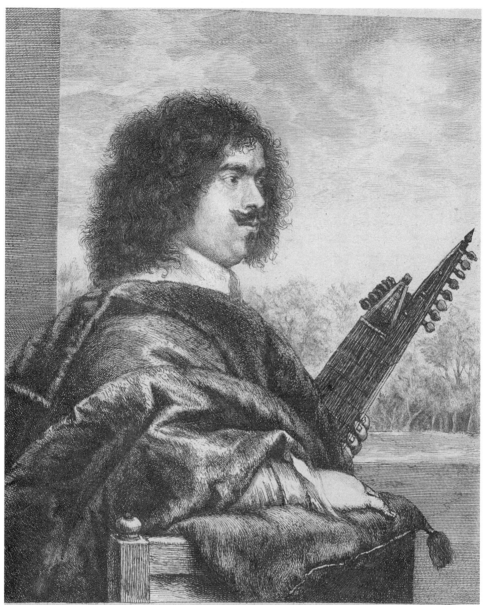

IACOBO GOVTERO INTER REGIOS MAGNÆ BRITANNIÆ ORPHEOS ET AMPHIONES
LYDIÆ DORIÆ PHRYGIÆ TESTVDINIS FIDICINI ET MODVLATORVM PRINCIPI
HANC E PENICILLI SVI TABVLA IN ÆS TRANSSCRIPTAM EFFIGIEM IOANNES LÆVINI
FIDÆ AMICITIÆ MONIMENTVM L M CONSECRAVIT.

Ioannes Livins fecit et excudit

FIGURE 1.24. Jacques Gaultier (c. 1600 to before 1660). "Lutenist." Engraving by Jan Lievens after a painting by Lievens. Staatsbibliothek zu Berlin—Preussischer Kulturbesitz und Mendelssohn-Archiv. Mus. P. Gouter, Jac. I, 1. Courtesy of the Berlin State Library (Staatsbibliothek zu Berlin).

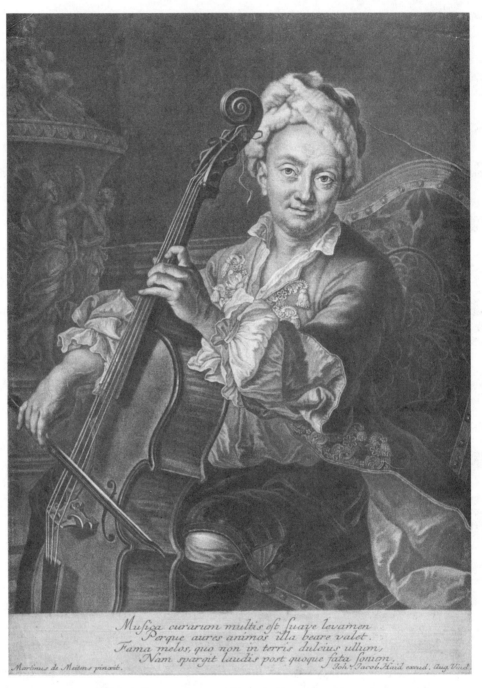

Musica curarum multis est suave levamen
Perque aures animos illa beare valet.
Fama melos, quo non in terris dulcius ullum,
Nam spargit laudis post quoque fata sonum.

Martinus de Meitens pinxit. *Joh.ᵉ Jacob Haid excud. Aug. Vind.*

FIGURE 1.25. Francesco Alborea, aka "Franciscello" (1691–1739). "Imperial violoncellist." Mezzotint by Johann Jakob Haid after Martin van Meytens. ÖNB Vienna PORT 00155552_01.

by John Faber, after Philippe Mercier, in a more humble, less courtly setting, yet with equal force and energy—the hands in action, the cello facing the viewer as Hebden leans energetically forward to read the score on the harpsichord's music desk (fig. 1.26).

THE COMPOSER AS READER

Through the assembled faces of the musicians gathered in his musical portrait collection, the Kapellmeisters and organists, the famed instrumentalists, court singers, keyboardists, and instrument makers, Bach was able to construct a picture of his profession as an art of great depth and breadth, practiced in church, theater, and chamber, flourishing in the present but rooted in the past. But this description fails to properly account for fully a third of the portraits in that collection. This third represented not practicing musicians of the past and present, but rather writers, ranging from antiquity to the present day, from classical scholars to contemporary theologians, from Renaissance occultists to modern poets. Many were experts in music and made major contributions to its theoretical literature, others were writers on aesthetics who touched on music in consideration of the arts in general, or poets who had created a body of work for composers to set to music. A minority seem to have had little if anything to say directly about music, instead contributing to other aspects of humanistic scholarship.

This large group of portraits highlights the scholarly and theoretical aspects of the art of music, its long-standing position at the center of humanistic debate, and its sisterhood with poetry, reminding spectators that music is an art with a rich critical and theoretical apparatus, tightly bound up with the literary arts. Above all, the portraits of writers and poets frame an identity for the collector himself as the product of a humanistic education whose cultural reach ranged far beyond the narrower confines of the seventeenth-century craftsman or the eighteenth-century virtuoso. As Jakob Adlung had stressed in the introduction to his encyclopedic *Anleitung zu der musikalischen Gelahrtheit* (Erfurt, 1758), to be learned in music was not only to know how to sing and play, or to compose, but "when many kinds of musical subjects were spoken or written about, to be able to understand such speeches and writings."[42] The learned musician must be well versed in music-critical and literary thought.

Bach entered eighty-four portraits in his inventory under the rubric *Schriftsteller* (writer), a few of them doubling as *Musicus* or *Componist*. He categorized eighteen more as *Lyrischer Dichter* (lyrical poets), and a handful of other literary figures received no classification at all (as if their names spoke for themselves: these included Virgil, Cicero, Dionysius, Epicurus, Homer, Plato, Seneca, and Descartes). Although constituting nearly a third of the whole collection (not counting the silhouettes), almost none of the portraits of writers and poets were framed. Instead, they were kept in the portfolios that eventually became the containers for the portraits of practicing musicians too, once the walls were

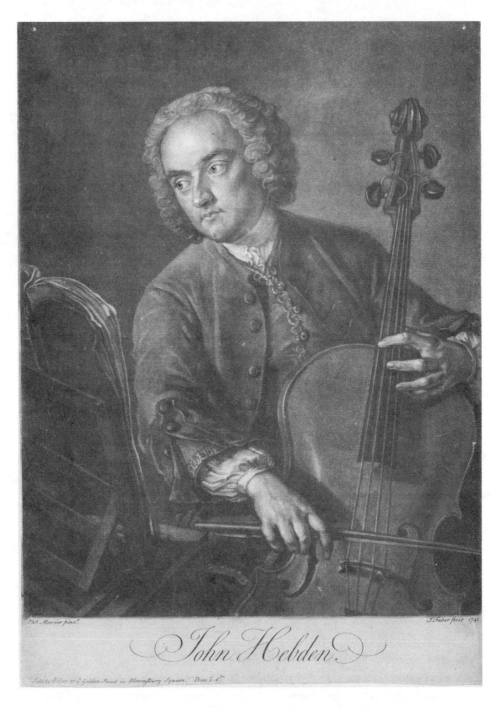

Phil. Mercier pinx.^t J. Faber fecit 1741

John Hebden.

Sold by Faber at y^e Golden Head in Bloomsbury Square. Price 1. s.

FIGURE 1.26. John Hebden (c. 1705–65). "Violoncellist in England." Mezzotint by John Faber the Younger after Philippe Mercier, 1741. Staatsbibliothek zu Berlin—Preussischer Kulturbesitz und Mendelssohn-Archiv. Mus. P. Hebden II, 2. Courtesy of the Berlin State Library (Staatsbibliothek zu Berlin).

full. The few exceptions were mostly very well-known figures of the eighteenth century, many of them doubling as professional musicians or composers, including Rameau, Rousseau, Marpurg, d'Alembert, and Athanasius Kircher.[43]

For the most part, though, Bach's portraits of musical writers and theorists were not on display. As with the composers and performers, they were a heterogeneous group. Reaching furthest back were figures such as the ancient Greeks Pythagoras, "the Inventor of Intervals,"[44] Callimachus, and Ptolemy, along with the Neoplatonic philosopher Porphyry. The medieval scholar Albertus Magnus (1195–1280) kept company with the early Italian humanists Marsilio Ficino (1433–99) and Angelo Poliziano (1454–94), the humanists and philologists Julius Caesar Scaliger (1484–1558) and Josephus Justus Scaliger (1540–1609); the Dutch humanist and anti-Reformation polemicist Alardus Amstelredamus (1491–1544), who published an edition of the works of Rudolf Agricola (1444–85), and Agricola himself in a drawing (now lost) by Bach's son, Johann Sebastian Bach the Younger. Information on life and works for all of these except Ficino and Alardus was available in Walther; for the latter two, who seemed to have contributed little to music, biographies were to be found in the late sixteenth-century volumes that were the source for the woodcuts, Nikolaus Reusner's portrait-biography books, *Icones sive imagines virorum literis illustrium.*[45]

From volumes of Reusner C. P. E. Bach could have obtained his woodcuts of the German theologian and music theorist Johannes Cochlaeus (1479–1552), the humanist and early supporter of the Reformation Helius Eobanus Hessus (1488–1540), who was at the center of the humanistic scholarly circle in Erfurt, and the Swiss humanist Conrad Gesner (1516–65). Of the three, Walther deemed only Cochlaeus worthy of an entry in his musical *Lexikon*. However, Walther offered a detailed account of the French humanist Guillaume Postel (1510–81), whose portrait in the Bach collection was an engraving made about 1760 by Gottfried August Gründler in Halle. Seventeenth-century musical scholarship was represented in the collection by figures such as Philipp Camerarius (1537–1624), who had earned an entry in Walther on account of his treatment of musical instruments in the eighteenth chapter of his *Operae horarum subcisivarum centuriae tres* (Frankfurt, 1624), and whose portrait was made by the master engraver Lucas Kilian (fig. 1.27a). The polymath Hermann Conring (1606–81), represented in an engraving by J. C. Böcklin, had been discussed at length by Mattheson in the *Grundlage einer Ehrenpforte* as the author of extensive contributions to music theory and especially writing on music and ethics. A grand folio-sized engraving (fig. 1.27b) by Johann Philipp Thelott brought into the collection the classical philologist Johann Conrad Dieterich (1612–67), whom Walther cited for the chapter on sacred music in his *Antiquitatibus Biblicis.*

For authors of opinions on sacred music there were numerous portraits to turn to in the portfolios. There was the opponent of pietism Samuel Schelwig (1643–1715) and the Lübeck rector and theologian Johann Heinrich von Seelen (1688–1762) (fig. 1.28a), both of whom one could look up in Walther for information on their musical writings. Also to be found in Walther was Caspar

FIGURE 1.27. (A, left) Philippus Camerarius (1537–1624). "Writer." Engraving by Lucas Kilian. Courtesy of the New York Public Library. (B, right) Johann Conrad Dieterich (1612–67). "Writer." Engraving by Johann Philipp Thelott the Elder. Herzog August Bibliothek, Wolfenbüttel, Portr. I 3178.

Calvör (1650–1725), superintendent at Zellerfeld (fig. 1.28b) and the author of a lengthy sermon on the importance of music in the divine service, written for the dedication of a magnificent new Arp Schnitger organ in 1702 and published that year in Leipzig as *De musica ac sigillatim de ecclesiastica, eoque spectantibus organis* (On music as ornament of the church, and a consideration of the organ). But Calvör was also the collector of an extraordinary library that contained some of the most important (unpublished) monuments of the northern German organ tradition, in tablature, including the Magnificats of Heinrich Scheidemann, and he was likely also a trained organist; this was not disclosed in Walther, but it was surely part of the Bach family lore, since from 1694 to 1697 Calvör had been the teacher of the young Georg Philipp Telemann (J. S. Bach's friend and C. P. E. Bach's godfather). Telemann was entrusted to Calvör's care by his mother, who hoped his interests would be directed away from music, but his musical development was instead encouraged by Calvör and flourished under him.[46] The family networks extended, too, to the educator Andreas Reyher (1601–73), present in

FIGURE 1.28. (A, left) Johann Heinrich von Seelen (1688–1762). "Lübeck rector and writer." Mezzotint by Johann Jakob Haid after Jürgen Matthias von der Hude. From Jakob Brucker, *Bildersaal*, vol. 8 (Augsburg, 1750). Herzog August Bibliothek, Wolfenbüttel, Portr. II 5108. (B, right) Caspar Calvör (1650–1725). "Writer." Engraving by Johann Georg Mentzel. ÖNB Vienna PORT 00153200_1.

the collection in an engraving by Georg Walch; headmaster of the gymnasium at Gotha, he was an important educational reformer and modernizer whose influential texts and educational method, in which music had a central place, would have been part of J. S. Bach's schooling, if not that of his sons.[47] Another figure more closely associated with education than music—and with C. P. E. Bach's generation more than with that of his father—was Johann Christoph Stockhausen (1725–84), rector in Lüneburg, where he taught Bach's friend Christian Daniel Ebeling, then in Darmstadt, and eventually superintendent in Hanau. He had also taught their mutual friend Johann Joachim Christoph Bode in Helmstedt in the early 1750s.[48]

Perhaps none of the literary figures of the older generation present in the portrait collection was more closely associated with J. S. Bach than Erdmann Neumeister (1671–1756) (fig. 1.29), Hauptpastor at St. Jacobi in Hamburg, "lyrical poet" (as he is classified in the portrait inventory), and creator of cantata texts, five of which had been set by J. S. Bach.[49] J. S. Bach's library contained two books

Effigiem, Venerande, Tuam, NEUMEISTER, et ora.
Artificum certet reddere docta manus.
Doctrinam ingenium, svadam, zelumq, fidemq,
Non dabit Illa libris exprimis ipse Tuis.

Io. Albertus Fabricius D.

FIGURE 1.29. Erdmann Neumeister (1671–1756). "Lyrical poet." Engraving by Christian Fritsch after Johann Salomon Wahl, 1721. Herzog August Bibliothek, Wolfenbüttel. Portr. I 9529.

by Neumeister (published in 1722 and 1731), perhaps gifts from the author; Neumeister, in turn, supported J. S. Bach in his application for the organist position at the Jacobikirche in 1720, and he likely was present at the organ recital J. S. Bach performed at the Katharinenkirche in Hamburg in 1722. That Neumeister does not appear in the major eighteenth-century music-biographical lexica (he is in neither Walther nor, at the end of the century, Gerber) suggests that by the second half of the century he was not seen as an important music-historical figure. That his portrait was nevertheless present in the Bach collection perhaps shows his continued presence in Hamburg's musical and theological circles, but it may also have reflected Neumeister's participation in the musical and intellectual genealogy of the Bach family.

AMONG THE PHILOSOPHERS AND POETS

While the networks of father and son overlapped and intertwined across the collection, clustered at its heart were the writers and poets, critics, theorists, and philosophers from Berlin and Hamburg who were central not to J. S. Bach's world, but to that of his son. These images brought together friends and professional collaborators, leading literary figures who both drew from and inspired C. P. E. Bach's work and bolstered his status as a star of the cultural firmament. On October 2, 1784, Bach asked his friend Johann Joachim Eschenburg for a portrait of the Braunschweig professor Justus Friedrich Wilhelm Zachariae (1726–77), a posthumous collection of whose writings Eschenburg had published in 1781: "Could you please, for love or money, obtain for me the copperplate portrait of the late Professor Zachariae?"[50] Zachariae was the author of popular tales and lyric poems, many of which were set to music by his contemporaries, and he also composed songs, including the *Sammlung einiger musicalischen Versuche* (1760–61/1768). His multiple talents were accurately reflected in Bach's pithy inventory entry for him: "*Zachariæ, (Fried. Wilh.)* Professor in Braunschweig, Composer."[51] Anyone invited to leaf through the portraits in their portfolios, or to look over Bach's shoulder as he opened them for interested guests, would have been reminded of the deep connections between C. P. E. Bach and the literary giants of his age.

In Hamburg, C. P. E. Bach was well attuned to the cultural legacy of the city where he had made the second part of his career. The significant group of portraits of Hamburg theologians, poets, hymn writers, and other literati from the turn of the eighteenth century to the present day brought into focus the culture that Bach, as director of music for the city, had inherited from his godfather and immediate predecessor Georg Philipp Telemann—whose portrait was one of the collection's treasures, a plaster relief on slate by an artist named Gibbons (now lost). Hamburg's Patriotische Gesellschaft was represented by its founding members, the professor and poet Michael Richey (1678–1761), shown gripping his lyre in an engraving by Christian Fritsch (1753) (fig. 1.30); the theologian and professor of philosophy Johann Albertus Fabricius (1668–1736), son of Werner

MICHAEL RICHEY

HISTOR.ET GR.L.IN GYMNASIO HAMBVRGENSI PROF. P. ORDINIS SVI SENIOR.
ANNO MDCCLII . AETAT. LXXIV.

Hac facie RICHEIVS erat, quum viuida nondum
Oscula desineret figere Musa seni.
Cynthius ingenium gravitate iocoque venustum
Rugosas tarde iussit habere vices.
Spirat adhuc candor, doctrinae gratia spirat,
Postque Deum Patriae proximus ardet amor.
O! sibi dulce diu pergant decus esse vicissim
Vir Patria dignus, Patria digna Viro!

Amico veteri ac vero
IOANNES HENRICVS A SEELEN.TH.L.

FIGURE 1.30. Michael Richey (1678–1761). "Professor in Hamburg and secretary of the Society of Musical Patriots there." Engraving by Christian Fritsch, 1753. Staatsbibliothek zu Berlin—Preussischer Kulturbesitz und Mendelssohn-Archiv. Mus. P. Richey, Michael, I, 1. Courtesy of the Berlin State Library (Staatsbibliothek zu Berlin).

Fabricius, in a grand formal print by Gustav Andreas Wolfgang (1749); and the poet Barthold Heinrich Brockes (1680–1747), in a quarto-format print after a painting by Balthasar Denner.[52] Tobias Heinrich Schubart (1699–1747), pastor at Hamburg's Michaeliskirche, had a place in the collection too, despite remaining absent from the standard eighteenth-century music-biographical sources (with the exception of Mattheson), classified like the others as a "lyrical poet" in a quarto-format engraving by Christian Fritsch.[53]

The august tradition of Hamburg authors of chorale texts threaded back through the collection to the previous century with the poet Johann Rist,[54] and into the present age with the portrait of the celebrated pastor at Hamburg's Petrikirche, Christoph Christian Sturm (1740–1784), Bach's friend and collaborator, engraved by Johann Christian Gottfried Fritzsch (fig. 1.31). Various engravings of Sturm by Fritzsch were in circulation, and Bach's inventory specifies only the name of the printmaker, but I like to think the one in Bach's collection was the image Fritzsch published in 1784 that named the artist, their mutual friend Andreas Stöttrup. This portrait print of Sturm, the great exponent of "nature religion," was a reminder of C. P. E. Bach's status within Hamburg's cultural elite: open on the ledge beneath the profile of the poet-theologian lies Sturm's famous *Betrachtungen über die Werke Gottes im Reiche der Natur* (1772), and beside it is an unbound copy of his most recent collaboration with Hamburg's renowned director of music, C. P. E. Bach—the second volume of their *Geistliche Gesänge* (Wq. 198), published in 1781, on which Emanuel Bach's name is perfectly visible. Those who owned copies of this volume knew that the title page itself showed a miniature double portrait of the pastor and composer being lofted to the heavens by an angelic choir above the Hamburg city skyline.[55]

At the center of Hamburg's cultural life during Bach's years stood the poet Friedrich Gottlieb Klopstock (1724–1803), like Bach, famous across Germany and, like Sturm, the composer's friend and collaborator. Perhaps surprisingly, this titan of northern German letters, whose most challenging and idiosyncratic poems were so often compared to Bach's music for connoisseurs, took his place in the portrait collection not in a lavish large-scale print, nor in a plaster relief or a beautiful drawing, but instead in a small engraving in duodecimo, likely taken from a frontispiece (since no artist's name is given, I have freely chosen his portrait here) (fig. 1.32a). To encounter Klopstock in the portrait collection, even in this form, was to come face to face with the quintessential poet of the sublime, whose experiments with meter and form, in his odes in particular, offered his contemporaries a parallel to the avant-garde music of C. P. E. Bach: "With Bach's keyboard music in particular, since these are more original than all other keyboard works," wrote the young J. F. Reichardt, "it is especially necessary that one get to know them as closely as possible before one plays them. Just so with Klopstock's verses. How few there are, though, who can correctly read [Klopstock] out loud, and [how few] can properly perform Bach's pieces."[56] The portrait might also remind a visitor of the artistic projects that Bach and Klopstock had accomplished together, from their production of the first German-language

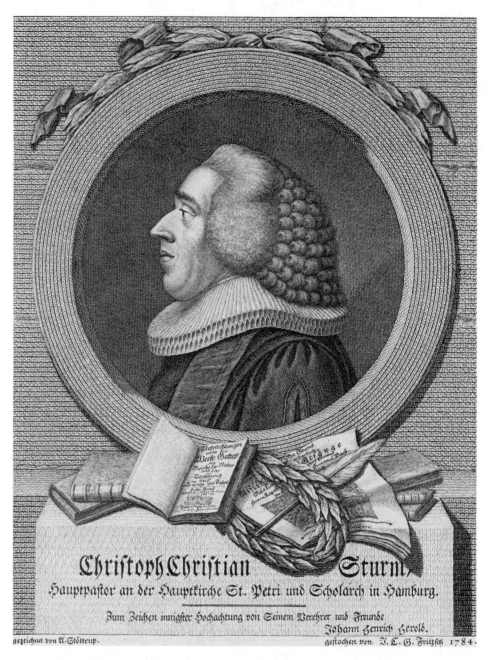

FIGURE 1.31. Christoph Christian Sturm (1740–84). "Pastor in Hamburg, lyrical poet." Engraving by J. C. G. Fritzsch after Andreas Stöttrup, 1784. Staats- und Universitätsbibliothek Hamburg.

performance of Handel's *Messiah* (1775), the text translated by Klopstock (fittingly, for the author of the great epic poem *Der Messias*) with their friend Christian Daniel Ebeling, to their collaboration on the late vocal work *Morgengesang am Schöpfungsfeste* in 1782–83.

Another distinguished member of their circle, the poet Heinrich Wilhelm

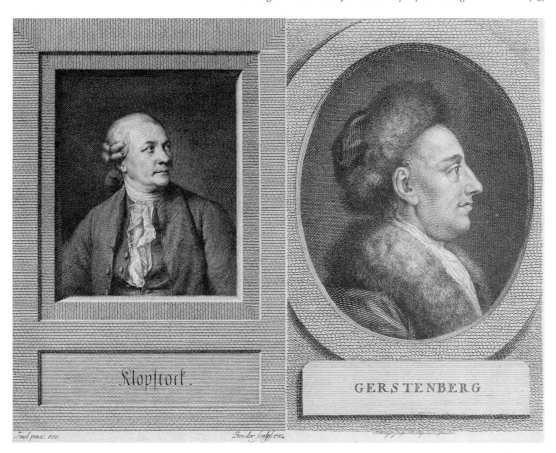

FIGURE 1.32. (A, left) Friedrich Gottlieb Klopstock (1724–1803). Engraving by Johann Martin Preisler after Jens Juel (1781–82). Statens Museum for Kunst, Copenhagen. (B, right) Heinrich Wilhelm von Gerstenberg (1727–1823). "Lyrical poet." Engraving by J. F. M. Schreyer. Herzog August Bibliothek, Wolfenbüttel, Portr. I 4876a.

von Gerstenberg (1737–1823), also found his way into the portrait collection by way of a fairly generic duodecimo-format engraving (again, I offer a substitute here) (fig. 1.32b). Gerstenberg was long a Bach admirer, engaging in cordial correspondence with the composer over music aesthetics and subscribing to several of Bach's publications, and his poetry also brought him into contact with numerous other musicians whose faces looked down from Bach's walls, including J. C. F. Bach, Johann André, Johann Friedrich Reichardt, and Ernst Wilhelm Wolf, all of whom set his texts. Bach, too, set Gerstenberg's poetry, including, in 1774, his cantata *Die Grazien*. In his turn, Gerstenberg was in close contact with the central German poets who formed the so-called Göttingen Grove (many of whose works Bach set), including Ludwig Christoph Heinrich Hölty (1748–76), whose portrait in the collection was a print in duodecimo by Daniel Chodowiecki (fig. 1.33a). Hölty could be contemplated alongside the Hamburg poet Friedrich von Hagedorn (1708–54), an important model for the Göttingen Grove poets, represented in an engraving by the same J. C. G. Fritzsch who engraved the por-

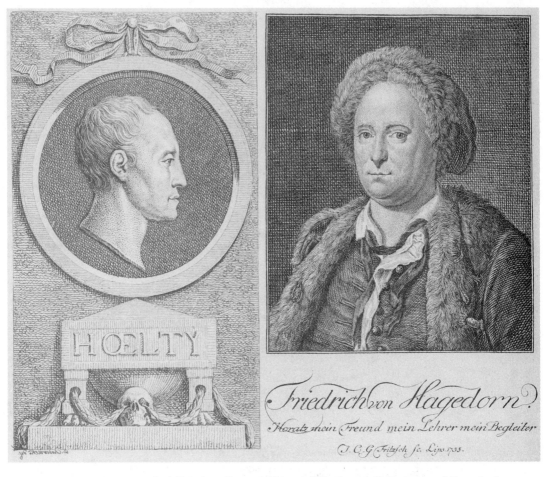

Friedrich von Hagedorn.

Horatz mein Freund mein Lehrer mein Begleiter.

J. C. G. Fritzsch sc. Lips 1755.

FIGURE 1.33. (A, left) Ludwig Christoph Heinrich Hölty (1748–76). "Lyrical poet." Engraving by Daniel Chodowiecki. (B, right) Friedrich von Hagedorn (1708–54). "Lyrical poet." Engraving by J. C. G. Fritzsch, 1755. Herzog August Bibliothek, Wolfenbüttel, Portr. I 6108 and Portr. I 5456a.

trait of Sturm (fig. 1.33b). Hagedorn's poems, especially the *Moralische Gedichte* (1750), presented an influential articulation of the ideals of *bürgerlich* life, with its pursuit of happiness, satisfaction, contentment with sober pleasures, friendship, and especially the much-vaunted self-conscious freedom of the Hamburg civic ideal.[57] The portrait collection contained a number of other prints by Fritzsch, including that of the Leipzig poet and moral philosopher Christian Fürchtegott Gellert (1715–96), whose *Geistliche Oden und Lieder* (1757) were set in two landmark collections by Bach in 1758 (H. 688, Wq. 194) and 1764 (H. 696, Wq. 195).[58]

The folders of portraits of writers and poets in the Bach collection documented Bach's familiarity with the intellectual and artistic currents of his age. It was likely through Klopstock that he encountered the Austrian poet Michael Denis (1729–1800), whose translations of Ossian, published in 1768–69, inspired the German Ossian craze.[59] Bach acquired the portrait of Denis, engraved by Jakob Adam and published in 1781, during the period of intensive collecting in the

1780s when he also obtained his engraving of Pietro Metastasio (1698–1782), the poet whose librettos he knew firsthand from his work as harpsichordist at the Berlin court and whose portrait, engraved by F. Gregory after a painting by Johann Nepomuk Steiner, was published as the frontispiece to the popular journal the *Neue Bibliothek der schönen Wissenschaften* (33/1) in 1787.

C. P. E. Bach's literary colleagues in Hamburg and the Klopstock circle were well represented in the collection, but so too were the leading literary figures in Berlin, from friends Bach had made during his time at the Prussian court, including Karl Wilhelm Ramler (1725–98), Gotthold Ephraim Lessing (1729–81), Moses Mendelssohn (1729–86), and Johann Georg Sulzer (1720–79), to more recent members of that circle. What sorts of things did Bach tell his visitors as they leafed through the folder containing these images? In many cases the portraits were a reminder of joint artistic efforts and shared aesthetic goals. The portrait of Ramler engraved by Johann Friedrich Kauke dated from this period (c. 1754), recording their friendship and their many collaborations. By the time of his death Bach would have written music for numerous poems by Ramler and have completed their ambitious joint project, the *Auferstehung und Himmelfahrt Jesu* (first performance 1774, publication 1787). The engraving of Friedrich Wilhelm Marpurg (1718–95), too, was a souvenir of the friendship circle of the 1750s (fig. 1.34). Made in 1759, also by Kauke, it depicted Marpurg at the height of his music-critical work, editor of the *Critischer Musicus an der Spree* (1749–50) and the *Historisch-kritische Beyträge zur Aufnahme der Musik* (1754–62), all four volumes of which were in C. P. E. Bach's library, and the encyclopedic *Abhandlung der Fuge* (1753–54), which cited Johann Sebastian Bach as the great fugal master and included C. P. E. Bach's Fantasia and Fugue in C Minor, Wq. 119.7, and the fugue Wq. 119.1.

While Ramler and Marpurg appeared as Bach had known them in the 1750s, Lessing and Sulzer had both been painted in the early 1770s by the brilliant Anton Graff (for the collection of Philipp Erasmus Reich in Leipzig), and it was prints of these portraits—Lessing's an etching by J. C. G. Fritzsch and Sulzer's an etching by Daniel Berger—that Bach chose to include in his collection. Not only had Lessing been part of the Berlin circle, but from 1767 to 1770 he was in Hamburg as director of the Hamburg National Theatre, overlapping in the city with Bach, who moved there in 1768. Lessing remained in touch with Bach even after leaving Hamburg to become the librarian at the Herzog-August-Bibliothek at Wolfenbüttel, sending a note to the writer Carl Wilhelm Dassdorf in Dresden in 1776 to recommend to him Bach's son, the young artist Johann Sebastian, who hoped "one day to find a position at the Dresden academy."[60]

Graff's portrait of Sulzer, made in 1774, couldn't have been more of a contrast to that of Lessing. Wigless and intense, here was a rugged, natural man, full of character (fig. 1.35). A longtime friend of Bach's,[61] Sulzer earned his place in the collection by the central position he gave to music in his best-selling encyclopedia of aesthetics and the fine arts, the *Allgemeine Theorie der schönen Künste* (first published in two volumes in the 1770s, but begun in the 1750s). The 243 entries

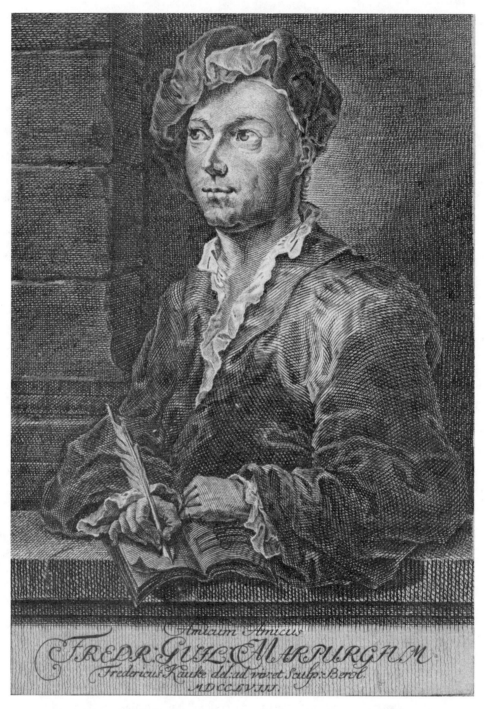

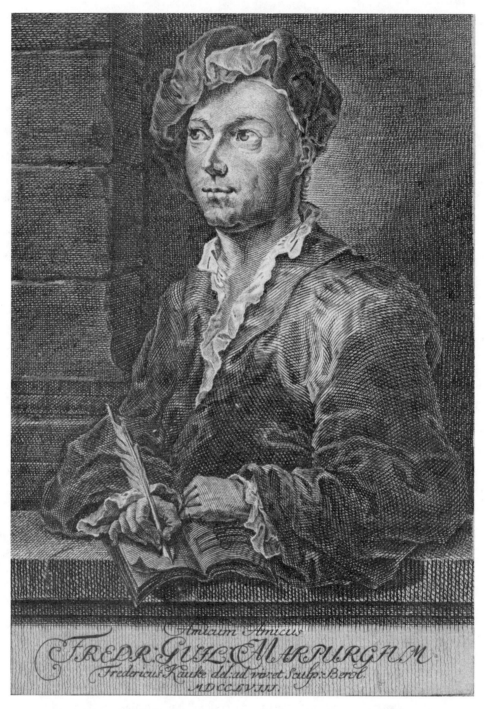

Amicum Amicus

FREDR: GUIL: MARPURGAM.

Fredericus Kauke del: ad vivet Sculp: Berol.
MDCCLVIII.

FIGURE 1.34. Friedrich Wilhelm Marpurg (1718–95). "Kriegsrath, writer." Engraving by Johann
Friedrich Kauke, 1758. Staatsbibliothek zu Berlin—Preussischer Kulturbesitz und Mendelssohn-Archiv
Mus. P. Marpurg, Fr. Wilhel. I, 1. Courtesy of the Berlin State Library (Staatsbibliothek zu Berlin).

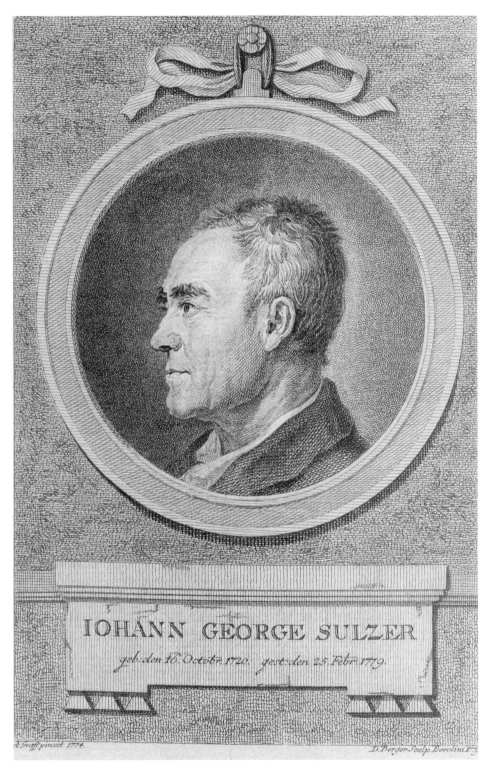

IOHANN GEORGE SULZER

geb. den 16. Octobr. 1720. gest. den 25. Febr. 1779.

A. Graff pinxit 1774. D. Berger Sculp. Berolini 17.

FIGURE 1.35. Johann Georg Sulzer (1720–79). "Professor in Berlin, writer." Engraving by Daniel Berger after Anton Graff, 1779. Staatsbibliothek zu Berlin—Preussischer Kulturbesitz und Mendelssohn-Archiv. Mus. P. Sulzer, J. G. I, 1. Courtesy of the Berlin State Library (Staatsbibliothek zu Berlin).

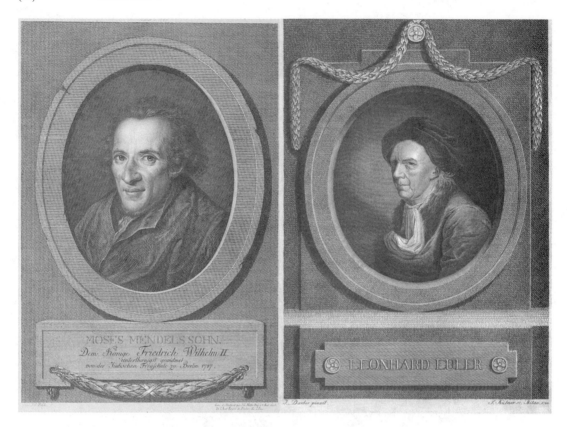

FIGURE 1.36. (A, left) Moses Mendelssohn (1729–86). "Writer." Engraving by Johann Gotthard Müller after Johann Christoph Frisch, 1787. Herzog August Bibliothek, Wolfenbüttel Portr. II 3513. (B, right) Leonhard Euler (1707–83). "Writer." Engraving by Samuel Gotlob Kütner after Joseph Friedrich August Darbes, 1780. ÖNB Vienna PORT 00121267_01.

on music (ranging from the short note to the extended study) constituted more than a quarter of the total entries in the encyclopedia, and C. P. E. Bach's music and practice stood at the center of them, most having been written in close collaboration with (or entirely by) Bach's colleague and friend the former J. S. Bach student J. P. Kirnberger (who was represented in Bach's portrait collection by a small oil painting), and with Kirnberger's student J. A. P. Schulz, who was himself an ardent admirer of C. P. E. Bach.[62] Bach was surely familiar with Sulzer's work, not only thanks to his personal connection with him, but also given the enormous success of the *Allgemeine Theorie*, an essential read for the man of culture.[63] Sulzer was a self-confessed music lover whom Burney found "well-read in books concerning music and an ingenious and refined thinker on the subject," and he subscribed to C. P. E. Bach's *Heilig* (H. 778/Wq. 217) in 1779.

Moses Mendelssohn was an essential addition to a collection that contained his friends Sulzer and Lessing, although we can tell that this portrait came late into the Bach collection, since the print by Johann Gotthard Müller was not produced until 1787 (fig. 1.36a). Mendelssohn was a central figure in the lively

debates going on since the 1750s on the aesthetics of the sublime and the beautiful, with his *Betrachtungen über das Erhabene und das Naive in den schönen Wissenschaften* (first published in Lessing's *Bibliothek der schönen Wissenschaften*, 1758, and much expanded for the 1771 publication of his *Philosophischen Schriften*) and with the *Briefe über die Empfindungen* (Berlin, 1755). But Mendelssohn's place in the portrait collection could also be justified by his contribution to music theory: having studied music with Kirnberger, Mendelssohn published a short treatise on equal temperament, the "Versuch, eine vollkommen gleichschwebende Temperatur durch die Construktion zu finden," in Marpurg's *Historisch-kritische Beyträge* (5/2, 1761). Gerber, knowing that Mendelssohn was in C. P. E. Bach's gallery, was perhaps overstating the case when he described Mendelssohn as "an outstanding music theorist," but his ideas on aesthetics more generally would certainly have influenced musical thought in Bach's milieu.[64]

For further reflections on aesthetics, especially the vexed question of music and representation that Bach's admirers had discussed so urgently with respect to his character pieces of the 1750s, that Gerstenberg had hoped to pursue further in the 1770s,[65] and that Bach touched on again in his review of the first volume of Forkel's *Allgemeine Geschichte der Musik* in 1788,[66] there was Johann Jacob Engel (1741–1802), professor at the Joachimsthaler Gymnasium in Berlin and author of *Über die musikalische Malerei* (1780) and *Ideen zu einer Mimik* (1785). Engel's portrait, sent to Bach by J. J. H. Westphal in 1787, was a mezzotint by Johann Elias Haid after a painting by Daniel Chodowiecki (see fig. 2.7 below). Also arriving in the collection after 1780 was another member of the Berlin circle, the Swiss mathematician, scientist, and philosopher Leonhard Euler (1707–83) (fig. 1.36b), who was at the court of Frederick the Great in Berlin from 1741 to 1766 and whose interest in music received considerable attention from Bach's Berlin music-theorist colleagues, including Marpurg.[67] That Euler remained a significant figure in music-theoretical circles at the end of the century is evident in the entry on him in Gerber, which lists his numerous writings on music and paraphrases the posthumous eulogy by Nicolaus Fuß (Basel, 1786) describing how the theorist took not only a theoretical interest in music but also a practical one, such that music offered him "the most pleasant recreation." In another reflection of the interlocking circles connecting items in the collection, Euler's portrait, based on a painting by J. F. A. Darbès, was executed by Samuel Kütner, a classmate of J. S. Bach the Younger's at the Kunstakademie in Leipzig, who had engraved the Haussmann portrait of J. S. Bach in 1774.

TO BE A BACH

There is one final point to consider here, as we return our gaze from the famous contemporaries to the eminent predecessors populating C. P. E. Bach's walls and filling his portfolios. With so many figures of German musical and humanistic culture of the past represented in the collection, could the kernel C. P. E. Bach

inherited from his father have gone beyond the handful of family portraits associated with the Bach family archive? Given the foundational status of Johann Sebastian Bach in music history in general and Bach studies in particular, it is not surprising that, as much as the C. P. E. Bach portrait collection has been discussed at all in musical scholarship, it is as a source of information on the father. Even credit for starting the collection, and for collecting well beyond the kernel of family portraits, has gone to J. S. Bach, with the suggestion that it was the father who began to assemble those Kapellmeisters, organists, violinists, lutenists, and especially the seventeenth-century theologians who by the middle of the eighteenth century had become fairly obscure and by its last decade were no longer relevant to the music-intellectual world.[68] Robin Leaver has suggested that J. S. Bach, closely connected as he was to key figures in early eighteenth-century Leipzig's burgeoning collecting culture, and aspiring to the status of a university-educated man, may have begun to acquire engraved portraits of figures who were not family members, among them musician friends and colleagues and distinguished visitors to his house in Leipzig. Not only did Leipzig's wealthy mercantile class early in the eighteenth century have the money and the motivation to engage in collecting that could demonstrate their means, status, and cultivation on a par with aristocratic rivals in court cities such as Dresden, but Leipzig's central position in the publishing and printing industry, along with its three annual international trade fairs, also meant that paintings and engravings were widely available there.[69] The city's famous private art collections included those of the banker Gottfried Winckler and of the brothers Johann Christoph and Johann Zacharias Richter; members of the Bach family would certainly have had access to the collection, housed in his villa in the Thomaskirchhof, of J. Z. Richter, whose third wife Christiana Sibylla Bose (married in 1744) was the godmother of two of the Bach children and a friend of Anna Magdalena Bach's.

Perhaps, too, Leaver has surmised, J. S. Bach began to acquire portraits in other areas that interested him, in particular theology. Leaver proposes that it was J. S. Bach who acquired the portraits of Martin Luther (1483–1546), the Erfurt theologian Nicolaus Stenger (1609–80), the Weissenfels superintendent Johann Olearius (1611–84), and Erdmann Neumeister in Hamburg. Books by all four of these men were in J. S. Bach's library. Perhaps it was also thanks to J. S. Bach that the collection contained portraits of Philipp Melancthon (1485–1547); of Desiderius Erasmus (1469–1536); of his follower and friend the humanist and reformer Beatus Rhenanus (1485–1547); of the theologian and reformer Wolfgang Musculus (1497–1563); of the professor, superintendent, and pastor at the Leipzig Thomaskirche Nicolaus Selnecker (1530–92); and of both Matthaeus Ludecus (1527–1606), dean of the cathedral chapter at Havelberg and author of four volumes of liturgical music, and Cyriacus Spangenberg (1528–1604), neither of whom was given a place in Walther's *Lexikon* yet who were in the C. P. E. Bach portrait collection as inventoried in 1790. One could make similar arguments for numerous other such figures in the collection, including Gottfried Reiche (1667–1734), J. S. Bach's chief trumpeter in Leipzig, and the flautist Pierre-Gabriel Buffardin (1690–1768): that they would have been of far

greater immediate relevance to J. S. Bach than to his son and that their portraits were therefore acquired by the father.

But there is no evidence that J. S. Bach acquired any of the portraits beyond those of members of the Bach family. Had J. S. Bach begun the collection, C. P. E. Bach would surely have let this be known, and his contemporaries would have commented on it. Neither Burney nor Gerber, who had firsthand information on how the collection was put together, mentions an origin with J. S. Bach. On the contrary, the older portrait subjects reflected the continued currency of the musical legacy of the cantorate system in northern German Bach circles and of the humanistic tradition that educated musicians sprang from. And as I shall discuss in the next chapter, it is evident from the remnants of C. P. E. Bach's correspondence that he was trying to acquire portraits of some of the theologians as late as 1787, including that of the Lübeck pastor Johann Heinrich von Seelen (1688–1762), the professor and rector at Danzig Samuel Schelwig (1643–1715), and the sixteenth-century Italian legal scholar Guido Panciroli (1523–99). The portrait of Luther listed in the inventory of 1790 was certainly his acquisition (fig. 1.37), since it was engraved by August Joseph Pechwell, an artist born in 1759, and dated from 1786.

In fact, Leipzig's collecting culture was likely to have influenced C. P. E. Bach's collection as much through his son, J. S. Bach the younger, as through his father. A talented draftsman and landscape painter, J. S. Bach the Younger (1748–78) had begun formal studies in 1770 with Adam Friedrich Oeser at the Kunstakademie in Leipzig, where he would have become familiar with the city's famous private collections. As Goethe later reported, Oeser (whom Goethe also studied with) introduced his students to the Richter and Winckler collections, teaching art history there and borrowing portfolios of works from them for students to study closely over extended periods. By the last decades of the eighteenth century, the Richter collection contained about four hundred paintings, including works by Rubens, Rembrandt, and Titian, over a thousand drawings, and thousands of engravings. The Winckler collection had been open to the public on Wednesday afternoons since 1765 (well after J. S. Bach's death), and it was one of Leipzig's main tourist attractions; its catalog, printed in 1768, listed 628 paintings, including works by Dürer, Holbein, Titian, and Rembrandt. As Oeser reported in a letter to the art critic Christian Ludwig von Hagedorn, J. S. Bach the Younger had "observed the best drawings and engravings at Winckler's with the greatest intensity [*Feuer*]."[70] J. S. Bach may well have had an interest in portraiture, but we must, like Burney and Gerber, credit his son Carl Philipp Emanuel—perhaps spurred on by his own son—with the creative and intellectual impulse, and the specialist knowledge, to have assembled the collection, although it may have included some items inherited from his father.

C. P. E. Bach saw himself as a cultured man, cosmopolitan in his musical knowledge even without having traveled beyond the borders of Germany, as he was at pains to point out in the autobiography added to the German translation of Burney's *Present State of Music*:

FIGURE 1.37. Martin Luther (1483–1546). "Reformer. Composer of many fine songs." Engraving by August Joseph Pechwell. Bpk Bildagentur/Kupferstichkabinett, Berlin/Volker-H. Schneider/Art Resource, NY.

I had to content myself, and did content myself quite willingly, with hearing—apart from the great masters of our fatherland—admirable things of all kinds, that the foreign lands sent to Germany; and I do not think that there is a single aspect of music left, upon which I have not heard some of the greatest masters [express themselves].

It would not be difficult for me to fill a great room with just the names of composers, singers (female and male), and instrumentalists of all kinds, whom I met, if I think broadly and make an effort to remember.[71]

He was of his time, but also a proud member of Germany's oldest musical family. The collection was a symbol of that past and of the cultured present, the sheer number and quality of its portraits politely proclaiming affluence and erudition, along with a collector's acumen, as Burney's account makes clear. Ironically, this arrival at wealth, standing, and refinement also pointed away from music as the family livelihood. All of C. P. E. Bach's brothers were musicians; neither of his own sons was. Even though the short-lived Johann Sebastian Bach the younger added his own gifts to the portrait collection, that his chosen art was different from that of his namesake grandfather confirmed that a watershed had been reached. What would these next Bachs do with a collection of musical portraits whose precisely detailed catalog was published only on C. P. E. Bach's death? It was left to his daughter Anna Carolina Philippina (the namesake, in her turn, of her collector father) to preserve, sell, or otherwise disperse it.

C. P. E. Bach's portrait gallery comprised a collection of famous and distinguished men (and some women) whose achievements reflected back on the collector, who was the collaborator and friend of many of them and had inherited a musical legacy rooted in the achievements of many of the others. Numerous networks might be traced out among the pictures, from the early number theorists and cosmologists (Galileo, Robert Fludd, Johannes Kepler) to d'Alembert; from the Americanist Christian Daniel Ebeling to Benjamin Franklin, "inventor of the harmonica";[72] from Gottfried Leibniz to the enthusiastic C. P. E. Bach promoter and writer on musical aesthetics Christian Friedrich Daniel Schubart. C. P. E. Bach was occupied, wittingly or not, with a project of self-fashioning: the collection bolsters an image of its assembler as a worldly, intellectually curious, learned musician, attuned to the breadth and depth of his art across its multiple manifestations nationally and internationally, in the past and in the present, with serious implications for how his own musical and scholarly legacy might be transmitted into the future.[73]

It is not hard to imagine that this might have been how C. P. E. Bach hoped to be perceived in the cultured and cosmopolitan circles of Berlin and Hamburg. The portraits in his music room offered connoisseurs and amateurs alike the backdrop and inspiration for elevated discussions of music and the other arts, for performances and their appreciation in an intimate circle of friends. The collection could encapsulate the idea of music culture itself and embody and promote the cultured musician-collector.[74] C. P. E. Bach's portrait collection achieved what

J. S. Bach was never able to do: it showed that the Bach family had transcended the craft-based guild traditions so brilliantly exemplified and taken to their pinnacle by Johann Sebastian, to escape that system entirely as university-educated, culturally sophisticated bourgeois subjects. Through his famous collection, C. P. E. Bach was able to project himself as the refined and erudite collator, caretaker, and critical mediator of the musical knowledge of his age.

Collecting: C. P. E. Bach and Portrait Mania

In 1781 the Berlin printmaker Daniel Chodowiecki published a set of twelve engravings lampooning the contemporary fad for collecting.[1] His depictions of *Steckenpferdreiterei*—hobbyhorse riding—one for each month of a popular pocket calendar, presented bourgeois citizens consumed by obsession with objects of all kinds, from paintings to natural curiosities, engraved prints to flowers, antiques to caged birds, horses, dogs, clothes, and heraldic crests (fig. 2.1).[2] The series ranges in tone from affectionate humor to sharp criticism, highlighting the way hobbyist acquisitiveness could descend into solipsistic obsession, overweening greed, and social pretension, even in the four long-respected areas of collecting: books, paintings, natural curiosities, and engraved prints. The superficiality of the book collector (*Der Bücher Liebhaber*) despite the magnificent library he has assembled, is betrayed by his fixation on his books' bindings: "Why should he ride deeper on [his hobbyhorse]," the epigram asks, "than various people of the highest rank, who puff themselves up with thousands of books but understand nothing more than their covers?"[3] The painting collector (*Der Gemählde Liebhaber*) dilettantishly parades the elegance of his connoisseurship and crassly draws attention to the expense of it all: "The colors are as if laid on with a breath, as if they had been dipped into Life itself. To be sure, the most difficult of the arts is painting, and after that, often the art of paying up [for it]."[4] If the book collector is superficial and the painting collector is ostentatious, the collector of natural curiosities (*Der Naturalien Liebhaber*) is oblivious: having turned the family kitchen into a cavelike curiosity cabinet, he neglects his duties as breadwinner as he spends all his money on the shells, fossils, stuffed crocodile, and other oddities lining his chamber: less of a show-off than the others, yet no less consumed by

Der Gemählde Liebhaber
„Die Farben sind wie hingehaucht,
„Und wie in Leben ein getaucht.
„Gewiß: Die schwerste Kunst ist Mahlen
Und nach ihr, offt die, zu bezahlen.

Der Bücher Liebhaber
Warum soll er nun tieffer reiten?
Als mancher von den höchsten leuten,
Der sich mit tausend Büchern bläht,
Und nur den Deckel dran versteht.

D. Chodowiecki inv. et Sculpsit.

Der Naturalien Liebhaber
Still Weib und Kind! so lobt doch nur
Den Schöpfer Herrlicher Natur
Der diese Steine färbt, gehäuset diese
 Schnecken
Der wird auch in der Noth euch nähren
 und bedecken.

Der Blumen Liebhaber
Aufs Pferdchen mit ihm steigen,
Ihm noch die Tulpe zeigen
Die er begiessen soll:
Ihr schönen thut daran nicht wohl;
Er Euch nur Pflegen soll.

FIGURE 2.1. Four panels from Daniel Chodowiecki, "Steckenpferdreiterei": Der Gemählde Liebhaber; Der Bücher Liebhaber; Der Naturalien Liebhaber; Der Blumen Liebhaber. From *Lauenburger genealogische Kalendar* (1781). Rijksmuseum, Amsterdam.

his collection, he remonstrates with his bedraggled family members: "Hush, wife and child! Just praise the creator of wonderful nature, who colored these stones, housed these snails, and who will also feed and clothe you when you are in need."[5] There's the dog enthusiast, whose motley group of hounds play, paw, and scratch but at least, for the price of a few bites, save their owner from having to kiss a woman, as the accompanying verse explains; the flower lover, absorbed in watering his tulips, is more concerned about them than about the ignored girl who gamely hops up behind him onto his hobbyhorse; the solitary bird collector, lovingly and misguidedly speaks to the birds, who understand nothing of his words except that he cruelly keeps them captive.

But the enthusiast for copperplate prints (*Der Kupferstich Liebhaber*) is different. Humbler than his fellow collectors, he is absorbed and sincere, standing straight and still, his prints hung on the wall in matching frames and straight lines or stored in folders in the cabinets neatly furnishing the room (fig. 2.2). Alone and quiet, the print collector intently admires his collection, privately enjoying the fruits of his labor, in an image that speaks of graceful cultivation and discreetly displayed social standing. His hobby appears less extravagant and more sincere than the others; yet it is no less wide-ranging; indeed, perhaps it is to be valued all the more highly, for all genres of visual art can find themselves represented in a print collection: "His horse has much humility / It prances without robbing colored nature / And yet leads as easily and as far / as every art, to every trace of beauty."[6] In contrast to the other images in the series, this one projects a gentle seriousness without the element of satire. It is as if Chodowiecki, the renowned printmaker, were reluctant to criticize his own art and its followers. Yet the inclusion of the print collector in the series of *Steckenpferdreiterei* is an acknowledgment that this too was a widespread mania with passionate adherents.

Indeed, so popular was print collecting as a method of signaling social status and good taste that the article on "copperplate engraving" in Johann Georg Sulzer's encyclopedia of the fine arts, the *Allgemeine Theorie der schönen Künste* (1771–74), turned almost immediately from an account of engraving itself to anxious remarks on the "universally widespread" (*allgemein ausgebreitet*) hobby of collecting engravings: "One finds in all countries a peculiar kind of collector [*Liebhaber*] who collects copperplate engravings in much the same way as, with great zeal, children collect colorful stones or other things that are completely useless to them, simply in order to keep themselves busy with something, and without drawing the slightest benefit from it other than finding satisfaction in an utterly pointless activity."[7]

But print collecting at its highest was far more than casual entertainment or ostentatious pomp: "One can establish collections of fine engravings for all sorts of varied purposes," explained Johann Caspar Fuessli in his 1771 introduction to prints and print collecting, the *Raisonierendes Verzeichniss der vornehmsten Kupferstecher und ihrer Werke. Zum Gebrauche der Sammler und Liebhaber*: "The one collects because he loves everything that serves pomp and can thereby nicely furnish a room; another, through an extensive and costly collection, hopes to

Der Kupferstich Liebhaber
Sein Pferd hat viel bescheidenheit
Es prahlt mit keinem Raub der farbigen Natur
Und führet doch so leicht und weit
Wie jede Kunst zu jeder Schönheits Spur.

FIGURE 2.2. Der Kupferstich Liebhaber. Daniel Chodowiecki, "Steckenpferdreiterei." From *Lauenburger genealogische Kalendar* (1781). Rijksmuseum, Amsterdam.

attain the reputation of a connoisseur and protector of the arts; yet another as a pastime and for his amusement; and finally, the few sensible ones collect to enrich their insights and to train and develop their taste."[8]

Handbooks such as Fuessli's, which accompanied the enormous expansion in print culture during the eighteenth century, made building art collections based on reproductions possible for the middle classes.[9] For new collectors building from scratch (rather than expanding on collections inherited from aristocratic forebears) Fuessli provided an introduction to aesthetic judgment (quality with respect to prints was to be judged in the way one would judge a painting), a summary of printing techniques, and a comprehensive list of European engravers, with details of their work. From here the collector could turn to the *Erste Grundlage zu einer ausgesuchten Sammlung neuer Kupferstiche* (Bern, 1776) (First fundamentals toward a select collection of new engravings) by the musician, cleric, and collector Carl Ludwig Junker, who recommended a "*Cabinetchen*" of one hundred prints after the work of well-known painters, helpfully priced at 370 Gulden: this was an affordable way to become an art collector, although, as Junker pointed out, "still quite a sum for an honorable man."[10] The journal *Der Teutsche Merkur* would advise in 1778, in answer to the question "How should one plan a print collection?" that "It is simply a matter of the forfeiture of time and money. Here too it can be said: without suffering one learns nothing."[11] Money was necessary, but so too was good judgment and educated taste. For the

right kind of collector, as Fuessli had made clear, the very process of building a collection would have the effect of refining taste.

COLLECTING CRAZE

That northern German music lovers were in the grip of a collecting mania was obvious to the Sondershausen organist Ernst Ludwig Gerber, who had himself been infected by the craze. In 1783 Gerber (who was the son of a J. S. Bach student), wrote an open letter to Carl Friedrich Cramer, the editor of the *Magazin der Musik* in Hamburg, to recommend a new collecting project for the *Musik-Liebhaber*, one that went beyond the acquisition of books and music. Gerber opened by explaining that while over the past twenty-five years his own collecting had resulted in a library of 178 volumes of historical, critical, theoretical, and practical German works on music, in addition to a large trove of sheet music from various eras and countries, this in itself would not particularly surprise his readers or attract their attention: "Indeed, this spirit of collecting is so natural to us *Liebhaber*, and consumes us so completely, that I would be saying little new to you and your readers should I want to speak more extensively about it."[12] Gerber wished, rather, to encourage readers to start collecting in a new direction, to enlarge their knowledge of music and its history by collecting portrait prints: "Imagine, as a keen admirer and connoisseur of music," Gerber wrote,

> a room in which immediately on entering it we find ourselves in a society for which we feel as much veneration as gratitude, for to [these people] we owe thanks for the sweetest, most heavenly hours of our lives; they who shared with us their experiences, showing us the more direct and simpler paths on the bitter road to Art; who lived in an unceasing effort to make for mortals the handful of days they have, which are often mixed with so many sad ones, pleasant and bearable! Wouldn't you feel happy in such a society, when, as you view it, you find constantly impressed upon your memory one master-trait after another, one beauty after another! When you can explore this great thought in the look and expression of the pictures? The gentle character in the portrait of a Graun; the seriousness in Bach's portrait, and the fire in the glance of a Haydn or Gluck?[13]

A chamber hung with portraits of musicians and composers would be a music room brimming with sources of inspiration and filled with like minds, its many countenances witnessing and shedding light on the music resounding there.

Gerber reported that he had already begun a collection of musician portraits, but the project was difficult, he admitted, partly because of Sondershausen's remoteness and lack of print sellers, but also because musicians had simply not received the attention from printmakers that he felt they deserved: more portraits of musicians needed to be engraved, and Gerber's letter includes a direct request to Johann Friedrich Bause, professor at the Kunstakademie in Leipzig since 1766,

for engraved portraits of the Austrian composer Carl Ditters von Dittersdorf, the Wolfenbüttel Kapellmeister Johann Gottfried Schwanenberg, and Ernst Wilhelm Wolf in Weimar.[14] As a service to those music lovers who would like to follow his example, Gerber then appended a list of the fifty portrait engravings currently in his collection. In addition, he suggested that collectors looking for information on the musicians whose portraits they had acquired might turn to Walther's *Musicalisches Lexikon* (Leipzig, 1732), Adlung's *Anleitung zu der musikalischen Gelahrtheit* (Erfurt, 1758), and the writings of F. W. Marpurg.

But the purpose of Gerber's letter to the *Magazin der Musik* was not only to speak of his own collection and the collecting craze he took part in. He also wanted to call publicly for information on another collection he had heard of, that of Carl Philipp Emanuel Bach in Hamburg: "According to my knowledge," wrote Gerber, "Herr Kapellmeister Bach owns the most extensive [portrait] collection. I most sincerely request that you provide us with its catalog in your magazine."[15] In a footnote, the editor Cramer, a regular visitor to the Bach house and a ready commentator on Bach's performances and his music, assured readers that Bach had agreed to supply this catalog, and that it would be printed in the magazine as soon as he received it. A year later, however, the exact contents of the Bach collection were still unknown, the only published report of it still that of Charles Burney: "According to Doctor Burney's assertion, the Herr Kapellmeister C. P. E. Bach in Hamburg owns a very large collection," wrote the Bach devotee and fellow portrait collector Hans Adolf von Eschstruth in an article on musical portraits in his *Musikalische Bibliothek* (1784): "Surely the largest amount of information [on musician portraits] could be supplied from there."[16]

The inventory of the Bach collection did not appear during Bach's lifetime. By 1790, when Gerber published the first volume of his *Historisch-biographisches Lexikon der Tonkünstler*, more detailed information had begun to circulate, and at the end of his entry on C. P. E. Bach Gerber could speak of it with some authority, although still only in general terms: "Finally, Herr Bach, earlier than anyone else, owned a treasure of 330 portraits exclusively of virtuosi, among which were to be found a particularly large number of paintings and drawings. It is to be hoped that this valuable collection comes, intact, into good hands."[17] By 1792 Gerber had seen the inventory of the Bach collection, published in the *Nachlassverzeichniss* (1790), and he admiringly reported in the second volume of his *Lexikon* that this "most important of all musician portrait collections" was significant both because it was the first such collection and because it included, along with a great number of prints, sixty-two oil and pastel paintings and drawings and four reliefs or busts in plaster or porcelain. Gerber had been in communication with Bach's widow, and he tells his readers that the collection had been painstakingly assembled over forty years in the cities of Berlin and Hamburg, with their plentiful supply of artists and artworks, and that it was beyond the dreams of any normal collector, not only on account of its cost, but also because the rare items it contained were irreplaceable: "As little as a collector [*Liebhaber*], even with the financial means that a high birth or fortune have afforded him, can flatter himself ever to

see such a treasure trove of rarities surrounding him, so much greater would be the loss should this collection be broken up,"[18] Gerber wrote. Not only was the Bach portrait collection of great value, it was also a remarkable achievement on the collector's part, demonstrating the depth of C. P. E. Bach's pockets and his discernment, the scope of his research, expertise and connoisseurship: "To create such a collection requires no fewer financial resources, no less knowledge and taste than were united in the Herr Kapellmeister."[19]

HOW TO MAKE A *COLLECTION*, NOT A *CONFUSION*

For the eighteenth-century collector of portraits, no tool was more useful than the book Gerber recommended to his readers, the *Anleitung wie man die Bildnisse berühmter und gelehrter Männer mit Nutzen sammlen . . . soll* (Guide to how one should profitably collect the portraits of famous and learned men . . .),[20] first published in 1728, by the Braunschweig professor Sigmund Apin. This handbook dispensed advice on the purpose and practice of portrait collecting in a series of chapters whose topics ranged from the significance of portraits in the ancient world to the principal genres of contemporary portrait collections, from basic advice on how to acquire, care for, and display a portrait collection to a discussion of the ends to which such a collection might be put.

Apin took pains to distinguish between the indiscriminate collector and the informed one. There are indeed, Apin writes, those who collect portrait prints simply because others do, going for quantity over quality, filling up whatever space they have with whatever they can get, with no discernible plan: "These, because they see that other people collect prints, . . . lump everything together, framed or not, however it comes, laying one thing under the other, higgledy-piggledy, and are satisfied with it only when they have a lot of pieces, which they can leaf through in idle hours."[21] Apin dismissed the result (using the fashionable French words) as not so much a *"Collection"* as a *"Confusion"*: "One might just call such a *Collection* an ordered *Confusion*, since it serves no other purpose than as pastime, and as a way to keep children quiet."[22] His advice was straightforward: take an organizing theme, and "stick to what you know." Also, know your subject. If a theologian wants to collect portraits, they should be of other theologians, a lawyer should collect lawyers, a doctor, doctors; a philosopher, philosophers; and so on through mathematicians, orators, poets, and so forth.[23] It was to be expected that a professional musician should collect portraits related to music.

A portrait collection, as opposed to a confusion, has a clear purpose: a collection, according to Apin, which is by definition executed with intent and discrimination, facilitates, supplements, and strengthens our understanding of our chosen profession or scholarly field and of its history. Concomitantly, as Apin explains, a critical aspect of the collector's job is to annotate, supplying (if the information is not already available on the print itself) names, dates, major works, and other relevant biographical details below or on the back of the portrait print.[24] When

the facts are attached to the face, those perusing the collection can all the better practice their knowledge of the history of the field. By the same token, Apin notes, facts are more telling, more vivid, and more easily remembered when associated with faces.[25]

In addition to its more public educational value, a portrait collection can serve as a tool for personal memory and recollection, giving aged collectors a portal into their own past: portraits "teach them new things, or they bring back to mind ideas of past things." The portrait has the power to conjure up for collectors "the lands, cities, and those places where they once were, or of which they have read, so that they see them anew, and silently address the portraits, 'Are you the renowned, honorable, righteous man of whom I have already heard or read, or indeed who I myself spoke to so many years ago?' and so, in the [comfort of their] study, in their old age, they undertake yet another distant journey."[26]

The portrait collection brings the long sweep of history into the present moment, communicating both the broad-brush impression produced by the collective and the emotional bonds of individual contact. It serves and preserves public, collective memory; at the same time, it vividly evokes personal ties and private past experience.

Theoretical reflections in Apin's book go hand in hand with practical advice. What do you need in a collection, and where do you find it? How do you organize and conserve your collection? How do you go about showing it off? A collector should keep within his means and not assume that a portrait collection is an investment: there may well not be as many portrait collectors around in the future as there are today, so after your death the collection may not be worth as much as you paid for it. A collector should build up his holdings slowly and patiently, looking, waiting, assessing what is available, and never making impulse purchases at high prices. Portrait prints (which are the main focus of Apin's advice, directed as it is at the middle-class collector) can be had from a variety of sources, and Apin is specific in his instructions: (1) buy published volumes of portrait prints, where you will acquire many portraits at once; (2) be sure to collect multiple different engraved portraits of a single sitter (*doubletten*), since some will be better than others; (3) try to obtain individual items (those that aren't in the published portrait collections), even if they are in poor condition, since there are so many more individual prints around that one cannot neglect to collect them, and this is the strength of a good collection; (4) collect French, Dutch, and English prints when they are affordable, since they are an adornment to your collection; (5) if you find portraits in the front of books of sermons, calendars, etc., take them out and put them in your collection; (6) include drawings, paintings, and coins if you can. In this way you will achieve a well-conceived, well-arranged collection.

The collection must be categorized coherently (not simply alphabetically), and a good alphabetical index must be made of it so that the owner can quickly take stock of what he has when making new acquisitions, and visitors and friends can find individual items easily.[27] Information to be entered in the index includes the name of the portrait subject, the artist, size, and medium, as well as an indication

of the source for a particular print (if it comes from a published collection). Then there is the question of how to store and display the collection. Apin stresses that portrait prints need to be framed and under glass if they are to be displayed, or they should be conserved in specially made cardboard folders, as part of a library, and even kept in specially made cabinets with narrow drawers, "the sort that merchants use for their correspondence."[28] Public display is a vital part of collecting practice, and the collector must be aware of both the drawbacks and advantages of showing the collection: negatives include potential time wasting (since, especially for large collections, tours will take time), but positives include the opportunity to demonstrate (gracefully, of course) commanding scholarly knowledge. Apin is full of helpful advice: (1) be wary of showing the collection to persons more distinguished than you are, since they may well want items of yours and will only resent you for not parting with them; (2) don't invite more than three people at once to see the collection, since with too many in the room the rarest pieces will be hard to see and, worse, it's easier for strangers to pocket something; (3) don't show your prints too often, for you waste too much time doing so; (4) discuss your portraits, but do it with humility and without affectation: by talking about the pictures, you'll demonstrate that you do not lack education and have a praiseworthy goal in collecting these pictures, and by playing them down you'll avoid having to answer to the envy of your friends; (5) go through the collection at least twice a year to dust everything and to make sure that worms and mice haven't found their way into the folders.

HOBBYIST COLLEAGUES

C. P. E. Bach was a devoted and energetic collector to the end of his life, keenly acquiring portraits even when there was little space to display them and even after his professional musical activities had ceased. Late in life he began to focus on wrapping up his affairs, making sure that all would be in order for his heirs, and shutting down his successful business. Nevertheless he continued to collect, sending out requests, and focusing time, energy, and money on expanding his holdings. The correspondence that survives from this period of his life reveals a collector with the experience and dedication of a connoisseur, fully in tune with music culture, present and past, as well as the collecting practices of his age, even as the obsessiveness of the enthusiast gripped him. He had succumbed to the collecting mania, yet his interests in and willingness to continue to invest in the portrait collection went well beyond obsessive hobbyism. The plentiful contemporary literature on collecting has much to say about how such a collection would have been assembled, organized, and displayed, but Bach's surviving letters offer a more intimate view of the composer as collector, demonstrating how far he was informed and engaged and showing how his collection was built not by accident and eagerness, but by intention and design.

Bach enlisted family members, friends, and acquaintances to help him procure

portraits. His printer, Johann Gottfried Immanuel Breitkopf in Leipzig, was an obvious partner in this, situated as he was at the center of the printing industry and in a city with a busy trade in engraved prints. Bach habitually slipped requests for portraits into a margin or postscript in his letters to this sympathetic and knowledgeable colleague. A typical exchange is recorded in their correspondence in 1775, as they worked on the publication of Bach's oratorio *Die Israeliten in der Wüste*. On February 24, Bach asked Breitkopf for an engraving of Christoph Gottlieb Schröter, the fourth member of Mizler's Correspondierende Societät der musicalischen Wissenschaften (to which his father had belonged): "I would very much like to have Herr Schröter's portrait in my now very respectable musical picture gallery. I suspect it is at the front of one part of Mizler's *Musikalische Bibliothek*. Would you not be able to get it for me for love or money?"[29] In April he again asked after the Schröter portrait and also replied to an offer by Breitkopf of a portrait of the Leipzig music director Johann Adam Hiller. He was already displaying an engraving of Hiller, he wrote, but he was eager to have as well the smaller image that he had heard about from his friend Christoph Daniel Ebeling. Having both images would allow him to select the better likeness (fig. 2.3): "I purchased Herr Hiller's portrait here as soon as it was available, and this honest worthy German has already been parading in my picture gallery for a long time. [That] portrait is in quarto. Herr Ebeling thinks the one in octavo is a better likeness. If it is not much trouble, I would also like the latter. Give my best regards to this admirable man."[30]

We do not know whether Breitkopf was able to send Bach the octavo format portrait of Hiller: only the one in quarto is listed in the 1790 inventory. Either the former was not available after all, or Bach did acquire it, thought it less good than the one he already had, and passed it on. As for Schröter, Bach asked repeatedly, on July 11 and again in December of that year, with some impatience: "What is happening with Herr Schröter's portrait?"[31] At last, the following January he discreetly suggested that they instead ask Bach's younger son, the artist Johann Sebastian, to hunt down the picture, his son being ideally placed to do so, since he was studying at the Kunstakademie in Leipzig and lodging in rooms at the top of Breitkopf's house. The suggestion begins with a little lament that many parents will recognize: "My son, who is very negligent in writing to us, can possibly look into the portrait of Herr Schröter you kindly promised for me, since you do not have much time to spare."[32] Although all the efforts to obtain the portrait of Schröter appear to have been in vain (it is not listed in the 1790 inventory), building the portrait collection was a regular topic in Bach's correspondence with Breitkopf: "Do get for me [Georg] Rhau's portrait, the book printer at Wittenberg in Luther's time. I will gladly pay for it," Bach wrote in the margin of a letter on October 9, 1784.[33] The following April he was still hoping to add the print to his collection, somewhat baffled at its failure to appear: "Is Rhau's portrait really not at all available? It is a woodcut. Your honest colleague."[34] Despite their joint efforts, Rhau's portrait did not enter the collection.

Similar requests for portraits and comments on portraiture pepper Bach's

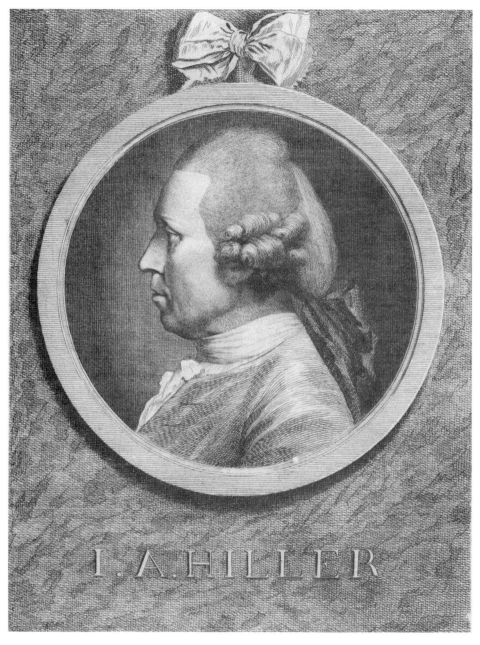

I. A. HILLER

FIGURE 2.3. Johann Adam Hiller (1728–1804). "Courland Kapellmeister and music director in Leipzig." Engraving by Christian Gottlieb Geyser after Heinrich Füger. Staatsbibliothek zu Berlin—Preussischer Kulturbesitz und Mendelssohn-Archiv Mus. P. Hiller, J. A. I, 1. Courtesy of the Berlin State Library (Staatsbibliothek zu Berlin).

letters to the Göttingen professor and organist Johann Nikolaus Forkel, who was himself a portrait enthusiast and would build a significant collection of his own. The two corresponded regularly, the conversation about portraiture running alongside their exchanges about Johann Sebastian Bach, as C. P. E. Bach supplied Forkel with materials for his landmark biography of his father.[35] Early in their correspondence, in 1774, Bach casually, though not without pride, mentioned, as Burney had, that he had a collection of more than 150 portraits. With the letter he enclosed an engraving of J. S. Bach, recently made by his son's Leipzig classmate Samuel Kütner from the Haussmann oil painting that Burney had seen in his gallery. He implied that that painting was not, at the time, in his collection and that he had only a portrait of his father in a medium, pastel, that was too fragile to allow it to be sent to Forkel for copying:

> With the delivery of these psalms, which should occur as soon as I receive them at the fair, I will have the pleasure of sending you a recently finished, clean, and quite realistic engraving of my dear father's portrait. The portrait of my father that I have in my musical portrait gallery containing more than 150 professional musicians is painted in pastels. I had it brought here from Berlin by water, since such paintings with dry colors cannot tolerate the shaking over the axle; otherwise I would very gladly have sent it to you to be copied.[36]

The letter continued with the promise of a new, up-to-date portrait engraving of Emanuel himself: "Perhaps I will be fortunate enough to present to you soon a clean engraving of my portrait, if it would otherwise be of value to you. The one you have does not have wrinkles, but the one I hope to send you will have all the more."[37]

The portrait business between Forkel and Bach continued to the end of Bach's life. In 1786 Bach sent Forkel a copy of his son's drawing of Padre Martini in Bologna (most likely a copy of the painting by Angelo Crescimbeni in the Martini collection): "The mail is about to leave, most esteemed friend; therefore in short! You are receiving herewith Pater Martini. The draftsman did his work rather well. Herr Kapellmeister Naumann, who studied with him, told me it is a good representation of Martini when he was younger." And along with the enclosed drawing of Martini came an extra item, an engraving of the seventeenth-century Hamburg poet and pastor Johann Rist: "I have enclosed a lyric poet, the honest Rist. I am making you a little present of both of them."[38]

Late in 1786 a new portrait enthusiast entered Bach's life, one who proved to be as energetic a collector as Bach himself, and not coincidentally an ardent admirer of the septuagenarian composer. In 1786 the thirty-year-old Schwerin organist Johann Jakob Westphal embarked on a project to assemble as complete a collection as possible of C. P. E. Bach's works, effectively stepping into the role of archivist for the famous composer. It was this archive that would establish the basis for Bach's posthumous reputation.[39] Their exchanges began in late 1786 after Westphal ordered a copy of the sixth *Kenner und Liebhaber* collection.

Bach was quick to see his chance, letting Westphal know he would be grateful for his help in obtaining portraits from this new correspondent: "I have a large collection of engraved portraits of musicians and musical authors. Should you have the opportunity to obtain a few recruits for me, please do so; I will gladly pay for them,"[40] Bach wrote on March 5, 1787, in a postscript to a letter to Westphal. When Westphal then shared with Bach details of his large library of books and music, and of his portrait collection (likely created after the example of the composer he so much admired), the dealings began.

While working to supply Westphal with a complete set of manuscripts and prints of all his works, Bach at the same time requested information on portraits and, when possible, individual items, from Westphal's collection, simultaneously playing the roles of collected and collector. Likewise, when he was able to offer Westphal a portrait he no longer needed, Bach enclosed it with the packet of music he was sending to fill out Westphal's collection of his works. On May 8, 1787, Bach wrote to thank Westphal for, among other things, information Westphal had sent along about his own collection of portrait prints. Examining the list of portraits, and comparing it with the catalog of Westphal's large library, Bach had noticed a discrepancy: "Since you have Baron's book, you should also have his portrait. You have not listed it."[41] The volume in question was Ernst Gottlieb Baron's *Historisch-theoretische und practische Untersuchung des Instruments der Lauten* (Nuremberg, 1727), which Bach, too, owned, and which contained an elegant frontispiece portrait of the author (fig. 2.4)—yet Baron's name was evidently missing from Westphal's list of portraits. Bach offered to send it along from his own holdings, in addition to two other portraits he enclosed with his reply: an engraving of himself (wryly noting its poor likeness), and another portrait he had noticed Westphal did not have, an engraving of the seventeenth-century poet and historian Daniel Georg Morhof: "If you should happen not to have it, it is also available to you, like the enclosed portrait of me (not a good likeness). I also leave the enclosed Morhof to you"[42] (fig. 2.5). In return, Bach wondered whether Westphal could spare portraits of Johann Jakob Engel, the professor of moral philosophy at the Joachimsthaler Gymnasium, and of the superstar French soprano Anne-Antoinette Clavel (Madame de Saint-Huberty), who created roles for Gluck and Piccinni at the Paris Opera in the late 1770s and early 1780s: "Without taking anything away from you I would like Professor Engel and M. de St Huberti from your portrait collection, if you have duplicates of these. I will pay for everything with pleasure."[43]

Westphal was able to fulfill Bach's wish and sent him the two pictures he had requested along with a portrait of the Cassel organist Johann Christoph Kellner just recently published in Kellner's *Orgel-Stücke von verschiedener Art* op. 14 (1787) (fig. 2.6). By comparison with many of the portraits Bach owned, these were relatively humble objects, but they were hot off the press and had been executed using the latest engraving techniques: the portrait of Engel was a mezzotint by J. E. Haid, after Daniel Chodowiecki (fig. 2.7), and that of Saint-Huberty was a red stipple engraving by Robert Endner (fig. 2.8; see also plate 1). Westphal appears

Ernst Gottlieb Baron

Candidatus Juris

J.W. Stör. sculp. Norib. 1727.

FIGURE 2.4. Ernst Gottlieb Baron (1696–1760). "Lutenist in Berlin." Engraving by Johann Wilhelm Stör (1727). Staatsbibliothek zu Berlin—Preussischer Kulturbesitz und Mendelssohn-Archiv. Mus. P. Baron, E. G. I, 1. Courtesy of the Berlin State Library (Staatsbibliothek zu Berlin).

FIGURE 2.5. Daniel Georg Morhof (1639–91). "Writer." Engraving by Diederich Lemkus. Staats-
bibliothek zu Berlin—Preussischer Kulturbesitz und Mendelssohn-Archiv. Mus. P. Morhof, Daniel
I, 2. Courtesy of the Berlin State Library (Staatsbibliothek zu Berlin).

I.C. KELLNER

FIGURE 2.6. Johann Christoph Kellner (1736–1803). "Court organist in Cassel." Etching by Christian Heinrich Schwenterley. Staatsbibliothek zu Berlin—Preussischer Kulturbesitz und Mendelssohn-Archiv. Mus. P. Kellner, Joh, Chris. I, 1. Courtesy of the Berlin State Library (Staatsbibliothek zu Berlin).

FIGURE 2.7. Johann Jakob Engel (1741–1802). "Professor in Berlin, writer." Mezzotint by Johann Elias Haid after Daniel Chodowiecki (1781). ÖNB Vienna PORT 00135116_01.

to have sent two copies of the Engel portrait, one of them unframed, the other framed, and on August 4, in his thank-you letter to Westphal, Bach described a little kerfuffle with the framed portrait of Engel:

> Now something about the portraits. I will take Kellner's. You have made me very embarrassed by your far too great kindness. I thank you most respectfully for Madame de St. Huberti and Herr Professor Engel. I wanted to keep the

FIGURE 2.8. Anne-Antoinette Clavel, Madame de Saint-Huberty (1756–1812). "Singer in Paris at the Académie royale de musique." Red stipple engraving by Gustav Georg Endner after Jacques Antoine Marie le Moine. Staatsbibliothek zu Berlin—Preussischer Kulturbesitz und Mendelssohn-Archiv. Mus. P. Saint-Huberty, A. C. I, 2. Courtesy of the Berlin State Library (Staatsbibliothek zu Berlin).

latter without a frame, since, for lack of space in my hall, I now put my remaining portraits unframed in a portefeuille and will deal with whatever new ones I receive in the same way. Well, I packed the Engel with the frame, but incompetent packer that I am, I was so unlucky as to break the glass, enfin I had to keep it, and I am hereby sending the Engel without the frame back to you. As some compensation for you, I have enclosed seven portraits that you do not yet have. Forgive me, therefore, and make do with them. I am still waiting impatiently for a few recruits who were promised to me, then my catalog of portraits shall certainly be printed.[44]

Even before he ran out of room, the portrait of Engel would likely have been placed unframed in a portfolio, alongside the myriad other portraits of writers stored in this way; but at an earlier stage, space on the wall would surely have been found for Kellner, a practicing musician whose pedigree led back to J. S Bach.[45] Bach thanked Westphal with a present of seven prints, presumably "doublets" or duplicates of items he already had and was glad to give away to a fellow collector who would appreciate them. Still the collecting continued with a passion, with Bach sending further requests to Westphal on October 25, 1787: "I would like [Franz Xaver] Richter from Strasbourg, [Peter] Schmidt (1642) from Magdeburg, [Johann Christoph] Schmidt the Saxon Kapellmeister and [Johann Caspar] Kerll, if they were available."[46] Westphal appears not to have been able to get hold of these in time: they are not listed in the estate catalog.

DEALING WITH DOUBLETS

It was important, Sigmund Apin had written, for a collector to obtain multiple different portrait prints of a single sitter (*doubletten*) when they were available, as some would be better likenesses than others, and only by comparison and elimination could a collection of the highest quality be built. This type of critical, discriminatory collecting is to be distinguished from practices in place by the end of the century, in Germany and in England, in which collectors set out to acquire complete sets of portraits of the same subject in different formats by different engravers, amassing vast numbers of individual images.[47] As the fragments of surviving correspondence show, Bach was alert to the currency of doublets: with Breitkopf he compared the quarto and octavo prints of J. A. Hiller, to Forkel he made a present of an engraving of Johann Rist, from Westphal he requested doublets. On the lookout for portraits to add to his collection, Bach had a good sense for where they were to be found. But more than that, he was operating as a well-informed collector, with a good knowledge of contemporary collecting practice and hewing closely to advice of the sort given by Apin.

This emerges with particular clarity on a sheet of paper conserved in a folder of miscellaneous items from the estate of J. J. H. Westphal in the library of the Royal Conservatory in Brussels.[48] Written by Bach's daughter and collaborator

Anna Carolina Philippina, with title and annotations in Bach's own hand, the document provided Westphal with two lists of names in alphabetical order. In each list, the names of portrait subjects are followed by the simple indication of the format of the image. The first, headed in Bach's hand "Mir fehlen" (I am lacking), lists fifteen engraved portraits that Bach wanted, perhaps from a list of doublets that Westphal had offered him from his collection. Those on the list ranged widely, from folio-format images of the saints Ambrose, Augustine, and Gregory the Great to octavo images of the Italian poet Pietro Metastasio and the Lutheran pastor Christian Friedrich Wilisch and images in quarto of the contemporary Erfurt organist Johann Wilhelm Haessler and the sixteenth-century Italian scholar Guido Panciroli (fig. 2.9):

Mir fehlen [I am lacking]:

> Alcaeus, 12
> Alex. M. 8
> Ambrosius, fol.
> Augustinus, fol.
> David, fol.
> Gregorius M. fol.
> Haesler, 4
> Metastasio, 8
> Pancirolus, 4
> Passerius, fol.
> Quiersfeld, 8
> Schelguigius, 8
> Joh. Andr. Schmidt, 8
> v. Seelen, fol.
> Wilisch, 8
> ───────────
> 15 *Stück* [pieces]

Westphal must have responded quickly, sending the portraits from his own collection posthaste, for every one of the wished-for items is listed in the inventory of 1790, none of them framed (as we have heard, the walls were already full). Their brief descriptions in the inventory allow us to identify them with some certainty: the portraits of Saint Ambrose, Saint Augustine, Gregory the Great, and King David, for example, were mezzotints from a series published in folio by the Augsburg engraver Christoph Leonhard Bürglin; the portrait in octavo of Alexander the Great, inventoried with the detail "*ex nummo argenteo*, . . . Von Heynsius. 8," must have been the engraving that showed the head on a silver coin ("*ex nummo argenteo*") and accompanied by a verse by the seventeenth-century Dutch classical scholar Daniël Heinsius (whose prominent name on the sheet led to Heinsius's being erroneously listed as the artist in the 1790 inventory). Duly listed in the 1790 inventory is a portrait in quarto of Hässler corresponding to the one on Bach's request list (fig. 2.10);[49] likewise, the inventory lists a portrait in octavo of Metastasio "by Gregory," surely referring to the portrait

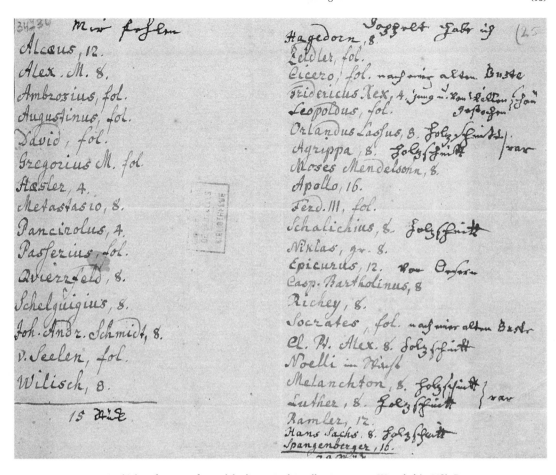

FIGURE 2.9. Bach's list of requests for, and duplicates in, his collection, sent to Westphal (1788?). Bc, 34.734 H.P. No. 25. Names in Roman script in lighter ink are in the hand of A. C. P. Bach, annotations in dark ink are in the hand of C. P. E. Bach. Koninglik Conservatorium Brussel.

engraved by F. Gregory after a painting by Johann Nepomuk Steiner, published as the frontispiece to the *Neue Bibliothek der schönen Wissenschaften* in 1787; the 1790 inventory lists a portrait in quarto of the sixteenth-century legal scholar Guido Panciroli, and a folio mezzotint by Johann Jakob Haid of Giovanni Battista Passeri, both corresponding to those on Bach's wish list.[50] There must have been some confusion over this latter portrait, however: a mezzotint by Haid in Jakob Brucker's *Bildersal heutiges Tages. . .*, vol. 7 (Augsburg, 1748), depicts the Italian scholar and antiquarian Giovanni Battista Passeri (1694–1780), who was neither a musician nor a writer on music. Bach and Westphal likely thought the portrait depicted the Giovanni Battista Passeri (c. 1610–79) who was described in Walther's *Lexikon* as a famous painter and musician and a member of various Roman academies (of whom there was no portrait engraved by Haid).[51] Bach's list also produced for the collection portraits of the German clergyman and writer on music Johann Quiersfeld (1642–86), the theologian Samuel Schelwig (Schelguigius) (1643–1715), the theologian and mathematician Johann Andreas

FIGURE 2.10. Johann Wilhelm Hässler (1747–1822). "Organist and music director in Erfurt." Engraving by [Christian?] Müller. Staatsbibliothek zu Berlin—Preussischer Kulturbesitz und Mendelssohn-Archiv Mus. P. Haesler, Joh. Wilh. I, 1. Courtesy of the Berlin State Library (Staatsbibliothek zu Berlin).

Schmidt (1652–1726), the Lübeck pastor Johann Heinrich von Seelen (1688–1762), and finally Christian Friedrich Willisch (1684–1759), superintendent at the cathedral in Freiberg.

The second list contains twenty-three names, again with an indication of the portrait format, listing duplicates from his own collection that Bach could offer to Westphal. Bach wrote at the top "In duplicate I have" (*Doppelt habe ich*):

Doppelt habe ich:

　Hagedorn 8
　Zeidler, fol.
　Cicero, fol. *nach einer alten Buste* [after an ancient bust]
　Fridericus Rex, 4 *jung und von J[oh]ann Willen [Wilten?] schön gestochen*
　[young and engraved by J. W. Willen (Wilten?)]

Leopoldus, fol.

Orlandus Lassus, 8. *Holzschnitt. rar* [woodcut, rare]

Agrippa, 8 *Holzschnitt rar*

Moses Mendelsohn 8

Apollo, 16

Ferd. III, fol.

Schalichius, 8 *Holzschnitt*

Niklas, gr. 8

Epicurus, 12 *von Oesern* [by Oeser]

Casp. Bartholinus, 8

Richey, 8

Socrates, fol. *nach einer alten Buste*

Cl. Pt. Alex. 8 *Holzschnitt*

Noelli in Wachs

Melanchthon, 8. *Holzschnitt rar*

Luther, 8 *Holzschnitt rar*

Ramler, 12

Hans Sachs, 8. *Holzschnitt*

Spangenberger, 16

23 *Stück* [pieces]

Seven of the "duplicates" of these items appear in the 1790 inventory in the same format as listed here: the poet Friedrich von Hagedorn in octavo; the Nuremberg Kapellmeister Maximilian Zeidler in folio (fig. 2.11); Cicero (fig. 2.14 below); and Socrates, both in folio; the emperor Leopold I in folio; the controversial sixteenth-century theologian Paulus Scalichius, an octavo woodcut; the German soprano Marie Sophie Niklas in *Grosse Octavo* (Gr. 8) (fig. 2.12). These were duplicates in the modern sense of the word, same portrait subject, same format, most likely identical image.

The rest, however, were duplicates only in the sense that they represented the same portrait subject. Formats, and in some cases media, of the portraits listed under these names in the 1790 inventory do not match those on the list of duplicates offered to Westphal. As the inventory shows, for example, the collection in 1790 contained a pastel in quarto of Frederick the Great (the musician-monarch who was also C. P. E. Bach's employer), in a golden frame under glass[52]—a prized, original item that rendered redundant the quarto-sized print (probably Johann Georg Wille's engraving of Antoine Pesne's portrait) of the young Frederick listed for Westphal. The copperplate engraving of Orlando di Lasso by Johann Sadeler listed in the 1790 inventory superseded the woodcut offered as a duplicate to Westphal; likewise Bach was able to part with a woodcut of the early sixteenth-century humanist Heinrich Cornelius Agrippa since he had a copperplate engraving of Agrippa in quarto, and of Hans Sachs, the Meistersinger of Nuremberg, he had a copperplate engraving by Georg Wolfgang Knorr (c. 1730) that was likely more refined than the woodcut on the doublets list.[53] Martin Luther, too, was

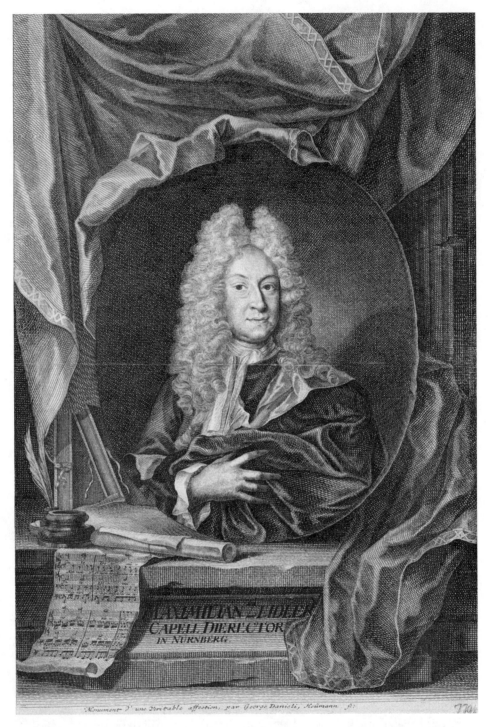

FIGURE 2.11. Maximilian Zeidler (1680–1745). "Kapellmeister in Nuremberg." Engraving by Georg Daniel Heumann. Staatsbibliothek zu Berlin—Preussischer Kulturbesitz und Mendelssohn-Archiv Mus. P. Zeidler, Maximilian II, 1. Courtesy of the Berlin State Library (Staatsbibliothek zu Berlin).

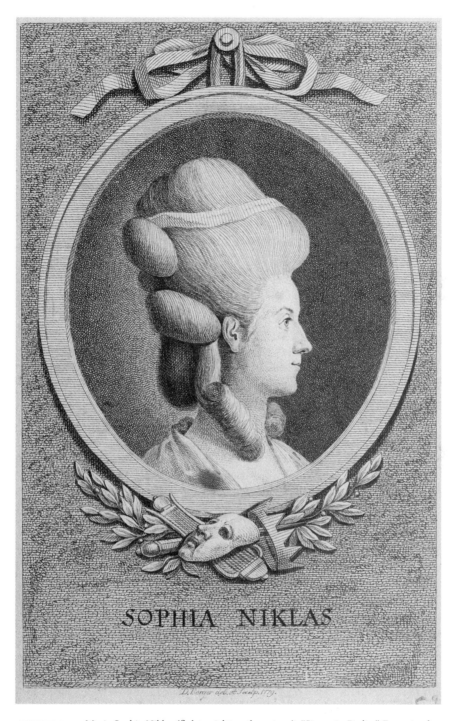

SOPHIA NIKLAS

FIGURE 2.12. Marie Sophie Niklas (fl. late eighteenth century). "Singer in Berlin." Engraving by Daniel Berger (1779). Staatsbibliothek zu Berlin—Preussischer Kulturbesitz und Mendelssohn-Archiv. Mus. P. Niklas, Sophie I, 1. Courtesy of the Berlin State Library (Staatsbibliothek zu Berlin).

represented in the collection in 1790 by a fine copperplate engraving by Joseph August Pechwell (1786) that hung in a gold-rimmed frame, presumably more compelling than the woodcut offered to Westphal as a duplicate (see above, fig. 1.37). Likewise, Bach preferred the folio woodcut after Lucas Cranach of Melanchthon, listed in the inventory of 1790, to the smaller woodcut in octavo that he offered to Westphal.

Bach was able to offer Westphal a small, duodecimo-format image of Apollo, since he had a gorgeous large-format engraving by Johann Martin Preisler, inventoried as "Apollo, Inventor Musicæ. Von J. M. Preisler. Gr. Fol." (see below, fig. 7.12). The small image of Epicurus (in duodecimo) offered to Westphal was presumably less interesting, or of lesser quality, than the fine folio engraving of Epicurus from Johann Ludwig Krüger's series of antique busts at the palace of Sans Souci listed in the 1790 inventory; and a portrait of Bach's collaborator and friend the poet Karl Wilhelm Ramler in octavo by Johann Friedrich Kauke allowed Bach to offer Westphal a smaller image in duodecimo. But image size or format cannot necessarily have been the deciding factor in Bach's choices of which portraits to keep and which to pass on: for Caspar Bartholin, author of one of the most important texts on organology well into the eighteenth century, the exhaustive *De tibiis veterum* (Rome, 1677), Bach kept a small image in duodecimo, framed, offering Westphal a print in octavo (possibly simply on the grounds that the smaller portrait was already framed and hung); for Ferdinand III he kept an image in octavo, offering Westphal an image in folio.

These lists are not dated, but they must have been sent not long before July 21, 1788, when, five months before his death, Bach passed on to Westphal all his remaining duplicates—twenty-three in total—and thanked him for the batch he had recently received: "Dearest friend, I am not well. Therefore short and sweet. You are receiving herewith all 23 of my doubletten and your music. . . . A thousand thanks for the money you sent and especially for the portraits I have taken from you."[54]

At about this time Bach promised Westphal another prized "duplicate," a wax relief or head of Bach's friend Georg Noelli, virtuoso on the pantalon at the Mecklenburg-Schwerin court.[55] The 1790 inventory of the Bach collection listed a portrait relief in plaster mounted on slate and framed, under glass, in a gilded plaster frame.[56] In his correspondence with Westphal in late July 1788 Bach mentioned a Noelli image that he was having difficulty finding a way to send—a likeness not in plaster on slate, but in wax: "The waxen Noelly belongs in a box that could not be enclosed this time. It shall certainly follow in the near future."[57] Two days later, he wrote that "Noelly again could not be enclosed. He is awaiting a dispatch, perhaps through a friend, who will take it along with him in person."[58] Having two images of the same musician, Bach had decided to keep the lavishly framed plaster relief, offering the wax version to the eager Westphal. But this object was more difficult to send than the prints and caused Bach and his family some trouble. The promise was finally made good in September 1790, after Bach's death, by his widow, who noted in her accompanying letter that she

had made a special effort to pack it up carefully: "I have the honor to send you with this a cast of Noelly in wax, which my dear husband would long ago have sent you, had it not been so difficult to pack with other things. I've packed it up in such a way that I hope it arrives undamaged."[59] What goes unremarked in the business of exchange transacted by the ailing collector and after him his widow is that, as the other admirer of his collection E. L. Gerber noted in his *Lexikon*, not only was Noelli a brilliant improviser in a manner similar to W. F. and C. P. E. Bach, but he was also a close friend of the latter. As we shall see, the ties of friendship were important reasons for including portraits in the collection. Sadly, neither image of Noelli survives today.

What emerges from the exchange of doublets between Bach and Westphal in 1787 is a glimpse of Bach the expert collector at work. Bach was not looking for completeness in the sense of trying to get every available portrait for his collection, with multiple images of individual subjects. He actively searched for relevant figures whose portraits were available, then made as sure as he could that he had the best available likeness: comparing for quality, he passed on to other collectors the images he liked less well. This was a matter of knowledge, experience, and aesthetic judgement. C. P. E. Bach, as the archival record suggests, was a devoted and expert portrait *Liebhaber*.

PORTRAIT-BIOGRAPHY BOOKS AND CARICATURE COLLECTIONS

As Apin explained, portrait prints could be obtained in a variety of ways: *Bildnisvitabücher* (portrait-biography books) were an excellent source, since they offered many portraits at once, with biographies attached. These collections of portraits of famous men published in books of woodcuts with short accompanying biographies, out of which a portrait collection might be assembled by those who could not afford oil paintings, had been available since the late sixteenth century (most famously, perhaps, in Giorgio Vasari's *Le vite de' più eccellenti architetti, pitori, et scultori italiani . . .* [Florence, 1550]). In 1587 the Strasbourg printer Bernhard Jobin issued Nicolaus Reusner's *Contrafacturbuch*, a set of biographies and portraits of illustrious men (the woodcut illustrations by Tobias Stimmer), quickly followed by Reusner's *Icones sive imagines virorum*, which appeared in numerous volumes and editions in Latin and German, circulating well into the eighteenth century.[60] Jean-Jacques Boissard's lavish collection of portraits of eminent men, the *Icones virorum illustrium*, in which each subject was presented in a high-quality copperplate engraving and supplied with a biography (first edition Frankfurt, 1597–98), met with such a warm reception that it was reissued regularly in new, ever-expanded, editions, culminating in the multiple volumes of the *Bibliotheca chalcographica* (Frankfurt, 1650–64), which contained 438 portraits and biographies of learned men (*Gelehrten*). If Boissard concentrated on *Gelehrten*, Anthony van Dyck's impressive and influential *Icones principum virorum* (first edition Antwerp, Gillis Hendricx, 1645), which contained over a hundred

portraits, was more wide-ranging, presenting princes, diplomats, intellectuals, and especially artists. Keenly acquired by collectors, the wide circulation of the prints in complete volumes or as individual pages imprinted the Van Dyck portrait type on the contemporary imagination.

So lucrative was this business by the middle of the eighteenth century that printers were eager to embark on portrait projects. The Augsburg engraver Johann Jakob Haid collaborated with the theologian Jakob Brucker to produce a monumental ten-volume set of *Bildnisvitabücher*, each volume containing ten portraits and biographies of contemporary writers (*Bildersal heutiges Tages lebender und durch Gelahrtheit berühmter Schriftsteller* [Augsburg, 1741–55]). The volumes presented only figures then living, in the fashionable medium of mezzotint; their runaway success led Haid and Brucker to follow this project with a retrospective set of volumes containing portraits and biographies of "Learned Germans" from the fifteenth century to the seventeenth. Volumes like these made portrait collecting available as a modish hobby, accessible to the cultured classes beyond the aristocratic elite.[61]

Although these books of prints were largely devoted to men of learning and not to musicians per se, and so were in some sense of limited use to a collector devoted to music, they provided numerous items for the "Musical Writers" section of Bach's holdings. A number of Bach's portraits came from Haid's *Bildersal* volumes, probably purchased as individual sheets. A relatively large number, too, appear to have come from Reusner's *Icones* volumes—another one-stop shop useful for anyone interested in relatively inexpensive woodcuts of Renaissance humanists and men of letters. Seven of the portraits Bach passed on to Westphal in 1788 likely came from Reusner, and another twenty-nine woodcuts found in the 1587 and 1589 volumes of Reusner's *Icones* remained in the collection (fig. 2.13).[62] One more, that of Albertus Magnus, was in the 1590 edition.[63]

Another set of prints that Bach seems to have acquired as a whole was the series of twelve engravings of antique statuary in the royal collection at the palace of Sans Souci (where Bach had often performed as court harpsichordist to the king) by the Potsdam architect, engraver, and draftsman Andreas Ludwig Krüger— a friend, or at least an acquaintance, to whom Bach sent his son Johann Sebastian for his first training in drawing.[64] From Krüger's *Première partie des antiquités dans la collection de sa Majesté le Roi de Prusse à Sans-Souci* (Berlin, 1769) came Bach's eight splendid prints in folio of Virgil, Cicero (fig. 2.14), Dionysius, Epicurus, Horace, Homer, Plato, and Seneca.

Then there were the caricatures engraved by Mattias Oesterreich after drawings by Pier Leone Ghezzi in the royal collection in Dresden, published in the first and second editions of the album *Raccolta di XXIV Caricature . . .* (1750, 1766). This collection was the subject of an exchange with Johann Nikolaus Forkel on May 13, 1786, in which Bach noted that of "the Oesterreich caricatures" he had only the Dresden court singer Domenico Annibali, the Württemberg Kapellmeister Niccolò Jomelli (fig. 2.15), and the "Bresciani"—the calascione player Domenico Calas and his brother. Rather than buying the whole volume, thanks to friends

LAVRENTIVS MEDICES, MVSA-
RVM PATRONVS incomparabilis.

Musarum Pater en, decorat quem laurea Phœbi,
Quàm benè Laurentis nomina digna gero!
LAVREN.

CLAVDIVS PTOLEMAEVS ALE-
XANDRINVS Mathematicus.

Per me doctrinæ totum diuina Mathesis
Corpus habet: cuius glorior esse parens.
A 4

LEONARDVS VINTIVS
FLORENT. PICTOR.

Laudis Apellea metuit sua sidera fulgor
Sospite me vinci, me moriente mori.
VAL. THILO L.
ANDREAS

ANGELVS POLITIANVS
POETA

Qui colui Musas, & quem coluère vicissim
Musæ, Phœbus eram, Flora superba, tuus.
G 4

FIGURE 2.13. Four woodcuts from Nikolaus Reusner, 1589: (A, top left) Lorenzo di Medici, "Grand Duke in Florence, good musician and patron"; (B, top right) Ptolemy, "writer"; (C, bottom left) Leonardo da Vinci, "Milan violinist and painter"; (D, bottom right) Angelo Poliziano, "writer and good musician." Division of Rare and Manuscript Collections, Cornell University Library.

FIGURE 2.14. Cicero. Engraving by Andreas Ludwig Krüger (1769). ÖNB Vienna, PORT 00146105_01.

like Forkel Bach acquired the three caricatures as individual sheets. He must subsequently have added (perhaps also via Forkel, in response to this letter) the caricature of a "German violinist and Italian secretary," also by Oesterreich/ Ghezzi but from a different set published in 1766.[65] Following Apin's advice, Bach's collection included French, Dutch, and English prints. By the middle of the century, the acquisition of first-rate English mezzotints like those in Bach's collection engraved by John Faber, John Smith, and Richard Purcell, with their

FIGURE 2.15. Two etchings by Matthias Oesterreich after Pier Leone Ghezzi: (A, left) Niccolò
Jomelli (1714–74), "Würtemberg Kapellmeister." From *Raccolta di vari disegni* (Potsdam, 1766). Staats-
bibliothek zu Berlin—Preussischer Kulturbesitz und Mendelssohn-Archiv. Mus. P. Jomelli, Nic. II, 3.
(B, right) Domenico Annibali (c. 1705 to c. 1779). "Alto at the Dresden court." From *Raccolta di XXIV
Caricature . . .* (Dresden, 1750). Houghton Library, Harvard University.

subtle painterly gradations of light and shade (see above, figs. 1.14 and 1.15),
confirmed a collector's discernment.

FRONTISPIECES

But Apin also directed his readers to cheaper sources, portraits published as illus-
trations or frontispieces to books, collections of sermons, or pocket calendars, and
it is no surprise that many items in the Bach collection were indeed frontispiece
portraits, some of them likely taken from books in his own library and music
collection, others acquired singly. As we've seen, Bach drew Westphal's attention to
the frontispiece portrait of Baron that was from a book in both their libraries. Two
music books published in 1689 supplied Bach's collection with portrait vignettes
of their authors on lavish title pages from which Bach either cut out the head or
framed the whole page: Jakob Kremberg's portrait came from the gorgeous title
page to his *Musicalische Gemüths-Ergötzung oder Arien* (Dresden, 1689) (fig. 2.16);

likewise, Johann Kuhnau's portrait was from the title page of his *Neue Clavierübung* (Leipzig, 1689), framed by Bach as a complete sheet according to the inventory listing of this portrait as in "folio oblongo." Bach framed the beautifully engraved title pages of French-born lutenist Nicholas Vallet's *Paradisus musicus testudinis* (Amsterdam, 1618) and Leipzig organist Daniel Vetter's *Musicalische Kirch- und HaußErgetzligkeit* (1709–13) for their portraits of the composers (each of these is listed in the inventory as being in "Folio oblongo") (fig. 2.17). Claudio Merulo's portrait, listed in the catalog as a woodcut in duodecimo, had likely been cut out from the title page of his *Ricercari da Cantare*, vol. 2 (Venice, 1607); Samuel Scheidt's, in quarto, was to be found on the verso of the title page of the *Tabulatura nova*, vol. 1 (1624), and a woodcut of the sixteenth-century Strasbourg organist Bernhard Schmid the Elder, in folio (as listed in the 1790 inventory), was in the front matter of his volume of organ tablature, *Zwey Bücher einer neuen kunstlichen Tabulatur . . . allen Organisten und angehenden Instrumentisten zu nutz* (1577). The portrait of the Hamburg violinist Johann Schop adorned the lower half of the title page of Schop's *Geistlicher Concerten* (Hamburg, 1644) and was reprinted in Schop and Johann Rist's *Himmlische Lieder* (Lüneburg, 1652), a book that was in C. P. E. Bach's library:[66] cutting the lower strip with the portrait off one of these pages would have supplied an image in the "Quer. 8" format specified in the 1790 inventory.[67]

Books containing music-theoretical writings, theology, and poetry were an important source of frontispiece portraits for the "Musical Writers" (*Musikalische Schriftsteller*) in Bach's collection. The lavishly bewigged Caspar Bartholin, in duodecimo, came from his *De tibiis veterum* (Rome, 1679); the portrait of Georg Frank von Franckenau, the seventeenth-century writer on medicine (and tangentially the curative power of music) was from the *Neue Bibliothek oder Nachricht und Urtheile von neuen Büchern*, 22 (Theil, 1714); the portrait of Martin Gerbert, the celebrated abbot and historian of music, came from the *Journal von und für Deutschland* 1786; and J. G. Fritzsch's engraving of the poet Friedrich von Hagedorn (fig. 1.33b) was widely available in, for example, *Zuverläßige Nachrichten von dem gegenwärtigen Zustande . . . der Wissenschaften*, 193 (Theil, 1756) or the *Bibliothek der schönen Wissenschaften . . .* 1, no. 1 (1757). The latter journal, in 1782, could also have provided Bach with the portrait of the Magdeburg composer and director of music, Johann Heinrich Rolle. The collection's portrait of Bach's friend Christoph Daniel Ebeling, an engraving by Daniel Beyel after a drawing by Christoph Heinrich Kniep, was published as the frontispiece to the *Allgemeine deutsche Bibliothek* 39, no. 1 (1786),[68] and that of Christian Friedrich Daniel Schubart, engraved by C. J. Schlotterbeck, was in the first volume of Schubart's *Gedichte* (Stuttgart, 1785) (fig. 2.18). Yet not all journals or volumes of sheet music were prefaced by a portrait. A collector must have bibliographic control, a network informed by subscription, reference, and referral. In short, he must be cultured and current but must also possess antiquarian expertise.

* * *

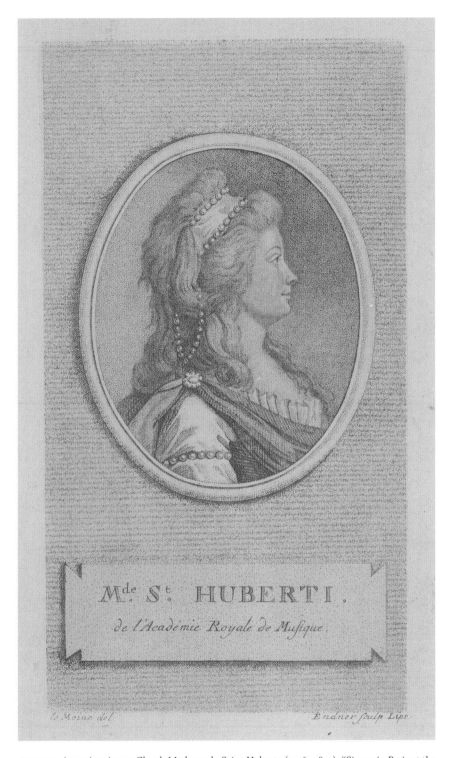

Mde St. HUBERTI.
de l'Académie Royale de Musique.

le Moine del. Endner sculp Lips.

PLATE 1. Anne-Antoinette Clavel, Madame de Saint-Huberty (1756–1812). "Singer in Paris at the Académie royale de musique." Red stipple engraving by Gustav Georg Endner after Jacques Antoine Marie le Moine. Staatsbibliothek zu Berlin—Preussischer Kulturbesitz und Mendelssohn-Archiv. Mus. P. Saint-Huberty, A. C. I, 2. Courtesy of the Berlin State Library (Staatsbibliothek zu Berlin).

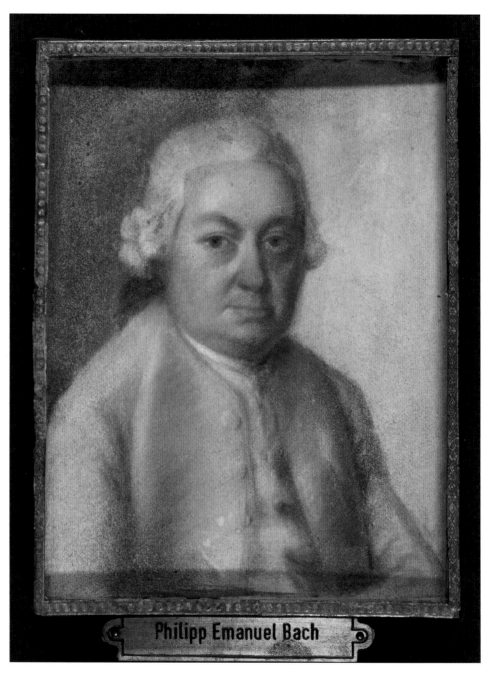

Philipp Emanuel Bach

PLATE 2. C. P. E. Bach. "In Hamburg, J. S. Bach's second son." Pastel by Johann Philipp Bach, c. 1777. 15 × 11.5 cm. Staatsbibliothek zu Berlin—Preussischer Kulturbesitz und Mendelssohn-Archiv. Mus. P. Bach, K. Ph. E. I, 1. Courtesy of the Berlin State Library (Staatsbibliothek zu Berlin).

PLATE 3. Young woman with a book. Oil on canvas by Pietro Antonio Rotari. 46 × 35.9 cm. Rijksmuseum, Amsterdam.

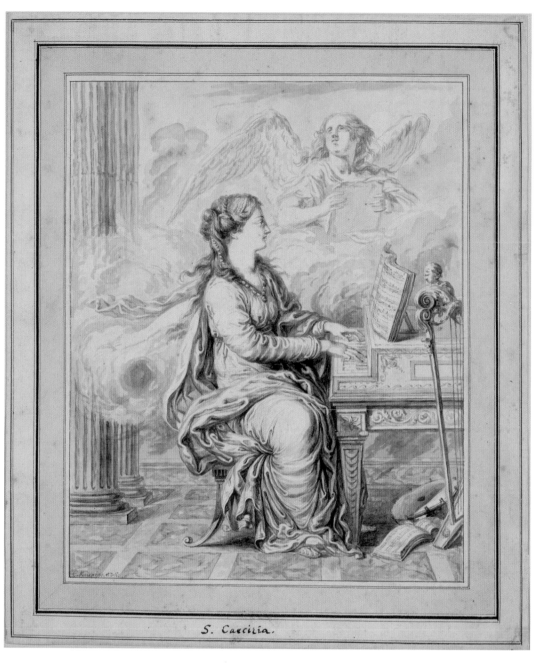

S. Cæcilia.

PLATE 4. Saint Cecilia, drawing in pen and brown ink, wash, by Christoph Heinrich Kniep. 32.9 × 28.3 cm. Inv. SZ Kniep 1. Bpk Bildagentur/Kupferstichkabinett, Berlin/Art Resource, NY.

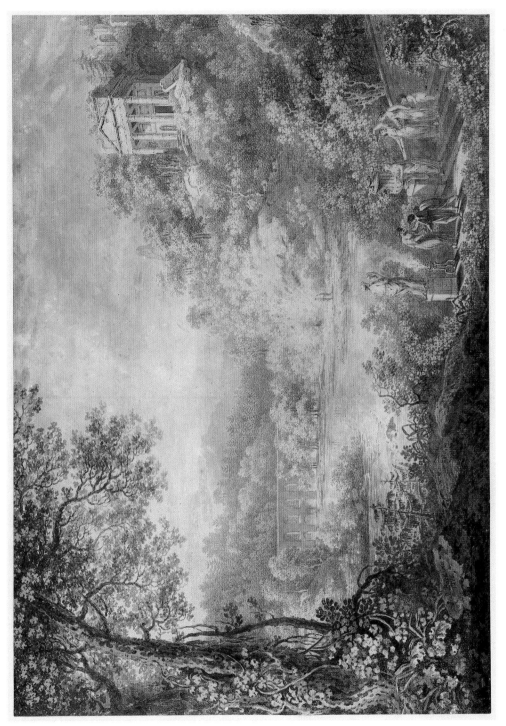

PLATE 5. *Arcadian Landscape with Aqueduct and Temple on a Hill* (1775) by Johann Sebastian Bach the Younger. Black and gray ink, green-gray wash. 32.2 × 45.7 cm. Bpk Hamburger Kunsthalle, Kupferstichkabinett.

PLATE 6. Johann Friedrich Reichardt (1752–1814). "Prussian Kapellmeister." Drawing in red chalk by Asmus Jakob Carstens. 9.5 × 8 cm. Staatsbibliothek zu Berlin—Preussischer Kulturbesitz und Mendelssohn-Archiv. Mus. P. Reichardt J. Fr. I 2. Courtesy of the Berlin State Library (Staatsbibliothek zu Berlin).

PLATE 7. (A, top) Antonio Lolli (c. 1725–1802). "Violinist." Drawing by Johann Andreas Herterich. Black and colored chalk on vellum. 20 × 16.5 cm. SBB. (B, bottom) Thomas Christian Walter (1749–88). "Secretary, composer, and director of the Royal Theater in Copenhagen." Drawing by Herterich. Black and colored chalk on vellum. 19 × 15 cm. Staatsbibliothek zu Berlin—Preussischer Kulturbesitz und Mendelssohn-Archiv. Mus. P. Lolli, Antonio I, 1, and Mus. P. Walter I, 1. Courtesy of the Berlin State Library (Staatsbibliothek zu Berlin).

PLATE 8. (A, top) Leopold August Abel (1718–94). "Violinist in Ludwigslust." Self-portrait, 1779. Black and colored chalk with wash on gray paper. 27 × 22.5 cm. (B, bottom) Carl Friedrich Abel (1723–87). "Violdigambist in London." Drawing by Ernst Heinrich Abel, 1786. Black, white, and colored chalk with wash on gray paper. 25 × 21 cm. Staatsbibliothek zu Berlin—Preussischer Kulturbesitz und Mendelssohn-Archiv Mus. P. Abel, Leop. Aug. III, 1, and Mus. P. Abel, Carl Friedrich I, 6. Courtesy of the Berlin State Library (Staatsbibliothek zu Berlin).

FIGURE 2.16. Jakob Kremberg (c. 1650–1715). "Electoral Saxon *Musikus*." Engraving by Moritz Bodenehr after Samuel Bottschild. Kremberg, *Musicalische Gemüths-Ergötzung* (Dresden, 1689). Staatsbibliothek zu Berlin—Preussischer Kulturbesitz und Mendelssohn-Archiv. Mus. P. Kremberg, I, 1. Courtesy of the Berlin State Library (Staatsbibliothek zu Berlin).

Portrait collecting was a demanding pastime, and a comprehensive collection, properly supplied with biographical information on the portrait subjects, was vital to the well-formed library of an eighteenth-century man of standing. Further, an extensive yet focused collection was evidence of its owner's education, sophistication, expertise—and, not least, means. In 1751 the Berlin scholar Georg Gottfried Küster, author of the biographies accompanying each of the one hundred portraits in that year's edition of Martin Friedrich Seidel's published gallery of illustrious men of the Mark Brandenburg, took care to introduce the volume by explaining that portrait collecting required connoisseurship in the visual arts, experience in the science of physiognomy, and knowledge of the character and achievements of those represented: "Three things must be found in those who want to take pleasure in good portraits: (a) a proper knowledge of good copperplate engraving and accurate drawing; (b) some knowledge and experience of physiognomy; and (c) sufficiently well-founded information on the spiritual nature and the fortunes of the subject represented in an engraving."[69]

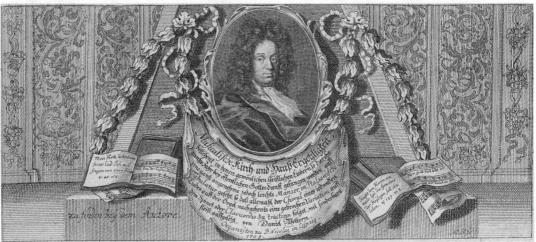

FIGURE 2.17. (A, top) Nicolas Vallet (1583 to after 1642). "Lutenist." Vallet, *Paradisus musicus testudinis* (Amsterdam, 1618). Engraving by Johannes Berwinckel after David Vinckeboons. ÖNB Vienna PORT 00015480_01. (B, bottom) Daniel Vetter (1657/58–1721). "Organist in Leipzig." Engraving. Vetter, *Musicalische Kirch- und Hauß Ergetzligkeit* (Leipzig, 1709). Staatsbibliothek zu Berlin—Preussischer Kulturbesitz und Mendelssohn-Archiv. Mus. P. Vetter, I, 1. Courtesy of the Berlin State Library (Staatsbibliothek zu Berlin).

FIGURE 2.18. Christian Friedrich Daniel Schubart (1739–91). "Music director and writer." Engraving by Christian Jacob Schlotterbeck. Schubart, *Gedichten*, vol. 1 (Stuttgart, 1785). Herzog August Bibliothek, Wolfenbüttel Portr. I 12177b.

Seidel's work appeared in Berlin when Bach was living there and when his collecting was getting under way. Bach would have known, as his admirers did, that portrait collecting demanded—and would put on display—time, money, and expertise.

For every true collector, considerations of quality tussle with sheer quantity as the collection grows and the urge continues—to keep adding, to fill gaps, to find and procure the rare item or the unique object. Yet to suggest, as some scholars have done, that Bach was simply acquiring anything he could get his hands on, plastering his walls with images willy-nilly, is to overlook the evidence in the archival record and to underestimate the degree of critical intelligence and knowledge demonstrated by Bach as collector. It is also to miss an opportunity to learn about Bach the composer, the Bachian milieu, music culture, and that culture's view of itself in the late eighteenth century. We cannot know Bach's intentions as he bought and exchanged portraits. But there is much that can be said about his familiarity with both contemporary practices of collecting and the particularities of portrait culture. It is a matter of paying attention to his concern with detail, his interest in the quality of a likeness, and his awareness of the techniques of the engraver or artist and the places where portraits could be found.

Much has been written on the "unruly passion" of collecting—on the art, in collecting, of maintaining a balance between order and chaos.[70] The collection, unlike a confusion, is more than the sum of its parts. As Susan Pearce reminds us, "the selection process is the crucial act of the collector." In building his collection, C. P. E. Bach solicited the help of friends and colleagues; he pursued particular portraits with alacrity, alert to the rare item he had heard of, had read about, had perhaps seen in other collections. He acquired multiple versions of the same subject when he could, judiciously choosing between them. The collection is rich in pages that could have been procured through published collections of prints, including those from Reusner or from print series such as those of antique statuary by Krüger. Bach took portraits out of books and from published music. He knew how to make a collection, not a confusion, one that classified and organized the music culture of his age—and of the age (or ages) out of which his own had grown. Far from being a random accumulation of objects, Bach's collection belonged to a culture in which, as another great late eighteenth-century collector, Johann Wolfgang von Goethe, showed, a collection was seen to map out connections and correlations, establishing whole areas of knowledge, with the greater narratives binding it together as a whole transcending the mass of individual objects. "By taking an object out of one context and choosing to embed it another," as Renate Schellenberger has written of Goethe, "the art enthusiast becomes a collector, actively constructing and shaping a different world."[71] But that very act of selection is one that reflects back on the collector, creating and revealing a picture of himself: "because it is predicated on interest, selection is important for its ability to reveal the personality of the collector, for it demonstrates concretely what he or she would like to see more of in the world."[72] The act of choosing items to include, and deciding how and where to integrate those

items into the growing assemblage of objects, depend on the identity, taste, and intellectual formation of the collector. As Goethe admitted, all the elements of the collection were connected inextricably to the collector himself: collecting for him was, he acknowledged, a matter of his personal education (*Bildung*)."[73] For C. P. E. Bach, the learned and expert late eighteenth-century collector, the creation of the portrait collection was unavoidably tied up with self-scrutiny and autobiographical reflection, concerns with historical legacy explored hand in hand with new conceptions of the self.

Speculating: Likeness, Resemblance, and Error

I have enclosed a copperplate engraving [of my late husband] that was made here, and which, like all of the other engravings of him, does not really resemble him.
Letter from Johanna Maria Bach to J. J. H. Westphal, September 1790

Sometime after 1797 the organist Johann Christian Kittel acquired the now-famous portrait by Elias Gottlob Haussmann of Carl Philipp Emanuel Bach's father, Kittel's teacher Johann Sebastian Bach—the portrait that had been a centerpiece of Emanuel Bach's collection (fig. 3.1). As Ernst Ludwig Gerber later reported, Kittel put the portrait to good use. Hanging it directly above the clavier in his music room, he equipped the large oil painting with a curtain and proceeded to use it as both punishment and reward for his students: for those who had failed to practice or whose composition exercises were poor, the curtain remained closed, the image stubbornly hidden. But for those whose "hard work was worthy of the harmony of this father," as Gerber recounted, the curtain that covered the portrait was drawn back, the imposing visage unveiled, as if the great "father" had himself stepped out of the past to bestow his approving glance on the trembling young musician below.[1]

That portraits could produce the magical effect of bringing long-dead forebears into the presence of the living was well known. The portrait, wrote Johann Georg Sulzer in his *Allgemeine Theorie der schönen Künste*, is a powerful tool for keeping alive our relationship with our ancestors; the sensitively executed likeness sustains our love and respect for the deceased just as if the dead were to circulate among us from time to time as living beings.[2] C. P. E. Bach, of all people, would have known this. While his portrait collection included many friends and contemporaries, Bach's holdings were weighted toward his predecessors—exemplary figures of the musical past who could offer inspiration in the present. At the heart of the collection, as Charles Burney had immediately noticed, were portraits of members of Bach's own family, including his grandfather Johann Ambrosius and his

FIGURE 3.1. J. S. Bach. "Kapellmeister and music director in Leipzig." Oil on canvas by Elias Gottlob Haussmann, 1748. 76.3 × 62.8 cm. Bach-Archiv, Leipzig.

father Johann Sebastian (the portrait that would eventually belong to Kittel). In a sprawling collection largely consisting of engravings, woodcuts, small drawings, and pastels, the large gold-framed oil paintings of Johann Sebastian Bach and other family members would have formed a striking focus.

C. P. E. Bach was an assiduous curator of the Bach family archive—a collection whose kernel he had inherited from his father and that, like any good library, included portraits as well as books and music.[3] He also inherited, and contin-

ued to amend, the family genealogy his father had compiled in 1735,[4] and his pride in his family legacy was on full view in the opening of the obituary for his father, which not only emphasized the musical gifts of the family going back in time, but also pointed to the importance of keeping such memories alive: "The obligation we have of establishing and keeping fresh the memory of worthy men will sufficiently excuse us to those who may have found this little excursion into the musical history of the Bach family too lengthy."[5] There was a considerable collection of his father's music, there were the old compositions of the Bach family ancestors, and there was the collection of music by other composers that his father had assembled. We can thank C. P. E. Bach for curating and preserving the Bach family history.[6]

By the time C. P. E. Bach died, his collection contained at least nine family portraits, including the oil paintings of his father and grandfather, an oil painting (now lost) by Antonio Cristofori of his stepmother, the singer Anna Magdalena Bach, a pastel by Joseph Eichler of his brother Wilhelm Friedemann Bach, an oil painting of his half-brother Johann Christoph Friedrich Bach (the "Bückeburg" Bach), a miniature of his younger half-brother Johann Christian Bach by Ernst Heinrich Abel (the brother of J. C. Bach's London collaborator Carl Friedrich Abel), a pastel of the Meinungen Kapellmeister Johann Ludwig Bach, executed by the sitter's son Gottlieb Friedrich Bach, and an old engraving dated 1617 of the Gotha musician Hans Bach. C. P. E. Bach owned two busts or reliefs of himself, one in plaster and another in wax; he also had in his possession at various times (and perhaps also at his death, although they are not listed in the catalog of his estate) copies of the various portrait engravings of himself then in circulation, as well as the set of silhouettes of himself and his wife and their three children made by Jacob von Döhren about 1776.[7]

Emanuel's letters to Forkel, Breitkopf, and many others often express concern with likeness—the accuracy of the visual representation and the depth of character revealed there—especially in depictions of himself and his father. He wanted to supply friends and colleagues with good-quality images (engravings, or originals for copying or engraving) that captured the sitter well. Portraits of himself, he generally felt, were unsuccessful. The engraving made by Johann Heinrich Lips for the Swiss physiognomist Johann Caspar Lavater (fig. 4.1 below) he thought "anything but a good likeness."[8] In 1786 he instructed the publisher Engelhard Benjamin Schwickert to drop the idea of having an engraved portrait made for the new edition of the *Versuch über die wahre Art das Clavier zu spielen* (1787), since there were already enough bad likenesses in circulation. Only one portrait of himself, he noted, had met its mark—likely referring to the pastel made in 1773 by Johann Philipp Bach (son of the Meinungen Kapellmeister Gottlieb Friedrich Bach, himself a fine portrait painter): "The only successful portrait of me is with pastels, framed, under glass" (fig. 3.2; see also plate 2). A pastel was too fragile to be sent, as Bach had remarked to Forkel in 1774 when discussing the portrait of his father, and, Bach mentioned, a copy in oils (more robust and better suited for transportation over rough roads) could be made. But still, the question of

FIGURE 3.2. C. P. E. Bach. "In Hamburg, J. S. Bach's second son." Pastel by Johann Philipp Bach, c. 1777. 15 × 11.5 cm. Staatsbibliothek zu Berlin—Preussischer Kulturbesitz und Mendelssohn-Archiv. Mus. P. Bach, K. Ph. E. I, 1. Courtesy of the Berlin State Library (Staatsbibliothek zu Berlin).

engraving would remain: "And in any case," he wrote, "I have been engraved badly often enough, so who particularly needs a new one?"[9] The apparent difficulty of accurately portraying Emanuel Bach seems to have been a family theme: when in September 1790 Bach's widow Johanna Maria sent J. J. H. Westphal the posthumous engraving of a memorial bust of Bach, published as the frontispiece

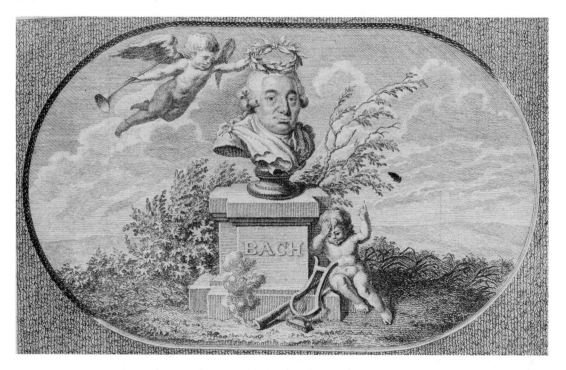

FIGURE 3.3. C. P. E. Bach, memorial bust as frontispiece to *Passions-Cantate*, Wq. 233. Engraving by Andreas Stöttrup, c. 1789. Staatsbibliothek zu Berlin—Preussischer Kulturbesitz und Mendelssohn-Archiv Mus. P. Bach, K. Ph. E. I, 5. Courtesy of the Berlin State Library (Staatsbibliothek zu Berlin).

to the vocal score of the *Passions-Cantate*, Wq. 233 (fig. 3.3), she wrote, "I have enclosed a copperplate engraving that was made here, and which, like all of the other engravings of him, does not really resemble him."[10] As a connoisseur of portraits, C. P. E. Bach was particularly sensitive to the problem of creating an accurate likeness of himself.

Often such concerns went hand in hand with the matter of his musical legacy and that of his father, whether in relation to the publication of the *Art of Fugue* (1751, revised edition with preface by F. W. Marpurg, 1752) or with materials for Forkel's biography of Johann Sebastian, or as part of his work with Johann Philipp Kirnberger on the edition of his father's chorales.[11] And yet, for all his investment in the family image, Emanuel Bach appears largely to have avoided, even rejected, acknowledging the family traits in his own music: the son who preserved and promoted the family legacy with such dedication did not engage overtly with his father's art in his own: "The figure of Sebastian, totemlike, was ubiquitous," Richard Kramer has written. "Everywhere, Emanuel felt the need to speak of his father. In his music, he fails to do so. The patrimony is not acknowledged there."[12] Kramer's reading is typically subtle: he goes on to explain: "What I mean to suggest is that Emanuel Bach's music tells us something about the relationship of the son to the father, in this complicated language of signification, at once abstract and concrete, that is the deepest reflection of feeling." Emanuel

Hamburg, ben 12ten Julius, 1774.

FIGURE 3.4. C. P. E. Bach's signature as a contrapuntal fragment. From Johann Friedrich Reichardt, *Briefe eines aufmerksamen Reisenden die Musik betreffend* (Frankfurt, 1776), ii, p. 22. Division of Rare and Manuscript Collections, Cornell University Library.

Bach staked his claim as a Bach in a language of difference, producing ambitious artworks that were, at their best, new, bold, original, and utterly unlike those previously associated with the family name.

But how can we account, then, for those moments preserved in the archival record (and even in print) when the father's voice appears to have been ventriloquized directly through the musical utterances of the son? There is the BACH signature entered by C. P. E. Bach into the album (*Stammbuch*) of Carl Friedrich Cramer in 1774, and again in a letter dated 1775—the son adopting the father's musical moniker, so prominently and poignantly a part of the story of the *Art of Fugue*, but making it his own in a contrapuntal fragment that ends unresolved and ambiguous, pointing forward, not back (fig. 3.4).[13] Then there is the case of Emanuel Bach's "first" piece—the Sonata in B-flat, H. 2 (Wq. 62/1), written in 1731, revised in 1744: the first movement, Presto, bears such obvious thematic similarities to J. S. Bach's F Major Invention, BWV 779 (c. 1720, rev. 1723), as to sound like, if not a parody, then a compositional exercise in pastiche (music examples 3.1 and 3.2).[14] As is well known, the young composer would have learned his art by sticking close to his father's model, even copying it—but in the case of Emanuel Bach, whose reputation was founded on originality, one might have expected such borrowing to have been consigned to the flames with the other juvenilia Bach burned later in life.[15] Instead, the piece was published in 1761 in

EXAMPLE 3.1. C. P. E. Bach, Sonata in B flat, Wq. 62/1, bars 1–8.

EXAMPLE 3.2. J. S. Bach, Invention in F Major, BWV 779, bars 1–9.

the *Musikalisches Allerley* and, deeply and irretrievably stamped with the image of his father, was entered into the *Nachlassverzeichniß* as no. 1, given the status of Emanuel's first admissible composition.

In another instance an arrangement, preserved in three surviving manuscript copies in Berlin (two of them copied by Emanuel's favored copyist, known as Anon. 303) records Emanuel's encounter with one of J. S. Bach's most beautiful organ chorales, his setting of "Ich ruf zu dir," BWV 639, from the *Orgelbüchlein*[16] (music examples 3.3 and 3.4). Emanuel leaves his father's setting intact but introduces and concludes it with three measures of his own, based on the father's accompaniment figure but accentuating the pulsating sighs of the original with suspensions and chromaticism; in the first half of the piece each phrase of the original is also interleaved with an extra measure of sighs that subtly inject into the baroque lament a more sentimental, *empfindsam*, tearfulness and speak a language more modern, more indulgently feeling, than that of the original. In a respectful confrontation of old and new, the identity of the father is preserved but reframed by that of the son. One might also cite C. P. E. Bach's *Magnificat*, Wq. 215, completed on August 25, 1749, and performed in the Thomaskirche in 1750, perhaps presented there as Emanuel's demonstration of his claim to the

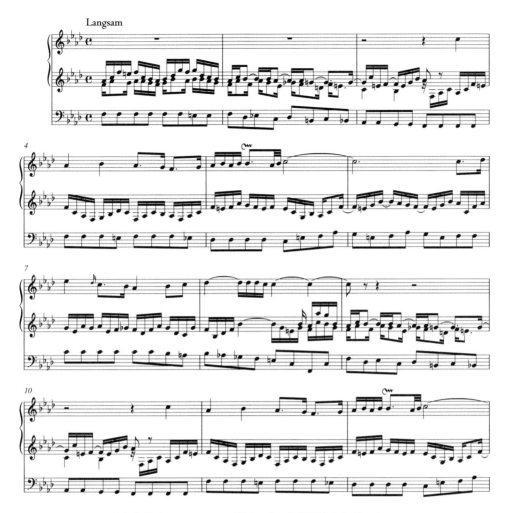

EXAMPLE 3.3. C. P. E. Bach, arrangement of "Ich ruf zu dir," BWV Anh. II 73, bars 1–12.

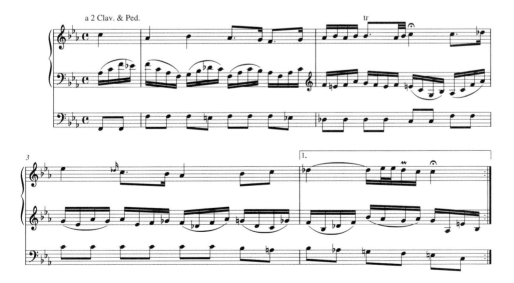

EXAMPLE 3.4. J. S. Bach, "Ich ruf zu dir," BWV 639 (from the *Orgelbüchlein*), bars 1–4.

family legacy, in the hope of succeeding his father as Thomaskantor. C. P. E. Bach's *Magnificat* leans heavily on his father's *Magnificat* setting, BWV 243, but it also includes music not only distinctly similar to, but virtually quoting the "Gratias" from the *Missa* and the "Et expecto" from the *Symbolum Niceum* of his father's B Minor Mass.[17]

It is not clear how we are to read these moments of the son's overt engagement with his father's art. They might be understood by the musician and music historian as acknowledgments of influence (with all its attendant anxieties) or as acts of homage. But I suggest that we might more productively approach such moments by imagining ourselves into another of C. P. E. Bach's adopted identities, that of collector of portraits—the connoisseur who detects the traits of likeness, those properties of resemblance that tie the painted face to its living original, or that draw a network of often subtle connections among family portraits. The portrait connoisseur feels out the limits of character and identity, tracing the lineaments of the family physiognomy, as he muses on his father's music. Divining a likeness, as we shall see, was a fraught task: reading a portrait required not only expert knowledge, but also a willingness to speculate. Seeing in some of Bach's pictures what he thought he saw, we can get a sense for the kinds of assumptions—and errors—made by the eighteenth-century connoisseur and remind ourselves, in turn, of the potential rewards, and risks, of listening for likeness.

(MIS)IDENTIFYING THE SUBJECT

Portraiture, as Richard Brilliant has written, is an intentional art form. The portraitist is engaged in recording and conveying to the viewer a particular likeness, whether mimetic, in the sense of capturing the sitter's outward appearance, or more interpretive, drawing out less visible qualities of character and feeling: "Fundamental to portraits as a distinct genre in the vast repertoire of artistic representation is the necessity of expressing this intended relationship between the portrait image and the human original. . . . the portrait, as an art work, contains in its own pictorial or sculptural content a deliberate allusion to the original that is not a product of the viewer's interpretation but of the portraitist's intention."[18] What the portrait means, in the sense of whom it represents, is not open to interpretation (although there are many other levels of meaning in portraiture beyond a straight identification of the subject). But what if the identity of a portrait subject has been lost or somehow rendered invisible? What if a mistake has crept into the collector's project, the wrong item acquired, or an object incorrectly identified? In the realm of error, of the not quite known, a space for interpretation opens. Bach's collection, which contained portraits of subjects both famous and obscure, both historical and contemporary, unambiguously identified with the music profession or only distantly associated with it, was assembled with diligence and expertise and painstakingly documented. Yet it was not immune to misidentification or oversight. In the inventory of the collection, as we have seen, Bach, the compulsive proofreader of his own works

and avenger of errata, described many of his portraits in detail. Yet some of his identifications appear to have been rooted in speculation or based on erroneous information; at the very least, they have spurred further speculation among later commentators on the collection. The uncertainties and ambiguities embedded in Bach's portrait collection reveal the concern of its creator and his contemporaries with questions of likeness and identity, and of the precarious divide between accuracy and error in the historiographical project—both art-historical and musical. Far from diminishing the historiographical importance of the Bach portrait collection, it is in these sometimes erroneous reflections that we see most clearly the mechanics of C. P. E. Bach's artful collecting, and the importance to portrait collecting of imaginative and expert speculation.

For C. P. E. Bach's contemporaries, the varied cast of characters in his portrait collection raised many questions. Most obviously, there was the matter of the portrait subject's importance to C. P. E. Bach himself and, perhaps more significantly, of his or her contribution to the art of music across the ages—even if such a contribution was only dimly to be perceived through the mists of history. This exercise in searching for explanations is perhaps best demonstrated in the work of Ernst Ludwig Gerber. Bach's portrait collection was a crucial source for names of people to be included in Gerber's own musical portrait collection, and hence in his groundbreaking work of music historiography, the *Historisch-biographisches Lexikon der Tonkünstler*. Numerous obscure figures found an afterlife in the *Lexikon*, both in its two-volume first edition (1790, 1792) and in the four-volume second edition (1812–14), simply because their portraits had been owned by Bach.[19] This prompted Gerber to speculate in print about what Bach knew, and to wonder what significance the portrait subjects had for him. Gerber's entry on the sixteenth-century German legal scholar Nicolaus Cisner (1529–83), for example, explained that Gerber had been unable to discover Cisner's contribution to music, apart from his inclusion in the Bach portrait collection.[20] In the case of Étienne Dolet (1509–46), the French lawyer burned at the stake as a Protestant in 1545, Gerber supposed that he had found his place in Bach's collection simply on the strength of the obscure mention of music in the punning aphorism attached to his woodcut portrait.[21] Yet because both Cisner and Dolet, as Gerber explained, had been included in Bach's collection of musicians' portraits, it was not for him to withhold them from readers of the *Lexikon*. In the case of the humanist Girolamo Fracastoro (c. 1478–1553), whose major contributions were in the fields of astronomy and medicine, Gerber simply admitted in the very first lines of the entry that he had no idea why Bach had included Fracastoro's portrait in his collection.[22]

Another figure who seemed to Gerber to have entered the collection by mistake was the English writer and physician Thomas Browne (1605–82), laconically captioned in C. P. E. Bach's inventory (probably borrowing spelling and wording from the print) as "*Brown, (Thomas) Dt. Med.* in Norwich, Schriftsteller [writer]" (fig. 3.5). Browne practiced medicine in Norwich from 1637 until his death, but he was best known for his learned, tolerant, and urbane writings—which had very little to do with music. His *Religio Medici* (1642) circulated widely in England

Within the engraving:

THOMAS BROWN,
In Syn Leven Ridder en Doctor
in de Medicyne tot Norwich.

FIGURE 3.5. Sir Thomas Browne (1605–82). "Dt. Med. in Norwich, writer." Engraving by Robert White. ÖNB Vienna PORT 00072483_01.

and Europe; it was followed by the *Pseudodoxia Epidemica: Enquiries into Vulgar Errors* (1646) and the *Hydriotaphia, or Urne Burial* (1658), an extended reflection on death, which was accompanied by an essay, "The Garden of Cyrus," devoted to the mystical figure of the quincunx. Speculating on why Bach acquired Browne's portrait, Gerber was again at a loss. Browne's treatment of music, he wrote, was limited to mention of swan songs and music's cure for the bite of the tarantula. In his view Bach had made a mistake, meaning instead to have a portrait of the eighteenth-century clergyman, writer, and amateur musician John Brown (1715–66), author of *A Dissertation on the Rise, Union, and Power, the Progressions, Separations, and Corruptions, of Poetry and Music* (London, 1763), a book that had been translated into German by Bach's friend J. J. Eschenburg (Leipzig, 1769).[23] Perhaps Gerber was right. Or was Bach in fact not mistaken? Like Bach, Thomas Browne was particularly interested in the human face and in the science of physiognomy: "There are mystically in our faces certaine characters," he wrote in the *Religio Medici*, "which carry in them the motto of our Soules, wherein he that cannot read A. B. C. may read our natures."[24] Whether Bach intended to procure a portrait of John, not Thomas, Brown(e) we cannot know.

For the English society lady Margaret Fordyce (1753–1814), earning a place on Bach's wall appears to have been simply a matter of being portrayed holding the right prop. Bach's catalog lists a mezzotint of one "Fordyce (Miss), lutenist."[25] Although Bach does not name the artist, the portrait in question must surely have been the image engraved by Corbutt (Richard Purcell) after a painting by Sir Joshua Reynolds, of the English lady Margaret Fordyce, showing her with her head prettily tipped toward a music book at the left of the picture frame while she plays the instrument she holds in her lap (fig. 3.6). Gleaning his information from the picture (or from Bach's catalog entry) and indulging in a little imaginative speculation, Gerber wrote in 1790 that Fordyce was "a talented lutenist" and "a pleasant and charming singer in the London theater, living around the middle of this century."[26] Thirty years and a good deal more research later, Gerber offered a shorter and dryer account of Fordyce, consisting merely of a reference to the portrait by Reynolds and Corbutt, followed by the perplexed admission that in the reference book of record for English prints, Henry Bromley's *A Catalogue of Engraved British Portraits from Egbert the Great to the Present Time* (London, 1793), the entry for Fordyce's portrait does not categorize her as a musician. In fact she was not a professional musician at all and is not known to have performed in public (or even to have been a particularly eager amateur); rather, as the sister of the banker Alexander Fordyce (who went spectacularly bankrupt in 1772), she had sat for Reynolds in 1761 with the quintessential accoutrement for the fashionable lady of the 1760s, a cittern.[27] The musical instrument (misidentified by Bach and in most later descriptions of the portrait) speaks to Fordyce's social status rather than to any particular talent in the art Bach had built his collection around.

With Fordyce, Bach had apparently mistaken musical prop for musical talent; in the case of the famous Italian soprano Lucrezia Aguiari (1743/46–83), nicknamed "La Bastardella," the error appears to have been less a matter of misconstruing a

FIGURE 3.6. Margaret Fordyce (1753–1814). "Lutenist." Mezzotint by Richard Purcell (alias Corbutt) after Sir Joshua Reynolds, 1762. Staatsbibliothek zu Berlin—Preussischer Kulturbesitz und Mendelssohn-Archiv. Mus. P. Fordyce, II, 1. Courtesy of the Berlin State Library (Staatsbibliothek zu Berlin).

visual archetype (what "Music" looked like), than wrongly perceiving a likeness. The *Nachlassverzeichniss* lists a mezzotint, also by Corbutt, of La Bastardella under glass in a black frame ("Bastardella [named Lucret. Angujari], a Soprano. By Corbutt").[28] Several images of the singer were in circulation, including a caricature showing Aguiari with skirts lifted high having artificial buttocks glued to her bottom by her husband, the composer Giuseppe da Colla[29] (fig. 3.7), but none

FIGURE 3.7. Satirical print, c. 1780, showing Lucrezia Aguiari and her husband, Giuseppe da Colla (possibly engraved by Francesco Bartolozzi after Philip James de Loutherbourg). London, British Museum, Department of Prints and Drawings © The Trustees of the British Museum.

FIGURE 3.8. (A, left) Ann Bastard (1743–83). Mezzotint by Richard Purcell (alias Corbutt) after Sir Joshua Reynolds. London, British Museum, Department of Prints and Drawings © The Trustees of the British Museum. (B, right) Lucrezia Aguiari, "La Bastardella." Oil painting, attributed to Pietro Melchiorre Ferrari. Parma, Museo Glauco Lombardi. Catalogo generale dei Beni Culturali.

is associated with the London-based Corbutt. Corbutt's output does, however, include a mezzotint after a portrait by Sir Joshua Reynolds of an Ann Bastard, in which the sitter, identified in the title inscription as "Mrs Bastard," faces the viewer with her head slightly tilted, her oval face elegantly framed by upswept hair, and her dress decorated with layers of lace and ribbon (fig. 3.8a).[30] Had Bach mistakenly acquired an image of someone quite different, not an Italian singer at all but a member of the English gentry? Not only might the names of the two women have become muddled, Bastard taken for Bastardella (and the absence of any obvious musical attribute in the engraving to be because the subject was a singer, not an instrumentalist), but to judge from extant portraits of Aguiari the two women looked enough alike that Bastard's portrait could have been taken for Bastardella's even by those, like Charles Burney, who had seen her in the flesh: Bastardella, too, appears in her portraits oval-faced, with arched eyebrows and hair piled on top of her head, her bodice striped and bedecked with bows—all similar indeed to the look of Mrs. Bastard (fig. 3.8b). The seductions of likeness (in name and face) have clinched an identification that is most likely just plain wrong.

As we ponder the presence of Fordyce and Bastard in Bach's collection, we are alerted to the element of speculation involved, for the eighteenth-century

connoisseur, in the vital tasks of acquisition and identification. At the same time, as our attention is drawn to Bach's (possible) errors, we are also given a glimpse of an underexplored aspect of his own identity: a lively interest in the contemporary theater scene and in opera—the one genre in which Bach never composed. His portrait collection was rich in images of female musicians and representations of women at music; ranging from the beautiful drawing by Johann Heinrich Kniep of the mythical Saint Cecilia to drawings and engravings of some of the most successful actresses and singers of his day, including Maddalena Allegranti (1754 to after 1801) in an engraving by C. F. Stölzel; Maria Felicitas Benda (1756 to after 1788) in a drawing by Johann Andreas Herterich; Francesca Cuzzoni (1696–1778) in an oil painting by Baltasar Denner; Faustina Bordoni (1697–1781) in an engraving by Lorenzo Zucchi; Madame de Saint-Huberty (1756–1812) in a red stipple engraving by Gustav Georg Endner; Franziska Koch (1748 to after 1796) in an engraving by Daniel Berger; Elisabeth Mara (1749–1833) in a drawing by L. A. Abel; Caterina Mingotti (1722–1808) in a drawing by Johann Sebastian Bach the younger; Marie Sophia Niklas (fl. later eighteenth century) in an engraving by Daniel Berger; Caroline Müller, previously Walther (1755–1826) in an engraving by Johan T. Kleve; and Maria Giustina Turcotti (c. 1700 to after 1763) in a caricature by Tiepolo; as well as the former star soprano, his stepmother Anna Magdalena Bach (1700–1760) in the oil painting by Cristofori mentioned above.[31]

Among the male stars of the opera, the collection included portraits of the castrati Farinelli (1705–82) and Senesino (1686–1758), both in mezzotints by Alexander van Haecken; Antonio Maria Bernacchi (1685–1756) and Domenico Annibali (c. 1705 to c. 1779) in Dresden (both caricatures engraved by Matthias Oesterreich); and the singers C. P. E. Bach had worked with at the Prussian court, including Giovanni Carestini (1700–1760) in a mezzotint by John Faber, Carlo Concialini (1744–1812) in a drawing by Emmanuel Gottlieb Stranz, Paolo Bedeschi (1727 to c. 1784) in a drawing by Johann Heinrich Christian Francke, Nicolò Reginelli (1710–51) in a caricature by Tiepolo, and Felice Salimbeni (c. 1712–51) in an etching by G. F. Schmidt.[32] The high-quality mezzotints of Fordyce and Bastard were both based on paintings by Sir Joshua Reynolds—justification enough, on visual grounds alone, for their inclusion in the collection—but it is a sweet irony that two women of standing but no particular musical ability should consort with the greatest singers of the eighteenth century.

RECOGNIZING A FAMILY FRIEND: GIOVANNINI, OR THE COUNT OF ST. GERMAIN

One of the more enigmatic items in the collection, whose identification, as with the portraits of Fordyce and Bastard, pits experience and memory against reputation and hearsay is the portrait Bach inventoried as "Giovannini, feigned Count St. Germain, composer and violinist. By Thönert."[33] The image this entry

refers to can only be the engraving by Medard Thönert after a portrait by Nicolas Thomas (dated 1783), which bears no mention of a composer named Giovannini but identifies the subject as "Le Comte de St Germain" or, in the Thomas version, "Le Comte de St Germain / Célèbre Alchimiste" (fig. 3.9). Of the obscure Giovannini little is known beyond Gerber's information that he was active as a violinist in Berlin in the 1740s and died in 1782.[34] That a musician going by the name "de Giovannini" was active in the C. P. E. Bach circle in Berlin around this time is evident from the inclusion of six songs by him in the third volume of *Sammlung verschiedener und auserlesener Oden* (Halle, 1741) and one in the fourth (1743), edited by Johann Friedrich Gräfe (who was himself represented in C. P. E. Bach's collection by a porcelain relief, now lost). Gräfe's song collections included music by C. P. E. Bach and Johann Gottlieb Graun as well as by Giovannini, setting texts by members of Bach's literary Berlin circle including Alexander Gottlieb Baumgarten, Christian Gottfried Krause, and Georg Ernst Stahl, among many others. Gräfe described Giovannini in his preface to the fourth volume as "a native Italian" (*ein gebohrner Italiener*) with "noble merits" or "the advantages of nobility" (*mit adlichen Vorzüge*);[35] but this was not his only connection to C. P. E. Bach, for he is presumably identical with the composer of the "*Aria die G[i]ovannini*" "Willst du dein Herz mir schenken," entered (in a clumsy hand) into the Anna Magdalena Bach notebook of 1725 (a piece once falsely ascribed to J. S. Bach and bearing the BWV number 518).[36] Given the association both with C. P. E. Bach's Berlin circle and with the Bach family, it is very likely that C. P. E. Bach would have met Giovannini and would have recognized his face.

What are we to make, then, of C. P. E. Bach's assertion in the portrait inventory, that the enigmatic Giovannini "pretended" to be Count St. Germain? As Ludwig Finscher has recently put it, St. Germain was "one of the most famous and most secretive figures of the eighteenth century."[37] His main known musical activities took place in London in the 1740s, where Horace Walpole met him and wrote that he "will not tell who he is, or whence, but professes . . . that he does not go by his right name. . . . He sings, plays on the violin wonderfully, composes, is mad, and not very sensible. He is called an Italian, a Spaniard, a Pole; a somebody that married a great fortune in Mexico, and ran away with her jewels to Constantinople; a priest, a fiddler, a vast nobleman."[38] In the 1750s St. Germain was astonishing Parisian aristocrats with his skill at improvising and accompanying by ear at the keyboard (as well as with his facility in painting in oils, using a "secret about colors" that he had discovered),[39] and later in life the man dubbed by Charles Burney in his *General History of Music* (1789) as "celebrated and mysterious"[40] was in Germany, active as a chemist (or alchemist). The Margrave Karl Alexander of Ansbach built him a laboratory in 1774, and his travels from 1776 to 1778 took him to Leipzig, Dresden, and Berlin, and to Hamburg when C. P. E. Bach was living there. His last patron was the Prinz Karl von Hessen-Kassel in Schleswig in northern Germany, who supported him in his last years on his estate at Eckernförde, near Schleswig.

Music scholars have long debated, and essentially debunked, the idea, to

FIGURE 3.9. The Count of St Germain. Engraving by Medard Thönert, after an engraving by Nicholas Thomas dated 1783. In NV 1790, "*Giovannini*, (vogegebner Graf *St. Germain*), componist und violinist. Von *Thönert*. 4." ÖNB Vienna, PORT 00102396_01.

their knowledge first put about by Gerber in the second edition of his *Lexikon*, that St. Germain was the Giovannini he had described in the first edition of the *Lexikon* as an Italian musician active in Berlin and London in the 1740s.[41] This, they have said, was an "unsubstantiated assertion" made for "unknown reasons" and "little more than conjecture on [Gerber's] part."[42] Yet given Gerber's reliance on the inventory of the C. P. E. Bach portrait collection, his assertion surely derives directly from Bach's own annotation. Further, Bach seems to have been describing a portrait of a man he knew as Giovannini but who was identified in the portrait inscription as St Germain. If there was an error, it was Bach's, not Gerber's. More likely, though, the skepticism of later scholars, who did not know about the connection to C. P. E. Bach's portrait collection and who had not seen the engraving with its single inscription "Le Comte de St Germain," has been misplaced. Bach's inventory entry suggests that St. Germain was indeed the pseudonym of a musician he had met in the 1740s as Giovannini (and whom he could well have met again in the 1770s in Hamburg), even allowing for the effects of memory over a stretch of several decades. The man must have looked, at least to C. P. E. Bach, like the person he knew. When the portrait collection's inventory entries are matched with the images they (most likely) refer to, the disparities and ambiguities that emerge are rich sources of new information for the historical record.

CARICATURING A COMPETITOR: GOTTLOB HARRER

Bach's collection was populated with people he knew, just as it was also crowded with those, from both past and present, he had never met. Yet some of those he knew, who took up occupancy on his walls or in his portfolios, he may not have recognized. An obscure entry in the *Nachlassverzeichniss* lists a caricature by Pietro Leone Ghezzi, engraved by Matthias Oesterreich, of a "violinist, a German, and an Italian secretary."[43] Bach owned four etchings of Ghezzi caricatures from Oesterreich's *Raccolta de vari disegni* (1750, second ed. 1766),[44] their subjects identified to varying degrees on the prints themselves. The caricature of the Dresden court alto Domenico Annibali, depicted on plate XIX in the 1750 edition of the *Raccolta* sitting in his housecoat as if in casual conversation, bears no inscription naming the subject (fig. 2.15). One has to turn to that volume's table of contents to find the name "Domenico Annibali" (though C. P. E. Bach may well have met the singer in person and have recognized his image—his father certainly heard him in Dresden at the first performance of Handel's *Cleofide* in 1731).[45] This was information shared by collectors buying individual sheets, as Bach's exchange with Forkel of May 13, 1786, indicates: Bach wrote that "of the Oesterreich caricatures I have only the Brescianis, Jomelli (under which is written Maestro in Vaticano) and Annibali sub No. XIX."[46] The "Brescianis" (fig. 3.10) too were musicians whom C. P. E. Bach may have heard perform: the caricature shows the two brothers, one with his back turned playing the guitar,

24.

Domenico con Suo Fratello Bresciani

Il primo, che é di faccià Suona mirabilmente il Calascioncino à
due Corde; l'altro che é di Schiena, l'accompagnava con la Chitarra
Furono nell'Mese di Aprile 1765, nell Palazze à Sans-souci, dove Sua Maestà il Ré di
Prussia li intese ambedue à Sonare.

FIGURE 3.10. Domenico Colas and his brother (fl. 1749–65). *"Calasciocinisten."* Etching by Matthias Oesterreich after Pier Leone Ghezzi. Plate 24 from *Raccolta di vari disegni* (Potsdam, 1766). Houghton Library, Harvard University.

the other, Domenico, facing the viewer with his two-stringed colascione—the long-necked plucked instrument associated especially with Neapolitan folk music. Originally made (and dated) 1752, the reissue for the *Raccolta* of 1766 carried more information, noting that the brothers had performed for the Prussian king at Sans Souci in April of the previous year.[47] Bach may well have heard them there.[48] The third caricature, showing the unmistakable figure of the porcine Jomelli, was indeed titled simply "Maestro in Vaticano," but the first quatrain of the accompanying verse revealed the maestro's name for anyone who could not recognize him (fig. 2.15 above).

At first glance the fourth Oesterreich/Ghezzi etching really is a generic caricature, its subjects designated in the verse below merely as a "German musician and an Italian secretary" (fig. 3.11). Published as plate 25 in the 1766 edition of the *Raccolta de vari disegni*, the caricature presents a comic duo: a tall man with a small head, prominent knotted brow, firmly set mouth and bulbous nose, with a violin tucked under his arm, presents a sheet of music to a short, large-headed fellow at eye level with his chest, with an impressive Roman nose and elegant posture; his hat is tucked under arm, one hand casually in his pocket and the other tucked into his coat, his sword discreetly visible. The two embody a humorous view of the distinct differences between Germans and Italians. But Ghezzi's table of contents names the figures as "Il Signor, Consigliere de' Rossi, è il Musico, Haar," and the artist's inscription on the drawing that served as the basis for the print gives more detailed information: from this we can speculate that the musician in the caricature was a figure C. P. E. Bach had very likely met, and whom he certainly knew by reputation.

De Rossi served as undersecretary to the Saxon aristocrat, musical connoisseur, and art collector Count Heinrich von Brühl, who became de facto prime minister in 1746, and he was in Rome with the count's entourage in 1739 when Ghezzi made the drawing this engraving is based on. So too was the Saxon musician Gottlob Harrer, who was a member of the count's musical establishment from at least 1733 until 1750, having traveled to Italy with the Saxon Kapellmeister Johann Adolph Hasse in 1738 on a study tour supported by Brühl, returning to Dresden only in 1741.[49] Harrer performed *Tafelmusik* for the Saxon electoral prince Friedrich Christian, who was in Rome on his Italian grand tour on the evenings of August 3 and September 5, 1739, as the prince reported in his diary (describing Harrer as Count Brühl's *compositeur*).[50] Ghezzi, getting the name only slightly wrong and assuming that Harrer was actually in the prince's service, wrote on the drawing the print was based on that the violinist depicted there, whose name he spelled "Haar" was a "composer [*compositor*] of music and player of the violin of German nationality, who was in the service of the prince elector of Poland and was very fine, and who favored me by coming to my musical academy."[51] Harrer was known to C. P. E. Bach. Notoriously, it was Harrer who succeeded J. S. Bach as Thomaskantor in Leipzig in 1750, thanks to the influence of the powerful Brühl. Harrer had even been promised the position in mid-1749, well before J. S. Bach's death,[52] making a mockery of the official competition for the

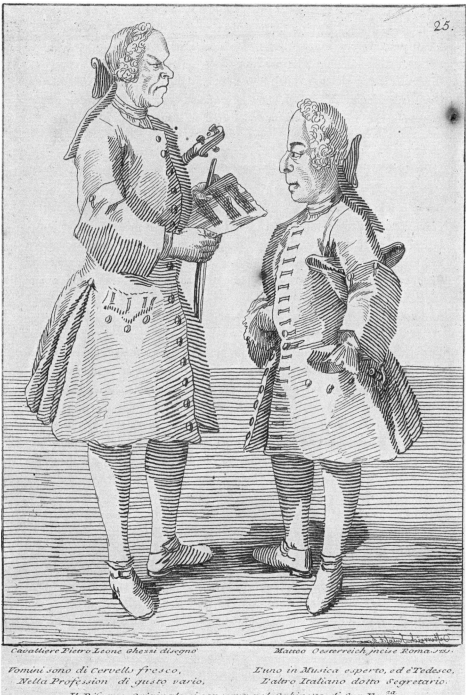

Cavalliere Pietro Leone Ghezzi disegnò *Matteo Oesterreich incise Roma 1751*

Vomini sono di Cervello fresco, *L'uno in Musica esperto, ed è Tedesco,*
 Nella Profeßion di gusto vario, *L'altro Italiano dotto Segretario.*
 Il Difegno Originale si conserva nel Gabinetto di Sua Ecc.za
 Monfignore Conte de Brühl Primo Ministro di Sua Maestà
 IL RE DI POLONIA ELETTORE DI SASSONIA

FIGURE 3.11. A German violinist and an Italian secretary. Etching by Mattias Oesterreich after Pier Leone Ghezzi, 1751. Plate 25 from *Raccolta di vari disegni* (Potsdam, 1766). 32.5 × 22 cm. Houghton Library, Harvard University.

position in which C. P. E. Bach, among others, would compete. This caricature remained unframed, arriving in the collection once the walls were already full; the generic inventory entry, following the title on the print, implies that Bach was not aware that it depicted his erstwhile rival—unless the object arrived so near to his death that he had not had time to update the inventory himself, leaving that to his daughter. Did Bach know he owned an image of Harrer? Or was he repressing Harrer from his memory and effacing him from his own history?[53]

LISTENING FOR LIKENESS

Bach's handful of errors having to do with the snares of likeness, misattribution, or failure to notice relevant detail are just as revealing as the solid biographical, lexicographical facts conveyed by his portrait collection and scrupulously cataloged by him. These telling mistakes encourage scholars to reconsider the matter of likeness—falsely and rightly identified—with the historian's detachment and the enthusiast's zeal. They also invite us to consider again how one might listen for likeness within the context of the Bach family history.

The dead father was on the wall, and on the minds of the living, when Charles Burney visited C. P. E. Bach in Hamburg in 1772. The conversation, over several days, addressed past and present music culture, the music and career of Emanuel Bach himself, and the legacy of his father. At Emanuel's house, Burney was treated to a memorable series of performances by Bach—of improvisation after dinner long into the evening and, earlier in the day, of music that included three or four of his "choicest and most difficult works" on his beloved Silbermann clavichord.[54] The gaze of the father on the ongoing music making in that salon would have been unrelenting, with no curtain to offer temporary relief. From Burney's words it is impossible to know what Bach played—the "compositions" in question were presumably notated works, and one can assume Bach was playing from a score, either manuscript or printed. But for the sake of bringing sound to this tableau, let's imagine that Bach tried out for Burney the first movement of the C Major Sonata, Wq. 55/1 (H. 244), that would be published as the first piece in his first volume of sonatas, rondos, and fantasias for *Kenner und Liebhaber* (1779)—opening an ambitious, comprehensive project that would eventually extend to six volumes and would encapsulate the idiosyncratic and brilliant compositional style, and expressive, demanding keyboard technique, of the Hamburg Bach. The first volume of the *Kenner und Liebhaber* series presented the first serious solo keyboard music Emanuel had published since the third volume of the *Veränderte Reprisen* sonatas in 1763.[55]

My selection is purely conjectural, and indeed Bach's own catalog of his works dates this sonata to 1773—the year after Burney's October 1772 visit (none of the sonatas in the volume were Bach's latest work by the time of publication: Sonatas I, III, and V were composed in 1773, 1774, and 1772; the others in the volume were earlier works, from 1758 (II) and 1765 (IV and VI)). But what if

EXAMPLE 3.5. C. P. E. Bach, Sonata in C Major, Wq. 55/1, 1st movement Prestissimo, bars 1–15.

we pursue the idea that Bach might have tried out for Burney, the cosmopolitan connoisseur, a working version of the piece a few months before its completion? At first hearing, this music seems an unlikely choice to display for Burney, setting itself apart from the more typical, avant-garde Emanuel style of the 1770s. It has little of the stopping and starting he was famous for, none of the sudden detours, textural and dynamic interruptions, excursions into the melancholic depths or sudden harmonic shocks that marked his work as both exquisitely learned and the "far-fetched music" of the future, to paraphrase Burney.[56] Instead, we are presented with an exercise in exactly the opposite: moto perpetuo passagework played prestissimo (his fastest tempo marking). The movement certainly requires "precision, delicacy and spirit"—the adjectives Burney used—and at its breakneck tempo is indeed difficult, yet this type of writing does not reappear in any of the other *Kenner und Liebhaber* volumes. What we hear seems less experimental and exploratory, or even expressive, than didactic[57] (music example 3.5). The C Major Prestissimo has the character less of a sonata movement than of a technical exercise—an etude or, to borrow the term used by Bach's contemporaries, a solfeggio.[58] Indeed, perhaps the closest analogue to the C Major Prestissimo, Wq. 55/1 in Emanuel Bach's oeuvre, is the much shorter C Minor Solfeggio, Wq. 117/2, also marked prestissimo, composed in Potsdam in 1766 and published in the anthology of easy pieces for amateurs, *Musikalisches Vielerley* of 1770[59] (music example 3.6).

If this movement bears a resemblance to an earlier attempt of Emanuel's, it

EXAMPLE 3.6. C. P. E. Bach, Solfeggio in C Minor, Wq. 117/2 (from the *Musikalisches Vielerley*, 1770), bars 1–13.

also resonates with the work of another Bach—the music of his father, who was so central a presence on that evening with Burney. The affinity to be perceived in this music is more than a distant echo. There is a tangible likeness, a physical resemblance, between this allegro and another prominently placed C-major movement in his father's oeuvre, the Prelude in C Major, BWV 846, that begins J. S. Bach's *Well-Tempered Clavier*, book 1 (music example 3.7). The concordance between these two pieces results not only from the shared key or simply from the feel of some of the arpeggios under the hand and the same starting position, but also from the nearly immutable pace of the familiar harmonic progressions. And even though the extreme tempo of Emanuel's prestissimo distinguishes it from the refined repose of his father's prelude, both pieces have a kind of objectivity, or perhaps inevitability, possibly a shared reference to keyboard study (and pedagogy): Sebastian's prelude served as an introductory study in broken chords—and indeed one of the first exercises of any kind—that the Bach children were given by their father. This had been a topic of conversation between Emanuel Bach

EXAMPLE 3.7. J. S. Bach, Prelude in C Major, BWV 846/1, bars 1–11.

and Burney: according to Burney, Bach had introduced him to the *Well-Tempered Clavier* earlier in the day, showing him two manuscript volumes by his father containing "pieces with a fugue, in all the twenty-four keys" and relating how as a boy he had labored at these pieces "for the first years of my life, without remission."[60] The broken chords and scales of Emanuel's prestissimo similarly exude the matter-of-factness of an etude.

Was Emanuel Bach thinking in terms of the family likeness when he chose to inaugurate what would become a major publishing endeavor in a manner curiously similar to the way his father had introduced the *Well-Tempered Clavier*?[61] If the image of the father hangs over this music, it is kept firmly in its place: the music humorously and confidently acknowledges its forebear while seeming to revel in super-high speed, a kind of performative one-upmanship, that now iconic work of restrained Bachian decorum transformed into a whirlwind of virtuoso bravura. It is a distinct pleasure to imagine this might be so, just as it is to become aware of the kinship between the pieces in the hands when played at the clavichord; the fingers recognize the likeness even more quickly than the ears do, an affinity—the family resemblance—that is undeniably there if you choose to hear and feel it.

Speculation is rarely a welcome guest in academic study. Rigorously source-based scholarship tends to frown on what might look like guesswork. The great projects of the past two centuries to retrieve and preserve the material traces

of music history necessarily privilege the ascertainable facts presented by the archive over the risky quagmire of interpretation. Although music scholarship has since moved into many other areas, this has long been a central tenet of Bach scholarship, especially where establishing the body of primary sources (the "facts") was of paramount concern, as in the landmark project to create the first complete critical edition of the works of C. P. E. Bach. There is little room for (overt) speculation in this kind of scholarship, in which the speculative raises the specter of the unconvincing or, worse, the ungrounded. Yet as literary scholars Arthur Bahr and Alexandra Gillespie have recently reminded us, the Latin *speculator* was an investigator, a scout, an intelligence gatherer: "While these are all risky professions," Bahr and Gillespie point out, "they are also rigorous and valuable ones." To speculate, they continue, "is not to guess, but rather to look both carefully and imaginatively: carefully to see the surviving picture as fully as possible, and imaginatively in due recognition of what that picture has lost and cannot include."[62]

The scenario I've sketched out here, imagining C. P. E. Bach playing for Burney an early version of the C Major Sonata, Wq. 55/1, and in so doing engaging musically with his own father, is speculation; not grounded in ascertainable fact, it combines a reading of texts—of the musical texts of J. S. and C. P. E. Bach and of Burney's literary one—with an imaginative hearing (and playing) of the music. Crucially, it is informed by the remarkable context in which this encounter is embedded: that provided by C. P. E. Bach's portrait collection. A skeptic might justifiably ask if these two C major Bachian "preludes" (one in the guise of a sonata movement) have anything more to do with one another than the respectable wife of an English squire and a pair of Italian prosthetic buttocks, a fashionable lady cittern player and a Reformation martyr, or a melancholic seventeenth-century English doctor with a dyspeptic eighteenth-century German court musician. The scholar would reply that these figures are indeed related, connected, like the two keyboard pieces, in the fertile realm of Emanuel Bach's portrait gallery and music room—a space in which the connoisseur's eye and ear are, and were, engaged in speculative judgment and imaginative research. Kindred questions of intention, affinity, likeness, and possible allusion are posed by the very portraits that mutely watched the musical proceedings that night. When Burney visited Bach in Hamburg, the commingling of past, present, and future vividly played out before him. At the nexus of present and past there stood family identities.

Bahr and Gillespie remind us that the best speculation is grounded in texts and archives: "Without careful regard of, and for, the texts and objects of the past, interpretations of them will indeed be ungrounded"; but it is precisely in the interstices of the known and provable that it is our responsibility to engage our imagination, for "without embracing the creative potential of the not-fully-knowable, there is no space for interpretation, only demonstration."[63] Bach himself was capable of seeing in some of the faces he had collected facts and connections that were not there, even while repressing truths that were. This is not to claim that Bach's musical faculties shared the strengths and faults of his connoisseurship

of portraits. Rather, the impulse to establish likeness brings portraits into dialogue with one another, as happens with musical pieces too. Do these connections become stronger or more obscure—or both—when the forebear himself looks on from above, when family traits are perhaps discernible in the face, hands, and music of the performer, his son? C. P. E. Bach's own decades-long practice as collector and speculator invites us to listen for likeness, if we will only take the trouble to look closely at the pictures.

Character: Faces, Physiognomy, and Time

I have a facial mask that fools artists, either because too many of its features blend together or because the impressions of my soul succeed one another very quickly and register themselves on my face, such that the painter's eye does not perceive me to be the same from one moment to the next and his task becomes far more difficult than he'd expected. I've never been well captured save by a poor devil named Garant, who managed to trap me, just as an idiot sometimes comes up with a witty remark. Whoever sees my portrait by Garant sees me. "Ecco il vero Polchinello." Monsieur Grimm has had it engraved, but he has not made it accessible. He is still waiting for an inscription which he will have only when I have produced something that will render me immortal.

DENIS DIDEROT, *Salon of 1767*

It is by the natural and unaffected movements of the muscles, caused by the passions of the mind, that every man's character would in some measure be written in his face.

WILLIAM HOGARTH, *The Analysis of Beauty* (1753)

"And have you seen my Lavater portrait," C. P. E. Bach asked at the end of a letter to Breitkopf on August 9, 1777, "which, it is generally agreed, is anything but a good likeness and more resembles someone sleeping than awake?" (fig, 4.1). Bach went on to express a somewhat equivocal opinion of the celebrated analyses contained in the most recent publication by the Swiss clergyman Johann Caspar Lavater, the age's most famous proponent of the science of physiognomy: "The good Lavater reasons so conclusively and certainly, although from what I know and have seen only two parts really meet the mark, namely [those on] Frederick [the Great] and Rameau."[1] Lavater's fragment on Bach was the centerpiece of the eighth section of volume 3 (1777) of his four-volume magnum opus, *Physiognomische Fragmente zur Beförderung der Menschenkenntnis und Menschenliebe* (1775–78) (Physiognomical fragments for the furthering of the knowledge of men and the love of mankind); this section, preceded and followed by reflections on the physiognomies of geniuses in the visual arts and in poetry, was devoted to musicians. Whatever his reservations about his own portrait, and about Lavater's often far-fetched readings, Bach must have been deeply flattered to have been included in Lavater's crowded pantheon among the famous historical and contemporary figures from all walks of life who were "characterized" there. It

Character: Faces, Physiognomy, and Time

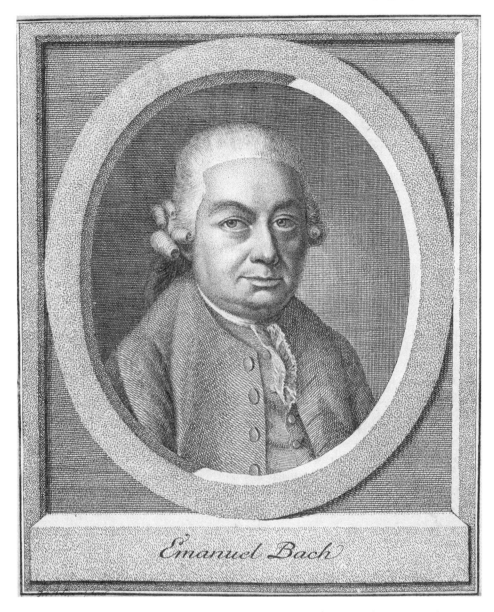

FIGURE 4.1. C. P. E. Bach, engraving by Johann Heinrich Lips after J. P. Bach, c. 1777. In Johann Caspar Lavater, *Physiognomische Fragmente*, III, plate LIX, facing page 200. Division of Rare and Manuscript Collections, Cornell University Library.

was surely a particular honor, too, to have been one of those whose names were attached to their portraits (unlike the vast number of Lavater's physiognomical subjects, who were identified only with a single initial). Lavater's effusive physiognomical description was certainly flattering (even if the reading was derived from a poor engraving of a portrait), a paean spun out over a series of typically convoluted paragraphs to describe that most compelling artistic character of the age, the Original Genius.

Lavater's treatment of C. P. E. Bach reflected and reinforced Bach's reputation as "the creator of a new taste" who "marks a new epoch:"[2] "He is the Original one! All his products are stamped with Originality. . . . Perhaps for that reason so few understand him; perhaps that is why [so] many speak about him. . . . He is the Original one, and one can only say what, in Music, as in all the arts and sciences, can be said of the Original."[3]

All this was etched into Bach's facial features to result in a physiognomy dominated by originality and creative power:

> Between the eyebrows, in the gaze of the eyes—an intelligent expression of his productive power seems to hover. He can, he will, he must, with such a Physiognomy, be able to perform in so many places with decorum and advantage. One also sees at the same time, that he is absolutely not given to condescension or resignation. As is the way with Originality. Taken up or thrown down, cherished or underestimated—In line with his composition, the Original follows the path ahead in his unity, abundance, and contentedness.[4]

Everything in Bach's face, Lavater writes, speaks to the necessity that this man will produce great things. Lavater notes that the portrait downplays the defect in the left eye, and yet

> Enough spirit remains still in the eye and eyebrows:[5]
> The nose, rather too rounded, still manages to convey an impression of refinement and creative power. The mouth, for all its simplicity, such a fine expression of delicacy, richness, dryness, assurance, and security; the lower lip somewhat artful and weak—with only a faint hint of awkwardness!
> Firmness, cheerfulness, courage, and conviction can be seen on the forehead. I do not know whether it is simply an illusion, but it seems to me at least that in most portraits of virtuosi the lower part of the face is not entirely successful; here, though, the outline of the chin is masterly.[6]

In addition to Bach, Lavater scrutinized the Mannheim Kapellmeister Niccolò Jomelli, whose portrait presents the very image of a romantic genius in the throes of invention (a far cry from the somewhat stilted engraving of Bach), with its powerful fleshy face, windswept curls, casual undress, and inspired upturned eyes (fig. 4.2). Lavater's analysis collapses together facial features, artistic achievement, and musical style: "More fire than precision in his works; more pomp than elegance; more ravishing force than soft, alluring tenderness—at least that seems to me to be what the face says clearly enough."[7] The eyes are courageous, the nose powerful, the chin abundant in a way that seems, to Lavater, to imply prolific creativity. Two further images of Jomelli, buttoned-up in court clothes and wig, prompt the physiognomist to reflect on how, even once the wild Italian composer (*Tonschöpfer*) has been transformed into a court flunky (having been "*verdeutscht,*" or "Germanized"), his face still projects the brilliant genius of the virtuoso (fig. 4.3).

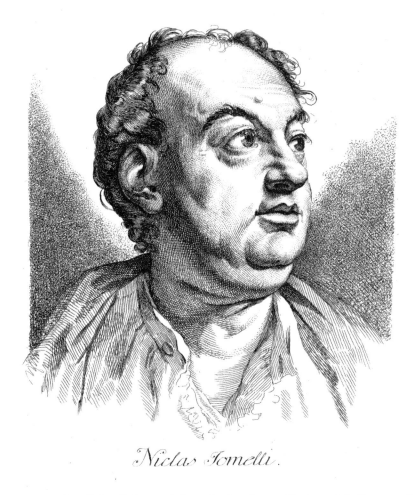

Niclas Jomelli.

FIGURE 4.2. Niccolò Jomelli (1714–74). Engraving from Lavater, *Physiognomische Fragmente*, III, facing page 197. Division of Rare and Manuscript Collections, Cornell University Library.

We can well imagine Emanuel Bach and his circle, during an evening at the Hamburg house of one of their wealthy friends, eagerly paging through the large, expensive volume in search of Lavater's judgments on musicians, perhaps laughing ruefully at the Bach engraving even if humbly acknowledging the physiognomist's complimentary conclusions. Perhaps, too, they would have wondered at just how much of the genius really did emerge from those bare line drawings of the bewigged Jomelli. Even admitting a degree of skepticism, as a keen and increasingly knowledgeable collector of portraits Bach would surely have been interested both in what Lavater had to say about him and in his extensive views on the human face more generally and the characters and characteristics it revealed. In particular, Lavater's ideas about the portrayal of musicians spoke of music and musicality, attempting, in an eccentric and sometimes garbled fashion, to articulate something specific about what it was to be a musician. At the heart

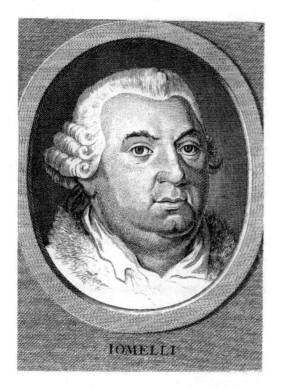

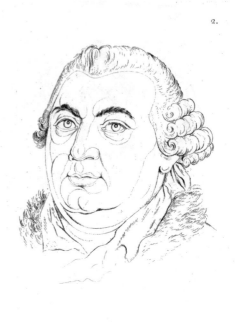

FIGURE 4.3. Two more images of Jomelli in Lavater, *Physiognomische Fragmente*, III, facing page 199. Division of Rare and Manuscript Collections, Cornell University Library.

of the writings of Lavater and his contemporaries on the production and interpretation of musician portraits lay the question of characterization, revisiting a debate on music's "characters" that was first articulated in a series of extensive essays published in Berlin in the 1750s by members of C. P. E. Bach's circle there. Those debates, I will argue in this chapter, turned on the problem of time and temporality that formed, for theorists in the period, the definitive distinction between music and painting.

EYES, EARS, AND TIME

Lavater claimed that physiognomy was a basic tool for daily life. Being able to read the signals transmitted by other people's faces was the key to knowing, judging, trusting—and loving—those around you. But the science of physiognomy went much further: it was the art of discovering truths about the soul. Lavater explained that the interior, the soul in all its complex variety, was made manifest in endlessly diverse ways on the surface of the human body, and especially in the face. Physiognomy, the science of interpreting these various signs, demanded highly specialized expertise and experience, skills honed by comparison and

differentiation based as much, for Lavater, in the study of portraits as in the observation of living faces.

Physiognomical analysis is a specialized reading of the structure of the human countenance; allowing for fleshy bumps and wrinkles, but more concerned with the underlying bone structure, it "visibilizes the invisible," in the words of art historian Barbara Maria Stafford.[8] Distilling readings of character largely from portraits, line drawings, and silhouettes, Lavater's approach to physiognomy raised portraiture to a high art, complex and demanding as perhaps no other branch of painting, concerned not just with the physical appearance of a face, but with the character, temperament, inclination, morality, and professional aptitude revealed there. Lavater was himself a skilled portraitist, but he was also a fanatical portrait collector: on his death the collection of drawings and engravings that formed his "Physiognomische Kabinett" contained about 22,000 sheets, more than half of them portraits.[9] He had much to choose from for the large folio pages of the *Physiognomische Fragmente*, which were densely illustrated with engraved portraits and silhouettes.[10] Across Europe, Lavater's work was disseminated not only in its precious German volumes, but also in an expanded and amended French quarto edition, *Essai sur la physiognomie* (1781–1803), and in a three-volume English translation *Essays on Physiognomy* (1788–99). That physiognomy is now discredited, especially after its appropriation by Nazi race theorists, should not lead us to underestimate its importance for the later eighteenth century: aimed especially at aristocrats, wealthy collectors, and reading societies (*Lesegesellchaften*), Lavater's volumes quickly found a market for their language of sentimentalism and emotional intimacy, for their breathtaking presentation of the infinite diversity of human character, and for their sheer lavishness.[11] Their popular success was achieved despite critical reactions ranging from the dubious to the outright scathing among fellow devotees of physiognomy, from Georg Christoph Lichtenberg to Goethe.[12] If there was a limit to Lavater's method, generating readings that could be seen as arbitrary or false, it was his tendency to focus on the predetermined physical structure of the head, failing to deal adequately with the effect on facial expression of the inner emotional life. As we will see, dynamism—the flux of character played out over time—was a central concern for many contemporary writers, including Johann Georg Sulzer and Carl Ludwig Junker.

Bach owned several of the portraits Lavater discussed, including the engraving of Bach's agent in Zurich, the young Johann Philipp Kayser, which Lavater enthusiastically analyzed two pages after Bach's, and a portrait (in simple outline—a favorite genre for Lavater) of the Weimar Kapellmeister and avid C. P. E. Bachist E. W. Wolf that was published in the fourth volume of Lavater's *Fragmente* in 1778 (Wolf acted as Bach's agent for the distribution of his publications in Weimar).[13] Lavater's interpretations of these images could serve as primers for viewing portraits in general, and musician portraits in particular, grappling as they did with the problem of fluidity and change that seemed especially a condition of

musicality. The analysis of Rameau in the first volume of the *Fragmente* (1775), which Bach had commended to Breitkopf, was also based on a portrait engraving that Bach owned, and it explicitly addressed the ways musicality could be identified in the facial features (fig. 4.4).[14] Intelligence, good sense, and goodness characterize Rameau's physiognomy in this reading, but the leading quality for the physiognomist—rather paradoxically, in view of Rameau's strong physical features, prominent nose, and confident chin—is a mysterious indeterminacy:

> The most perfect, loveliest harmony has created this form. Nothing sharp, nothing angular in the whole outline, everything floats, everything hovers, [yet] without faltering, without being undetermined. This presence affects the soul in the same way as an inspired piece of music: our heart is entranced, filled by its pleasantness, and at the same time gripped, emboldened, without knowing why. It is truth, rightness, the eternal law of attuned nature, which lies hidden under pleasantness.[15]

In fact this analysis was written by the young Goethe, contributing enthusiastically, if anonymously, to Lavater's project (contributions he would later disavow). Goethe's reading suggested that each individual feature of the composer's face speaks of, and to, music. In the forehead and temples reign "pure tonal proportions"; the eye "does not see, does not notice, is all ear, all attention to inner feeling." Yet the physiognomist detects softness, a blurred quality to the image despite its not being "unclear," one that seems to represent for him the essence of music and musicality.[16]

In seeing Rameau's sharp profile in terms of indeterminacy and fluidity, and in describing Rameau's eye as "all ear," Goethe anticipated the distinction Lavater would make two years later, in volume 3, between the physiognomies of musicians and those of visual artists. The faces of musicians, Lavater wrote in the general preface to his fragments on Bach and Jomelli in that volume, are always "more floating, more fluid, looser" than those of painters, "as their natural susceptibility to emotion and to the communication of emotion appears to demand."[17] Here Lavater addresses the problem of hearing versus sight, and what he sees as the fundamental challenge of musician portraiture. Not surprisingly, perhaps, the ear is the part of the musician's body of greatest interest to the physiognomist: unlike the pleasingly symmetrical and tellingly evocative eye of the painter, the ear is an irregular organ, a grotesque flap whose unruly whorls and cavities evoke dynamism rather than stillness.[18] Eyes, by contrast, especially in portraits of artists, tended to be vivid and telling, readily expressing genius. What is at stake in the distinction between eyes and ears is the fundamental difference of the operation of time in the two arts: while painting is the art of the frozen moment, music is concerned with expression in real time: "Music is the imitation of the sounds of nature [*Naturtöne*]. What the painter must see, the virtuoso must hear. The painter must have a sense for the unity of the moment. The musician for [temporal] succession."[19] Their physiognomies, as a result, will be

FIGURE 4.4. Jean-Philippe Rameau (1683–1764). "Organist, composer, and writer." Engraving by Augustin de Saint-Aubin after J. J. Cassieri. Mus. P. Rameau, Jean Phil., I, 7. Staatsbibliothek zu Berlin—Preussischer Kulturbesitz und Mendelssohn-Archiv. Courtesy of the Berlin State Library (Staatsbibliothek zu Berlin).

quite different—the painter's fixed, graspable, the musician's slippery, evasive, tending to the indeterminate.

As explained by the prolific writer on music and art Carl Ludwig Junker (whom we met in chapter 2 as the author of the *First Fundamentals towards a Select Collection of New Engravings* [1776]), the problems created by a musician's portrait were only intensifications of those fundamental to portraiture: the difficulty of capturing in an instant a multiplicity of emotional states. In an essay published in 1778 titled "Presentation of Character in the Portrait of Individuals" (Charakteristische Vorstellung des einzelnen Menschen Porträt), Junker borrowed from both Lavater and the writings of Johann Georg Sulzer to explain how the portraitist must mediate between the still, deathlike body and the vibrant passions that bring it to life, patiently observing over time as his subject gives himself over to the feelings that animate the corpselike stiffness of his body and enliven his otherwise fixed facial features. The portraitist must observe the subject existing in and moving through time, watching the play and progression of feeling:

> The painter who wishes to immortalize his art and his subject at the same time does not capture him at just any moment when he commits [his subject] to canvas. [Rather], he observes the man's happy moments, his joyful lovers' trysts; or perhaps he himself understands the art of setting him in an interesting situation. The man feels; this feeling enlivens the dead, impassive state of his facial features and the unmeaning stiffness of his body, it rises up and animates every muscle; now the man begins to be susceptible to elevated expression, the painter catches him at this moment, and achieves thereby an eternal guarantee of his good taste.[20]

It is the moment of animation, of the expression of feeling, that the skilled portraitist fixes for eternity. The aim of portraiture, Junker reiterated, is less to represent the subject in the heat of a particular passion than somehow to evoke the transition from one passion to another, the ebb and flow of feeling:

> To make man fully recognizable in his variability and similarity, in the various manifestations of his abilities and desires, and then to be able to bind him fast in a moment with painterly expression! What art! What knowledge![21]

Suggesting that portraits might be motivated by family members' pride, respect, and love as much as by an individual's desire to project, or uphold, a lineage or heritage, Junker stressed that in either case what is preserved in the portrait must transcend the moment. In a successful portrait the viewer is moved not so much by the idea of the beloved as by the sense of the ideal, an ideal representation of character that will speak for all time.[22] This required sleight of hand with regard to time: the frozen moment should suggest a past and a future, feeling played out over time beyond the apparent capture of the image in a single instant.[23]

In this, music has an advantage. Music not only arouses and intensifies emo-

tion, Junker argued, it can also depict it, both as a gradual progression toward the height of passion and in a single concentrated moment. Superior to poetry in its ability to represent the inexorable movement of the passions, "climbing rung by rung the whole ladder of the emotions," music can represent the ebb and flow of this progression with the subtle gradations of mezzotint.[24] By the same token, Junker acknowledged that painting and music differ fundamentally in the way their subjects engage time: "Painting is motionless art," Junker writes, "for it is the sensual concept of an *object*, and that object is always perceived at the very moment. Music is progressive, for it is the sensual concept of our *feelings*."[25] This was a familiar distinction between music and painting; it had been treated at length in Charles Avison's widely circulated *Essay on Musical Expression* (London, 1751), whose discussion of the action of time in the two media was singled out for praise by Johann Nikolaus Forkel in his review of the German translation of Avison in the *Musikalisch-kritische Bibliothek* (1778–79).[26] The notion that a visual image—a painting, say—is perceived all at once has since been contested by many art theorists, and I won't argue it here; what is crucial to the present discussion is the necessity described by writers such as Junker, Sulzer, and Lavater for the portraitist to magically represent the flow from one shade of emotion to another across time.

PAINTING CHARACTER, HEARING EMOTION

In the article "Painting in Music" in his encyclopedic *Allgemeine Theorie der schönen Künste* (1774), Johann Georg Sulzer confirmed that music, the temporal art, was in fact ideally suited to "characterization": "The actual material that serves music is passionate sensation. But it is also acceptable that it just depicts characters, at least insofar as they show themselves in sound and movement."[27] Music's ability to depict human character and characteristics, and the necessity—or not—for verbal cues, had been debated in intellectual circles in Berlin since the 1750s, especially among the group of amateur and professional musicians that included C. P. E. Bach: Friedrich Wilhelm Marpurg; Christian Gottfried Krause, the lawyer and author of *Von der musikalischen Poesie*; and Johann Georg Sulzer himself, along with the court musicians Johann Joachim Quantz, Johann Friedrich Agricola, and Johann Gottlieb Graun. Poets and men of letters in this circle included Karl Wilhelm Ramler, Gotthold Ephraim Lessing, and Johann Wilhelm Ludwig Gleim. A flurry of publications in these years, with musical contributions by several members of the circle including C. P. E. Bach, directed attention toward the French *pièce charactérisée*, associated especially with François Couperin: a short piece, usually for the keyboard, taking as its topic a particular character trait or emotion and equipped with a title that could guide both listener and performer in their understanding of the music. This was music that Sulzer knew: "Some French composers, particularly Couperin," Sulzer wrote, "have portrayed quite individual characters of specific people. And after him, C. P. E. Bach has published

some short keyboard pieces through which he has quite successfully expressed various characters of his friends and acquaintances."[28]

Couperin had introduced his character pieces explicitly in terms of portraiture: "In composing these pieces," he wrote, in the preface to the first volume of *Pièces de clavecin* (1713),

> I have always had an object in view, furnished by various occasions. Thus the titles reflect my ideas; I may be forgiven for not explaining them all. However, since among these titles there are some which seem to flatter me, it would be as well to point out that the pieces which bear them are a kind of portrait which, under my fingers, have on occasion been found fair enough likenesses, and that the majority of these flattering titles are given to the amiable originals which I wished to represent rather than to the copies which I took from them.[29]

The degree to which music's characters could be specific enough to be identifiable even without a title was an open question, caught up with the much larger debate about the meanings of instrumental music—but that music could indeed characterize with the effectiveness of painting was clear: "Imitative [*nachahmende*] Music," wrote Marpurg, in a definitive essay in his *Historisch-kritische Beiträge*, is "a music in which all the passions are expressed, correctly after their own character, and are then delineated according to the motions of the body that are associated with them."[30] Music's "characters" should be as definite as those of any painting—as the influential theories of Charles Batteux had proposed. Marpurg quoted from Batteux's *Cours de belles-lettres*: "We should judge in the same manner of a piece of music as of a picture, I see strokes, and colors in it whose meaning I understand. The piece strikes, it affects me."[31] The problem had to do with the particularity of what was being expressed—slippery territory in the case of music without words (instrumental music), whose meaning or subject might be as obscure as that of an abstract painting *avant la lettre*: "But what would be said of a painter, who should content himself with laying on his canvas a parcel of bold strokes and a heap of the most lively colors, without any sort of resemblance to any known object?" Adding explanatory titles could help make these riskily indefinite "characters" recognizable.

For Christian Gottfried Krause, however, the question was less whether music was clear in its representations of character than the degree to which music—playing out in time, embodying change in the moment—was better at this than painting:

> Painting breathes life into the canvas; Music, however, expresses the emotions themselves by means of a language that is common and intelligible to all people, and so is far more natural than any language in the world. The painter creates an angry man, but he cannot depict him in his painting [engaged] in more than a single physical movement. The composer, on the other hand, gives to the tender one, the sorrowful one, the merry one that he creates all sorts of thoughts, emotions, all sorts of expressions and movements. The painter presents

only the [single] event; the musician can let various events happen once again almost to their full extent.[32]

Two years later Krause made a subtle analogy between the musical character piece and contemporary painting that pointed to the modern concept of feeling as fluid and subject to change over time. Krause, like Marpurg, defended, and advocated, the explicit assigning of verbal cues to music to identify and clarify its affects for performer and listener alike: "I have a strange fondness for so-called character pieces [*characterisirte Stücken*], and very much wish that they were once again fashionable with us. I cannot persuade myself that one couldn't also successfully make larger pieces into character pieces."[33] But he specifically rejected characterization in what he calls the French sense, literal sonic imitations of a creaking door or the turning sails of a windmill, suggesting in so doing that music has a high yet subtle degree of specificity and accuracy in its portrayal of the shifting palette of human characters and characteristics. He recommends instead musical versions of small scenes that enact complexes of emotion, miniature domestic dramas of feeling. Musical character pieces, Krause suggests, might go beyond the depiction of a single affect to evoke past and future feeling enveloped in the present. The resulting complexes of human emotion might include

> the sighs of a beloved one, the groans of an unhappy one, the threatening gestures of one enraged, the laments of a sorrowing one, the begging of one destitute, the reproaches of an abandoned beauty, praise at the first friendly expressions of the beloved, joy on receiving the word "Yes," sorrow over the rejected proposal, anger at suffering the contempt of the beloved, the affection of a child. . . .[34]
>
> In this way most of the following Characters also lend themselves to musical expression: friendly encounter, passionate embrace, cordial agreement, utter deflation and collapse of courage, (with the help of long bow strokes that become increasingly weak) . . . confusion and fury, indecisiveness, exultant, exuberant joy, the brittleness of the beloved . . . openness, obstinacy, noble kindheartedness, unease, fortitude. Etc."[35]

To portray character in this sense is to retail the quotidian life of the emotions, with its irritations, joys, disappointments, and delights, in small-scale scenes whose verbal titles or accompanying miniature narratives would allow performer and listener to arrive at precisely the correct complex of emotions represented.

Krause speaks here in terms of a genre of contemporary painting, also imported from France and hugely popular in Berlin's Francophile court circles, the small-format paintings known as *petits sujets* or *petits portraits* created by Watteau, Lancret, Chardin, and many others, which offered direct representations of emotions, or characters, embedded in the stuff of daily life. These paintings would have dominated the visual field for the art-conscious intellectuals, bureaucrats, and artists associated with the court of Frederick the Great. In his palaces at Rheinsberg, at Charlottenburg, at Potsdam, the king indulged his taste for contemporary French

painting, often hanging his precious pictures in the private apartments where he made music. Likewise, the recently built picture gallery at Sans Souci was lined with the most recent works by French painters. The *petits portraits* were particularly prized, especially those that showed an individual engaged in a seemingly trivial activity, projecting a particular emotion or complex of emotions—images that concentrated on private human interactions, on the subject captured in an intimate moment. These were understated, charming encapsulations of a single instant that could point to universal and eternal human emotions and values.[36]

One of the best-known painters of such scenes, and in some sense the inventor or reinventor of the genre in the early eighteenth century, was Jean-Baptiste-Siméon Chardin, whose work was so comprehensively collected outside France—especially by Frederick the Great, his sister Friedericke Luise of Sweden, and Catherine the Great of Russia—that French critics lamented that Chardin's paintings hardly ever remained in their country of origin.[37] These paintings that so brilliantly "captured attitudes and characters," as one French commentator explained,[38] were already by the end of the 1740s being disseminated in engraved versions whose titles, or moralizing verses, tended to congeal the subject into one particular characteristic or emotional character such as *Industry*, *Idleness*, *Folly*, or *Innocence*. Focusing on a single human figure or face, as a critic wrote in 1753, Chardin "catches nature in the act. He has the gift of capturing what would escape any other painter; . . . The head of the girl is so expressive that one can almost hear her talk; one can read in her face the sorrow she feels for not knowing her lesson well."[39] The human face, captured in a moment, reveals a history of feeling that transcends the fixity of the instant at which it is depicted.

The Prussian king bought many Chardin paintings, including *The Return from the Market* (1738), which now hangs in Schloss Charlottenburg in Berlin, as well as its companion piece *Woman Scraping Vegetables*. Paintings like these convey a sense of a world somehow outside time, "a stopped world (but without surprise), a world at rest, a world of infinite duration," as Chardin scholar Pierre Rosenberg puts it.[40] The repetitive action of the stooped vegetable peeler in *Woman Scraping Vegetables* is suspended and fixed for eternity (fig. 4.5). The representation of character in such paintings is a precarious confrontation with time, a constant and careful balancing of permanence and evanescence: the complex and profound truths engraved in the face indicate a history of feeling as well as feeling's accretion into the complete present character of the sitter. It is a reminder, also, of the poignant truth of time's limits: to immortalize in a portrait is to recognize mortality. As René Demoris has commented,

> Though [Chardin's] figures are clearly represented in action, there is no *movement*. They are caught at a timeless moment of their action, which puts them at *rest*. . . . For the sometimes-brief lapse of time recorded in the canvas, the human figure is, in fact, motionless. It is caught at a precise instant, free from activity, in a moment of leisure, no matter how fugitive. . . . It is a lost moment where time stands still, and the human being, center of activity, is seen for what

LA RATISSEUSE

J.B. Siméon Chardin pinxit.

Lépicié Sculpsit 1742.

Quand nos Ayeux tenoient des mains de la nature, l'Art de faire un poison de notre nouriture,
Ces légumes, garants de leur simplicité, N'etoit point encore inventé.

Paris chez l'Auteur au coin de l'abreuvoir du Quay des Orfevres.
Et chez L. Surugue graveur du Roi rue des Noyers vis à vis le mur de saint Yves. Avec Privilege du Roi.

FIGURE 4.5. *La Ratisseuse* (Woman scraping vegetables). Engraving by Bernard Lepicié after Jean Siméon Chardin (1742). Harris Brisbane Dick Fund, 1953. Metropolitan Museum of Art, New York.

it is, beyond the grasp of any practical exigency. This still moment of uninhab-
ited time (for we do not know what has caused the servant to look up, and the
expression on the mother's face eludes us) transcends the time taken up by the
activity depicted: there is a sense of infinity about these human figures which
are shown caught in action and yet detached from it.[41]

The remarkable attention to temporality in Chardin's work is encapsulated
in the enormously successful *Soap Bubbles*, which he painted in several versions
and which circulated across Europe in engraved prints (fig. 4.6), a painting that
magically captures the moment when a magnificent bubble blown by a boy leaning
on a window ledge is frozen on the verge of bursting, highlighting the tension
between seriousness and play, the suspension of time in absorbed activity, and
especially the fragility of the instant.

Turning from 1750s Berlin, let's consider another painter, much admired in
Dresden, Pietro Rotari. (Rotari's work was familiar to C. P. E. Bach, who owned
an engraving of his portrait of the Dresden court Kapellmeister Johann Adolf
Hasse.) The way a sense of time passing and past might complicate the delicate
generic distinction between head study, portrait, and genre scene emerges vividly
from Rotari's extraordinary series of sixty-two small-format portraits of young
women, old women, boys, and old men produced for the Dresden court from 1753
to 1756. Described by the art critic and collector Christian Ludwig von Hagedorn
(the younger brother of the Hamburg poet Friedrich von Hagedorn) as "Têtes de
fantaisie," *Fantasy Heads*, the series, which Rotari hung in the Dresden gallery,
began with a self-portrait of the artist as if it were a title page. The paintings
constituted an encyclopedic study of human physiognomy—of the effects of the
emotions on facial and physical expression.[42] (Later, with the help of assistants,
Rotari produced more than 368 of these paintings for Catherine the Great of
Russia, all of them hung tightly together at the Peterhof, where they can be seen
today, to create the effect of a seamless wallpaper of faces.)[43] Many of Rotari's
"fantasy heads" presented the viewer with particularized human emotions, their
visual vocabulary borrowed from Charles le Brun's seminal manual for painters,
Conférence sur l'expression générale et particulière des passions (1696).[44] Perhaps
not surprisingly, contemporary descriptions of Rotari's paintings in the Dresden
gallery's inventory meticulously focused on their representation of individual
passions, taking affects such as thoughtful (*andächtig*), mischievous (*schalkhaft*),
very sad (*sehr traurig*), or irritated (*verdrüßlich*) to be the principal subjects, used
as titles of the paintings.[45]

But other paintings in the series elevated study heads to subjects in their own
right and evoked a more complex and sensitive view of human emotion (fig. 4.7;
see also plate 3). Many are indeed stand-alone portraits that represent both the
habitual attributes of the sitter and the momentary agitations of the soul. In a
number of Rotari's *Fantasy Heads* small domestic objects are introduced into
the paintings to transform the study into a miniature narrative, in the manner
of Krause's imagined scenarios for musical characterization: a girl looks out

LES BOUTEILLES DE SAVON

FIGURE 4.6. *Les bouteilles de savon* (Soap bubbles). Etching by Pierre Filloeul after Jean Siméon Chardin (1739). Gift of Georgiana W. Sargent, in memory of John Osborne Sargent, 1924. Metropolitan Museum of Art, New York.

FIGURE 4.7. *Young woman with a book*. Oil on canvas by Pietro Antonio Rotari. 46 × 35.9 cm. Rijksmuseum, Amsterdam.

coquettishly from behind her fan, another weeps into a white cloth, another holds her head in her hand as she reads a letter or, as in figure 4.7, glances up from a small leather-bound book. In a "portrait" like this, the effect is one of a private emotional scene, of absorption in the moment into which the viewer is drawn, as if invisibly involved in the sitter's emotional world, or almost shockingly included in a knowingly intimate exchange.[46]

A similar effect can be experienced in one of the largest and most spectacular items in C. P. E. Bach's portrait collection (one of the most expensive prints listed in the 1790 inventory), Jean Moyreau's etching of Antoine Watteau's drawing of the composer Jean-Féry Rebel (fig. 4.8). Rebel, glamorous in a striped silk housecoat, looks up—quizzically, imperiously—from his work as if interrupted just for the moment by the visitor (the viewer): the ruddy-faced composer is in the act of writing down an idea, composing at the harpsichord, as the hand that still touches the keys suggests.[47] Time is suspended, the sense of frozen energy palpable, as if the quizzically cocked head will return its attention to the page as soon as the visitor has turned away, the pen will scratch out the completion of the phrase, the fingers on the keys find their way to a new configuration of tones.

BACH'S CHARACTER PIECES AND THE ART OF THE MOMENT

If Berlin's cultured classes in the 1750s were fascinated by questions having to do with characterization and portraiture, it comes as no surprise to find that C. P. E. Bach, court harpsichordist to Frederick the Great, should have entered the arena with his own series of musical portraits. From 1754 to 1757 Bach composed twenty-four character pieces for keyboard that ranged from the representation of generalized character traits with such titles as "La capricieuse," Wq. 117/33 (The capricious one), "La complaisante," Wq. 117/28 (The complacent one), "L'irresoluë, Wq. 117/31 (The indecisive one), to personalized portraits; indeed, the series is dominated by a musical gallery of friends and acquaintances from Bach's circle of poets, thinkers, courtiers, and music lovers. Bach listed these miniatures in his own catalog of his works as *petites pièces*, a genre designation that perhaps echoed contemporary painting's *petits sujets*,[48] and in the 1750s and 1760s they were published in Berlin in anthologies for amateurs.[49] They circulated widely and retained their fascination even thirty years after their composition: "While he was still in Berlin," wrote one commentator in 1784, "Carl Philipp Emanuel Bach characterized several ladies that he knew with appropriate keyboard pieces; and several persons that knew each individual in those days assured me their temperament and manner in company were felicitously expressed in [these pieces]; one simply had to hear them played by Bach himself."[50] There are obvious errors in this account, since only a few of Bach's *petites pièces* do in fact refer to women—the feminine article *La* refers to *pièce*, not necessarily to the subject of the representation. Nevertheless it is surely correct in suggesting that the pieces may be understood in terms of portraiture, like the Couperin pieces they were modeled on.

Most of Bach's musical portraits depict men of stature, including the poet Johann Wilhelm Ludwig Gleim; privy councillors and amateur musicians Johann Wilhelm Bergius and Ernst Samuel Jakob Borchward; and privy councillor and court physician Georg Ernst Stahl, whose home J. S. Bach stayed in during his visit to Berlin in 1741 and two of whose family members were godparents to C. P. E. Bach's children. At their simplest, Bach's *petites pièces* seem to be straightforward

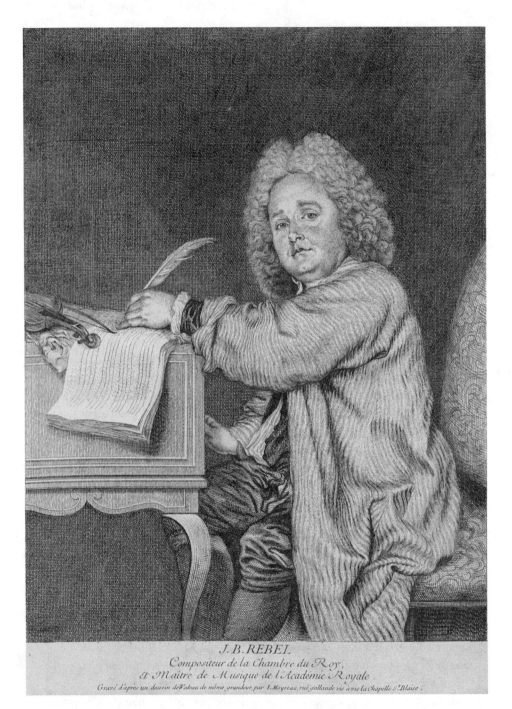

J.B.REBEL.
Compositeur de la Chambre du Roy,
Et Maître de Musique de l'Académie Royale.
Gravé d'après un dessein de Watteau de même grandeur, par J. Moyreau, rue gallande vis à vis la Chapelle S.! Blaise.

FIGURE 4.8. Jean-Féry Rebel (1666–1747). "Ober-Kapellmeister and composer in France." Etching by Jean Moyreau after Antoine Watteau, 1726/31. Staatsbibliothek zu Berlin—Preussischer Kulturbesitz und Mendelssohn-Archiv. Mus. P. Rebel, J. B. II, 1. Courtesy of the Berlin State Library (Staatsbibliothek zu Berlin).

depictions of a single definitive character trait. "La Louise," Wq. 117/36, for example, whose graceful little D major allegretto in 3/8 is a miniature rondo with relatively consistent refrains, no harmonic shocks or pauses, and a charming continuity of thematic ideas, presents one main idea—one principal trait (an optimistic and rather lively one)—that characterizes this Louise (whoever she may have been). But few of the portraits present their subjects as consistent, monochrome characters. "La Caroline," Wq. 117/39, for instance, is a simple binary movement, but the performance indication "allegro mà con tenerezza," the minor mode, and the strange shift toward the end suggest a more detailed and personal exploration of character (perhaps the Caroline in question might have been Bach's own daughter, Anna Carolina Philippina, who was eight years old when the piece was composed).[51] Indeed, far from concentrating on a single affect in the manner of the conventional character piece, Bach's musical portraits seem to address many of the questions to do with the representation of character, emotional complexity, time, and evanescence mulled over by Sulzer, Lavater, and Junker.

The portrait of Georg Ernst Stahl "La Stahl," Wq. 117/25 (music example 4.1), is one of those, a work that projects grandeur and pathos yet, instead of unity or stability of affect, seems concerned with the representation of changeability. Grand gestures constituted by dotted rhythms and thick chords give way to a written-out meterless dissolution that might seem to belong more properly to the free fantasia, perhaps evoking the mercurial temperament of the melancholic, whose fluidity (as Lavater, and perhaps Krause too, might have said) music is uniquely suited to represent. If we are to venture further thoughts on the mercurial character of "La Stahl," we might turn to Stahl's father, the famous doctor Georg Stahl the elder, who trained his son in Stahlian medicine and its attendant philosophy. The Stahlian approach rejected the received and unyielding post-Cartesian absolute dichotomy between mind and body and argued, radically, that there was a constant interplay and interdependence between the two.[52] Thus it might be claimed that the person portrayed, Georg Stahl the younger, himself subscribed to a philosophy of medicine that in a sense validated Bach's fluid musical depiction of his character: the fallibility and flux of mind and body in continuous concert that is at the heart of Stahlian medicine is played out before us. Rather than abstract ideas—pure reason—we have embodied thoughts as they fluctuate, in all their propensity for doubt and joy: Krause's affective scenarios, Junker's man of feeling followed through time, as he thinks and senses.

In "La Stahl," Bach makes the most out of these changes of mind and manner in what appears formally to be a modest piece in binary form of a mere thirty-eight measures. "La Stahl" is short enough that its tiny slice of time can "fix" its subject, yet within its sounding moments the piece plays with the idea of evanescence in the curiously inconclusive fade-out of its ending—a gesture that would be recapitulated in the final moments of the Fantasia in C Major from the sixth book for *Kenner und Liebhaber*, Wq. 61/6, published in 1787 (music example 4.2). In fact, the troubling question of ending in "La Stahl" seems to enter much earlier

EXAMPLE 4.1. C. P. E. Bach, "La Stahl," Wq. 117/25.

than the actual close of the piece. The "saraband" half-notes midway through the
B-section at bar 24, followed by the chordal sigh and long rests, recall the opening
and seem to signal a recapitulation. But they are followed by the fullest of chords
in dominant preparation (bar 26), which vex still further the melancholic mien
of the opening. After another long rest with pointed aspirations on the dominant
harmony at bar 27—poised for closure yet resisting—the booming fortissimo
chords are repeated verbatim before the piano quarter-notes of bar 29 seem at
last to move out of this chordal consternation. Yet all the material that follows,
even for its apparent qualities of fantastical exploration, can be heard merely as

EXAMPLE 4.1. (*cont.*)

a prolonged dominant elaboration. That is, with the "recapitulatory" motive at bar 24 the piece seems to call for its own end but then can't seem to accede to its own demand, consuming a quarter of the total number of bars in the piece before the hot and bother of fantasy expire in the resignation of the final two bars. That final gesture extends far beyond the low-register sixths Bach often draws on at the close of pieces in his *Kenner* style, the entire "recapitulation" constituting an expansion of the final cadence until eventually disappearing into it. The point is that the play of character over time resists the completion implied by an emphatic ending—as if, as the observer lingers before the portrait

EXAMPLE 4.2. C. P. E. Bach, Fantasia in C Major, Wq. 61/6, bars 209–end.

to contemplate the character depicted there, time is momentarily suspended in the potentially infinite flux of feeling.

In the portrait of the poet Johann Wilhelm Ludwig Gleim, "La Gleim," Wq. 117/19, which Bach listed in the *Nachlassverzeichnis* immediately before "La Stahl," the exploration of the changing topography of character is conducted more delicately, with a less obvious play of light and shadow; yet here too changeability seems to be the focus as character unfolds across the cycles of stasis and movement that constitute the rondeau. Despite Bach's concentration on rondo forms in many of his *petites pièces*—the form favored by his French models—"La Gleim" is the only one actually designated "Rondeau."[53] By contrast with the imposing and affecting "La Stahl" or the emphatically energetic perpetual motion of "La Böhmer," Wq. 117/26 (presumably Johann Samuel Friedrich Böhmer, professor of law at the university in Frankfurt an der Oder and Stahl's brother-in-law), "La Gleim" is all tenderness and sensitive simplicity (music example 4.3). The lilting 6/8 refrain in A minor is the simplest eight-bar antecedent-consequent phrase, its stepwise descents elaborated by upper and lower neighbor tones in a gentle oscillation that speaks of a delicate pastoral intimacy. Each couplet offers a new perspective on the main idea: in the first, in D minor, the mournful descending gesture is drawn in larger lines that give way to syncopated upward leaps that play out over suspensions in the inner voice and a dominant pedal below, suggestive of both yearning and hesitation. In the second couplet, a good-humored exchange in C major, complete with affecting octave echo, is interrupted by a sudden flash of pathos expressed in diminished harmonies and appoggiaturas before the rather demure, becalmed C major returns. In the extended third couplet, quirky self-assertion (expressed in leaps and staccato right-hand chords) gives way to a softly pleading descent, which at first falters in a strange loud halt on the E minor harmony it had begun with, moves on quietly before stopping, again forte, at C major, and continues, sighing but insistent, to a sudden fortissimo outburst on a D-sharp diminished seventh. Only with repeated, hesitant effort do we arrive at the final cadence.

EXAMPLE 4.3. C. P. E. Bach, "La Gleim," Wq. 117/19.

As is to be expected, each couplet alternates with the refrain, appearing un-
changed even if cast in a new light by what has preceded it. In the sixteen bars
of the *IIème Partie*, which is in fact merely an extended final couplet, we seem
to have entered another landscape entirely. In sunny A major, the right hand
romps in thirds over an insistent A pedal that runs right to the cadence, evoking
a shepherd's drone, perhaps, without guile or art but rich with hearty if temporally
static fun. Gleim comes across as a man of sentiment, of delicate moods that
yet have their clouds—the man who had had to leave Berlin and his beloved
friends eight years earlier to take up a position in Halberstadt. There—bereft,
lonely, desperately missing his friends—he set about keeping them present in a
Friendship Temple constituted of specially commissioned portraits (which I'll
say more about in the next chapter).[54]

EXAMPLE 4.3. (*cont.*)

Games with time, a reveling in evanescence as much as in the frozen moment, take a different form in a third piece from 1755, the obscurely titled "L'Aly Rupalich," Wq. 117/27 (music example 4.4). Here too the circularity of rondo, with its tension between progress and stasis, ghosts the form, though in unconventional and unstable ways. This is a bizarre piece, a faux Turkish romp whose murky bass, with its insistent rocking octaves (present in all but nine measures of the piece), seems to present the musical equivalent of the repetitive workaday ges-

EXAMPLE 4.3. *(cont.)*

tures of Chardin's vegetable peeler, yet whose extravagant leaps from harmony to harmony clash loudly with the monotonous treadle action chugging along below. The elaboration of a tonic pedal at the opening of a piece is standard eighteenth-century stuff, and one could cite many of Bach's sonatas that do the same, but few do so at such extended length. Again one notes the foregrounding of temporality: the murky bass fakes movement, its energetic repetitions being fundamentally without direction, and for all its frenzy of activity the piece spends

EXAMPLE 4.4. C. P. E. Bach, "L'Aly Rupalich," Wq. 117/27.

a long time going nowhere—it stays where it began. In this case the opening pedal, an even twenty-four bars, symmetrically divisible and subdivisible, without warning is ratcheted up a whole step in the bass (at bar 25), the common tone in the right hand with oddly doubled Cs—the seventh of the seventh chord on D—hardly constituting coherent, conventionally convincing modulation. Over the next six bars (note the less regular scansion), a serpentine move to the actual dominant (G) at bar 35 brings us back to the pedal point, and to the same antic gestures as the opening. This time, at bar 58, after the dominant

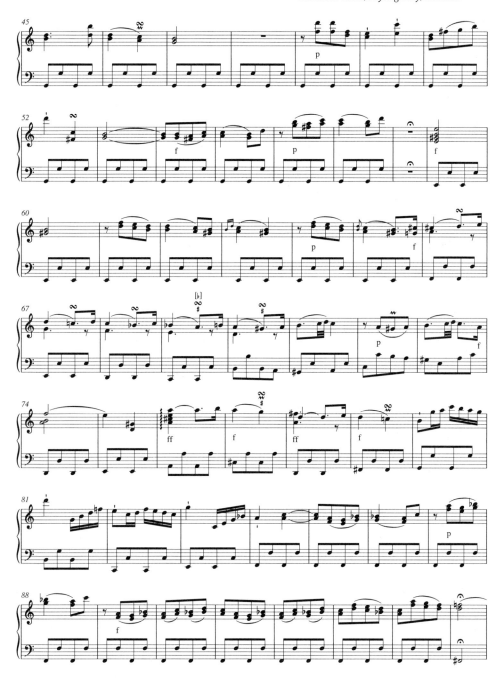

EXAMPLE 4.4. (*cont.*)

elaboration, Bach deploys one of his standard tricks: rather than performing an unmediated jump to another harmony, he does the impossible—stopping the perpetual motion immediately and without warning as the frenzy collides with silence—only for the pause to end with an even bigger sidestep than the previous move to D-7, this time to E major.

 After a somewhat shorter pedal (now an even more irregular unit of seven

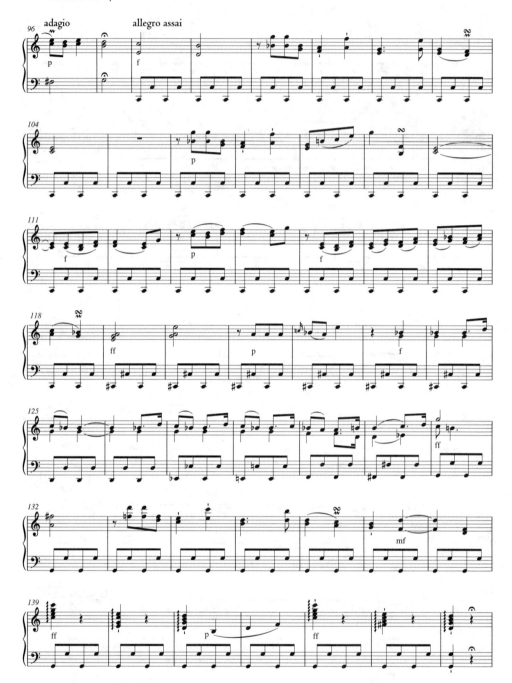

EXAMPLE 4.4. (*cont.*)

bars), the relentless upward motion of the bass teeters back down to C by parallel
sevenths in the outer voices, the fourth in the inner voice left unresolved in the
mayhem, before a short-lived abandonment of the murky bass for a bit of some-
thing that might even be called counterpoint, and that is at least "legitimate"
two-part writing (bars 69–73). This snippet recalls another of the character

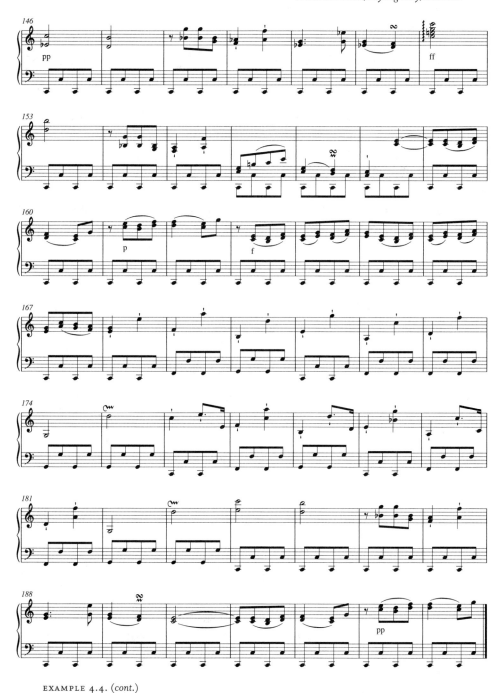

EXAMPLE 4.4. (cont.)

pieces composed in 1755, "La Buchholtz," Wq. 117/24 (music example 4.5), and would appear again in the allegretto middle movement of the D Major Sonata, Wq. 61/2, from Bach's last book for *Kenner und Liebhaber*, published some three decades later (music example 4.6)—perhaps a kind of internal colloquy in the musical representation of this circle of friends. "L'Aly Rupalich" is full of one-off

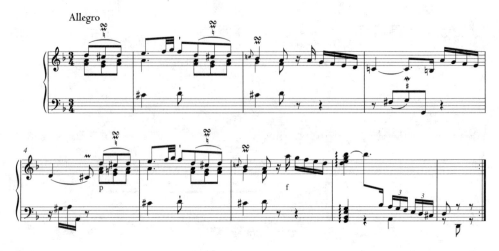

EXAMPLE 4.5. C. P. E. Bach, "La Buchholz," Wq. 117/24, bars 1–8.

EXAMPLE 4.6. C. P. E. Bach, Sonata in D Major, Wq. 61/2ii, Allegretto, bars 1–16.

ideas, as if the constancy of the left hand prompts random outbursts of fancy, as in the eruption of sixteenth-note figures at bars 80–83 (sixteenth notes being otherwise unexampled in the piece). Then there is the dwelling on a diminished octave—at the half-note (here with fermata) suspending motion in both hands simultaneously at bar 95, followed by the adagio resolution with another fermata on the dominant, waiting there as the murky program reboots, and then the allegro assai assault commences once again. Here mock pathos works ironically against the mock, or perhaps mocking, happiness of the murky bass.

Toward the end, the tonic-subdominant-dominant cadential loop suggests possible conclusion, going through their routine four times from bar 169 onward until landing for the final tonic pedal at bar 184. By now, as Darrell Berg has written, "the ear is convinced that any modulation may take place and that the tonic pedal may have almost any harmony above it."[55] At the very end Bach pulls another joke, playing on the abrupt rests heard earlier in the piece, but this

EXAMPLE 4.7. C. P. E. Bach, Rondo in C Minor, Wq. 59/4, bars 107–end.

time setting up a pianissimo echo only to drastically cut off "L'Aly Rupalich" in midflow. What began as forte hijinks vanishes into uncertain silence: the last fleeting sonority an open fifth with a fugitive G in the highest voice caught in the act of escape. The end, or perhaps non-end, of "L'Aly Rupalich" is quintessentially C. P. E. Bach—and leads us to the alternative title for the piece, entered in Bach's own hand in an early copy (and then scratched out), "La Bach."[56] One cannot be certain which member of the Bach family this title might refer to, but the exaggeration of devices so typical of C. P. E. Bach's style, indeed a signature of it (again, finding their apotheosis in his excursions into fantastic style), suggests that "L'Aly Rupalich," whose murky bass was a device energetically dismissed by C. P. E. Bach in the *Versuch* as the refuge of poor composers, with its dangerously close to inept harmonic shocks and jokes, may indeed present less a character than a caricature, perhaps in Turkish disguise, of C. P. E. Bach himself.[57] The piece is jammed with the pitches B, A, C, H, but only very occasionally and with rapid obscurity in the proper order to spell out his name: the fixing of identity would be too simple, too obvious—it is enough to merely flirt, if heavily, with the signature.

What is particularly characteristic of this Bach's music is its concern with temporality. Indeed, taken as a whole his oeuvre presents the weakest emphasis on closure and finality of any composer of stature in the eighteenth century, as if, especially in the late keyboard music, the piece would continue forever if not for some puncturing gimmick that suddenly erases the tableau.[58] Often this tactic involves a verbatim repeat of an opening rondo theme and nothing more, as if the piece would or should cycle onward forever but is prevented merely because the player stops, as in the C Minor Rondo, Wq. 59/4, from the fifth *Kenner und Liebhaber* book (music example 4.7). The long dying close—as in "La Stahl," and most famously in the later rondo *Abschied von meinem Silbermannschen Clavier*, Wq. 66—marks a kindred refusal to let go, a lingering in time that ultimately cannot be sustained but is all the more pathetic, all the more sentimental for having tried so hard and so sensitively to do so. (I'll say more about this, and about self-portraiture, in chapter 6.) Both abruptness and reluctance at the ending of a piece reveal an extreme saturation in the temporality of music. Both the sudden stopping and the dying echo, long fought against, heighten the moment even as they let it go.

Bach puts music into the service of portraiture, playing out over time and

embodying changeability. His musical portraits evoke the spontaneity of emotion, the complexity of character, the immediacy of (for us) indefinite yet (also for us) very vivid personality. I am not claiming that these pieces precisely conjure up personal traits, or that we can necessarily understand the ways Bach's friendship circle would have discerned such characteristics in this music. Theirs too would have been an oblique reception, recognizing a truth about the character they knew partly because they had been told to do so (by the title if nothing else). The melancholy of "La Stahl," the self-doubting pastoral of "La Gleim," or the mania of "L'Aly Rupalich" may have presented a recognizable portrait to those who knew the dedicatees.[59] For us, at a considerable historical remove, the pieces ask us—as they also asked their original players and listeners—to ponder and enjoy the complexity of emotion and of the character, or characteristics, represented, to recognize music's ability to embody newly fluid conceptions of the emotions and to portray its subjects in the moment, exploring its minute and endless possibilities just as Chardin did in the best of his work.

PHYSIOGNOMY, CHARACTER, PORTRAIT

Lavater's theories of portraiture were heavily indebted to the ideas of his friend and fellow countryman Johann Georg Sulzer. Sulzer summarized contemporary thinking in the lengthy entry "Portrait," published in 1774 in the second volume of his *Allgemeine Theorie*. There he gave credence to the conflation of physiognomy, portraiture, and the exploration of human character that underlay Lavater's method. Sulzer, who was personally invested in the art of portraiture, and well-informed about it thanks to his son-in-law, the brilliant portrait painter Anton Graff, opened his discussion by marveling at the power of the face to reveal the complex life force that animates the lumpen clay of the human form. A good portrait painter, Sulzer writes, sees beyond the everyday external appearance of the subject to look through the window that the face opens onto the soul. Portraiture at its most elevated presents an amalgam of character, morality, and feeling: if the face is the visible manifestation of the soul, a skilled painter of faces shows the interior life in the exterior form: he or she is a painter of souls, a *Seelenmahler*. The portrait painter, in short, must be a physiognomist who is able to "see the soul completely in the body," who has the sharpest eye for the tiny detail, who has the imagination to see the relation between the parts and the whole, and who combines these with the highest level of sensitivity.[60] To be a successful portrait painter, then, is to have greater gifts, and greater insight into human nature, than are required of virtually all other artists. The portrait painter is a diviner, a reader of souls, a translator of the ineffable and hidden into the physical and visible—perhaps also the audible.

In Sulzer's discussion of the portraitist's art, the central concern is with character. This, in all its variability and variety, is what the artist translates into the strokes of paint on canvas or the marks of pencil on paper—into line, shading, and color:

The art of the portrait painter is interesting to us in manifold ways, since he familiarizes us with the characters of men. As long as he himself is a connoisseur of men, as every good portrait painter must be, and as long as he who looks at the portrait has enough feeling to be able to see the soul in the material, thus every good portrait, even one of an unknown person, is, for the observer, a remarkable object.[61]

Indeed, given the constant flux of human emotion and the continual play of feeling, it is in the portrait, rather than in the actual face, that character in all its complexity can best be seen, captured as a single complex entity by the skilled painter:

> It follows from the observation above that every perfect portrait is an important painting, for it reveals to us a human soul of individual, personal Character. . . .[62]
> . . . We see in [the portrait] a being in which intellect, inclinations, attitudes, passions, good and bad attributes of the mind and heart are mixed together in a way that is particular and unique to him. . . . We even see these for the most part better in a portrait than in nature herself; for [in nature] nothing is stable but is quickly changing and constantly in flux: indeed, we seldom see faces in nature in the favorable light in which the skillful painter has presented them.[63]

A good portrait projects a powerful sense of presence and represents character in all its complexity: the portraitist is a physiognomist skilled at observing and describing the complex range of characters engraved physically on the face that signal a complete personality.

But physiognomists (professional or amateur) must be adept at more than the painstaking visual observation of the face (in life or on the page), knowing how to compare traits across many faces, their task one not only of visual observation but also of verbal description. They must have, and develop, an extensive vocabulary with which to describe the characters and characteristics they detect. Johann Caspar Lavater gave a detailed account of this process in a book that served as a preview of, and manifesto for, the *Fragmente*, published four years before the first volume of that work. In his miniature treatise *Von der Physiognomik* (1771), Lavater described how his physiognomical analyses were generated by, first, his executing a portrait drawing of his subject—which necessitated close observation of each facial feature. Soon images give way to words, with Lavater as portraitist first conversing with the sitter, then beginning to formulate a verbal vocabulary with which to describe what he sees. Later, as he considers, critiques, and tries to classify the portrait he has made, the verbal and the visual oscillate, each subject to continual correction, refinement, and eventually abstraction and generalization. The method is one of trial and error, observation and comparison: what is seen in the moment is tested against what is held in the memory, all the while gradually building up a store of references, a honed critical faculty, and confident powers of judgment.

The process of organization and classification was achieved with the help of

Lavater's own vast store of portrait drawings, prints, and paintings. Searching to identify and classify characters and characteristics—indeed, to develop a whole theory of human character (and its relation to the divine), he sorts through his portraits (with the one he has just made in mind) based on what he knows of the history, the deeds, and the writings of the men represented there:

> I compile the characters who resemble each other, on account of history or their deeds and writings. I make a row out of Clarke, Locke, Pope, Newton; another from Homer, Klopstock, Milton, Bodmer; another from Boileau, Voltaire, Corneille, Racine; yet another from Gesner, Thomson; yet another from Swift, Rabener; yet another from Tessin, Moser; yet another from Lycurgus, Montesquieu, Mirabeau; yet another from Albin, Haller, Boerhave, Morgagni; yet another from Socrates, Plato, Xenophon; yet another from Zwingli, Calvin, Bullinger.[64]

Sorting according to "profession"—Swiss reformers, classical philosophers, epic poets, English men of letters, French men of letters—he analyzes and compares, noticing similarities and differences; he rearranges according to other points of contact among them; describes them according to both what he sees and what he already knows of the moral and intellectual character of the portrait subjects. The process is painstaking, detailed, systematic; a gradual progression from part to whole, continual comparison, constant to-and-fro between what is seen and what is known, to what is in front of the eye and what is in the memory.

As the physiognomist identifies an ever-expanding repertoire of individual character traits, so must he continually work to enrich and nuance a vocabulary with which to describe what he sees. Lavater begins with words that already come to mind, at first inspired by the pictures in his collection; then, as he explains, he combs through dictionaries, etiquette manuals, philosophical writings, always expanding his register of "characters":

> Thus I go once again through my whole collection of portraits and design at the outset a taxonomy of every kind of facial expression, affect, inclination. I put down one after the other under the rubric "*Geist*" the words profound perspicacity, genius, inventiveness, readiness to observe, delicacy, cheerfulness, fire, liveliness, speediness, wisdom, cleverness, cautiousness, mediocre intelligence, mixed ability, slowness, weakness, shallowness, stupidity, folly, senselessness, madness.[65]

Crucial to this process is the collection itself. It is the *collection* of portraits that allows the complexities of character and the individual characteristics of human nature to emerge. The comparative approach enabled by the collection gives rise to a new vocabulary with which to describe and classify while at the same time training the eye to see, detect, infer. The science of physiognomy, which encourages observation of living beings as a useful tool for social life, is rooted in, and a product of, the art of making, viewing, and above all collecting portraits.

* * *

Let us turn back to Bach's portrait collection for a final reflection on the relation between the musical character piece and visual portraiture. When he was asked about character pieces in the 1770s, Bach seems to have held on to the language of the debates of the 1750s. To summarize an oft-repeated story, the poet Matthias Claudius reported to their mutual friend Heinrich Wilhelm von Gerstenberg a conversation with Bach about character pieces (and the famous trio sonata depicting a conversation between a "Sanguineus" and "Melancholicus," Wq. 161/1), held in 1768 (not long after Bach's arrival in Hamburg), that concluded with Bach's dismissing both them and the topic. Claudius wrote out the encounter as if transcribing their dialogue:

> Here I looked him straight in the face:
>
> CLAUDIUS: "You composed some pieces in which characters are expressed. Have you not continued with that work?"
> BACH: "No, I made the pieces on occasion and forgot them."
> CLAUDIUS: "But it is nevertheless a new path."
> BACH: "But only a lesser one, one can come closer when one brings words to it."[66]

Gerstenberg continued the conversation in a letter to Bach in September 1773 in which he discussed instrumental music and the problem of meaning—reflecting his preoccupation around that time with setting texts to Bach's instrumental works, or perhaps more accurately in his view, extracting texts from them, perhaps most famously the Hamlet and Socrates monologues to the quintessentially unvocal (and affectively heterogeneous) C minor free fantasia published in the second part of the *Versuch über die wahre Art das Clavier zu spielen* (1762). Gerstenberg began by reporting on a recent musical gathering at which certain concertos (for solo keyboard) by "the old" Johann Nikolaus Tischer had been performed, which had been composed on specific biblical texts, as Tischer admitted on the title page, during a period of his own illness. Tischer's pictorialism had provoked scornful laughter from the audience, but Gerstenberg had set out to defend this music: "Any attempt to give the clavier expression and meaning appeared to me to be worthy of praise, even if it failed."[67] Gerstenberg suggested to Bach that he might write a collection of sonatas that would delineate in music as accurately as possible the most moving passages of the Psalms:

> What precision of expression, otherwise so difficult to attain! Of course, it is the possibility of just this precision, this completely determined significance of a musical passage, that is always questioned the most. But why impossible . . . ?
> . . . Indeed, the feelings that a certain admirable man brings forth in me so often in his clavier sonatas are already such marked feelings even without the help of a text.

That words, titles, could clarify the content even further was all to the good, but this was not confined to music. Painting, too, might benefit from the addition of verbal explanation:

C. P. E. BACH.

FIGURE 4.9. C. P. E. Bach, silhouette from Lavater, *Physiognomische Fragmente*, III. Division of Rare and Manuscript Collections, Cornell University Library.

> Whoever wants to have fixed rather than vague ideas thanks the musician for every means of help, the use of which becomes a widening of pleasure. In my view a painter might even add a motto under a praying David, if he truly trusted himself to express the content of the motto well through his painting. It would always be preferable to see in the painting *what* David prays [about], rather than simply *that* he prays.[68]

At the end of this remarkable letter, the author turns to portrait painting and to a project under way regarding Bach's own portrait, spearheaded by Bach's former student the Danish harpsichordist and composer Niels Schiørring:

> Herr Schörring is thinking of having your portrait engraved. I have composed the inscription to it for him in Danish; it reads (with your permission): "A Rafael in sound, new, multifarious, beyond his time" [Ein Raffael durch Töne, neu, mannichfaltig, über ein Zeitalter.] Herr Schörring, who approves of this inscription, often plays something for me in gratitude for it, from the treasure of sonatinas he brought with him. I hope that [Johann Martin] Preisler will engrave it, if he has time.[69]

"A Rafael in sound . . . beyond his time." The engraved portrait with its verbal inscription explicitly announces its concern with time and temporality, with the sitter's relation (usually an exemplary one) to his or her own era, and the sitter's

transcendence of that time as he or she is inscribed into the long trajectory of history. The engraving would serve to encapsulate achievement and to cement posthumous reputation—if not immortality. The portrait of Bach, with Gerstenberg's inscription, not only would have confirmed the visionary qualities of the composer considered by his contemporaries to be "beyond his time," but would also have implied that this composer's music would resonate long after his death.

To Gerstenberg's enthusiastic suggestions regarding words and music Bach famously replied rather cryptically, indeed equivocally: "A clavier player, especially if he has a highly inventive genius, can do a great deal. However, words always remain words, and the human voice always has an advantage over us."[70] Bach neither dismissed nor embraced Gerstenberg's suggestion (or Claudius's hint) outright, even while suggesting that his own efforts at specific characterization were a thing of the past. Regarding the portrait inscription, though, he was touched: "One more thing! You embarrass me with your ingenious inscription to my portrait, thereby letting me know what further good you wished of me."[71] For Bach, as for Carl Ludwig Junker, portraits were not merely decorative, nor were they simply the culmination of a lifelong obsession. In the portrait collection the intimate portrayal of the individual that Bach experimented with in his *petites pièces* is cast against a grander vision. The musical character piece brings its subject to life, however enigmatically, delineating the shifting emotions of the individual through time; the visual portrait, by contrast, freezes the face at a single moment even as it reaches for a deeper truth about character's fluid complexity. In Bach's great pantheon of faces, the individual moment is set in a paradoxical relationship with the timeless eternity of artistic achievement.

Friendship: Portrait Drawings and the Trace of Modern Life

I am just returned from our dear Mrs. James's, where I have been talking of thee for three hours.—She has got your picture, and likes it: but Marriott, and some other judges, agree that mine is the better, and expressive of a sweeter character. But what is that to the original? Yes I acknowledge that hers is a picture for the world; and mine is calculated only to please a very sincere friend, or sentimental philosopher.—In the one, you are dressed in smiles, with all the advantages of silks, pearls, and ermine;—in the other, simple as a vestal—appearing the good girl nature made you;—which, to me, conveys an idea of more unaffected sweetness, than Mrs. Draper, habited for conquest, in a birthday suit, with her countenance animated, and her dimples visible.

<div align="right">Laurence Sterne, letter to Eliza Draper</div>

Preserved in the Kupferstichkabinett in Berlin is a large pen and ink drawing of Saint Cecilia, the patron saint of music (fig. 5.1; see also plate 4). Clad in flowing classical costume, her hair dressed in a loose knot entwined with strings of pearls and falling in tresses around her shoulders, she sits at a beautifully painted harpsichord. Her face in profile, her body slightly turned toward the viewer, she plays from a book set on the music desk. A jumble of musical objects occupies the right edge of the frame—a score lying open, a drum, and an elegant harp. The hall where she plays is grand, with fluted columns and marble floor. Behind the harpsichordist hovers a singing angel in a smoky cloud that billows its heavenly mist into the room, ruffling and blurring Cecilia's cloak and hair and spilling over the harpsichord. The image is redolent of movement and mystery, of divine musical inspiration. It is signed in the lower left corner by the artist Christian Heinrich Kniep ("C. Kniep inv. et del."). Below, in the center of the inked-in frame, there is a wobbly inscription in black ink: "S. Caecilia." The handwriting is that of C. P. E. Bach, his late-life gouty shake unmistakable.

Saint Cecilia was an important figure in a collection of music portraits, even as she transcended the contemporary and the historical to vault, like several other items in the C. P. E. Bach collection, into the realm of myth. Perhaps Emanuel Bach himself commissioned the drawing as a centerpiece for his collection, or it may have been a gift from a friend, or friends. Bach entered the drawing into his inventory as "Saint Cecilia, beautifully drawn by Kniep. Folio. In a golden frame,

FIGURE 5.1. Saint Cecilia, drawing in pen and brown ink, wash, by Christoph Heinrich Kniep. 32.9 × 28.3 cm. Inv. SZ Kniep 1. Bpk Bildagentur/Kupferstichkabinett, Berlin/Art Resource, NY.

under glass."[1] Its conjunction of subject, artist, owner, and medium points to a facet of the collection that moves beyond the mass accumulation of engraved prints of historical subjects, speaking of expertise and public knowledge, to the more personal space of friendship—from the friendship networks of midcentury Berlin to Bach's Hamburg circle in the 1770s and 1780s—and to a medium, drawing, that was particularly associated with the private and the personal, the realm of feeling and sentiment in the here and now.

When Burney visited C. P. E. Bach in 1772, he worried about Bach's celebrated

"originality," commenting that "Emanuel Bach seems to have outstript his age."[2] For Burney, as for many of C. P. E. Bach's German admirers and critics, Bach was in danger of coming unmoored from his own time, his music "made for another region, or at least another century."[3] With Bach, it seemed, esoteric difficulty came at the expense of popular appeal, and experimentation with an eye to the future took precedent over an engagement with the present. Indeed, as Burney surveyed Bach's portrait gallery he might have regarded Bach's collecting, too, as governed by another time. The pantheon of great musicians hanging on the walls reflected musical achievements of the past that would resound into the future. But just as it traced out circles of influence, acquaintance, even friendship among those older paragons, so too Bach's collection encapsulated and reflected back music culture (in its broadest sense) in the present moment.

As we have seen, Bach worked on his collection intensively in the last decade and a half of his life; during that period, even as the number of prints in the collection more than doubled, he took a particular interest in drawings executed in pencil, ink, and, most current of all, pastels. In this chapter I will concentrate on a selection of the portrait drawings to show how they reveal a facet of the elderly composer that Burney would perhaps have found hard to recognize: a man fully engaged until the end of his life with contemporary culture both visual and musical, interested especially in young artists, regularly attending concerts, welcoming visiting virtuosi into his home, and as busy with young musicians as he was with the established poets, writers, theologians, and scholars who flourished in Hamburg society. The drawings of colleagues, composers, instrument makers, and performers, made for the collection in Hamburg and its vicinity, provide a compelling view of the vibrant interlocking circles of friends and colleagues that formed the backdrop for Bach's own artistic activities late in his life. The portrait drawings in the C. P. E. Bach collection turn away from Bach's sense of the past to make vivid his experience of the present.

THE APPEAL OF DRAWINGS

Drawings were relatively quick to make and cheaper than paintings, but they were particularly valued by eighteenth-century collectors. Sulzer's entry on drawing in the *Allgemeine Theorie* summed up the genre's appeal: "The drawings of great masters are very highly prized by connoisseurs and artists. . . . For since they are generally made in the full fire of inspiration, in the true moment in which the artist feels with the greatest intensity and works with the greatest pleasure, so too the greatest fire and life is to be found in them."[4] Two of the most important art connoisseurs in Hamburg, the brothers Friedrich Johann Lorenz Meyer and Johann Valentin Meyer, who were part of Bach's circle, possessed important collections of drawings. "For the man of taste," wrote F. J. L. Meyer in his *Skizzen aus seiner Vaterstadt Hamburg* (1801),

drawings have a particular appeal. They are the magical strike [*Zauberschlag*] of the creative imagination, offspring of the heart of the great master . . . Liberated from the constraint of painstaking execution, of academically correct rule, of the anxious training and calculated effect of artistic expedience, the genius of the artist sets down the sublime thoughts that grip it in the sacred moment of conception, in the first fervor of enthusiasm.[5]

C. P. E. Bach was acquainted with the Meyer collections and must have viewed them with great interest, not least to compare the drawings contained there with the works of his own son, Johann Sebastian, who had chosen to pursue a career as an artist and was keenly supported in that goal by his father.

After his studies in Leipzig and Dresden, where he attracted the attention of the collector and art critic Christian Ludwig von Hagedorn,[6] the young J. S. Bach spent several months in 1776 with his parents in Hamburg before leaving for Rome in September of that year. The young Bach was a diligent contributor to his father's collection, drawing copies of paintings in other collections and making his own portraits as well as obtaining drawings for it as he traveled in Italy. The portrait of Tommaso Antonio Vitali (fig. 1.20), inventoried by Bach simply as an "Italian drawing," may well have been one of these. Works of his own produced for the collection included the beautiful drawing of Caterina Mingotti, copied from the pastel portrait by Anton Rafael Mengs in the royal gallery at Dresden (fig. 5.2), as well as drawings of Pierre Gabriel Buffardin, Giovanni Battista Martini, and Johann Gotthilf Ziegler, and an oil painting of Carl Friedrich Abel.[7] To his father's great sorrow, his talented son became ill and died in Rome on September 11, 1778, just two weeks shy of his thirtieth birthday.[8] On Johann Sebastian's death, large numbers of his own works as well as his study collection of drawings by other artists came into C. P. E. Bach's hands.[9] Drawings by the young Bach were also bought by several of the leading Hamburg collectors, including Johann Valentin Meyer, into whose *Stammbuch* Johann Sebastian had entered his name on the day before he left for Rome.

In 1783, five years after the young Bach's death, Meyer's twenty-three-year-old younger brother Friedrich Johann Lorenz would, in the course of his own travels in Italy, assemble an album containing more than one hundred drawings "by splendid living artists, all personally known to me and most of them my valued friends."[10] The album's value lay as much in its record of friendship as in its artistic content—in the personal and emotional connection afforded by drawings. As Meyer wrote in 1801,

In the friendly [*freundlich*] *Kabinett* in my house, where I safeguard this little treasure, the most beloved of my possessions, I am in the midst of my friends, the artists: here the individual image of each master is conjured in my mind, and with it, the golden age of [my] youth; . . . before these pages I draw for my children each scene, living it again with them.[11]

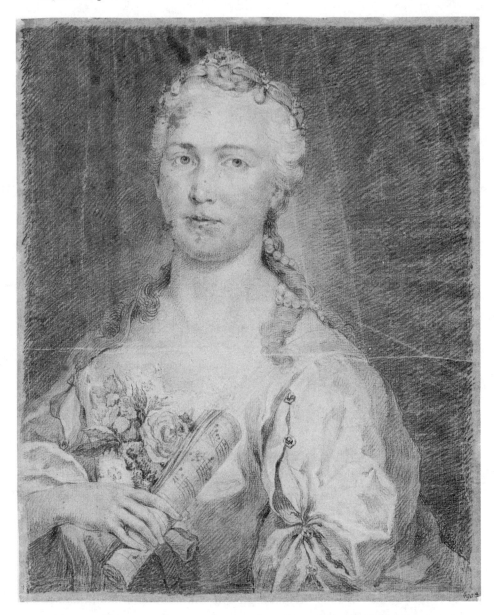

FIGURE 5.2. Caterina Regina Mingotti (1722–1808). "A German singer." Drawing in black chalk with white highlights by Johann Sebastian Bach the Younger. 38.5 × 31.5 cm. Staatsbibliothek zu Berlin—Preussischer Kulturbesitz und Mendelssohn-Archiv Mus. P. Mingotti, Cath. III, 1.

Albums like these were opened and shown to visiting friends and acquaintances, their contents the catalyst for conversation, stories, and recollection. When Elisa von der Recke, the noblewoman and writer from Courland, traveled to Hamburg in 1785 with her friend Sophie Becker, they visited not only C. P. E. Bach, but also the houses of both Meyer brothers, where they were shown the paintings and drawings hanging framed on the walls or preserved in large portfolios, including the precious album of drawings assembled in Italy.[12]

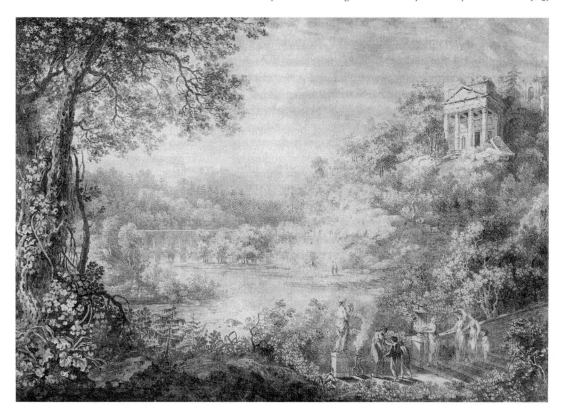

FIGURE 5.3. *Arcadian Landscape with Aqueduct and Temple on a Hill* (1775) by Johann Sebastian Bach the Younger. Black and gray ink, green-gray wash. 32.2 × 45.7 cm. Bpk Hamburger Kunsthalle, Kupferstichkabinett.

C. P. E. Bach, too, must have turned the pages of that album, and discussed the quality of its drawings, with poignant interest: many of the friends whose work was gathered together there were part of the colony of German artists who had welcomed his son to Italy in 1776, looked after him during his illness, and then buried him. As Meyer later wrote, memory of the young Bach was still strong among them in 1783: "The artists of Rome mentioned the name JOHANN SEBASTIAN BACH with the veneration that hallows the memory of deceased men of eminent merit. . . . In him his friends treasured at once the excellent and inspired artist, and the most noble man, and they spoke with wonder of his calm and fortitude in his death, which was one of the most extremely painful."[13] How proud C. P. E. Bach must have been had Meyer spoken to him of his son in the same terms with which he later wrote of him: "His services as an accomplished landscape painter are well enough known, the high flight of his poetic inspiration in his own compositions, the happy choice and truth in his imitations of nature, the power and precision in the expression and pose, and the great taste, especially in the composition and drawing of his groups of trees"[14] (fig. 5.3; see also plate 5).

Meyer was able to describe to the grieving father his visit to Johann Sebastian's

grave and to report on the plans among his friends in Rome to erect a monument to him there, an account later published in his *Darstellungen aus Italien*:

> Only a flat stone without an inscription marks his grave, in the romantic vicinity of the pyramid of Cestus. People spoke of erecting a marble memorial to him, which would have presented few difficulties in terms of the cost, if the friends he had left behind in Rome, the artists and especially the sculptors, had been interested in it. A simple marble stone with his name and the year of his death would suffice to preserve the memory of a person who, as an artist and a man, is so deserving that the place where his ashes rest shall not remain unmarked and shall not be forgotten.[15]

Perhaps inspired by the great importance of drawing in his own family, and in the collections of connoisseurs such as the Meyers, C. P. E. Bach expanded his portrait collection in the 1780s with portrait drawings obtained from friends at his specific request. That Bach was particularly interested in drawings suggests a sensitivity to the quality of character that a well-drawn portrait could convey: in all their candid immediacy drawings were less formal than oil paintings, less prone to distortion than prints. A drawing could offer a vivid likeness that communicated feeling, confirming and fostering friendship. "How happy I would be," Bach wrote to his friend the Braunschweig professor Johann Joachim Eschenburg (translator of the first volume of Burney's *General History of Music*) on December 1, 1784, "if I could add your dear portrait, drawn, to my collection. You are not only an amateur and connoisseur of our art, but also a writer, of which I have several [portraits in my collection], and NB. one of my best friends."[16] On February 25, 1785, a letter to the English musician Alexander Reinagle included a similar request: "At the same time, I ask you to let me have your portrait and that of your brother, drawn only, to include them in my cabinet of portraits of musicians. That will serve to help me remember your friendship."[17] Reinagle and his cellist brother Hugh had visited Bach in Hamburg in 1783; now, in response to Reinagle's request that Bach send him copies of his music, Bach asked for a pair of portrait drawings for his collection. To be represented among the musician portraits collected by one of Europe's most distinguished composers was an important confirmation of professional accomplishment; but to be included there in a specially commissioned drawing, in a medium valued for its sensitivity, intimacy, and ability to convey insight into the character of the sitter, was an indication of a more personal relationship between portrait subject and collector.[18] The hall of fame was, at the same time, a temple of friendship.

FRIENDSHIP TEMPLES

The blurring of the boundary between portrait and genre painting that marked midcentury visual culture in Berlin, as I discussed in chapter 4, pointed to a fundamental change in portraiture itself—a move from the formal, representative

portraits of the baroque, with their standard gestures and symbolic paraphernalia, to a more intimate and personal representation of the sitter. In turn, the response to the portrait from the collector, or viewer, would be characterized by an increasingly sensitive emotional exchange. Portraits were as much private records of a relationship, made for a circle of friends or for family members, as they were the immortalization of great achievements.[19] In his comprehensive study of German eighteenth-century portrait culture, Roland Kanz cites the example of a touching set of *Andenken der Gelehreten für das schöne Geschlecht* (Mementos of learned men for the fair sex), published anonymously in the early 1760s, which constitutes a reinvention of those grand volumes of engraved portraits of famous men, now presented as a miniature object of private affection and intimate exchange among women. The tiny pocketbook (20 × 18 mm) contains a little collection of engraved portraits of fourteen early Enlightenment and anacreontic poets, among them Hagedorn, Klopstock, Gellert, Ramler, and Lessing; the pictures are accompanied by quatrains that offer light versions of the traditional summaries of achievement attached to engraved portraits in *Bildnissvitabücher*.[20] Not so much a matter of learning, this is about female fandom, a collection of faces to be swooned over. "He who is your favorite poet, you beauties, let him be softly kissed," runs the book's opening instruction to its buyers.[21] The booklet concludes with a swerve from the love of poetry and poets to the longing for real lovers: into an empty frame on the last page the book's owner is invited to draw a portrait of her own beloved: "On this page, you beauties, paint the portrait that your heart values more than all poets."[22] Poems and portraits go hand in hand in a little book carried intimately on the body, whose purpose is to encourage gaining a sense of immediate emotional connection to the poets collected there by gazing adoringly at their faces. Portraiture makes the object of affection physically present.

No clearer expression of the idea of portraiture as an emotional substitute for absent affection could be found than in the expansive project begun in the late 1740s by C. P. E. Bach's friend Johann Wilhelm Ludwig Gleim, to create a Friendship Temple in the form of a collection of specially commissioned portraits of literary friends—many of them members of their shared Berlin friendship circle (who would also appear in Bach's portrait collection). Gleim began with his dearest friends, Johann Georg Sulzer and Karl Wilhelm Ramler.[23] That the portrait could provide the sense of a living presence, re-creating, even if only virtually, the warmth and affection of a lively social circle emerges with humor and charm from a letter written jointly on August 6, 1749, by Sulzer and Gleim in Halberstadt to Ramler in Berlin:

Sulzer: . . . At this moment, as I write to you, I'm sitting across from you. I chat with you, I smile at you, I flatter you, like Pygmalion his statue. You remain for us a mere shadow, [so you should] rip the chains that bind you to Berlin and come to us here on the wings of friendship.

Gleim: . . . Ramler, you look so serious, like a cuckoo. Sulzer says like a cat. If you're going to talk with us between 3:00 and 5:00 p.m., don't look like such a stuffed shirt.[24]

Gleim felt famously lonely in Halberstadt, desperately missing his Berlin comrades. His solution was to commission their mutual friend, the painter Gottfried Hempel, to provide him with portraits, all in the same format (they would all be framed the same way) of those he so loved. He wrote to Ramler on April 11, 1752: "No room in my house pleases me more than the one where you are. I am constantly running to you there, and looking at you, and kissing you, and Kleist, and Langemack and Klopstock, and then I say, "'Oh, the dear Hempel, who made all these beloved heads for me.'"[25]

In his turn, Ramler took a portrait of Gleim back with him to Berlin after a visit to Halberstadt in September 1752: "I am so happy that I brought my Gleim with me," he wrote to Gleim, "that I hardly know what life would be like if one didn't have one's friend's portrait. Now I address a thousand naive questions to you, I drink wine with you, and so naturally that, along with my fellow drinkers, I clink my own glass with yours. Long live my Gleim!"[26]

By 1764 Gleim owned about twenty-five portraits. On the back of many of them he noted what it was that most drew him to the portrait subject—like C. P. E. Bach's annotations on the portrait inventory, explaining their inclusion in his Temple: Christian Fürchtegott Gellert, "Author of the Fables" (*Verfasser der Fabeln*) was painted "for his love for mankind" (*wegen seiner Menschen Liebe*); Anna Louise Karsch "for her virtues more than her genius" (*wegen ihrer Tugenden mehr als wegen ihres Genie*), Karl Philipp Moritz "for his *Anton Reiser*" (*wegen seines Anton Reisers*), Christoph Friedrich Nicolai, "for his battle with evil spirits" (*wegen seines Kampfs mit bösen / Geistern*), Ramler, "for his odes" (*wegen seiner Oden*).[27] As the collection grew, it expanded beyond the private temple of friendship into an object with more public—and eventually historical—significance. By the end of Gleim's life (in 1803) it had become a monument to contemporary German letters and was open to the public. To be included in it was a significant honor (see fig. 5.5a).

But by the 1780s Gleim was already coming to think the collection might have meaning after his death. By then Bach and Gleim were old friends. Gleim had had the chance to see Bach's portrait collection, thickly peopled with both historical figures and friends, in 1785, when, as he reported to Johann Gottfried Herder, he visited "my dear old Bach" in Hamburg.[28] Bach, in his turn, would have seen the beginnings of Gleim's Friendship Temple three decades earlier when he spent a few days with Gleim in Halberstadt in the summer of 1751.[29] At that stage the portraits in Gleim's collection, by Hempel, depicted several members of their shared circle, including Ewald Christian von Kleist, Karl Wilhelm Ramler, Lucas Friedrich Langemack, and Christian Gottfried Krause. There was also a portrait of Sulzer, painted by the Magdeburg portrait painter Böhlau in 1745, as well as portraits of Gleim himself—one of them, by Hempel (painted c. 1750), in the pose of the elegant Man of Feeling as a musician holding a flute, the instrument most indicative of fashionable sensibilities. Bach and Gleim surely discussed portraits, likeness, physiognomy, and collecting. It is curious that, despite having set Gleim's poetry to music and counting him among his friends, Bach had no portrait of

FIGURE 5.4. Karl Wilhelm Ramler (1725–98). "Professor in Berlin, lyrical poet." Engraving by Johann Friedrich Kauke. Herzog August Bibliothek, Wolfenbüttel Portr. I 4876a.

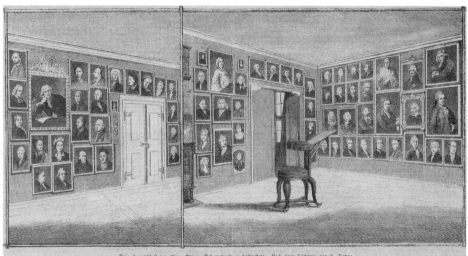

Der „Freundschaftstempel" in Gleim's Geburtshause zu Halberstadt. Nach einer Zeichnung von C. Jordan.

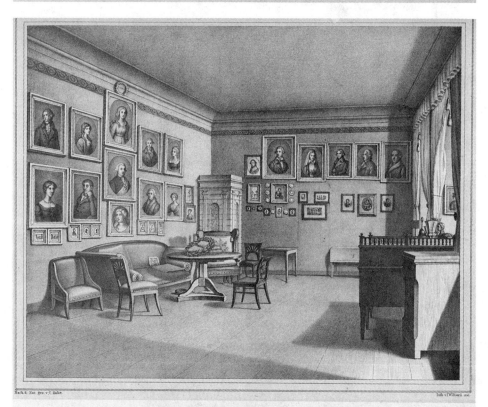

Erinnerung an Elisa von der Recke und C. A. Tiedge.

FIGURE 5.5. (A, top) The interior of the Gleimhaus "Freundschaftstempel," c. 1800, after a drawing by C. Jordan. Gleimhaus Halberstadt—Museum der deutschen Aufklärung, Ca 9718. (B, bottom) The Dresden salon of Elisa von der Recke. Lithograph by Johann Anton Willard after C. Haße (1841). Gleimhaus Halaberstadt—Museum der deutschen Aufklärung, Ca 2840.

Gleim in his collection (though as we have seen he had portrayed Gleim musically in the character piece "La Gleim"). But Bach could hardly have been offended that he was not included in the Gleim collection, which specifically focused on writers.[30] In fact, Goethe was troubled by the complete lack of musicians in the collection when he visited the *Freundschaftstempel* after Gleim's death in 1805. Having admired all the faces hanging there, he wrote: "In the process of such a viewing all sorts of thoughts came to me; I'll only say one of them out loud: one saw over a hundred poets and literati, but among them not a single musician or composer. How so? Should that Eminence [Gleim] whose utterances appear only to come to breath and life when sung, have had no idea of actual song? Of music, the true element from which all poetry springs, and to which it returns?"[31]

As the reputation of Gleim's Friendship Temple grew, other collectors followed suit. In Leipzig beginning in 1771 Philipp Erasmus Reich (publisher of Sulzer's *Allgemeine Theorie* as well as Lavater's *Physiognomische Fragmente*) began to assemble a collection of portraits of literary friends that quickly became the subject of public chatter. The philosopher Christian Garve wrote excitedly to his mother to describe Reich's recent return from Berlin, where he had taken the portrait painter Anton Graff so that Graff could paint portraits of the theologian Johann Joachim Spalding, the philosophers Johann Georg Sulzer and Moses Mendelssohn, and the poet Karl Wilhelm Ramler.[32] (In due course Gleim in Halberstadt would own a copy in oils of the Sulzer portrait that Graff had made for Reich, and C. P. E. Bach would own the engraving of it made by Daniel Berger [fig. 1.35 above].)

Our Herr Reich has made a journey to Berlin with Herr Graff, the portrait painter, solely for the purpose of painting the four heads of Spalding, Sulzer, Moses, and Ramler. The matter was completed in eight days. Herr Graff is back, and I have seen the heads. Among the four I know only Moses personally, but that is so striking a likeness that it was as if I saw him again before me. Spalding has a very pleasant, engaging physiognomy, just like his character, but he has something of a superintendent about him that I didn't expect. Sulzer's head is exquisitely characterized: but he almost has something about him that at first glance must come across as frightful. He is a perfect Swiss.—Ramler's head says the least, and he appears to be somewhat affected. Half the city has gone to see these heads. Tomorrow Graf is taking them with him to Dresden, where he will complete the painting, and then Bause will engrave them one after the other.[33]

Reich's temple of literary friends was, like Gleim's, a collection of specially commissioned paintings, but unlike Gleim's, his could claim to be of outstanding artistic quality thanks to Graff's involvement, and perhaps also on account of advice from his friend and collaborator Adam Friedrich Oeser, J. S. Bach the Younger's teacher at the Kunstakademie. Reich also arranged for portrait paintings in his collection to be engraved so that the portrait gallery could be widely circulated, even if it could not be visited in person—supplying material for the less well-off, but no less committed, *Portrait-Liebhaber*, who would build collec-

tions of engraved portraits.[34] J. S. Bach the Younger, studying in Leipzig, would certainly have visited the Reich collection, passing judgment on its contents just as Garve had done and perhaps even, like him, sending reports on the portraits back home to a very interested parent. In her turn, Elisa von der Recke would eventually create her own collection of portraits of friends and cultural paragons in the salon of the Dresden apartment where she lived from 1798 (fig. 5.5b).[35]

BACH'S TOKENS OF ADMIRATION

For a touring virtuoso visiting Hamburg in the 1770s and 1780s, to be able to claim publicly to have won the approval of the city's distinguished director of music, C. P. E. Bach, was an important feather in the professional cap. Relatively few such musicians appear to have been able to get reports of Bach's approbation into the Hamburg newspapers, but those who did included the Italian violinist Antonio Lolli (c. 1725–1802) in 1775, the singer Maria Felicitas Benda (1756 to after 1788), and the blind flautist Friedrich Ludwig Dülon (1769–1826), the latter two in 1783. Tellingly, all three sat for portraits for Bach's collection: reports of Bach's approval were not, it appears, empty publicity.

In early 1783 the young Dülon's tour, undertaken in the company of his father, brought him to Hamburg. There he performed publicly and, as the *Hamburgischer unpartheyischer Correspondent* reported at length, he also made a special visit to C. P. E. Bach at home. Renowned for his accomplished technique and extraordinary memory, the young musician passed with flying colors the various tests Bach set. Bach was impressed: as the newspaper's correspondent reported, "Mr. Bach was astonished at the genius of the youngster, and the writer of this article, who was present, shared his astonishment."[36] Not only did the encounter boost Dülon's reputation, but some months later a drawing of him by the young Danish artist Asmus Jakob Carstens was added to Bach's portrait collection.[37] As Dülon later recalled in his autobiography, Bach had asked Dülon's father to have a portrait made of his son to add to his "exquisite collection of paintings of famous musicians."[38] Traveling on to Lübeck, the Dülons heard of a fine artist there and wasted no time in going to him so the son could sit for a portrait—one that the blind Dülon (who could not see it for himself) proudly describes as having been praised as an excellent likeness: "When the painting was finished, the general verdict agreed upon by all who saw it, was that it lacked nothing but the faculty of speech."[39] On returning to Hamburg, the father and son visited "the great Bach" again and made him a present of the portrait, to his sincere pleasure. In concluding the account, Dülon stresses the excellence of the artist, gives his name, Carstens, and explains again how proud he was both to have been part of the collection and to have been immortalized in its published catalog: after Bach's death, "it flattered me not a little, when the estate catalog was read, to hear my name in it."[40]

FIGURE 5.6. Johann Friedrich Reichardt (1752–1814). "Prussian Kapellmeister." Drawing in red chalk by Asmus Jakob Carstens. 9.5 × 8 cm. Staatsbibliothek zu Berlin—Preussischer Kulturbesitz und Mendelssohn-Archiv. Mus. P. Reichardt J. Fr. I 2. Courtesy of the Berlin State Library (Staatsbibliothek zu Berlin).

The portrait Carstens made of Dülon is lost, but his drawing of another musician that was in the Bach collection survives in the Berlin State Library; unsigned, it is not ascribed to the artist in Bach's 1790 inventory.[41] This small drawing in red chalk (a specialty of Carstens's) was not a commission from Bach but was most likely a gift to the composer from its subject, Johann Friedrich Reichardt, entered into the inventory as "an Italian drawing. 12°" (*"Eine italiensiche Zeichnung. 12"*) (fig. 5.6; see also plate 6). The portrait remained unframed, and Bach appears not to have known that it had been made by Carstens at the request of Johann Caspar Lavater during a stay in Zurich two years earlier, as Carstens himself related. Both Carstens and Reichardt had been on their way back to Germany after Reichardt's successful trip to Italy (his only visit there) and Carstens's unsuccessful one that

he'd had to abandon before getting much farther than Mantua. The drawing Reichardt gave the elderly Bach was the basis for a portrait of Reichardt that is still to be found in the Lavater collection (there properly ascribed to Carstens).[42] Reichardt must have kept one of Carstens's two drawings for himself and then have given it to Bach, perhaps in the midst of one of the busy social gatherings that numerous visitors to the Hamburg Bach circle describe. Had the conversation focused mostly on the trip to Italy and back when the drawing had been made, the elderly Bach could have mistakenly thought the portrait was an Italian drawing. For Reichardt such a gift would have been both a token of friendship and a mark of his ambition to be included in Bach's musical pantheon.

Several months after Dülon's visit to Hamburg in 1783, another indication of Bach's endorsement of a contemporary performer appeared in the Hamburg press, reported by Carl Friedrich Cramer in his *Magazin der Musik*. According to Cramer, the German singer Maria Felicitas Agnese Benda was not, as had been claimed in another journal, a poor performer, with a "very humdrum cantabile" and a "merely mediocre" allegro;[43] on the contrary, "men such as Bach . . . who are indeed [qualified] judges" had numbered her among the finest singers in Germany, on a par with the best Italian virtuose. That Bach had indeed heard and admired Madame Benda is suggested by his already owning her portrait (fig. 5.7), an elegant drawing by the Hamburg artist Johann Andreas Herterich (whose name Bach lists in the catalog as "Hardrich"), dated August 1781.[44] The portrait shows the singer in a loose-fitting Grecian-style dress, hair piled on her head and dressed with strings of pearls (like Kniep's Saint Cecilia).[45]

Bach's interest in Madame Benda was both professional and personal: as the wife of Friedrich Ludwig Benda, she was the daughter-in-law of Georg Benda, the Gotha Kapellmeister and a friend of C. P. E. Bach's (who was represented in the portrait collection by a small engraving by Christian Gottlieb Geyser). In 1779, after the disbanding of Abel Seyler's theater troupe in Gotha, the couple traveled together to Berlin and then to Hamburg, where he took the position of music director at the Hamburg Opera from 1780 to 1782. Bach wrote to Breitkopf on May 13, 1780, expressing his admiration at Friedrich Ludwig Benda's appointment: "Benda's good fortune is astounding. I wish him joy with it. Do tell me, how did he do it?"[46] Bach would have had many opportunities to hear Madame Benda not only at the opera, but also in concerts with her husband. They gave their first performance together at the Hamburg Schauspielhaus on October 21, 1780, and offered a series of twelve subscription concerts the following year. In 1782 F. L. Benda was appointed first violinist and chamber composer to the Duke of Mecklenburg-Schwerin at Ludwigslust (joining many other musicians at the court who were represented in the Bach portrait collection), and the couple moved away from Hamburg. The drawing of Madame Benda dates from their sojourn in Hamburg, and an inscription on the back, likely in the artist's hand, explains that it shows her in the role of Parthenia in Anton Schweitzer's opera *Alceste*: "Maria Felicitas Benda / born Ritz in the role of Parthen[ia] / from Alcest[e] drawn from life / by Herderich in the month of August 1781." Benda may have

FIGURE 5.7. Maria Felicitas Benda (1756 to after 1788). "Singer in Ludwigslust." Drawing by Johann Andreas Herterich, 1781. Black chalk on white paper. 26 × 20.5 cm. Staatsbibliothek zu Berlin—Preussischer Kulturbesitz und Mendelssohn-Archiv. Mus. P. Benda, M. F. I, 1. Courtesy of the Berlin State Library (Staatsbibliothek zu Berlin).

performed this virtuosic role alongside the singer Francisca Romana Koch (also a member of Seyler's troupe), who was renowned for her interpretation of the work's title role; engraved portraits of Koch and Schweitzer (fig. 5.8) were part of the Bach collection, along with the drawing of Madame Benda.[47]

In a similar conjunction of portraiture, public approbation, and private admiration, Bach obtained a drawing of the Italian virtuoso violinist Antonio Lolli,

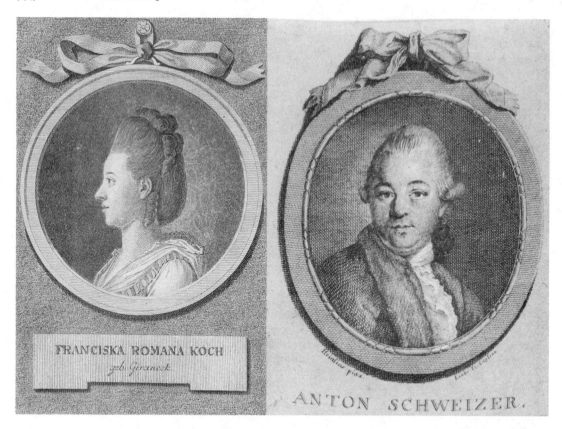

FRANCISKA ROMANA KOCH
geb. Giraneck.

ANTON SCHWEIZER.

FIGURE 5.8. (A, left) Franziska Koch (1748 to after 1796). "Singer and actress." Engraving by Daniel Berger. (B, right) Anton Schweitzer. "Kapellmeister in Gotha." Engraving by Christian Gottlob August Liebe after Johann Ernst Heinsius. Staatsbibliothek zu Berlin—Preussischer Kulturbesitz und Mendelssohn-Archiv. Mus. P. Koch, Francisca Romana I, 1, and Mus. P. Schweizer, Anton, I, 1. Courtesy of the Berlin State Library (Staatsbibliothek zu Berlin).

also by Herterich (fig. 5.9a; see also plate 7). Lolli was a regular performer in Hamburg, and he is known to have played there many times in 1773 to 1784. Later writers described him as a musician capable of legendary technical feats, though given to a capricious temperament, in Gerber's view more of a shaman than a great musician.[48] C. F. D. Schubart reflected a more sympathetic view when he wrote that Lolli was "[perhaps the] Shakespeare among violinists," and a master of the comic, who "not infrequently clowned around in Harlequinades, and [thereby] made listeners laugh in the middle of the stream of feelings. But just as the fool at King Lear's side in Shakespeare is not merely sufferable but has the most powerful effect, so it was with Lolli."[49] Lolli played at a concert on January 30, 1775, the *Hamburgischer unpartheyischer Correspondent* reporting that his "extraordinarily moving Adagio" had earned him warm praise from the critics, "and particularly from our famous Herr Kapellmeister Bach."[50] The portrait in colored chalk on vellum presents Lolli within an oval frame, turned slightly toward the right and looking back toward the viewer, the full lips turned up in

FIGURE 5.9. (A, left) Antonio Lolli (c. 1725–1802). "Violinist." Drawing by Herterich. Black and colored chalk on vellum. 20 × 16.5 cm. (B, right) Thomas Christian Walter (1749–88). "Secretary, composer and director of the Royal Theater in Copenhagen." Drawing by Herterich. Black and colored chalk on vellum. 19 × 15 cm. Staatsbibliothek zu Berlin—Preussischer Kulturbesitz und Mendelssohn-Archiv. Mus. P. Lolli, Antonio I, 1, and Mus. P. Walter I, 1. Courtesy of the Berlin State Library (Staatsbibliothek zu Berlin).

a hint of a smile. An inscription in gray pencil beneath the oval identifies the sitter, "Antonio Lolli"; on the reverse of the sheet the collector Georg Poelchau, who acquired the portrait in the early nineteenth century with many others after the eventual sale of Bach's collection, noted its provenance "from the Bach collection" (*aus der Bachschen Sammlung*).

Beyond representing a man in middle age, the portrait of Lolli offers few clues as to when it was made. But another portrait in the collection can shed light on this drawing's dating. Bach's catalog lists a third drawing by Herterich, a portrait of a certain "Walther, Secretary, Composer and Director of the Royal Theater in Copenhagen . . . in a golden frame under glass"[51] (fig. 5.9b; see also plate 7). In the collection of the Berlin State Library today is a portrait drawn in colored chalk on vellum. Its size and format are similar to those of Lolli, and its subject is also presented within an oval interior frame—both portraits recall the format and design of miniatures, and Herterich indeed worked mainly as a miniature painter.[52] The sitter is identified as "Walther" by an inscription in gray pencil in the lower margin. On the reverse, an annotation by Poelchau confirms

its provenance as the Bach collection. The subject is the Danish composer and government official Thomas Christian Walter, whose successful early career at the Danish royal theater was cut short when he was forced to leave the country in 1775 after his public ill treatment of his wife.[53]

Herterich's portrait of Walter is remarkably similar to that of Lolli, differing chiefly in its palette: the faded browns of Lolli's coat and skin, the dark green of the background shadow and the intense green-brown of the eyes give way in Walter's to the startling light blue of the eyes, the coat, and the space on the right, the dark black in the background shadow, and the delicate pink tones on the cheeks and mouth. Both Walter's portrait and Lolli's hung in gilded frames, and the two portraits would have made a pair, the youth and freshness of Walter contrasting with Lolli's middle age. Walter was no traveling virtuoso, but he was an admirer of Bach's (he had subscribed in 1774 to Bach's publication of *Cramers übersetzte Psalmen mit Melodien*, Wq. 196), and the three-year study trip he undertook on being banished from Copenhagen in 1775 began in Hamburg.[54] The presence of his portrait in Bach's collection suggests that he met Bach and may have studied with him during that year: he made a strong enough impression on the composer that Bach sent him to Herterich to be drawn. If Walter's portrait was done in 1775, it seems likely that Lolli's was made at about the same time, which would have coincided with Lolli's Hamburg performances of 1774–75 that Bach publicly praised.

Although the written record bears scant witness to Bach's interest in other young musicians passing through Hamburg in the 1770s and 1780s, the drawings in his portrait collection document his lively engagement with—and willingness to invest in—the newest talent.[55] In 1783 Regina Strinasacchi, the rare female to perform publicly on the violin, played in Hamburg to considerable critical acclaim on November 27 and December 4, 1783. Bach acquired a drawing of her (now lost) made by the artist Haack (first name unknown), which he hung in a golden frame.[56] That he was still attending public concerts even late in life is confirmed by the diary of Sophie Becker, who met him at a concert on the evening of October 29, 1785: "Next to our box sat Bach with his daughter, and we chatted until the music started."[57] Even as late as 1787, the year before his death, C. P. E. Bach was still hearing the new performers and acquiring their portraits. In that year the young keyboard virtuosa Maria Theresia von Paradis, who like Dülon was blind, performed in Hamburg. That Bach was impressed by her is evident from his acquisition of her portrait (now lost), a drawing by an artist named Schubart.[58] Fifteen years later Bach's daughter Anna Carolina Philippina was able to attest to the drawing's fine likeness when she sold it to the collector J. J. H. Westphal: "If the good Mademoiselle Paradis knew that she had found herself in such good hands, she would be glad. Her portrait is a speaking likeness."[59] Such a claim could hardly have derived from a passing encounter in a concert hall; rather, it suggests that Paradis, like so many other noted musicians including Dülon, had enjoyed an evening at the Bach home.

THE INSTRUMENT MAKER AND THE ARTIST:
JÜRGENSEN AND KNIEP

Bach's portrait drawings present a glimpse of the characters that populated his Hamburg milieu. In the items made for it and those acquired during the 1770s and 1780s, his collection formed a visual counterpart to journals such as Carl Friedrich Cramer's *Magazin der Musik*, their pages crammed with miscellaneous information on contemporary musical life in northern Germany. One such item in Cramer's *Magazin*, a notice dated March 1783 from the "Instrument-maker Jürgensen" in Schleswig, announced two new keyboard instruments: a *clavecin royal* with numerous stops and a built-in swell mechanism, and a "Bellesonorereal" that, with only five stops, could make over forty-eight combinations. Jürgensen's advertisement claimed that on account of the latter instrument's remarkable "silvery tone" (*Silberton*) the name "Bellesonore" had been given it by "one of our leading Clavier players" (*einer unserer ersten Clavierspieler*).[60] Johann Christian Jürgensen (a relative of the artist Asmus Jakob Carstens, who lodged with Jürgensen before his departure for Copenhagen in 1776),[61] had set up his workshop to make keyboard instruments in Schleswig by the late 1770s, but his instruments appear to have been (and still are) relatively little known. Cramer, who owned a clavichord by Jürgensen, added in a footnote to this notice that he had personally seen both instruments and could attest that although Jürgensen's name still lacked public recognition, he was one of the "most eminent artists" who concerned themselves with instrument making.[62] His clavichords in particular were outstanding, reported Cramer, and for their singing tone and power they could not only stand beside, but even surpass "the instruments of Friederici, Krämer, and, in Copenhagen, Müller."[63] It is hard to read such an opinion of a clavichord maker, expressed in Hamburg in 1783, without wondering whether Cramer was transmitting the views of Hamburg's leading clavichord expert, his friend Emanuel Bach; perhaps indeed it was Bach to whom Jürgensen himself was coyly referring as that "one of our leading clavier players" who had praised the silvery tone of his Bellesonorereal.

Jürgensen was no obscure keyboard maker; he surely was known to Bach and the other members of his Hamburg circle, if not in person then at the very least by reputation. The musically talented son of a baker, Jürgensen had started in his father's profession, like his father practicing in his spare time as a highly skilled cabinetmaker. By 1769 he had gone into instrument making full time, building both clavichords and his specially designed fortepianos. But he was also known for his interests and skills in the physical sciences: in the orbit of Duke Carl von Hessen (the local aristocrat at Eckenpförde and patron of the mysterious Comte de St. Germain, aka Giovannini) and inspired by the count's principal engineer General Major von Wegner, he worked on numerous mechanical inventions, including leveling machines, planetariums, monochords, barometers and thermometers, and optical instruments including microscopes and telescopes.[64]

FIGURE 5.10. Johann Christian Jürgensen (1744–1823). *"Clavierist.* A Dane." Drawing by Christoph Heinrich Kniep, 1779. Pencil and black chalk on white paper. 18 × 17 cm. Staatsbibliothek zu Berlin—Preussischer Kulturbesitz und Mendelssohn-Archiv Mus. P. Jürgensen I, 1. Courtesy of the Berlin State Library (Staatsbibliothek zu Berlin).

A regular summer guest among the local aristocracy, he built a hot-air balloon after Mongolfier, which he brought to Kiel, Lübeck, and Eutin so that, by 1784, people in this corner of northern Germany could claim to be the only people outside France who had actually seen the fabulous balloon that everyone else had only read about. (Montgolfier's first demonstrations of his balloon had taken place only the previous year.) Jürgensen also made and sold lightning conductors.[65]

In 1781 Jürgensen was a subscriber to Bach's second set of Sturm songs (Wq. 198), but a further connection between the two, and, indeed, perhaps an indication of Bach's respect for Jürgensen at the early stages of his career, is implied by Bach's having owned a portrait drawing of the instrument maker, made in 1779 and, like his Saint Cecilia, the work of Christian Heinrich Kniep[66] (fig. 5.10). Executed in black chalk with white highlights, and signed and dated by the

artist, the portrait shows Jürgensen in profile in a fashionable tie wig, the careful shadowing behind the head and under the chin, as well as the termination of the thick neck, contributing to the effect of a plaster relief; in its circular format, the portrait mimics a memorial coin or medallion. The format is identical to a portrait drawing Kniep made in Hamburg in 1780 of the Danish artist Jens Juel, now in the Statens Museum for Kunst in Copenhagen. Traces of a black ink margin remain at the outer edges of the paper, suggesting that this image, like the one of Saint Cecilia, was presented within its own set of inked margins, and perhaps it too, before it was trimmed, had been annotated by Bach with the name of the sitter.[67]

Kniep lived in Hamburg from 1778 to 1780. Although C. P. E. Bach's name does not appear in the meager literature associated with Kniep's Hamburg stay, the artist's work as a maker of portraits brought him into close contact with C. P. E. Bach's circle. Kniep was only six years younger than Bach's son Johann Sebastian, and he arrived in Hamburg at age twenty-three in 1778, the year Johann Sebastian died in distant Rome. Like Johann Sebastian, Kniep too would travel to Italy, and he is now largely remembered as the artist who accompanied Goethe on his Italian journey. Kniep was welcomed in Hamburg by the group of writers and Hamburg literati who were Bach's closest friends. In Kniep's obituary, his friend C. F. C. Haller, who had known him in Naples, recalled the tales Kniep had told of his Hamburg sojourn: "Thus he had the enviable good fortune to become acquainted personally with men such as Klopstock, Johann Heinrich Voß, Claudius, Campe, Reimarus, and Schröder. Even into his latest years his voice and eye would become animated when Kniep told stories of the nightly symposia in which those stars of Germany shone and expressed their benevolent influence."[68] In addition to the poets Klopstock, Claudius and Voss, Kniep's circle included Christoph Daniel Ebeling and Johann Georg Büsch, and he drew portraits of both of them that were subsequently engraved.[69] Kniep also knew the collector Johann Valentin Meyer, of whom he made a masterful portrait drawing in 1780, and the artist Andreas Stöttrup. All these men were friends of C. P. E. Bach's. It was while Klopstock's portrait was being painted by another artist passing through Hamburg, Jens Juel, that Kniep made the drawing of Juel mentioned above, which would subsequently be engraved by Stöttrup.[70] The set of interlocking connections is not unlike that represented by Stöttrup's own drawing of himself making a double portrait of C. P. E. Bach and the Hamburg pastor Christoph Christian Sturm (fig. 5.11), in a grand Hamburg drawing room (Sturm's? Bach's?) hung with pictures.[71]

FAMILY FRIENDS: BACHS AND ABELS

In the circle of artists and musicians Bach moved in, portraiture could fix and immortalize for the future, but it could also capture the living present. Artistic inspiration, emotional connection, the ties of friendship and collegiality of the

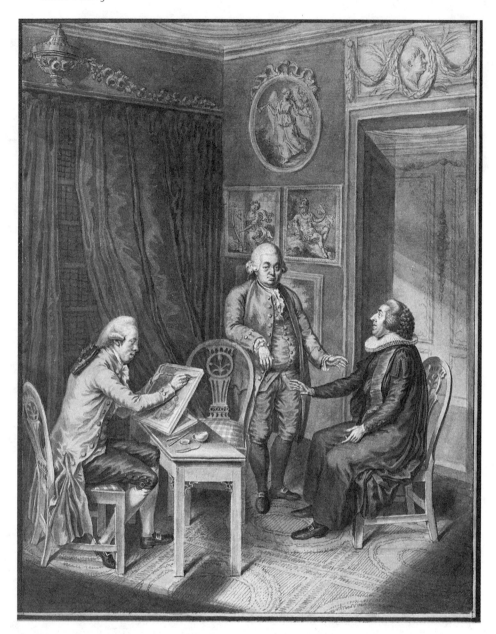

FIGURE 5.11. "The artist Andreas Stöttrup, the composer C. P. E. Bach, and the Pastor Christoph Christian Sturm." Drawing by Andreas Stöttrup, 1784. Pen and ink. The inscription reads "Nach dem Leben gezeichnet und zusammengesetzt von And. Stöttrup. Hamburg 1784." Bpk Bildagentur/ Hamburg Kunsthalle Kupferstichkabinett/Christoph Irrgang/Art Resource, NY.

vibrant here and now could all be stored up and revisited in portrait drawings. The circle extended from newcomers like Kniep to old family friends such as the members of the Abel family, which, like the Bachs, included painters as well as musicians. In 1779, the same year Kniep drew Jürgensen, the Ludwigslust court violinist and painter Leopold August Abel provided for the collection a vivid drawing in black chalk (fig. 5.12) of the celebrated singer Elisabeth Mara, then

FIGURE 5.12. Elisabeth Mara, née Schmeling (1749–1833). "Singer." Drawing by Leopold August Abel, 1779. Black chalk with black ink on cream paper. 21 × 18 cm. The inscription reads "Mademoiselle Schmelling: ou Madame Mara: 1779." Staatsbibliothek zu Berlin—Preussischer Kulturbesitz und Mendelssohn-Archiv Mus. P. Mara, G. El. I, 8. Courtesy of the Berlin State Library (Staatsbibliothek zu Berlin).

at the height of her career on a Europe-wide concert tour.[72] Mara performed at the Drillhaus in Hamburg with her husband, the cellist Ignaz Mara, on July 7, 1779.[73] Bach probably heard her there, and Abel may also have been in Hamburg then. Or did Mara sing at Ludwigslust and sit for Abel there at Bach's request?[74]

That same year Leopold August also made a finely executed self-portrait in black and colored chalk for the Bach collection, meticulously labeled, "Leopold August Abel. Musician. Drawn by my own hand. Ludwigslust. Anno 1779, the 24th March" (fig. 5.13a; see also plate 8). Seven years later, in 1786, Leopold August's

brother, the artist Ernst Heinrich Abel, made for the collection a drawing of their elder brother, the London-based gambist Carl Friedrich Abel (fig. 5.13b; see also plate 8).[75] The image is a beautiful companion to the self-portrait by their brother, similar in size, and like that one executed in colored chalk, ink, and wash, also presenting the sitter within a trompe l'oeil oval. Bach hung both in black frames with the inner rims gilded, and the two portraits could well have been placed together, their sitters facing slightly toward one another. The drawing of Carl Friedrich Abel was made some seven years after the Leopold August Abel self-portrait and must have been designed to complement the earlier one, either at the request of Bach himself, or perhaps at the suggestion of the artist, who would have been familiar with Bach's collection and the portrait of his brother (by another brother) already hanging there.

These two portraits offer the opportunity for a final reflection on the circles of friendship and extended connections among families that eddy through the Bach portrait collection. There had long been close ties between the Abel and Bach families, both of them rich with musicians and painters. The father of the three brothers mentioned here, the violinist and gamba player Christian Ferdinand Abel, had been a colleague of Johann Sebastian Bach's at Cöthen from 1717 to 1723, and Sebastian Bach stood as godfather to Carl Friedrich's sister Sophia Carlotta in 1720. According to Burney and Gerber, his son Carl Friedrich Abel became a student at the Thomasschule in Leipzig under Sebastian Bach on the death of his father in 1737. In 1743 he was employed as gambist and cellist at the Dresden court where Wilhelm Friedemann Bach was organist at the Sophienkirche. In the late 1750s, with the outbreak of the Seven Years' War, Abel left the Dresden court, and in 1759 he settled in London, where he spent most of the rest of his career, closely associated with Johann Christian Bach, with whom he mounted the famous Bach-Abel concerts from 1765 to 1781. At the end of 1782 Abel returned home to Germany as a guest at the court of Friedrich Wilhelm, crown prince of Prussia, in Potsdam; he took the opportunity to visit his brother Leopold August at Ludwigslust and probably also his younger brother Ernst Heinrich, the artist, in Hamburg, where he may also have dropped in on C. P. E. Bach.

Leopold August had studied with his father, and then in Dresden with Franz Benda, and from 1769 he was employed as first violinist at the court of Mecklenburg-Schwerin in Ludwigslust, where C. P. E. Bach had numerous friends, to judge from the large number of musicians associated with that court in his portrait collection. The artist Ernst Heinrich is mentioned in a C. P. E. Bach letter of July 21, 1769, complaining of the lack of interest in culture and the arts in Hamburg, the mercantile city that had recently become his home: "There is no taste here," Bach wrote. "Mostly queer stuff and no pleasure in noble simplicity. Everything is glutted. . . . Herr Abel, the painter whom you knew in England, has been here for a year and is earning almost nothing. The English colony understands its business, and nothing more."[76] Perhaps Bach had sent the singer Josepha Duschek to Ernst Heinrich as a way to help him financially, for the inventory lists what must surely be a spectacular drawing of Duschek by E. H. Abel, in *Gr. Folio* in

FIGURE 5.13. (A, left) Leopold August Abel (1718–94). "Violinist in Ludwigslust." Self-portrait, 1779. Black and colored chalk with wash on gray paper. 27 × 22.5 cm. (B, right) Carl Friedrich Abel (1723–87). "Violdigambist in London." Drawing by Ernst Heinrich Abel, 1786. Black, white, and colored chalk with wash on gray paper. 25 × 21 cm. Staatsbibliothek zu Berlin—Preussischer Kulturbesitz und Mendelssohn-Archiv Mus. P. Abel, Leop. Aug. III, 1 and Mus. P. Abel, Carl Friedrich I, 6. Courtesy of the Berlin State Library (Staatsbibliothek zu Berlin).

pastels (its current location is unknown). Perhaps made during the Duscheks' visit to Hamburg in 1782, the drawing was impressive enough that it was priced, on the collection's eventual sale, as one of its most expensive items, costing the same as the oil painting of Anna Magdalena Bach.[77]

The Abels and the Bachs shared many colleagues and professional friends (many of them present in Bach's portrait collection), including the English violinist John Abraham Fisher (1744–1806), who found his way into the collection in a golden-framed miniature (no artist's name is listed in the inventory), perhaps a gift from Fisher himself. If Ernst Ludwig Gerber's biographical entry on him in 1790 reflected general opinion, Fisher was notorious for playing (and dressing) in a highly mannered style, and though, as Gerber reported, he was favorably compared by some to Lolli, he was also criticized for playing that was too rough and wild; he was said, Gerber concluded, to have combined with his art "a great deal of charlatanry."[78] The flamboyant Fisher performed in Hamburg on March 7 and April 21 and again on November 5, 1785[79]—and Bach, very likely at one of these performances, made him welcome in his house and his circle of friends. Again Sophie Becker provides an eye-witness account, for when she and Elise von der Recke visited Bach on October 28, 1785, Fisher was there. As Bach sat

at the piano and improvised, Fisher sat beside him, entranced. Afterward, as Sophie Becker reported, he too treated the gathered company to an improvisation: "After Bach had first played a rondo on the clavichord, he sat down at the piano. Fischer [sic], an Englishman and violin virtuoso, accompanied, and Tossoli sang. . . . At the end Bach improvised, and Fischer, who had sat himself down at the piano, was, virtuosically, entranced. Afterward he too improvised at the request of the company."[80]

We catch a glimpse here of the spur-of-the-moment music making among friends that would lead to the very late arrangement for keyboard and violin of Bach's final fantasia in F-sharp minor, *C. P. E. Bachs Empfindungen.*

<p style="text-align:center">* * *</p>

Portrait drawings were framed and displayed in Bach's house, where visitors were given the opportunity to admire the many faces on his walls, and musician and artist friends were invited to make their own contributions—perhaps even given suggestions as to how their work should look beside the portraits already hanging there. Bach's drawings register his interest in young musicians as well as old ones, in young artists as well as established figures; collected together, they now bring to life the individuals who caught Bach's attention and whose images he treasured. Even while the aged Bach was concerned with securing his posthumous reputation as a composer worthy of the great figures of the past seen on his walls (not least his own father), he seems also to have been motivated by the desire that his portrait collection remain both a work in progress and a monument of the collector's art, a project to be ranked alongside the musical masterpieces of his last years. Bach's careful integration of commissioned pieces into his already comprehensive collection speaks not only to his meticulous curating of his holdings, but also to the old man's vigorous engagement with younger musicians and his recognition of their contributions. They were eager to be enshrined in the musical Hall of Fame that was his Hamburg house and especially flattered to be numbered among those belonging to his Temple of Friendship. More than just a panoply of images reflecting their owner's acquisitiveness, these "nearly speaking" likenesses are not silent but tell us, if we care to listen, of a Bach alive to his own time, attuned to his friends and to the art he loved.

Feeling: Objects of Sensibility and the "Portrait of Myself"

Behold (v.): To hold or keep in view, to watch; to regard or contemplate with the eyes; to look upon, look at (implying active voluntary exercise of the faculty of vision) . . . to receive the impression (of anything) through the eyes, to see.

Oxford English Dictionary

[Sterne] forsook family portraiture and made anatomical drawings of the human heart.

J. J. BODE, Preface to Laurence Sterne, *Yoricks empfindsame Reise*

From the framed painting hanging resplendent in an entry hall or staircase to the master engraving or drawing preserved from light in a portfolio and brought out for the private contemplation of a connoisseur, or from the simple frontispiece kept in or cut out of a book or journal to the wearable miniature, painted or drawn, perhaps treasured in a locket or tucked into a pocket, portraits can take many forms. In all except formal oil paintings, the subject's face is intimately in touch with, and easily touched by, its loving or admiring owner; these portraits are objects that can be handled—held as well as beheld, contemplated, regarded, kept hold of in the attention of the observer, carried in the heart. Portraits function as currency, tokens of exchange, in the economy of sensibility.

On March 4, 1788, at the palace of Count Esterházy, a portrait of the aged C. P. E. Bach was passed from hand to hand among an audience of Viennese aristocrats and court functionaries. The occasion was a concert organized by Baron van Swieten, with Wolfgang Amadeus Mozart conducting an orchestra eighty-six players strong, a choir of thirty, and a full complement of soloists in C. P. E. Bach's setting of Ramler's cantata *Die Auferstehung und Himmelfahrt Jesu*. The musicians had had the unusual benefit of two full rehearsals and, as the press reported, the performance was "all the more perfect" for that (there were also performances on February 26 and on March 7, the latter at the court theater). At the instigation of Count Esterházy, the composer's portrait was circulated among the audience members, where it could be touched, held, and admired. It was as if the composer himself had been asked to stand up among them to receive their praise. As the *Hamburgischer unpartheyischer Correspondent* reported a few days later, "At the performance on the fourth the count let the copperplate engraving

of the portrait of the Herr Kappellmeister Bach circulate around the room. The assembled princesses and countesses and the whole glittering nobility venerated the great composer, and there followed a great cheer, and a loud threefold affirmation of applause."[1]

When C. P. E. Bach read the account of this event he was thrilled and flattered, even taking the trouble to send a copy of the newspaper report to his friend J. G. I. Breitkopf in Leipzig, claiming that Breitkopf, as publisher, should take some credit for the work's success (despite its relatively poor sales): "I do not deny that the enclosed report gives me much pleasure," he wrote in the margin of his letter, "but the fact that I am sending it to you does not result from ridiculous egotism, but for your consolation as publisher of this cantata. The essential truth will always remain and will always find admirers."[2] Bach's portrait functions in this anecdote as an object that arouses wonder, focuses admiration, and catalyzes the emotional response of the gathered listeners. It is the quintessential object of sensibility, the physical thing that mediates between mind and body, thought and feeling. Thinking about the object of sensibility leads us into the center of the culture in which portraiture and music, character and feeling, operated in C. P. E. Bach's circle, casting a new light on how feeling is communicated and how meaning—especially in music without words—is conveyed.

OBJECTS OF SENSIBILITY

Somewhere in the midst of the fourth volume of Laurence Sterne's best-selling novel *Tristram Shandy* (1761), a curse rips into a conversation among friends:

The expletive blows a hole in the ongoing chatter, just as it explodes the narration itself, collapsing words into a single flat line at the limits of language, stretching across and down the page, simultaneously evoking both the shocked silence that follows and the long-lasting reverberations of the scream.[3] The interjection quickly prompts hilarious attempts at musical interpretation from the assembled company: "One or two who had very nice ears, and could distinguish the expression and mixture of the two tones as plainly as a third or a fifth, or any other chord in music—were the most puzzled and perplexed with it—the concord was good in itself—but then 'twas quite out of the key, and no way applicable to the subject started."[4]

Others, "who knew nothing of musical expression, . . . imagined . . . that the desperate monosyllable Z———ds was the exordium to an oration." But the mysterious utterance is none of these. Instead, it marks the moment when sensation, sentiment, sound—and a burn to the groin—collide, the expletive forced from

Phutatorius's mouth when a hot chestnut rolls off the table he and his friends are gathered around and drops directly through his open fly: an "aperture" or "hiatus" that was, we are told, "sufficiently wide to receive the chestnut;—and that chestnut, somehow or other, did fall perpendicularly and piping hot into it."[5]

As readers of Laurence Sterne's work will know, this famous moment is typical of his art and, by extension, of the art of sensibility. In the literature of sensibility, meaning is conjured through deflection and derailment, often via sudden tears in the fabric of the narration, at which point feeling (sensation) comes to the fore. Many writers on eighteenth-century aesthetics of sensibility have shown how contemporary theories of feeling were wrapped up with physiological exploration into the nervous system (of both humans and animals), and a notion of a new sensitive, *sensible* body, in which intricate webs of connection, fibers and fluids, mediated between sense and sensation and vice versa: when to be touched by something seemed intricately bound up with the physical reality of touching it.[6] Yet, as David Fairer has written, those pioneers of scientific discovery were not quite so confident about just what the link was between mind and matter, or exactly how emotion was communicated across the gaping void between idea and feeling.[7] More often than not, in the literature of sensibility the mediation between the physical and the mental, the real and the ideal, thought and emotion is accomplished by way of a physical object—usually one less painful than the hot chestnut. Samuel Johnson defined "object" in just this way: "*Object*: Something presented to the senses to raise any affection or emotion in the mind."[8] That sentimental moment at which affection or emotion is aroused or transmitted, when mind and matter swerve into one another, is effected by a thing, a physical presence—even if an unseen one such as music: "As sound in a bell, or a string, or other sounding body, is nothing but a trembling motion, and the air nothing but that motion propagated from the object, in the *sensorium* it is a sense of that motion under the form of sound."[9]

The figure of the hot chestnut tumbling into an accidentally open fly is re-configured later in *Tristram Shandy* in the minor mode as Corporal Trim lets his hat fall to the floor to convey the sad news of young Bobby's death:

> "Are we not here now;"—continued the corporal, "and are we not"—(dropping his hat plumb upon the ground—and pausing, before he pronounced the word)— "gone! in a moment?" The descent of the hat was as if a heavy lump of clay had been kneaded into the crown of it.—Nothing could have expressed the sentiment of mortality, of which it was the type and fore-runner, like it,—his hand seemed to vanish from under it,—it fell dead,—the corporal's eye fix'd upon it, as upon a corps,—and Susannah burst into a flood of tears.[10]

The object, the hat, and the simple gesture of its dropping, brings death itself into the kitchen, the physical thing mysteriously yet powerfully transmitting the truth of mortality in its full force, far beyond anything Trim's words, and his fine delivery of them, can do.

In thinking about *Empfindung* (feeling) and *Empfindsamkeit* (sensibility) we come to the central knot that ties together portrait culture and music in the C. P. E. Bach circle—that circle of avid readers of Laurence Sterne that included not only the man responsible for translating Sterne into German, the publisher and amateur cellist Johann Joachim Bode, but also Klopstock and Bach himself, both of them listed among the subscribers to the first volume of Bode's translation of *Tristram Shandy*. Portraits, as physical tokens, were the mediators of the currency of character—that central unit of the individual, the new feeling subject. In the Bach collection, the portrait—the nexus where the living and the dead, past and present, authority figure, family member, friend, meet—was embedded in a music culture that struggled with the magnetic interference between poles of emotion and mind, feeling and thinking. In the 1770s Bach professed to have lost interest in the character piece as genre—dismissing those small works of the 1750s as dead-end experiments, even as he continued to feed his obsession with collecting portraits of musicians and other great men. But he was not done with characterization. If the enigmatic "L'Aly Rupalich" might have hinted at self-portraiture (or at least family portraiture) in miniature, with its early title "La Bach," the Free Fantasia in F-sharp Minor, Wq. 67, composed in 1787, explicitly explored the idea of self-characterization on a far larger canvas, its title (in the version made for keyboard with violin accompaniment, Wq. 80) "CPE Bachs Empfindungen" transforming the fantasy into perhaps the ultimate character piece, whose physiognomy of shifting emotion proclaims itself as an immortalizing in tones of the sensibility of the composer himself. To hear the musical representation of his "feelings" was to see anew the composer's face, just as Burney had recorded in his diary.[11]

Perhaps no music has been more deeply implicated in the aesthetics of sensibility than the personal, highly rhetorical late keyboard works of C. P. E. Bach. This music, characterized as it is by a lively flirtation between high and low, plays out over an unstable terrain where the high-minded tussles with the entertaining, the elevated discourse is undermined by insinuating charm, the seemingly lighthearted troubled by intellectual ambition—a topography mapped out most explicitly in the genre-blurred confrontation of free fantasias and rondos in the extraordinary collections of keyboard music *für Kenner und Liebhaber* ("for Connoisseurs and Amateurs") published from 1779 to 1787.[12] The free fantasias, perhaps C. P. E. Bach's greatest claim to fame, have been taken (then and now) as the paradigmatic music of feeling—expressly designed to stir the hearts of the listeners, and even to expose the creative interior of the improviser/composer himself: idea translated into emotion through the touch of the clavichordist and the touching effects of the instrument's quivering strings.[13] But it was not only fantasias, whether published in the late keyboard collections or as exclusively private musical improvisations, that Bach's contemporaries understood as projecting "characterizations" of the composer himself. Much was revealed, too, in the extended rondos of the late 1770s and early 1780s published in the *Kenner und Liebhaber* collections. Normally characterized by light and catchy themes

and a range of characters that included insinuating charm, delicate tenderness, and rustic simplicity, the rondo's appeal was above all to a fashionable market eager for the natural, the unaffected, the easy—the source of a quick profit for even the most mediocre composer; indeed, as the *Magazin der Musik* declared in 1783, the rondo was so popular that it was ubiquitous in performances and publications "to the point of revulsion."[14] Yet from the second *Kenner und Liebhaber* collection (1781) on, every volume in the series would contain rondos, for a total of thirteen works: long studies in the genre, all but three of them composed in 1778 to 1782.[15] That C. P. E. Bach would stake so much of his late artistic efforts, indeed his legacy as keyboard giant, on the rondo, a genre with such a diluted pedigree, speaks to a grappling with high and low, naïveté and sophistication, and the many other dualities that make the *Kenner und Liebhaber* series—whose very title tries to span a kindred dichotomy—such a rich and often paradoxical collection in which the pathetic and the humorous converse, cavort, and glower at each other across guttering candles and the charged silence of fermatas. Just as Laurence Sterne claimed of his sometimes baffling *Tristram Shandy* that "'Tis a portrait . . . of myself," much of this music was heard by Bach's friends, colleagues, and acquaintances as an intensely personal expression of his own emotional character, varied and complex as that might be.

BETWEEN CHARACTERIZATION AND CARICATURE

Seemingly contradictory impulses of sincere characterization and ironic caricature, representation and self-representation, revelation and concealment seem to be endemic in C. P. E. Bach's keyboard music. While the light fare for ladies that he was also adept at producing might be superficial and pleasing, the ambitious late works are rife with bipolar turns, puffy sublimity followed by the most disarming sweetness. The way these turns and collisions, fragments and effusions, are understood by player and listener is hardly stable. If ever there was music that demonstrates the intentional fallacy in almost every bar (and especially in every barless fantasy), it is Bach's *Kenner und Liebhaber* collections. As we know from his conversations with Gerstenberg and Claudius, Bach himself was at pains to point out—despite having supplied a blow-by-blow program for the first movement of his "Sanguineus and Melancholicus" sonata in 1749—that fixing meaning was something of a fool's errand.[16] Just as so many rapturous critical readings from Bach's own circle lauded his humor (his "*Laune*"), his music invites his twenty-first-century epigones to listen for Bach's self-ironizing mode. Responses will be subjective, even variable, from one hearing to the next. Is Bach being serious? That is the ubiquitous question, and one that—as befits the great man's often enigmatic genius—can never truly be answered. Can we, and should we be able to, tell the difference between bathos and sincerity?[17]

Bach's position at the center of the historiography of musical *Empfindsamkeit* is not the invention of latter-day writers. The extensive critical writing on the

composer from those who knew and heard him is redolent with the effusions of sympathetic listening. The description published in 1776 by the twenty-four-year-old J. F. Reichardt (soon to be appointed Royal Prussian Kapellmeister at the Berlin court) of C. P. E. Bach and his music—and especially his clavichord playing—advertised an up-to-date aesthetic sensibility on the part of the aging composer and his young listener. About Bach Reichardt was effusive, opening the second volume of his *Briefe eines aufmerksamen Reisenden die Musik betreffend* (Reichardt's somewhat presumptuous reply to Charles Burney's travel diary *The Present State of Music*) with a lengthy description of his visit to the famous composer's house in Hamburg, and of their conversations and meetings with Bach's many friends—including Klopstock, Bode, the Americanist and director of the Handelsakademie Christoph Daniel Ebeling, and the mathematician, economist, and music lover Johann Georg Büsch (the cast of characters we have already met in the company of Sophie Becker and Elise von der Recke, as well as Christoph Heinrich Kniep).[18] Reichardt emphasized how Bach's music revealed his spirit in all its originality and creative genius, and he gave pride of place to a firsthand account of Bach's clavichord playing, a response to and confirmation of the description Burney published three years earlier. Like Burney, Reichardt relished the apotheosis of musical expression—of feeling—in Bach's playing. Burney had written of the "cry of sorrow and complaint, such as can only be effected upon the clavichord, and perhaps only by himself." Reichardt amplified Burney's report to praise the "Soul, expression, the ability to stir the feelings" that Bach had given to the sensitive keyboard, and to describe the uncanny songlike quality of the instrument under Bach's fingers, its ability to sustain long notes capable of every gradation of dynamic intensity.[19]

Given the general critical view that the rondo was a debased genre, an explanation was needed for Bach's late-career turn to the composition and publication, alongside free fantasias, of that genre of public music for the less refined listener and less skilled player, whose wild popularity helped confirm the degeneracy of public taste. The easy accusation, leveled by some contemporaries, was that his trafficking in rondos was just yet another example of Bach's cynical approach to the market, a way, as with his "Sonatas for Ladies" and other successful publications for beginners and amateurs, to increase his personal wealth at the expense of artistic integrity. Yet those closer to this ambitious and self-conscious composer presented more subtle critical readings. Not only are these pieces complicated exercises in generic mixture, refusing the simplistic opposition between rondo and fantasia by overtly bringing elements of each one into the other,[20] but the opportunity the rondo form provided for return, reframing, and revisiting lent itself well to notions that this music might be about characterization, the representation of the shifting phases of feeling that constitute identity.

If evidence were needed for the musical depth of Bach's rondos, Carl Friedrich Cramer's review of the fourth book *für Kenner und Liebhaber* (1783) in the *Magazin der Musik* pointed to the controversial genre-bending seriousness in the rondos of this collection, evidenced in that at least one of them, the second, in E major,

CLAVIER-SONATEN

UND

FREYE FANTASIEN

NEBST

EINIGEN RONDOS FÜRS FORTEPIANO

FÜR

KENNER UND LIEBHABER,

COMPONIRT

VON

CARL PHILIPP EMANUEL BACH.

VIERTE SAMMLUNG.

LEIPZIG,

IM VERLAGE DES AUTORS.

1783.

FIGURE 6.1. Title page to C. P. E. Bach, *Clavier-Sonaten und Freye Fantasien . . . für Kenner und Lieb-haber*, IV, Wq. 58 (1783). Division of Rare and Manuscript Collections, Cornell University Library.

composed in 1781, was designed for connoisseurs—"for the private pleasure," Cramer claimed, "of a few clavichord players."[21] As Cramer goes on to explain, where the clavichord was ideal for private, solitary music making, the usual vehicle for social music (*gesellschaftliche Musik*) was the less-nuanced fortepiano. Bach himself appeared to have subscribed to this opposition in the title pages of these collections, assigning rondos to the fortepiano, sonatas and fantasias to the clavichord (see fig. 6.1). It is striking, then, that Cramer, who knew Bach well and seems often to quote Bach's views on his music in his writings, queried the distinction on behalf of the lowly rondo, pointing to Bach's particularly complex stance toward the critical binaries of contemporary musicoliterary discourse and performance culture and to the cult of musical *Empfindsamkeit* in which he was so deeply implicated.

Cramer is at pains to stress the full play of feeling that characterizes the E major rondo, "the flow, the way the melodies are attached to one other, the light and shade distributed over them in multiple ways, the use of a certain musical chiaroscuro"—those qualities that make the piece so suitable to the "first of instruments," the clavichord.[22] "Finesse" and "touch" are the catchwords in Cramer's writing on this collection, and they are key to his understanding of the third rondo, in B-flat major (Wq. 58/5, the oldest piece in the collection, composed in 1779). Here I will linger on that rondo, which Cramer distinguished as "one of the most beautiful of all pieces in the *Kenner und Liebhaber* collections."[23] The B-flat major

EXAMPLE 6.1. C. P. E. Bach, Rondo in B-flat Major, Wq. 58/5, bars 1–20.

rondo, Cramer insists, must be played with the most refined and precise delicacy (*Delicatesse*): "The player must feel each tone, and with considerable subtlety slip from one to the next."[24] The discourse of sensibility comes to terms with the tension between high art and its less lofty sisters: this rondo, Cramer suggests, displays the naive wantonness of Thalia (the muse of comedy and the playmate of Venus, representing both laughter and love) gracefully dancing toward you.[25] Cramer celebrates the erotic resonance of the work: "Oh Father Bach! In your 68th year, such a mischievous piece, worthy of the bridegroom's brightest hour! One can well see, that Genius does not grow old."[26] And yet, where the music is vivid, language stumbles in the face of the delicacy of feeling: "Words would strive in vain to evoke the allure and the lightness of the sweet flirtation that is already fully present in the [opening] theme."[27] In its combination of playfulness and vigor, the piece seems to both reflect and characterize, for player and listener, the eternal youthfulness of the aged composer himself.

Cramer's effusive review of the B-flat major rondo brims with expressions taken from the glossary of *empfindsam* listening. He is seduced by the light eros of the theme: frolicking, full of jumps and octave displacements, its insouciance ranging across the five-octave compass of Bach's keyboards and nearly uncontainable by it. As befits a rondo, the theme is a four-square contra dance; pure simplicity—or naïveté, as Cramer puts it—in its scansion and harmonic silhouette each four-bar unit rounded off with a full cadence, as if even the marginally more complex diction of question and answer were too artificial (see music example 6.1). The flirtatious theme is marked by Cramer as feminine, erotic, enticing. The upward-straining paired slurs in the left hand (bars 1–2) are like sighs not of sorrow but of sensual expectation and excitement. The subsequent exhibition of right-hand

EXAMPLE 6.2. C. P. E. Bach, Rondo in B-flat Major, Wq. 58/5, bars 146–57.

fleetness is applauded by the thunderous octaves giving the emphatic virtuosic close weight that indeed sounds heavy-handed after the frippery of the first four-bar segment (bars 4–8). That this will make way for introspective pathos—or a version of it—is to be expected. It would be surprising if there were not such "surprising" shifts of emotional range. The "piano" interlude that follows (bars 8–12) is more *coquetterie*, followed by a fortissimo shift to G major at bar 21 that, though sudden, is hardly shocking by the standards of Bachian ellipsis. Likewise, the badinage between the theme and the wallflower interludes that follow is standard operating procedure, above the level of the run-of-the-mill rondo, but certainly not genius or even pretending to be. The whirring triplet passages that recur, trailing off into nothing or arriving at booming pedal points, are an off-the-shelf Bachian garment that allows Thalia some fancy raiment.

But all is not so straightforward. The rupture, or swerve, comes late, toward the end, after an exaggerated dominant pedal culminating in fortissimo octaves interleaved with whispered parallel thirds (bars 146–57, music example 6.2). After the usual itinerary to other keys, the opening theme has now returned in the tonic in the unaltered form in which Bach hatched her. But the expected reiteration is suddenly slowed down to what a connoisseur might consider a ridiculous pace: the leap up to the high B-flat is held for nearly two full bars, the D in the left hand for four full bars (music example 6.3). The unexampled quarter-note triplets that follow stage a metrically enforced adagio—rather than the sublime thing itself, to be executed at the noble discretion of the performer, according to her well-developed tastes and sensibilities. It looks odd on the page and sounds perhaps even odder. (Should one cleave to the beat, as Bach recommends in the "Sanguineus and Melancholicus" sonata, where this kind of juxtaposition is rampant, or follow a more "affective" musical instinct and play with the timing?)

An idiosyncratic decoration, an upside-down turn, draws extra attention to the shamelessly long high G in the midst of this passage (bars 169–72). This ornament, being the favorite Bachian marker of poignancy and pathos, implies that we are in the realm of bathos, at least an ironic posturing toward, and

EXAMPLE 6.3. C. P. E. Bach, Rondo in B-flat Major, Wq. 58/5, bars 163–86.

staging of, the affective crux of the piece. If this is an outpouring of emotion, it is being cast in a very rigid mold—braced by barlines, easily mass-produced and unabashedly indulging in cliché. When the theme begins again the left hand joins the concluding run, an emphatic increase in intensity and a sense of closure. But this is not the end. More pyrotechnics ensue toward the final tonic utterance of the rondo melody (see music example 6.4). At this point generic expectations are clear: the end is in sight. One awaits a flip parting gesture, a quizzical half-smile, an arch flick of the robes around the corner. As any Bach lover knows, his humorous rondos prefer to conclude (when they truly conclude at all) with the short chord then rest—the retiring sigh into silence (or abrupt goodnight).

But this one is different, veering off course into a free cadenza that, as it casts aside barlines, transforms the sweet game playing of the rondo into the baffling affective hesitation of the free fantasia. At one level this is a clever transition to the fantasias that follow in the volume: the barless terrain of the first of these, the fantasia in E-flat, Wq. 58/6, visible on the other side of the book's opening, the enigmatic, even daunting fermatas looming there in the thicket of heavily beamed runs and flourishes. What better way to move from rondo to free fantasia than with a postlude to the former that also acts as prelude to the latter? We arrive at this postlude through typically Bachian echoes between left hand and right. The final thirty-second-note flourish is the classic stuff of robust show and manly self-assertion, escaping the seductress—if we might riff on Cramer—for the self-pleasures of the virtuoso: the heat-seeking missile of the last run hitting its abrasive target of E-natural and holding it for a recalcitrant half note (music example 6.4); the dominant seventh chord in the left hand low—such a fistful of rebuke to the flirting coos of the left-hand's rondo material—and the high trill unencumbered and resolute before the last chord, held out in brazen self-affirmation rather than suddenly released as in the famous C minor fantasia that

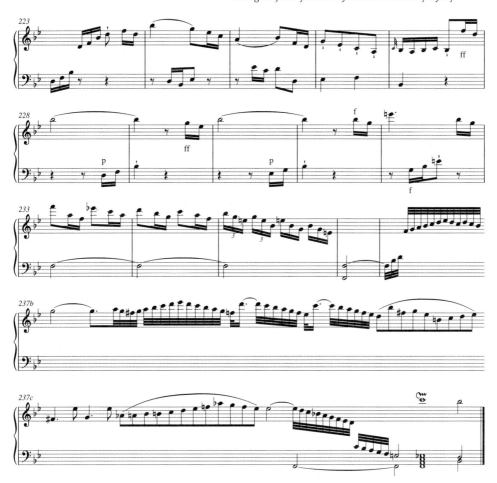

EXAMPLE 6.4. C. P. E. Bach, Rondo in B-flat Major, Wq. 58/5, bars 223–end.

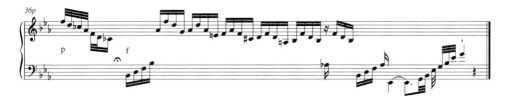

EXAMPLE 6.5. C. P. E. Bach, Fantasia in E-flat Major, Wq. 58/6, end [36p to end].

had concluded Bach's best-selling *Essay on the True Art of Playing the Keyboard* (1753) or, for that matter, that thirty-second-note tossing-off of the E-flat fantasia that follows across the page (music example 6.5).

THE SORROWING RONDO

By the late 1770s and early 1780s descriptions of Bach's performances for intimate groups of friends circled around an aesthetic of feeling and an intensely expressive

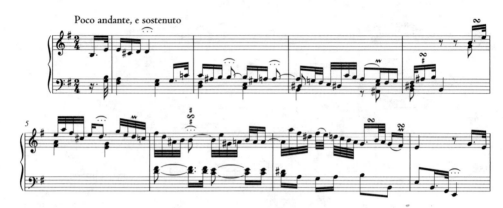

EXAMPLE 6.6. C. P. E. Bach, Rondo, *Abschied von meinem Silbermannschen Klaviere*, Wq. 66, bars 1–8.

performance style made possible by the instrument, the Silbermann clavichord (heightened by the seemingly magical way that Bach's highly intellectual approach to harmony and modulation could at the same time be deeply affecting). Indeed, the Silbermann clavichord, with its uncanny agency and its own voice (its cry of sorrow and complaint), seemed to be the ultimate sentimental object. Perfect for humorous intimacy and the ironic knowingness of a group of friends, it was at the same time the ideal medium for transmitting sincere feeling: touched and touching, its agency was confirmed in its ventriloquizing of Bach's sorrowful farewells, reanimating the composer's touch in the now famous E minor rondo, *Abschied von meinem Silbermannschen Clavier*, Wq. 66, that Bach sent with the clavichord on its sale in 1781 to his former student, Dietrich Ewald von Grotthus[28] (music example 6.6). With the forthright gesture of valediction implied by its title, this "characterized" rondo brings to mind the musical characterizations explored in the rondo forms of the earlier *petites pièces*, now expanded and exploited to maximum expressive effect.[29] As Grotthus later reported, Bach's difficulty in parting from the instrument was like a painful leave-taking from a beloved child, and the music written to express that sorrow was an explicit demonstration that a rondo could be the vehicle for melancholy: "This much is certain," Grotthus wrote,

> it seemed as if I had received all the joys of life from his hands. He however felt like a father who had given away his beloved daughter: he was pleased, as he himself put it, "to see it in good hands," yet as he sent it off, he was overcome by a wistfulness as if a father was parting from his daughter. The following rondo (*Rondeaux*) is evidence of this, which he sent to me in a letter with these words: "Here you receive my darling. In order that this sonata may fall only into your hands, I copied it out myself from my first draft. It stands as proof that it is possible also to compose a mournful rondo, and it cannot be played on any other clavichord than on the one you possess."[30]

The relationship between public and private is oddly, unexpectedly, inverted— the public, lighthearted rondo become the vehicle for personal, self-revealing

expression, one that explores and plays with the tension between the serious and the humorous, sincerity and the joke.

Conduits for the transfer of feeling, rondos could indeed also be tragic—communicating the truth of death like Corporal Trim's hat. Perhaps the most profound, though not publicly acknowledged, demonstration of this was the Rondo in A Minor, Wq. 56/5, composed in 1778 and published in the second book for *Kenner und Liebhaber* in 1780—and, like the *Abschied* rondo, a musical record of sorrow for a departed child. This one had no "characteristic" title. But when Elise von der Recke and Sophie Becker visited Bach in 1785, Bach himself spoke to them about the piece. Over the course of a week of regular visits to the Bach household, the two women were treated to many performances by Bach, usually including rondos. On October 22 they heard "the great Bach playing his compositions [*Kompositionen*] on the clavichord, and his improvisations [*Phantasien*] on the fortepiano," noting, like Cramer, the youthfulness of the elderly man's playing, his astonishing facility, the spiritedness in the fingers, and the way his ideas fluctuated from sublime joy to sweet melancholy.[31] On October 28 they heard Bach play a rondo on the clavichord, then turn to the piano to play with the violinist Abraham Fisher, after which, as we heard in the previous chapter, he improvised with Fisher beside him at the piano, perhaps with Fisher's delicate interjections in a manner that would eventually find its way to the written page in the form of the fantasia *CPE Bachs Empfindungen*. On November 2, before they sat down to dinner, Bach played at Sophie Becker's request "the Farewell rondo" that she knew thanks to her friendship with her fellow Courlander Grotthus (a reminder, perhaps, of the shared private delights of music, clavichords, and company on rainy evenings in Mitau).[32] But on October 26, when Bach again played for them, he played the A minor rondo from the second *Kenner und Liebhaber* set, Wq. 65/5, and Becker learned that it had developed out of the flood of emotion on hearing the tragic news from Rome in the autumn of 1778: "The Rondeau in A minor in his second collection arose from his first feelings about the death of his son, and that is why it is so expressive,"[33] she later wrote in her diary.

On its publication in the second *Kenner und Liebhaber* collection in 1781, the A minor rondo, with its hesitations, fragmentations, and obsessive repetitions, had immediately caught the attention of reviewers (music example 6.7). The reviewer for the *Hamburgischer unpartheyischer Correspondent* (likely Bach's friend Joachim Friedrich Leister) had heard Bach play this piece and remarked on its "lamenting and melancholic" (*klagend und melancolisch*) quality and emotional power: he "had rarely sensed [*empfunden*] the power of harmony to such a degree as then, when he first heard Bach play this rondo on the fortepiano."[34] With its taxing length and strange combination of insistent, static repetition, constant pauses and tenutos that, as Leister reported, "must be held for as long as the instrument will allow,"[35] and dramatic thirty-second-note outbursts, the rondo seems to traverse every emotion, shading from one to the next, uncontrolled and uncontrollable, having moved far beyond the straightforward juxtaposition of characters or even gently fluctuating emotion to explore feeling at its most turbulent. As Heinrich Poos has suggested, the quintessentially unstable aesthetics

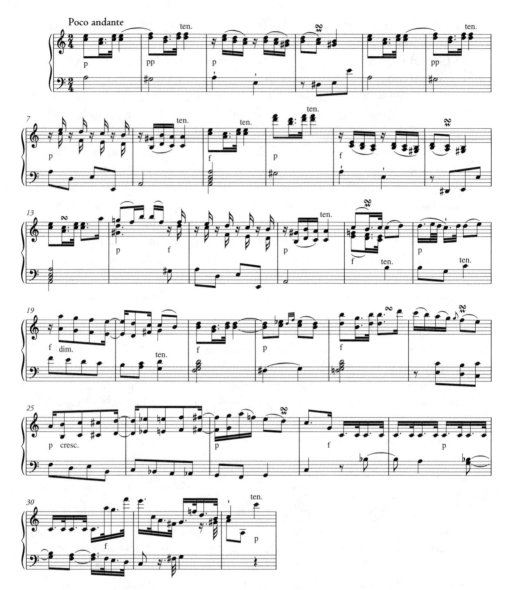

EXAMPLE 6.7. C. P. E. Bach, Rondo in A Minor, Wq. 56/5, bars 1–32.

of sensibility are presented here at their most profound, in a tragicomic work that swerves from the sublime to the grotesque.[36] Given the clue as to the A minor rondo's "meaning" (Gerstenberg would have been glad to have been given exactly this sort of information), it is not hard to hear it as a precursor and pendant to the *Abschied* rondo, an equally poignant, though more extended and effusive, exploration of grief and loss—the loss of not a beloved "daughter" but a son.

In this long, seemingly directionless rondo there are many junctures where Bach could—perhaps even should—stay his grieving and end the piece. The reprise at bar 138 already signals a rounding off (music example 6.8). Instead, a twelve-bar digression of bleak hesitation and reiteration opens up a "terrible

yawning abyss of emptiness"[37] in the crushing chromatic descent through the octave and more—one step per bar. The emotion surges to fortissimo, then abates to pianissimo and wells up again through alternating tenutos and fermatas—before a second reiteration of the theme in the tonic, analogous to its opening twofold presentation. (The theme itself is essentially a reiterated fragment, a motto, consisting of just two chords, the tonic and a diminished seventh.) This second presentation near the close of the piece is replete with the agonized diminished octave (bar 159, music example 6.8) first heard long ago in bar 14. We have borne the theme enough times: it is spent. But the mourner is not ready to let go, in a figurative or even tactile sense, of the object of his grief, the conjured image of his son and his own feeling for him. The outburst of thirty-second notes starting in bar 162 is poured into the theme's harmonic scheme, a kind of varied reprise gone mad with futile anger. After the full cadence to the fortissimo octave in bar 169, the theme is aired a final time above the pedal point, receding along with the fading sonority of the long-held bass. This clinging to dying tones also concludes the *Abschied* rondo and the final fantasia in the last *Kenner und Liebhaber* set, that in C major, Wq. 61/6. But unlike those pieces, the A minor rondo offers no fermata: the sound is not allowed to die out completely of its own accord: the parting is more sharply delineated, cut off. Why not a slower parting, a lingering good-bye, after this epic of despair? The hat falls.

The rondo lent itself not only to the simple and easy but also to the exploration of profound emotion. Bach cultivated the genre most intensively in the years immediately following his son's death (seven of the thirteen extended late rondos were composed in 1778 and 1779, another three in 1780 and 1781).[38] Although he continued to work steadily, Bach was almost incapacitated by grief: "Dearest compatriot," he wrote to Breitkopf on October 9, 1778 (his son had died on September 11), "I can barely put pen to paper since I am still stunned by the sad report of the death of my dear son in Rome. I know you have sympathy for me, and may God protect you from the same grief."[39] It was presumably for the bereaved father that Adam Friedrich Oeser made a lovely drawing of Johann Sebastian (dated 1778), showing him turned slightly away, absorbed in a book and already cast in shadow, the glorious background illumination falling on the open page to reveal the obelisk or monument that might honor his premature death (see fig. 6.2).[40]

Through Oeser, Bach sent a silhouette of his beloved son to Breitkopf as a small memento of the talented youth whom Breitkopf too had known and loved, a reminder of the currency and effectiveness of the "likeness" in keeping the memory of a lost loved one alive: "Most cherished compatriot, you will receive through Herr Professor Oeser a silhouette of my dear late son. I know you loved him too. The likeness is very good. A young artist here used this style to great advantage. Darker and better than those of Lavater. Inexpensive. Keep this portrait in memory of me."[41]

The silhouette could keep Bach's departed son present, but so too could Johann Sebastian's own works of art. Poignantly, just over a year later Bach asked

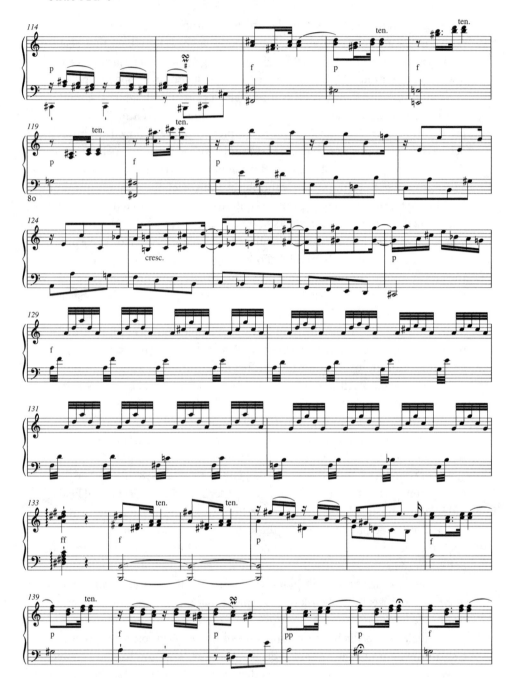

EXAMPLE 6.8. C. P. E. Bach, Rondo in A Minor, Wq. 56/5, bars 114–72.

Breitkopf to send him three copies of the engraving of his son's drawing of the penitent Mary Magdalene, after a painting by Pompeo Batoni in the royal gallery in Dresden, which had recently been produced by the professor of engraving at the Leipzig Kunstakademie, Johann Friedrich Bause (fig. 6.3). One copy Bach would keep for himself, the other two were to be given to friends. There is

EXAMPLE 6.8. (cont.)

FIGURE 6.2. Drawing of J. S. Bach the Younger by Adam Friedrich Oeser (1778). Klassik Stiftung, Weimar.

particular pride, and an intense sense of loss, in Bach's letters about his son—a son whose own art and artistic potential he had greatly admired. He was also an honored partner in Bach's creation of the portrait collection, the old father vicariously participating, through his hobby, in his son's professional life. The younger Bach had made drawings for the collection, and he had procured others on his travels: as Gerber reported, the collection would have been even richer in drawings had the younger Bach not become ill and died.[42] Perhaps, too, the

FIGURE 6.3. *Die heilige Magdalena* (1774). Drawing by J. S. Bach the Younger after Pompeo Batoni, engraved by Johann Friedrich Bause (1780). Philadelphia Museum of Art.

collection might have contained a portrait drawing of his father—one that at last presented a true likeness.

In a letter to the writer Julie Clodius, wife of the poet Christian August Clodius, on February 20, 1779, Bach emphasized his pride in his late son and his own role in fostering the youth's talent—correcting C. A. Clodius's poetic assumption that Johann Sebastian had been a starving artist: "My son was not poor, either here or abroad. I supported him honestly, and indeed with much pleasure. He was never in need of anything. He lived purely out of my purse and therefore was under no other protection, least of all that of a patron, but only under my purse when he travelled to Italy."[43] Bach does not hold back in describing his grief: "I will not say what this successful son cost me; otherwise my heart will bleed, not out of irritation but from fond memory of the pains he endured and from fatherly love. If we did not think as Christians, who know his current happiness, then I would still give everything away to have him back again."[44]

With her condolence letter Clodius had included an elegy for Johann Sebas-

tian that her husband had written for Bach to set to music. Bach was grateful, and indeed moved: "You have touched me most tenderly with your fine letter and the heartfelt sympathy for my grief. Kindly accept my sincere thanks and the best wishes for your well-being. . . . The . . . beautiful poem on my dear late son, in his honor, brought me to tears, tears that will not soon be overcome."[45]

Yet he could not consider composing music for the poem. Explaining himself, he presents an image of a composer who, even when working on the smallest scale, and at the best of times, is a man of sentiment, unusually susceptible to feeling: "I am accustomed, with all of my compositions, even with purely instrumental pieces, be they ever so small, to think perhaps with more sentiment [Empfindung] than many other composers. Accordingly, I consider myself much too soft-hearted to set this beautiful poem to music."[46]

THE SELF-PORTRAIT OF THE MAN OF FEELING

The empfindsam musical milieu is one of close-knit circles of friends and connoisseurs adept in sympathy and humor, who get the jokes and know the points of reference, who have been told about the private grief or who see the fun in a particular pun, who recall the in-the-moment gestures of Bach's performance (without which, as they are quick to tell their readers, you can't really understand the music): who knew the man and recognized the man in the music. Both the portraits and the music hover between private and public, veering now one way, now the other, their meanings and the feelings they communicate shifting accordingly, the composer himself seen in various lights and recognized to varying degrees in his works. It is a condition that hovers at the limits of language. As Cramer wrote, "It is difficult to say anything specific about instrumental pieces, when one doesn't want to continually break out in general exclamations, or in bare technical detail list the harmonic beauties, the modulations, their transitions, etc."[47] The richer, subjective account of impressions, of feelings aroused and emotions moved, in scenes the music conjures in the imagination, seems more telling: "To that end, in order in some way to give an account of my feelings, I generally think up some sort of character, that could correspond to an excellent piece of music."[48] What results is a mode of listening and a way of writing criticism that emphasize above all sympathy and emotional engagement, the arousal and echo of feeling, the recognition of character, of an individual held and beheld, of the emotional makeup of the composer himself.

Bach's rondos transcended fashion, as his Hamburg colleagues knew: "Despite his majesty and dignity," Cramer wrote, "he always kept up with the taste of his century; not obstinate, but also not betraying himself, like his English brother; . . . always moving ahead with the stream, not swimming on top of it, but rather diving deep below, fishing pearls out of the sea bottom; and not so much following as leading contemporary taste."[49] For Cramer, the Kenner und Liebhaber rondos were serious works of art: "One can rightly number them among the most beautiful

forms in music, and they have about them something of the excellence of the almighty God. We will surely hear Bachian rondos as part of the celestial string music of the New Jerusalem."[50] Much of what Cramer wrote about his friend's music seems to report on personal conversations with the composer, transmitting his responses to Bach's own performances, his recollection of discussions with literary, philosophical, critical, and aesthetically up-to-date mutual friends, and bringing to a hungry public Bach's private views on his work. On the vexed question of Bach's rondos and the critique of sensibility, Cramer appears to have put the question to him directly. Bach was reluctant, as ever, to give a straight answer: "He spoke himself of these pieces," Cramer wrote, "with the air of a rich man dealing with trifles: — 'When one gets old,' he recently quipped to me, 'one indulges in pranks.'"[51]

C. P. E. Bach's rondos balance precariously between sympathetic feeling and ironic laughter, adumbrating all that lies between. The music puts on trial private feeling and its public display, public sympathy and its private expression, questioning the complex dance of multiple kinds of stimulus, sensation, and response. Given the tendency to "think . . . with more sentiment than many other composers," to compose a song on a poem in memory of his son was beyond him. Not so, though, a rondo — the veiled language of instrumental music allowing freer indulgence in feeling. With a portrait or a rondo one can hold absent friends or a departed son, keeping them close for a moment, regarding them in the shifting light of memory and feeling. The A minor rondo was not merely a representation of grief or just a portrait of the emotional devastation of the bereaved father-composer. Like the F-sharp Minor Fantasia "CPE Bachs Empfindungen," it was an exploration of the emotion itself and the composer's own characteristic susceptibility to that emotion: not a triumph over sensibility but a surrender to it, to the feel and sound of it at the keyboard — that sensitive extension of the composer's soul.

Memorializing: Portraits and the Invention of Music History

Above all I wish that one of the most skillful engravers would take the trouble to make a catalog of such a collection, out of which one could see the beginning and progress of the art, by the various notable stages through which it has arisen to perfection. This collection would amount to a series of pages, in which each subsequent one would have something in its treatment that is absent from the previous one, and through which the art of engraving, or etching, has been brought a step further. Such a collection would represent the true history of the art in the clearest way.

J. G. SULZER, *Allgemeine Theorie*, s.v. "copperplate engraving"

In the entry "Portrait" in the *Allgemeine Theorie der schönen Künste* Johann Georg Sulzer explained that portraiture could at last take its place beside history painting at the top of the hierarchy of the visual arts. Moreover, as Sulzer continued, history painting was itself intricately bound to portraiture:

The portrait stands immediately beside history [painting], which itself derives a portion of its value from the portrait. For the expression, the most important aspect of a history painting, will be all the more natural and powerful, the more physiognomy actually taken from nature is to be found in the faces. A collection of very good portraits is, for the history painter, an important tool for the study of expression.[1]

An effective history painting depended on the convincing representation of the individual actors playing out the historical scenes on the canvas. History, in this sense, might be understood as a collage of individual faces, and an essential tool for every history painter was a collection of "very good portraits." But if, as Sulzer maintained, the portrait was central to the construction of history, it could also be understood to negate historical time by bringing the past vibrantly into the present. Everyone, writes Sulzer, wants to know what they looked like—those great men of the past whose works or deeds we have admired. What wouldn't we give, he asks, to see the face of an Alexander, a Socrates, a Cicero, and other such men. The portrait serves a vital function in fulfilling this desire.[2] But portraiture is not simply the cool presentation of visual information. The genre arouses

feeling, reaching out beyond the frame to shrink geographical distance or to bridge the gulf of death.[3]

Sigmund Apin's 1728 treatise had suggested that a fundamental impetus for building a portrait collection was to create a connection with the past: portraits might help us to remember friends and forebears, but they were also important tools for conceptualizing history. The owner of a collection of portraits of "learned men," he explained, will have acquired an extensive historical knowledge and be able to demonstrate it, fixing in his memory the works and deeds of great men by attaching them to their faces. The portrait collection, then, functioned as an aide-mémoire — one constructed by the collector, who must supply the annotations on life and works that are the crucial supplement to the pictures:

> As far as the history of literature is concerned, it is easy to observe that with so great a number of those who rendered outstanding services to scholarship, one proceeds only with great difficulty when one wants to familiarize oneself with the names of the subjects, how they wrote, when they lived, how they achieved fame, what sort of fate they had, what they wrote, where and when they died, etc. This, however, can be achieved all the more easily when one collects their portraits, writes next to them the most notable circumstances of their lives as well as their writings, and by leafing through the same, gains a lasting impression of it all.[4]

That Apin spoke not only to collectors in 1728, but also to those active across the eighteenth century — and to those interested in music — emerges clearly from the seventy-three-page supplement on portraits (with its own fifteen-page preface) appended by Ernst Ludwig Gerber as the conclusion of his two-volume *Historisch-biographisches Lexikon der Tonkünstler* (1790, 1792). Listing the thousands of individual portraits of musicians then available, and providing an authoritative and comprehensive list for the would-be collector, the appendix was an essential supplement to the biographies and anecdotes that constituted the main text of the *Lexikon* it was attached to. In the supplement's preface, Gerber cites Apin's book as the basic instruction manual for the new collector; the bibliography he helpfully supplies lists, among many other items, the most important published portrait-biography books also cited by Apin, including the volumes of Reusner, Boissard, Van Dyck, and Haid that were sources for numerous portraits in the C. P. E. Bach collection.

Gerber saw his portrait collecting as crucial to the project of conceiving music history, and he recognized the same in the C. P. E. Bach collection. To the readers of Cramer's *Magazin der Musik* in 1783 he had advocated collecting portraits as "a new kind of music history," history in physical form hung on the wall of the music room.[5] It was essentially an expanded collection of the biographical anecdotes attached to his own portrait collection that constituted the *Historisches-biographisches Lexikon*. "Ten years ago," he wrote in the preface to that work, "my

plans consisted of nothing more nor less than to prepare an alphabetical catalog for my collection of composer portraits, which, in order to aid my memory, would consist of a short biography alongside the principal works of [each of] the composers in this collection."[6] As Gerber made clear, that collection had taken Emanuel Bach's as its model and point of departure. So seminal was Bach's collection as a document of music historiography that Gerber, as we've seen, dared not omit from his *Lexikon* subjects collected by Bach, whether or not he could find any connection to music. In addition to his inclusion of Cisner, Dolet, and Fracastoro, as I mentioned in chapter 3, he explicitly admitted his debt to C. P. E. Bach in the entry on the Renaissance humanist Beatus Rhenanus (1485–1547), explaining that he "was included among the musical writers by Hr. Kapellmeister Bach, although I have not been able to find anything relevant to music in his writings"[7] and appealing to his readers for information on Rhenanus's service to music. Likewise, of Giovanni Pontano (1429–1503), who appears in none of the other major music-biographical works of the eighteenth century, Gerber wrote, "Among the writings he left I can find nothing that would merit him a place in this work [a lexicon of composers/musicians]. Yet I did not want to withhold him from my readers, since the late Kapellmeister Bach in Hamburg numbered him among his musical writers and included his portrait in his collection of musician portraits."[8] In the expanded second edition Gerber took a different tack, explaining that "Not on account of his services to music (since he had none) but rather since he was a lyrical poet, did Bach include his portrait in his collection."

The driving force that the portrait exerted on the historical-biographical project emerges even more clearly where Gerber's information mirrors the biographical annotation in Bach's catalog (itself often based on the portrait caption). The final item in Bach's catalog, before the listing of silhouettes, describes an engraving of the child prodigy Nicolaus Zygmuntowski: "Virtuoso on the cello, a child of 6¾ years."[9] The entry quotes verbatim the caption on the portrait itself, a portrait in which the genre's claims to sympathy and feeling come fully to the fore (fig. 7.1): no major figure for emulation or inspiration, the little boy in the picture elicits more pity than admiration. The disproportionately big head, the rosebud mouth, turned-up nose, and curling blond locks are those of a little boy—a boy in a fancy grown-up suit, a medal of honor pinned to the waistcoat, with shadows under his enormous eyes and the trace of a bruise above his right eyebrow. Such unnaturally large, bright eyes are less those of a proto-genius than of a victim of abuse. Gerber's entry on Zygmuntowski elaborates on Bach's text and that of the portrait itself only to let us know that the child was already dead: "a Virtuoso on the cello, born 1769, aroused awed admiration in all those who were witnesses to his talent; but died very young."[10] By the publication of the second edition Gerber was able to add that Zygmuntowski had died at age eleven, having been overworked, beaten, and starved by his father.[11]

For C. P. E. Bach and his fellow collectors of musician portraits, physiognomies, and musical works, lifetime achievements and posthumous fame were intimately connected. Each individual engraving spoke of these, and the accumulated collec-

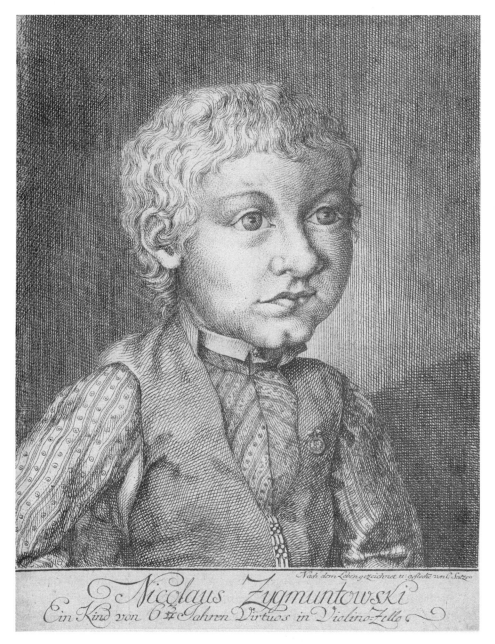

FIGURE 7.1. Nicolaus Zygmuntowski (c. 1771 to c. 1782/86). "Virtuoso on the cello; a child of 6¾ years." Engraving by Satze (Carl Salzer?). Staatsbibliothek zu Berlin—Preussischer Kulturbesitz und Mendelssohn-Archiv. Mus. P. Zygmuntowski, Nicolaus I, 1. Courtesy of the Berlin State Library (Staatsbibliothek zu Berlin).

tion as a whole revealed all the more. Acquiring, curating, and organizing such a collection required knowledge, means, and devotion; it also both demanded and, more important, fostered historical awareness. To show the portraits to friends and acquaintances required knowing at least the basic facts of the subjects' lives and musical accomplishments. Collections as a whole both demonstrated and augmented the collectors' knowledge of music history, while effectively constructing that history out of those individuals who had collectively created it. The C. P. E. Bach portrait collection, famous as it was and widely copied, spoke far beyond what it said (to the attentive) about C. P. E. Bach himself and the Bach legacy. Its assembled faces showed that music was an art with a history—even one with heroes.

PORTRAIT COLLECTING IN THE BACH CIRCLE

By 1790 and the publication of the long-awaited inventory of the Bach collection, making music-related portrait collections was a passionate pursuit among C. P. E. Bach's admirers. Bach's collection was the most important of all—the oldest, dating back over forty years as Gerber reported, and containing the largest number of rare items. But there were other collectors whom Gerber credited with significant expertise. Major von Wagener, stationed with the Knobelsdorff regiment at Stendal in the early 1780s, whom Gerber called an "honorable expert in music history," had, by the 1790s, amassed a collection of over five hundred framed portraits, without duplicates, twelve of them drawings and the rest engravings. Another collaborator and member of Gerber's network was a collector in Sondershausen, Kammerregistrator Spek, who, Gerber acknowledged, owned a large number of *Iconographie* volumes and an excellent collection of portraits of writers as well as a collection of virtuoso portraits. Closer to the Bach circle there was the collection of the devoted Bachist Hans Adolf Friedrich von Eschstruth, author of a piece about musical portrait collections in his *Musikalische Bibliothek* in 1784 that included a list of his own portrait holdings (for which he published a silhouette of C. P. E. Bach as the frontispiece).[12] Perhaps the most significant collection besides Bach's was, according to Gerber, that of "our wonderful writer of the history of music," J. N. Forkel in Göttingen: Gerber reported that, not counting his silhouettes or the many *doubletten* in different formats, Forkel's collection contained 347 portraits, including eight drawings and two plaster reliefs.[13]

Gerber mentioned two further collections he would have liked to know more about. First there was the collection of the famous teacher and scholar Giambattista Martini in Bologna. For Martini, Gerber reported, portraits had been critical as a means of "spurring himself on to emulation and courage during the laborious preparation of his *History [of Music]*."[14] Martini's collection differed from Bach's in that it focused largely on contemporary musicians (with only a small number of historical figures) and in being constituted largely of oil paintings (of mixed quality), almost all of them specially made for the collection (whether

new portraits, copies of other paintings, or even paintings made from prints).[15] Its almost exclusive focus on musicians, by contrast, throws into a striking light the very broad view of music culture C. P. E. Bach took in his collection and his decision to embed the portraits of practicing musicians among those of writers, poets, philosophers, patrons, and theologians.

When Charles Burney visited Martini in Bologna at the end of August 1770 he appears not to have been aware of the collection; he did, though, know of Martini's growing interest in portraits and his sense of their place in the historiography of music: as Martini told Burney, the fifth and final volume of his comprehensive *Storia della musica* was to have been a set of biographies of the most famous musicians, along with engraved portraits of each of them (on the model of the famous *Vite* of Georgio Vasari). Although some portraits were in Martini's possession earlier, his idea to create a uniform and comprehensive collection of musician portrait paintings in oils, which would be publicly exhibited (as opposed to prints and drawings, which would generally be kept in folders and portfolios) appears to have matured at the beginning of the 1770s, at about the same time that the rules for admission to the composition class at the Accademia Filarmonica were reformed. Eagerly pursuing students, colleagues, and contemporaries in letters sent across Europe during the ensuing years, Martini appears to have built almost the whole collection in little more than a decade.

Burney made no mention of a portrait collection in Martini's possession, as if it were not yet a project of significant interest. Yet by 1774 Johann Gottlieb Naumann wrote to Martini from Dresden that he knew Martini was building a collection of portraits of famous "maestri," ancient and modern.[16] C. P. E. Bach and his colleagues in Berlin must have known something of it even earlier, since Martini had written to Johann Friedrich Agricola in Berlin in July 1761 seeking portraits of German musicians, especially of Agricola himself and of Johann Joachim Quantz. In August 1773 Martini wrote in a letter that he had made a collection of "more than eighty portraits, many of them my students." In 1788 a visitor to Bologna described Martini's famous "studio" in the Convent of San Francesco as a great room, two stories high, which contained "more than four hundred portraits of professors and composers of music."[17]

Most of these portraits depicted Italian musicians, but Martini also solicited contributions from abroad, and it was considered a distinct honor to be included in his gallery: some of the finest portraits were the result of such requests, including the famous Gainsborough portrait of J. C. Bach; other non-Italians included Johann Joseph Fux, Handel, Rameau, Charles Burney, Frederick the Great, Martin Gerbert, Gluck, Haydn, Mozart, and the Danish dilettante Thomas Christian Walter in a beautiful painting by Angelo Crescimbeni. Crescimbeni was one of the most distinguished painters to have been closely associated with the collection, and he produced thirty paintings for it, among them the portrait of Padre Martini himself. Another way Martini acquired portraits for the collection, of the living but especially of the long dead, was by commissioning local Bolognese painters to create oil portraits from portrait prints. A reflection of Martini's intensified

ambitions for the collection in the early 1770s is the cluster of such "copies" dated 1773. The result, as with Gleim's *Freundschaftstempel* in Halberstadt, was an overall uniformity of format, style, and frame, the collection's focus being less on artistic quality than on representation: a collection like this drew attention to the portrait subjects, not the painters; the coherence and symmetry of its presentation offered an orderly progression through music history that amplified and expanded on the other materials of the library—its manuscripts and scores, treatises and books. Yet for all its impressive extent by Martini's death in 1784, the actual contents of the collection appear to have been little known north of the Alps, and its impact on German collectors of musician portraits was relatively small.

Closer to home, and back in Bach's immediate circle, the other extensive portrait collection Gerber wished to know more about was the collection in Dresden of J. S. Bach's student Christoph Transchel, who was C. P. E. Bach's agent in that city. Transchel's collection had, Gerber wrote, "been known to collectors [*Liebhaber*] for a long time, on account of the rarity and number of its pieces," although Gerber could tell his readers no more—catalogs were not available for either the Transchel or the Martini collection. More information about the Transchel collection was to circulate in 1796 in a guide to the writers, artists, book and art collectors of Dresden: "One can truly say that he cultivated himself to become one of our finest art critics. He owns a very impressive library of books on music, [which includes] the most important works by ancient and modern writers in English, French, Italian, German, Greek, and Dutch, and has in that an enormous advantage. Equally impressive is his collection of music of all kinds."[18] But even with only a general knowledge of the extent and content of the collection, Gerber was able to confidently explain that Transchel's extraordinarily refined musicianship was the result of the learning embodied in, and gleaned from, his library and portrait collection. Transchel, Gerber wrote, played "the Klavier with extraordinary delicacy and refinement, in the Bachian manner."[19] But the beauty of his performances was achieved in the combination of natural talent and perfect technique with the knowledge gleaned from books and portraits:

> As a man of science, he was not satisfied in his art with mechanical facility and perfection; rather, he sought through the study of the theory and history of music to ennoble his knowledge of art, his taste, and above all his musical conversations, and to cultivate himself to become one of the finest musical critics. This is also the reason that his repository of books on music is as richly filled with volumes as his cabinet of sheet music. Moreover, he also owns one of the most excellent and extensive collections of portraits of famous musicians and musical writers.[20]

To create and recreate music at the highest level it was necessary to have a profound knowledge *about* music. A collection of books and portraits together provided the essential tools.

Finally, there was the portrait collection that supplemented Gerber's own

library. Not including silhouettes, this contained (in 1792) 252 items framed under glass, including seven drawings and three "heads and reliefs" (*Köpfe und Abdrucke*) in plaster and wax. Of these 168 were "*Virtuosen Bildnisse*"—portraits of musicians—and the rest were writers on (or for) music.[21] In short, Gerber describes a lively community of collectors, for all of whom portrait collecting was intimately connected with building a library and with an ambitious notion of a new music history—the history of music conceptualized through the myriad contributions of its individual participants across a long historical sweep.

DYING AND BUYING: THE FATE OF THE BACH COLLECTION

The Bach collection, assembled with care, effort, and taste over four decades, was valuable: as Gerber pointed out, it was rich in rare treasures. But its worth lay less in the special individual items it contained than in what the portraits represented as a whole. It was this that elevated Bach to the realm of the connoisseur rather than the hobbyist collector, and it was precisely for this reason that selling the collection piecemeal was to be prevented if at all possible. As Gerber wrote, "As little as a *Liebhaber*, even one with the financial means that a high birth or fortune affords him, can flatter himself ever to see such a treasure trove of rarities surrounding him, so much greater would be the loss, should this collection be broken up."[22]

Although other materials from the estate were auctioned in 1789, Bach's wife and daughter appear to have tried to keep the portrait collection largely intact in the first years after his death, perhaps at the urging of collectors such as Gerber.[23] They allowed only a few items to be bought by particularly insistent or deserving collectors, including Gerber (who was eager to get items for his own collection, despite his protestations that the Bach collection should be kept together), as well as Forkel and Westphal, both of whom had been so involved in building the collection in the first place. In May 1797, however, after the death of Bach's widow, her daughter, Anna Carolina Philippina, initiated the project to sell off portraits, enlisting Westphal as her principal adviser. Westphal helped to price the prints in the collection, marking up a copy of the estate catalog, and the drawings and paintings were priced with the help of the portrait painter and engraver Friedrich Wilhelm Skerl; the Hamburg collector Major van Wagener also helped with the prints.[24] Copies of the price list were distributed in October.

Bach's daughter had been so closely involved in helping her father with his affairs in the last years of his life that she knew the portrait collection well, and she understood the challenges and implications of selling it. Acknowledging the scale and value of the collection, her letters to Westphal have a defensive tone: "Truly it is to be regretted, that this collection must be broken up; however, I think it is better for this to happen during my lifetime rather than its possibly being scattered and sold dirt cheap after my death—and I was very near to death this past winter."[25] She planned, she writes, to start to dismantle the collection:

"On the advice of various friends I have now decided to sell the musical portrait collection piecemeal, as soon as I can. . . . Partly I believe that it will be difficult to find a *Liebhaber* for the collection as a whole; partly I shall be requested to do so; and partly lack of space on moving apartments necessitated that I take this path."[26] Aware of the hobbyist nature of most portrait collecting—it was "largely a matter of *Liebhaberey*" (weil es hiebey hauptsächlich auf Liebhaberey ankömmt)[27]—she knew (perhaps paraphrasing Gerber) that a collection of this scale, with its rare drawings and expensive oil paintings, would be beyond the means of an average buyer. Certain that it would be easier to sell the prints than the drawings and paintings, she wrote to Westphal: "The paintings and drawings, of which there are a considerable number, and which are naturally much more expensive than the copperplate engravings, will not be sought after, since the enthusiasts [*Liebhaber*] are seldom so well off that they can spend very much on their hobby, and generally limit themselves in their collecting to engravings."[28]

But Gerber, Westphal, and Forkel were eager potential buyers, perhaps in competition with one another. To judge from annotations Westphal made in his copy of the Bach inventory of 1790, he himself acquired about 160 of the portraits listed there. Most of these were prints, but there is additional evidence, in fragmentary drafts for a catalog of his collection that survive in the Brussels Conservatory library, that Westphal also acquired some of the more expensive "treasures":[29] on one of the draft pages of his catalog under the heading "Aus der Bachischen befinden sich in meiner Sammlung" (From the Bach [collection] are to be found in mine) four items are listed:

— Bononcini (Giov.) from Modena in Italy in gr. 4. Drawn [aus Modena in Italien in gr. 4. Gezeichnet]
— Fisher, doctor of music painted in miniature [Doctor der Musik in miniatur gemahlt]
— Lotti (Mad. Santa Stella) in fol. Drawn; a very good likeness [?] Gezeichnet sehr [ähnlich?]
— Paradis (Maria Theresia) *NB not drawn*, but painted in pastels by Schubart [*NB nicht gezeichnet*, sondern in Pastell gemahlt von Schubart][30]

Westphal's list relies on Bach's wording to describe these items, although he offers a small correction on the drawing of Maria Theresia von Paradis, noting that it is not a drawing (Bach's inventory describes it as "drawn" [*Gezeichnet*]) but rather a painting in pastels.[31] In addition to these four drawings and paintings, Westphal also inventoried several busts and reliefs that had been in the Bach collection and that he had acquired either during the busy period of swapping and collecting portraits in 1787–88 or from Bach's widow. In the section in the catalog draft that lists items in plaster or wax, he starts as before by noting the important provenance of his prize items: "From the Bach [collection] are to be found in my collection: Telemann, G. F. In plaster by Gibbons [presumably the plaster relief mounted on slate that appears in Bach's inventory as "*Telemann, (George Phil.)* Kapellmeister and music director in Hamburg. On slate in plaster"];

. . . Noelly, in plaster. . . . , Noelly . . . in wax, by Sirl, . . . Bach, C. P. E. in plaster by Schubart."[32] In addition to the wax relief of Noelly that Westphal had been promised by Bach in 1788, he had also acquired the plaster one listed in the 1790 inventory. The plaster relief, or bust, of Bach himself was a gift from Anna Carolina Philippina Bach in June 1798, in gratitude for Westphal's help with the sale of the collection.[33]

Westphal continued to add to his holdings, such that in 1803 Johann Christian Friedrich Wundemann, the author of a guide to "culture, art and taste" in Mecklenburg, described the Westphal collection as one of the great wonders of the region:

> The number of theoretical-musical works climbs above six hundred volumes and the music collection consists of over three thousand works. In addition there is a sizable library of reference books and pertinent [*einschlagend*] works in aesthetics. And in order that this collection is lacking nothing, Herr Westphal has also brought together the portraits of the most famous old and new composers and virtuosi in copperplate engravings, among which there are to be found not only very rare pieces, but also some paintings, drawings, and plaster reliefs. This collection contains about four hundred pieces, of which half are in frames under glass, the rest preserved in portfolios.[34]

By 1819 Westphal's portrait collection, which he considered an integral part of his vast library of music and books on music, stood at 518 items.[35]

In June 1798 Anna Carolina Philippina Bach had let Westphal know that the engraving of the Weimar Kapellmeister and Bach admirer Ernst Wilhelm Wolf that Westphal had asked for had already for some time been in the possession of the physicist and acoustician Ernst Florens Friedrich Chladni (1756–1827). Chladni was a passionate collector of musician portraits, and unlike the average Liebhaber, he had the resources to buy some of the more expensive items in the Bach collection—which he had done, along with numerous prints, even before the more general offering of the collection for sale. Once the dispersal of the collection began, he had helped Anna Carolina Philippina by sending copies of the marked-up inventory to other collectors and potential buyers. As she wrote to Westphal, "Doctor Chladni, who has received many pieces from me, is very kindly making every effort on my behalf to direct enthusiasts [*Liebhaber*] to my collection. I have annotated various copies of the catalog with the prices in pencil, and these are making the rounds under his direction."[36]

Chladni's own collection was full of treasures. Although no catalog of it is extant, Gerber had either examined the Bach collection in person or at least received from Chladni a list of its contents by 1814, the time of publication of the fourth volume of the second edition of his *Lexikon*. There Gerber described numerous items belonging to Chladni, including Bach's drawings of the singer Folega (a caricature in pen and ink, by Tiepolo) and the violinist Pugnani (also a caricature, which Gerber thought was probably by Tiepolo); there were also three other Pugnani caricatures that had not come from the Bach collection.[37]

Chladni possessed an Italian drawing in red pencil of Palestrina, which Gerber thought was probably the one listed in the 1790 Bach inventory.[38] Other special items in Chladni's collection (these had not come from the Bach collection) included a caricature drawing of the famed castrato Bernacchi,[39] a medallion "in flesh-coloured wax" of Johann Gottlieb Naumann, a copy in copper of a memorial medal made in 1785 of Padre Martini, an original large-format drawing of Vallotti by Ignazio Colombo (after which the engraving had been made), and a copy in pastels (*en crayon*) of a painting of C. H. Graun (after an original by Fritsch owned by Zelter in Berlin, copied by Wolf in Berlin). Chladni himself was very proud of his collection. In his autobiography of 1824 he described how he had saved his "very numerous and well-ordered collection of portraits of musicians" (sehr zahlreiche und gehörig geordnete Sammlung von Tonkünstlerbildnisse) from fire even while losing almost all his other possessions (except his important mineralogical collection).[40] His early biographer Wilhelm Bernhardt wrote that "he owned a collection of portraits of musicians from the earliest times, assembled with a great deal of effort; for the connoisseur it certainly had real value, and he himself showed it off with particular satisfaction." Tellingly, Bernhard was able to describe how the collection was displayed—suggesting, in turn, how the Bach collection that had inspired it may also have been hung: "It was organized chronologically and concluded with his own portrait, drawn by Lavater's son." After Chladni died in 1827 the collection was broken up and sold off.[41]

Chladni's musical portraits may have been saved from the fire, but the collection of another Bach admirer was not so lucky. Nils Schiørring, the Danish composer and keyboard player who had studied and collaborated professionally with C. P. E. Bach, and of whom Bach had written to Breitkopf in 1787 that "Schiörring is one of my best friends, and thoroughly honest,"[42] amassed an enormous music library with portrait collection, which passed to the state and was largely destroyed by a fire at Christiansborg Castle in 1794. Gerber's 1814 supplement gave information on the special items that had been in Schiørring's holdings, including medallions in various media of Lully, Naumann, and a Danish keyboard player named Gierlöw; a drawing in pen and ink of Georg Rhau; a colored print of Padre Martini; and an oil painting of C. P. E. Bach by Kanzleyrath Bünnich, 1772, "a very good likeness" (sehr ähnlich gemalt). According to Gerber, the portrait showed C. P. E. Bach sitting with a sheet of music paper inscribed with the contrapuntal signature (fig. 3.4 above) that Reichardt had reproduced in his *Briefe*.[43] This surely is the portrait Heinrich Wilhelm von Gerstenberg had reported to Bach that Schiørring was thinking of having engraved in 1773, as I described in chapter 4. Bach, in his turn, possessed a lovely portrait drawing of Schiørring in black chalk, ink, and watercolor by Thomas Bruhn, dated 1770 (fig. 7.2)—a testament to Bach's professional and personal relationship with the Danish musician.

Dying and buying were oddly connected in this culture, death making long-sought-after prizes available to the living. Forkel, who bought some items from the Bach collection after Bach's death, also managed to acquire the collection of Christoph Transchel lock, stock, and barrel after Transchel's death in 1800,

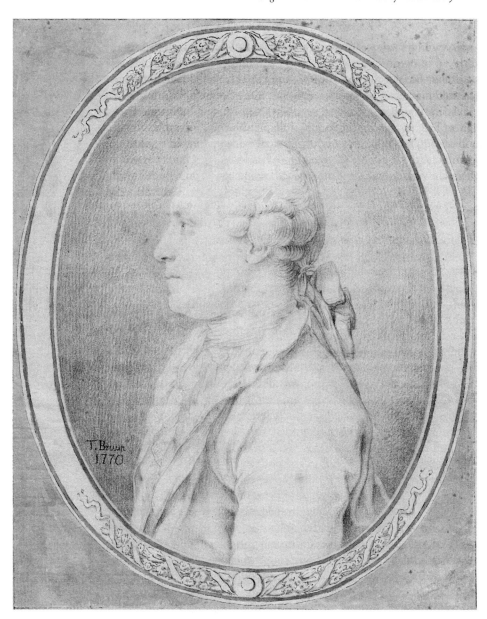

FIGURE 7.2. Nils Schiørring (1743–98). "Royal musician in Copenhagen." Drawing by Thomas Bruhn in black chalk, india ink, and watercolor on cream paper, 1770. 22.5 × 18 cm. Staatsbibliothek zu Berlin—Preussischer Kulturbesitz und Mendelssohn-Archiv Mus. P. Schiörring, Nils I, 1. Courtesy of the Berlin State Library (Staatsbibliothek zu Berlin).

in what must have been something of a coup. Gerber reported in the *Lexikon* of 1814 that Transchel's collection had been completely dispersed, but a letter from Forkel to Carl Friedrich Zelter in Berlin, dated July 11, 1802, and published in the *Allgemeine musikalische Zeitung* in 1874, suggests otherwise. Forkel had visited Dresden the year before and sought out the heirs of the recently deceased

Transchel (so little known by then that Forkel had to work hard to find them). He was glad he had made the effort, since he found there an "impressive estate of musical books and copperplate engravings" that he brought back with him, intact.[44] That this was a great amount of material is confirmed by the apology with which he began the letter to Zelter, explaining that it had taken him a year to write to thank him for his hospitality in Berlin on that same trip a year earlier because the many "musical treasures" he had brought back with him had kept him so busy for the whole year that he'd found no time for writing thank you letters.

By the time Forkel died in 1819—at which point his collection was broken up and sold off piecemeal—his library contained 2,328 books (on music as well as aesthetics, philosophy, literature, etc.), 1,661 items of printed or manuscript music, and a collection of over six hundred portraits, largely prints but including paintings and drawings (mostly copies by an artist called Loggan of other drawings and paintings), along with forty-six silhouettes.[45] In Schwerin, Westphal, in possession of the printed auction catalog of the Forkel estate, tried hard to ensure that the fate of Forkel's library would not befall his own. Desperate to keep his collection together, he hoped to find a single buyer for all its constituent parts. In June 1819 (the year of Forkel's death) he answered a request from a local Schwerin dignitary, who had inquired about buying Westphal's painting of Johann Joseph Fux, that he was very reluctant to part with items, especially the finer ones in the collection, because he was trying to sell his library as a whole—not just keeping the portraits together, but preserving their connection to the books and music:

> As I am now growing old, I had hoped to find a *Liebhaber* who would like to buy my whole musical library, which I have assembled over forty years with effort and expense, so that it stays together and does not meet the fate of the precious library of Doctor Forkel, which has now been broken up; for a *Liebhaber* who would take the whole thing I would sell cheaply. My musical library, to which the portraits also belong, contains over seven hundred theoretical works, and the practical works amount to over a thousand; one can easily imagine that among them are old and rare works, and as easily can one imagine that even without taking into account the cost, such collections would not be so easy to put together now as they once were.[46]

After Westphal died in 1825 his heirs did indeed try to sell the collection as a whole, eventually succeeding when most of his library went, in 1838, to François-Joseph Fétis in Brussels. After Fétis died it was divided between the Royal Library in Brussels and the library of the Brussels Conservatoire. It is not clear, however, whether the portraits went too, and they have since disappeared.[47]

In 1783 Gerber had voiced his concern in the *Magazin der Musik* that there were not enough portraits available for would-be collectors, and that more portraits of musicians needed to be engraved. By the early decades of the nineteenth century vast portrait collections had been assembled, with enormous investment of time and money, with portraits, especially engravings, proliferating. This dra-

matically changed the landscape for the musical portrait collector. But still, and with increasing clarity, the connoisseurs, enthusiasts, professional musicians, and music historians who made these collections—all of them closer or more distant members of the Bach circle—took their point of departure from the Bach collection: it was C. P. E. Bach who had begun the craze and who had set the standard for all who came after him.

TOWARD AN ARCHIVE OF MUSIC HISTORY

Anna Carolina Philippina Bach died in 1804, and what was left of her father's estate was sold at auction on March 4, 1805. It was at this sale that a number of the more expensive portraits, those she had feared would not be of interest to the print *Liebhaber*, were bought by the Berlin-based music collector and Bach devotee Georg Poelchau. These included the large drawings of the singers Paolo Bedeschi (fig. 7.3) and Caterina Mingotti, the latter a drawing by J. S. Bach the younger. Poelchau was careful to note the prized provenance of these items, in considerable detail, on the portraits themselves: on the reverse of the Mingotti portrait (fig. 5.2), for example, Poelchau noted "Catharina Mingotti (geb. in Neapel 1726 + 1807 in Neuburg am Donau), nach dem pastell Gemälde von Mengs in Dresden, von Joh. Sebast. Bach (Sohn von Emanuel B.) aus der Sammlung der Hamburger Bach. G. Poelchau, 1805"; on the Bedeschi portrait, "Paolo Bedeschi: genannt Paolino, Sopranist in der königl. Kapelle zu Berlin (geb. in Bologna 1727 + 1784) Gezeichnet von Franck. Aus der Bachschen Sammlung. G. Poelchau 1805." Continuing to eagerly acquire portraits from the Bach collection whenever they came on the market, Poelchau subsequently bought items from the Forkel estate and from other sales later in the 1820s and early 1830s—perhaps even from the Chladni and Westphal estates. One of these later additions was the drawing of Nils Schiørring; on the reverse of the sheet of paper Poelchau's inscription runs, "Nils Schiörring Königl. Musicus in Copenhagen. +1800. / Gezeichnet von Bruhn. Aus der Bachschen Sammlung. G. Poelchau 1832." By the time of his death in 1838, Poelchau had amassed a collection of more than a thousand musician portraits.[48] Its catalog, beautifully written in Poelchau's hand and minutely detailed, is extant in the Staatsbibliothek zu Berlin, the record of a careful and expert collector.[49]

In Vienna, Aloys Fuchs, who, like Poelchau, was an important buyer of Bach manuscripts and other musical sources, assembled a collection of a similar size.[50] A copy of Fuchs's catalog in the Staatsbibliothek in Berlin, "Alphabetischer Catalog über die in meiner Sammlung befindlichen Portraits von Tonkünstlern / Aloys Fuchs," dated 1837 but bearing annotations up to 1851 (Fuchs died in 1853), richly documents Fuchs's holdings and their accumulation.[51] His collection, like Poelchau's, contained many instances of multiple exemplars in different formats for the same sitter (*Doubletten*); his handwritten catalog seems to reflect the long hours the hobbyist spent at his collecting, rich with doodles (small profiles,

FIGURE 7.3. Paolo Bedeschi (1727–84?). "Royal Prussian singer." Drawing by J. H. C. Franke in black chalk with white highlights on blue-gray paper. 43 × 34 cm. Staatsbibliothek zu Berlin—Preussischer Kulturbesitz und Mendelssohn-Archiv Mus. P. Bedeschi, P III, 1. Courtesy of the Berlin State Library (Staatsbibliothek zu Berlin).

handwriting practice, words copied several times, "Fuchs" written several times on a page), and with late additions squeezed into the appropriate alphabetical category. A second, thinner document in the library, with the title "Alphabetischer Namens-Katalog über die Tonkünstler-Portrait-Sammlung des Alois Fuchs in Wien," gives an overview of the collection as it stood in 1841, divided into the familiar categories: (1) German composers; (2) Italian composers; (3) French composers; (4) English composers; (5) Singers; (6) Violinists; (7) Cellists; (8) Lu-

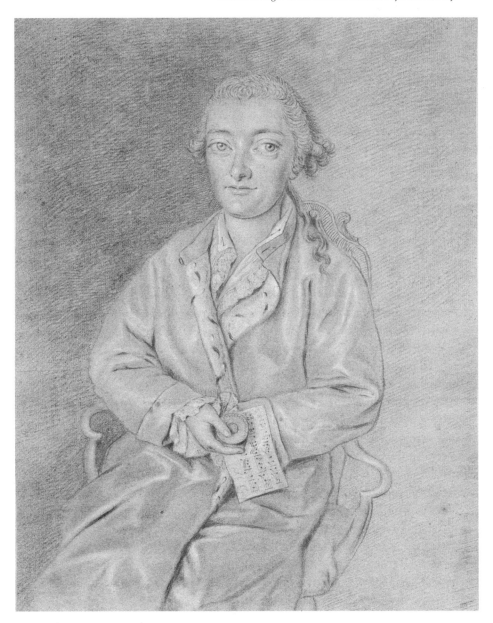

FIGURE 7.4. Carlo Concialini (1744–1812). "Royal Prussian soprano." Drawing by [Emanuel Gottlieb] Stranz in black chalk with white highlights on cream paper. Inscription in red ink by Aloys Fuchs. 41 × 32 cm. Staatsbibliothek zu Berlin—Preussischer Kulturbesitz und Mendelssohn-Archiv. Mus. P. Concialini, Carlo III, 1. Courtesy of the Berlin State Library (Staatsbibliothek zu Berlin).

tenists; (9) Organists; (10) Virtuosi on other instruments; (11) Musical writers; (12) Dilettantes; and (13) Busts and medals. A convenient annotation notes that there are 887 portraits plus 200 to 250 "*Varianten.*'" Fuchs also owned items that had originally been in the Bach collection, including the large drawing by Emmanuel Gottlieb Stranz of Carlo Concialini, the castrato soprano at the Berlin court (fig. 7.4)—now in the State Library in Berlin, with an annotation in red ink

on the card the drawing has been pasted onto, taken from the entry describing it in C. P. E. Bach's *Nachlassverzeichniss*: in the center of the lower margin the subject is identified as "Carlo Concialini / Sopranist im k[öniglichen] Preuß[ischen] Diensten." Below the lower right corner of the drawing the collector has written that it is an "original drawing by Stranz (Berlin)" (Original Handzeichnung von Stranz [Berlin]).[52]

Georg Poelchau began negotiations to sell his vast library of books, sheet music, and musical portraits to the Royal Library in Berlin (now the Staatsbibliothek) in the early 1820s. The library eventually bought the collection in 1841. As justification for the library's wholesale purchase of his holdings, Poelchau explained that his "Archive for the Art of Music" would be a crucial resource for the study of an art that remained largely uncollected, and hence impossible to study over its long history. The visual arts had long been collected "with painstaking care and limitless expenditure" (Mit ängstlicher Sorgfalt und gränzenlosem Aufwande), he wrote, with public galleries, museums, and private *cabinettes* doing the work of preserving great artworks and making them accessible, and with the art of engraving allowing for the dissemination of copies among "all classes of art lovers." Thanks to the resulting collecting mania, he wrote, there was a "wealth of collections in which the works of the artists are assembled, now according to this, now according to that perspective, such that one already complains of superfluity and wastefulness."[53] For the "monuments of music," however, the situation was entirely different: "Only rarely does one find public, even less often private, collections of this art. Artworks that sent our ancestors into raptures, and that garnered applause for several generations, have become the prey of mold or the welcome booty of the junk shop."[54] It was a question of creating an archive not only for the study of individual works but, more ambitiously, for the scientific study of the history of music: "Only [in this way] will it be possible . . . all at once at a single glance to survey the stepwise development and the manifold variations of the art, to experience centuries in a few hours, to compare periods with periods, people and artists with artists."[55] This, Poelchau explains, was the motivation behind his extraordinary collection. But it was not just a matter of assembling manuscripts, printed music, and theoretical works: from the start, portraits were an essential part of the project, "a gallery of the most instructive and sublime artists, . . . to preserve the memory of the men, who to the honor of the fatherland achieved sublime and beautiful things in this art."[56] And at the heart of his portrait collection, as he explained, was the collection of C. P. E. Bach, and after him that of Forkel: "Numerous journeys undertaken to this end and important acquisitions from the estates of C. P. E. Bach and Dr. Forkel contributed significantly to the expansion of my collection and allowed me to lay the foundations for a great whole that, in its current form, can compete with all the private and public collections known to me."[57]

It is thanks to the work of Poelchau especially, and the preservation of his collection in the Berlin State Library, but also thanks to Fuchs and the vast collection of portrait prints in Vienna, that it has been possible to reassemble much

of what Bach so assiduously built. Though broken up, much of his collection went to enthusiasts committed to and inspired by the careful, expert collecting pioneered by Bach himself.

THE PORTRAIT COLLECTION AS HISTORIOGRAPHICAL PROJECT

Let us return to the late eighteenth century, and to C. P. E. Bach the portrait collector and music historian. From the portrait collection as historiographical aid to history as annotated portrait collection was but a small step. Indeed, one of the most successful historiographical projects of the second half of the eighteenth century, James Granger's *Biographical History of England* (first edition 1769) constructed the multifaceted history of England (political, religious, intellectual, and social) solely based on portraits—"heads" whose character and deeds were recounted in accompanying anecdotes, as his full title explained: *A Biographical History of England, from Egbert the Great to the Revolution: Consisting of Characters Disposed in Different Classes, and Adapted to a Methodical Catalogue of Engraved British Heads: Intended as an Essay towards Reducing Our Biography to System, and a Help to the Knowledge of Portraits: Interspersed with a Variety of Anecdotes, and Memoirs of a Great Number of Persons, Not to Be Found in Any Other Biographical Work.* Granger's *History* was nothing more nor less than the catalog of a virtual portrait collection, arranged chronologically, with biographical notes and colorful anecdotes to elaborate on the more important scenes or events depicted in the portraits. This history in portraits and anecdotes would, Granger claimed, "serve as a visible representation of past events, become a kind of *speaking chronicle*." Vivid, "speaking," and avoiding long causal trajectory, the rage Granger started was so popular that the supplement to the eighth edition published in 1774 was printed on only one side of each page, giving owners the opportunity to paste in the prints listed in the text. As with the first edition, twenty special sets of the *History* were produced with interleaved blank pages—the reference book, as Marcia Pointon has described, transformed into a scrapbook.[58] Granger's project spawned a vast network of collectors, continually circulating prints along with information on their identity and iconography, and providing a constant supply of correction and amendment. Extra-illustrated—"Grangerized"—copies of the Biographical History could run to as many as twenty-seven volumes and contain thousands of engraved heads.[59]

Granger's *History* focused on individuals and the stories associated with them—stories that freely called into question the distinction between biographical fact and fictionalized anecdote and the relation of them both to history. Simultaneously, its volumes functioned as albums designed to frame and contain collections of portrait prints, codifying and justifying such collections in the name of history.[60] In a history like this, the collected faces were to be read not only as emblematic of the deeds of great men, but also as keys to character—as the individual elements in a mosaic of physiognomical history. Such a method of conceiving

history had a long pedigree, running back through Giorgio Vasari (1511–74), whose influential *Vite de'piu eccellenti pittori, scultori, ed architettori* (Lives of the most excellent Italian painters) (1550), still current in the eighteenth century, mapped biographical anecdote onto critical appreciation of works of art. Vasari's project could be traced all the way to Plutarch, and indeed the manifesto found at the opening of Plutarch's *Life of Alexander the Great* found new currency in the second half of the eighteenth century. Plutarch makes it explicit that true historical insight is to be gained from the knowledge of individual character, and he casts the historian as a collector of biographical anecdotes who has a knack for character analysis: "My design is not to write histories but lives. Besides, the most glorious exploits do not always furnish us with the clearest discoveries of virtue, or vice, in men; sometimes a matter of less moment, a singular expression or a jest, informs us better of their manners and inclinations, than the most famous sieges, the arrangements of the greatest armies, or the bloodiest battles."[61]

"History" here is collapsed with everyday "life" and further distilled to matters of personal, emotional interest—to character—revealed in a sudden facial expression, or a momentary display of wit. Plutarch goes on to compare his "biographical" historian to the portrait painter:

> Therefore, as painters when they draw a portrait are more exact in the lines and features of the face, from which we may best discover the peculiar disposition of the mind, than in the other parts of the body, so let me be allowed to exhibit a picture of the lives of these great men, by chiefly studying and describing those particulars which most distinctly characterise their temper and genius, leaving their more splendid actions and achievements to be treated of by others.[62]

Sir John Hawkins, author not only of the *General History of the Science and Practice of Music* (1776), but also of the first full-length biography of Samuel Johnson, alluded to this tradition when he wrote in the preface to his *General History* that "For the insertion of biographical memoirs and characters of eminent musicians, it is but just that their memories should live. . . . Besides which it may be observed, that in various instances the lives of the professors of arts are in some sort a history of the arts themselves."[63]

By the end of the eighteenth century, the new validity of the "portraitist" approach to historiography in a culture increasingly attuned to the personal and the sentimental—and to character and feeling as engines of political and social change—can be seen from the reevaluation of some of the fundamental works in the historiographical canon. Even Tacitus, the chronicler of Imperial Rome whose chronological narrative histories took an approach widely different from that of Plutarch, could come to be characterized as a brilliant "anatomist of the heart," whose annals "may be called an historical picture gallery" in which feeling has managed to animate "the dry regularity of the chronological order, and to spread a charm through the whole."[64] Hugh Blair's prescriptions for historical writing codified in his *Lectures on Rhetoric* (1783) praised the "great improvement"

in recent "Historical Composition" as due in large part to the important role biography played in historical understanding, with its concomitant increase in attention to the individual and to the personal: "Nay, it is from private life, from familiar, domestic and, seemingly trivial occurrences, that we often receive most light into the real character."[65]

In his account of later eighteenth-century British historiography, Mark Phillips has stressed the way "manners and customs," as revealed in anecdotes and biographies, were as important to historical understanding in this period as chronological narratives of events. Phillips cites George Thomson's 1797 *The Spirit of General History* as a classic articulation of this view:

> Latter [*sic*] historians have not contented themselves with a sterile narrative of facts, but, by investigating the causes of the facts they relate, and having discovered them in the passions and interests of men, they assign the true motives which influenced to action, those who make a figure in the history of nations . . . their histories are a pleasing and instructive picture of the human mind.[66]

Phillips discusses the new historiography of the eighteenth century in terms of an increased effort at intimacy, a shedding of that "aloof generality" that eighteenth-century readers associated with earlier forms of history in order to turn to a more personal mode formerly associated with biography and memoir. In the construction of a complex interplay of presence and distance, the resort to a panoply of literary and subliterary genres, including letters, anecdotes, and memoirs, was essential. To this list should be added the portrait: verbal or visual, portraiture was a critical tool in creating presence, presenting character, and evoking feeling.

MUSIC CRITICISM'S PORTRAITIVE MODE

Within the unifying frame of its carefully classified contents, the Bach collection was diverse and miscellaneous. Gold-framed oil paintings of ancestors faced off against tattered woodcuts of obscure heretics, grotesque caricatures of virtuosi against elegant engravings of poets, intimate drawings of musical friends against formal prints of distant theorists: portraits from Bacchus to La Bastardella, Erasmus to Ebeling, Luther to Lessing, Leonardo da Vinci to Abt Vogler. No wonder a superficial glance at the catalog might give the impression of an indiscriminate collector greedily acquiring whatever he could get his hands on. In this sense, the portrait collection was an anthology, presenting its kaleidoscopic vision of music culture in multiple media and dependent for its cohesion and coherence on an equally heterogeneous literary-critical apparatus. The portrait collector must be able to give an account of each item in his collection, knowing about artists and engravers, about physiognomy, and above all about the portrait subjects themselves.

C. P. E. Bach's library gives us a sense for how this was achieved.[67] There were the obvious sources of historical-biographical information: Walther's encyclopedic *Musicalisches Lexicon*;[68] Mattheson's *Grundlage einer Ehrenpforte*, with its biographies and autobiographies of musicians; Adlung's *Von der musikalischen Gelahrtheit*; Marpurg's *Historische-kritische Beiträge*,[69] begun in 1754. There was Mattheson's translation of Mainwaring's biography of Handel and Eschenberg's translation of Burney's account of Handel's life at the beginning of his description of the 1784 Westminster Abbey commemoration; Martin Geier's funeral sermon for Schütz (listed in the 1789 auction catalog as Schütz's "biography" or *Lebenslauf*), and Johann Thilo's funeral sermon for Werner Fabricius (likewise listed as Fabricius's *Lebenslauf*). C. P. E. Bach owned the first volume of Forkel's *Allgemeine Geschichte der Musik* (1788), and he must also have had at least the first volume of Burney's *General History of Music*, since his name is listed in its subscriber list.[70]

But there was also another set of music-critical publications in C. P. E. Bach's library that we should not overlook: the numerous pocket-sized collections of writings that Bach had also gathered, marketed as musical libraries or magazines or, in line with the most fashionable trends in literary publishing, as almanachs. These included the three-year run of the *Musikalische und Künstler Almanach*, 1782–84, edited (anonymously) by Carl Ludwig Junker; the four volumes of the *Musikalischer Almanach für Deutschland*, 1782–84 and 1789, edited by Forkel; Forkel's *Musikalische Bibliothek* (1778–79); and the *Musikalische Bibliothek* (1784–85) of H. A. Fr. von Eschstruth (which devoted many pages to reviewing the almanachs of Forkel and Junker), and even the satirical attack on Junker, *Sichtbare und unsichtbare Sonnen- und Mondfinsternisse, die sich zwar im musikalischen Handbuch oder Musikalmanach fürs Jahr 1782 befinden aber nicht angezeigt sind* (Visible and invisible solar and lunar eclipses, which are to be found in the musical handbook or almanach for 1782 but aren't announced there). Finally the end point of the stargazing, Marpurg's collection of biographical anecdotes, *Legende einiger Musikheiligen* (Legends of some music saints), published under the pseudonym Simon Metaphrastes, marketed as a "Supplement to the Almanachs and Pocketbooks of our age" (Ein Nachtrag zu den Almanachen und Taschenbüchern jetziger Zeit) in 1786.

In these booklets, musical knowledge was presented in a miscellany of formats, enhanced by satirical engravings or portrait silhouettes, laid out in lists or tables, elaborated by anecdotes and verbal portraits, focusing above all on character and (artistic) person(ality). Like the diverse objects in the portrait collection, the pocket-sized periodicals trod the line between private and public, between serious and humorous, between factual and fictitious. In these volumes, as in the portrait collection, the miscellaneous and accidental jockeyed for position against intention and design. Indeed, viewing these music-critical productions through the lens of the portrait collection allows us to see how far the music-critical discourse was focused on the individual, on character study and physiognomical listening, and how together portraiture and biography contributed to a new

sense of the artistic self, a new view of music as an art with a history, and a new consciousness of what such a history might mean.

As any almanach reader knew, the contents of the little volumes—miniature collections of musical knowledge, centered on sets of individual composers, performers, and writers—were entertaining and various, but the entertainment provided could be serious and informative.[71] Prefaced by calendars that laid out the progress of the year, with moon cycles, birthdates, and astrological prognostications, Junker's almanachs included, in addition to the artist characterizations, an essay on artistic pride (*Künstlerstolz*); a set of observations on the aesthetic qualities of individual instruments; witty anecdotes about musicians and artists (including one on the enormous annual incomes of London musicians such as J. C. Bach, along with their gigantic debts); a bassist baffling a pack of circling wolves in Hungary with his playing; a list outlining the items that are essential to a library of music (these include Pergolesi's *Stabat Mater*, the Allegri *Miserere*, the "last Mass" by Jomelli, Gluck's *Alceste* and *Iphigenia*, Graun's *Tod Jesu*, and works by Handel and Hasse); news of current and recently auctioned collections (including a collection of engravings extending to 4,096 lots, auctioned the year before); the news that Gluck's *Iphigenia* was performed in Paris 175 times the previous year; and a detailed announcement for Carl Friedrich Cramer's *Polyhymnia*— the publication project whose third part was devoted to a collection of songs by C. P. E. Bach (some reworkings of older works, some completely new, "all under Bach's supervision" [alles unter Bachs Aussicht] as the notice proclaimed). The miscellaneous contents of the 1784 volume included an extensive essay on appropriate dress for female performers ("Vom Kostum des Frauen spielens") as well as several verbal portraits or characterizations of living musicians whose portraits Bach had, or would acquire, including Madame Benda, Noelli, Paradis, Kellner, Koch, and Saint-Huberty.[72]

Stories about individual artists predominate, fact often superseded by feeling, biography by "characterization," in the same way that Junker had characterized twenty individual composers to construct a "History of Modern Music" in his earlier *Zwanzig Componisten* (1776). The almanachs, too, presented that music-historical project as one of portraiture: "Since our paintings shall be true imitations of nature (and hence we call them Portraits), we can do nothing if sometimes— a hunched, one-eyed, brooding face appears; for so it was exactly in the nature that we copied—and we indeed wanted simply to copy."[73]

To understand an individual artist's (or musician's) contribution in terms of portraiture could be taken quite literally: in a copy of the 1783 almanach held at the British Library (BL: Hirsch IV 1128), interleaved between the pages of Junker's text are single pages printed with an elaborately decorated oval picture frame. The frames remain tantalizingly empty, facing the verbal portraits of, say, W. F. Bach or Rose Cannabich, but ready to have the actual portrait pasted, or drawn, into them—to be Grangerized. Junker's almanachs, as the British Library volume suggests, offered to music *Liebhaber* their own miniature collection of portraits in words, easily supplemented with those visual likenesses that were available by

the insertion of extra pages. By the same token, the individual likenesses, taken together, constituted the history or—synonymous for Junker—"character" of the art of music, anchored by key individuals. If a history of German music were to be written by a foreigner (could Junker be thinking of Burney here?), all that would be needed would be a discussion of Gluck and C. P. E. Bach: "in order to correctly designate the national character of German music in his *History* or *Characteristic* of music, the foreigner would have to hold himself to no other men than these."[74] Indeed, C. P. E. Bach had the honor of a long, serious entry in the first of Junker's *Musikalischer Almanachs* (1782) (as also in the *Zwanzig Componisten*), which celebrated his brilliance and originality.

Forkel's three-volume *Musicalisch-kritische Bibliothek* (1777–78) and the four volumes of his *Musikalischer Almanach für Deutschland* took a less emotive, more scholarly approach to musical knowledge and music history.[75] Forkel pulled no punches in savaging Junker. Not for him the paraphernalia and hocus-pocus of the pocket calendar. No pictures, no astrological tables or meteorological information, no saints' days (or musicians' birthdays). Instead, Forkel provided annotated lists giving essential biographical information on the principal living writers on music in Germany (in first place, C. P. E. Bach, conveniently at the top of the alphabet), the principal living composers (first, C. P. E. Bach), singers (male and female), instrumentalists, categorized by instrument—Forkel's classifications matching Bach's categories for organizing his portrait collection. In addition there are lists of personnel in the best musical establishments at German courts; of music shops and distributors; of publishers and printers (and a short history of printing technology); and of the best instrument makers. Music culture is contained as a list of names, collected, collated, cataloged.

Forkel's volumes lack Junker's effusive characterizations, yet their focus still is on the individual musician, even if with a more deeply historical perspective. Even the category of musical inventions, usually the place for an account of culture at its most modern, offers the opportunity for a sketch of nothing less than the history of music, from Guido of Arezzo's "invention" of the earliest musical writing to Jean de Muris, credited with inventing the modern notation system; to Dunstan, in England, the inventor of counterpoint, and to Ludovico Viadana, cited as the man credited with inventing thorough bass and the sacred concerto. Next comes the invention of the sacred oratorio, followed, at the beginning of the seventeenth century, by the invention of recitative (credited to Cesti). Forkel's overview culminates in the invention of duodrama by Rousseau and Benda. A more conventional list of inventions follows, devoted to instruments and especially keyboard instruments, yet again giving the long historical view rather than simply a report on the latest thing: starting with the organ (and the ancient Greeks), moving to the clavichord, the harpsichord, and the rich variety of experiments and improvements made to keyboard instruments during Forkel's own century (including the Bogenflügel, Fantasie-Machine, pantalon, and harmonica).

In each successive issue of Forkel's almanach the lists are updated and expanded, keeping information current.[76] The scholarly and critical essays, extensive as some

are, are followed by shorter sections that reflect the demand of the genre that its contents be miscellaneous, even entertaining: extracts from letters containing news on music from countries around Europe, including one of particular interest for the would-be music historian, about Padre Martini's creation of a comprehensive music library with the financial support of his friend, the retired and wealthy castrato Farinelli, in order to write his groundbreaking *History of Music* (*Storia della musica*).[77] Other sections carry news of recent performances, of inventions, of deaths (obituaries offering useful biographical information), and anecdotes. In the 1783 and 1784 editions there are also extended biographies of, in 1783, notable composers of the eighteenth century (Sacchini, Trajetta, Pergolesi, Grétry) and, in 1784, great figures of the more distant past (the Reformation composer Johann Walter, Orlando Lasso, Ludwig Senfels, and Agostino Steffani).[78]

Of further interest to a collector like Bach, with his extensive holdings of portraits of "musical writers," were Forkel's reviews of recent music-critical publications in the 1784 almanach (updating his earlier *Musikalisch-kritische Bibliothek*, 1778–79), many of them books that Bach would, or already did, own or have access to, all of them by men whose portraits would be included in Bach's collection by the time of his death. The list of books reviewed includes Engel's *Über die musikalische Mahlerey*, 1780; Hiller, *Ueber die Musik und ihre Wirkungen*, 1781 (his translation of Michel Guy de Chabanon's *Observations sur la musique*, Paris 1779); J. J. Eschenburg's *Abhandlung über die Musik der Alten* (1781), a translation of the *Dissertation on the Music of the Ancients* that formed the first part of the first volume of Burney's *General History*; Johann Philipp Kirnberger's *Grundsätze des Generalbasses* (1781); and H. A. Fr. von Eschstruth's *Versuch in Sing-Compositionen mit vollstimmiger Begleitung des Claviers*. There can be no doubt that C. P. E. Bach read these volumes, if only for Forkel's groundbreaking writing on his own music, epitomized in his essay on the sonata in F minor from the third *Kenner und Liebhaber* volume in 1784.[79] In Forkel's almanachs, weighty, important scholarly writing enabled the music *Liebhaber* and connoisseur alike to gain commanding knowledge of music culture in contemporary breadth and historical depth.

INVENTING MUSIC HISTORY

Charles Burney's visit to Hamburg in 1772 came at the end of his second European tour (the first having been spent in France and Italy). Armed with conversations and anecdotes, books and manuscripts, he was now well equipped not only to write the second installment of his musical travels, but also to present himself to the public in a new guise, as a music historian.[80] The first volume of Burney's four-volume *General History of Music* appeared four years later, in 1776 (with C. P. E. Bach among its subscribers) (fig. 7.5a and 7.5b).[81] Burney's *History*, along with its main competitor, Sir John Hawkins's *History of the Science and Practice of Music* (whose five volumes were published in the same year as Burney's first), would eventually come to be seen as foundational texts for the emerging academic

discipline of music history.[82] Lengthy reviews of both *Histories* appeared soon after in Germany in Forkel's *Musikalisch-kritische Bibliothek*; Forkel would go on to produce not only the first full-length biographical study of J. S. Bach but also, perhaps inspired in some measure by Burney and Hawkins, his own never-completed *General History of Music* (*Allgemeine Geschichte der Musik*, 1788, 1801) (fig. 7.5c), whose first volume was reviewed—or perhaps more accurately, puffed—in turn, by C. P. E. Bach.[83] In all these historiographical endeavors portraiture was key, as was the verbal elaboration of the portrait, the biographical anecdote: indeed, the seminal late eighteenth-century music histories are characterized by the free admixture into chronological narration and accounts of musical style of verbal vignettes, biographical information, anecdotes, reminiscences, and character analyses. In a colorful hodgepodge of literary (and visual) genres, the diachronic flow is continually interrupted by a kind of synchronic bubble, the momentary welling up of a vibrant present. Suddenly the light shines too brightly, and for too long, on an individual, a personality, a character: history gives way to portrait. In Burney this is often achieved through the verbal portraiture he had honed in writing his musical tours, with physiognomical description enlivened by biographical anecdote; in Hawkins the historical narrative is further diverted by the inclusion of an actual picture, a visual anchor for the verbal description to follow.

That later readers were disturbed by this lurch into portraiture and anecdote is obvious from the scissor and fig leaf job done in the most widely available edition of Hawkins, the "reprint" that appeared in 1853.[84] Hawkins's account of Arabella Hunt can serve as an example: hardly a major figure in the history of English or European music, Mrs. Hunt nevertheless intrudes conspicuously into Hawkins's narrative: in the first edition, her portrait (a version of the Kneller/ Smith mezzotint in the Bach collection, fig. 7.6) fills most of a page and is followed by an account of her role at court, a lengthy footnote relating an encounter with Henry Purcell, some gobbets of hearsay about her voice, and then a coy reference to her marriage: Hunt "had the misfortune to be married to a man, who, for reasons that may be guessed at, ought to have continued for the whole of his life in a state of celibacy." (She had in fact married a cross-dressing woman, Amy Poulter, remaining married for six months until she petitioned for an annulment.)[85] To cap the disturbance, the historical narrative slips from prose into verse as the account finishes with four lines of poetry by Congreve from an ode to Hunt, originally printed under the engraving of her portrait. In the nineteenth-century edition, by contrast, this mixture of visual and verbal, and of multiple literary genres, has been cleaned up to result in a smoother, more consistent historiographical narrative less dependent on portraiture or anecdote. Here the portrait has been removed to a separate volume, the lines of poetry cut out, and the story of Hunt's marriage expurgated: the editors state merely that "She was unfortunate in her marriage."

Yet for the eighteenth-century historian, such interruptions were fundamental to the fabric of the text. Charles Burney celebrated the mixed and variable texture of his narration. Having suffered intolerable boredom, he claimed, as

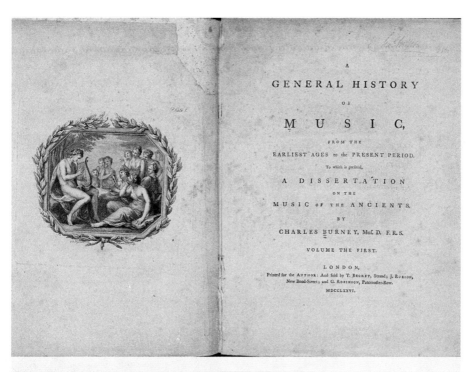

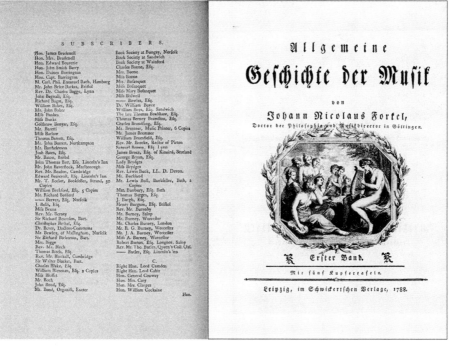

FIGURE 7.5. (A, top) Frontispiece and title page to Charles Burney, *A General History of Music from the Earliest Ages to the Present Period*, vol. 1 (1776). (B, bottom left) Part of the extensive list of subscribers to Burney's *General History*, with "M. Carl.Phil.Emanuel Bach, Hamburg" seventh in the left column. (C, bottom right) Title page to Johann Nikolaus Forkel, *Allgemeine Geschichte der Musik*, vol. 1 (1788), its vignette a version of Burney's frontispiece.

Mrs ARABELLA HUNT Dyed December 26th 1705.

Were there on Earth another Voice like thine, | The late afflicted World some hopes might have,
Another Hand, so Blest with skill Divine; | And Harmony recall thee from the Grave.

G. Kneller S.R. Imp. et Angl. Eques Aur Pinx. I. Smith fec. et ex. 1706.

FIGURE 7.6. Arabella Hunt (1662–1705). "Singer and lutenist in England." Mezzotint by John Smith after Sir Godfrey Kneller, 1706. Herzog August Bibliothek, Wolfenbüttel Portr. III 787.

he undertook the research for his *General History*, he was keen not to inflict the same punishment on his own readers;[86] hence the inclusion of multiple literary or subliterary genres, the frequent resort to biography, vignette, gossip, and fable: "I have blended together theory and practice, facts and explanations, incidents, causes, consequences, conjectures, and confessions of ignorance, just as the subject produced them . . . and though the mixing of biographical anecdotes, in order to engage attention, may by some be condemned, as below the dignity of science, yet I would rather be pronounced trivial than tiresome."[87]

Within a few years German writing on music, too, would be full of anecdote-driven sketches. More and more collections of anecdotes began to appear in journals, music-historical writing, and especially in the ubiquitous almanachs of the 1780s. Ranging from the potentially informative to the obviously spurious, from the moralistic to the prurient, anecdotes related the stories of familiar luminaries alongside obscure figures, of great virtuosi and amateur musicians, of misguided aristocrats and drunken students, of blind players, cases of mistaken identity, and trial by virtuosity. Here we learn of the hungry young J. S. Bach's encounter with two herring heads, tossed from a window to land at his feet during the long walk home from Hamburg to Lüneburg, and found to hold two Danish ducats in their mouths;[88] or we read about the trick played on Sulzer by Quantz and Agricola in Berlin, mercilessly proving their suspicion that Sulzer had never heard a fugue, despite his regular pronouncements against learned counterpoint;[89] and there are the endless castrato jokes, like the story of the French musician in Venice who, needing a shave but not reading Italian very well, goes to what he thinks is a barber's boutique and finds the razor blade ominously heading for the wrong end of his body.[90] Stories like these complicate the relation between fact and fiction: immediate, vivid, and immersed in the everyday, they foreground the individual historical actor and traffic in emotional reaction, inviting the reader to admire, to recognize, to pity or scorn, to learn and to laugh.

In the historiographical project anecdotes function in much the same way as the portraits to which they were so often attached. "Propelled by the force of the contingent," literary scholar Paul Fleming has written, "anecdotes create a space for something new to emerge, that is, something utterly unexpected that re-organizes any sense of predictable chronology."[91] "The anecdote opens up history," Fleming writes, "because only an anecdote (as opposed to large historical narratives) allows history (as the unforeseeable) to truly happen."[92] Despite Burney's claim that his biographical anecdotes and character sketches were mere antidotes to boredom, portraits and verbal vignettes do far more work for the late eighteenth-century historical imagination than simply entertain. Anecdotes and portraits perturb the historical narrative, complicating historical distance with a sense of presence and troubling the relation between character, event, and—in the history of music—artistic production. In the same way, the portrait—slippery, unreliable, and vivid—interrupts chronological narrative with individual life, personal achievement, the complex and unpredictable vortex of

character. As Granger's *History of England* demonstrated, not only could portrait and anecdote open up history, they could create it.

* * *

As Elizabeth Fay has written, the fad for portraiture and biography in the eighteenth century indexed changing perceptions of the individual and of the self: "The corresponding frenzy around portraiture [and biography] created a descending synechdochal chain that led from art (as painting) to the portrait (as the most popular genre) to the head or likeness (the substance of the portrait), to a representative individual (who embodies the cultural moment), to the viewing self (the desiring subject)."[93] The painted or drawn portrait, or the engraving, became, she has written, the "increasingly dominant representational genre thanks to its ability to characterize the modern epoch's changing perception of relations between the self and the world."[94] Portraiture peaked in popularity in the 1780s, the decade of C. P. E. Bach's most intense activity as a collector, and the same decade that saw the "flourishing of other forms focusing on the individual's sensate and imaginative experience: the cult of sensibility, Grangerism, biography, brief lives in imitation of Plutarch, and autobiographical forms (memoirs, journals, apologias)."[95] Portraiture went hand in hand with anecdotal and historical biographical narrative; enthusiasts of biography and history could buy volumes of engraved portraits with accompanying biographical sketches, but they offered only a pale substitute for touring a personal collection in the company of the collector who could tell the stories, scholarly and personal, associated with the faces on show.

When Bach looked at his charming portrait of the young Danish composer and government official Thomas Christian Walter hanging on his wall in a golden frame (see fig. 5.9b), he could have admired the quality of the drawing and perhaps recalled details of Walter's musical abilities that have not come down in the historical record. As we have seen, Walter was in Hamburg in 1775, and he may have met Bach and played for him. More than likely the sensitivity and delicacy conveyed by the fragile lines and subtle coloring brought to mind the man's sad story: against the wishes of his parents he married the singer Carolina Fredrika Halle, but they separated and later divorced when she fell in love with the violinist Christian Friedrich Müller and fled to Sweden with him. Shortly afterward Walter left Denmark for Tranquebar, an outpost of the Danish East India Company in South India, where he remained until his death. Gerber's laconic entry on Walter (about whom he knew so little that he was unable to supply his first names or initials) retails the story, with the introductory remark that Walter "is better known outside his own country for the story of his marriage with the famous singer Madame Müller than through his services to music."[96]

If Bach wanted to pursue the web of personal connections further, he had only to turn to the portrait he owned of Walter's wife—which also hung on his wall, in a black frame—an engraving made in 1777 just a year into her marriage, and perhaps sent to him by Walter along with his own portrait drawing (fig. 7.7):

FIGURE 7.7. Carolina Fredrika Müller (1755–1826). "Singer and actress in Stockholm." Engraving by Terkel Kleve after Cornelius Høyer, 1777. Staatsbibliothek zu Berlin—Preussischer Kulturbesitz und Mendelssohn-Archiv. Mus. P. Walter, Karoline II, 1. Courtesy of the Berlin State Library (Staatsbibliothek zu Berlin).

the young singer-actress is dressed in full costume as if on the stage, presented in profile so that her elaborately dressed hair, swept high up off her forehead, entwined with pearls, plume, and train, appears at its finest; on the stone ledge that supports the frame encircling her head appear the emblems of her profession: a smoking torch and mask symbolize the theater; a lyre, a scrap of sheet

music, and the bells of two oboes refer to the art of music. The caption presents the young Carolina Fredrika Walter at the height of her art, confounding the viewer with her ability to dissemble and to move: "Has she any need of art? The illusion is complete: / she is that which she plays, she cries, she smiles. / Her beauty even lends charm back to nature, / and it is the heart that applauds it" (Qu'a t'elle besoin d'art? L'illusion est sure: / elle est ce qu'elle joue, elle pleure, elle rit. / Sa beauté prête encore un charme à la nature / et c'est le coeur qui l'applaudit). By 1781 she was in Sweden, principal singer at the royal opera in Stockholm, and married to Müller. That Bach knew her story and wrote his entry on her portrait sometime in the 1780s is clear: she appears there not as she is named in the picture, but as "Müller (Mrs. Car. Fried., separated from Walther [sic], divorced), singer and actress in Stockholm."[97] Would Bach have wondered, in the style of Lavater, at the strong profile presented in her portrait? Was there a determination in the chin, a sharpness in the nose, an air of self-satisfaction about the eye and forehead? And in her deserted husband's face, could one not help but notice the gentle curves of cheek and chin, the soft fullness of the lips, the gentle gaze of the blue eyes? Or did the prettiness and dreaminess there merely disguise a hard interior, a character flawed by petulance and a tendency to cruelty (the grounds on which Carolina sued for divorce, and the reason Walter was sent away from Denmark to India)?

These two portraits give a sense of the personal and idiosyncratic nature of Bach's collection, but their wider resonance, their presence in Gerber, and their ability to generate anecdotes, indicate the interconnectedness of Bach's portraits with history—in which even acquaintances whose long-lasting contributions to music were slight could play a role. The bulk of Bach's portraits indeed constituted a pantheon of musical geniuses and great cultural figures from the present and the past who would be remembered in the future, among them the trio cited by Sulzer in his article on portraits: Alexander, Socrates, and Cicero. Projecting a powerful sense of history, the collection mapped out visibly a personal lineage that included members of Bach's family as well as the composers who had influenced his father and therefore, at least indirectly, himself. One such was the German organist-composer Johann Adam Reincken, organist at the Katharinenkirche in Hamburg—one of the churches for which C. P. E. Bach would later pro-vide concerted music—whose importance for J. S. Bach had been recounted in a famous anecdote in the biography written by C. P. E. Bach and J. F. Agricola in the form of the obituary of 1754. The obituary reports how, as a schoolboy in Lüneburg J. S. Bach had journeyed to Hamburg to hear Reincken play the organ and how in 1720, at nearly one hundred years of age, Reincken was present at J. S. Bach's famous organ recital at the Katharinenkirche. The climactic moment in the anecdote (and the one remembered long thereafter) comes with the aged Reincken's apodictic statement to Bach: "I thought that this art was dead, but I see that in you it still lives" (Ich dachte, diese Kunst wäre gestorben, ich sehe aber, daß sie in Ihnen noch lebet).[98] The engraving of Reincken hanging in a black frame in Emanuel's gallery presented the dashing, lavishly bewigged composer at

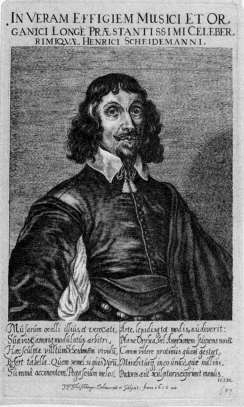

FIGURE 7.8. (A, left) Johann Adam Reincken (1623–1722). "Organist in Hamburg." Engraving. Berlin Staatsbibliothek, Musikabteilung. (B, right) Heinrich Scheidemann (c. 1595–1663). "Organist in Hamburg." Engraving by Johann Friedrich Fleischberger, 1652. Staatsbibliothek zu Berlin—Preussischer Kulturbesitz und Mendelssohn-Archiv Mus. P. Reincken, Joh. Adam II, 1, and Mus. P. Scheidemann, Heinr., I, 1. Courtesy of the Berlin State Library (Staatsbibliothek zu Berlin).

his most opulent and haughty (fig. 7.8a), looking directly out at those who came after and gesturing to the laudatory inscription on the plaque below. Here was a figure whose achievement and posthumous reputation reflected directly on the accomplishments of the Bach family. But the unbroken line of history extended much further back through the collection, running from portrait to portrait, to Reincken's Hamburg predecessor and father-in-law Heinrich Scheidemann (fig. 7.8b), to Scheidemann's fellow Sweelinck student Samuel Scheidt (fig. 1.2), to the "father of German music" Heinrich Schütz (fig. 7.9), to Athanasius Kircher (fig. 7.10a) and Girolamo Frescobaldi (fig. 7.10b, whom C. P. E. Bach cited as an influence on his father), back to the sixteenth century with Orlando di Lasso (fig. 7.10c), Luther and Melancthon, on back to Lorenzo di Medici and still further to antiquity with Pythagoras and Ptolemy, Homer and Horace, the biblical King David, and even to the mythical foundations of music with Mercury (fig. 7.11) and Apollo (fig. 7.12).

FIGURE 7.9. Heinrich Schütz (1585–1672). *"Ober-Kapellmeister* at the Saxon court." Engraving by Christian Romstet after Christoph Spetner. Staatsbibliothek zu Berlin—Preussischer Kulturbesitz und Mendelssohn-Archiv Mus. P. Schütz, Heinr. I, 3. Courtesy of the Berlin State Library (Staatsbibliothek zu Berlin).

FIGURE 7.10. (A, top left) Athanasius Kircher (1601–80). "Writer." Engraving by Cornelis Bloemaert, 1664. Herzog August Bibliothek, Wolfenbüttel, Portr. II 2835. I. (B, top right) Girolamo Frescobaldi (1583–1643). "Organist in Rome." Engraving by Claude Mellan. (C, bottom left) Orlando di Lasso (1532–92). "Bavarian *Kapellmeister*." Engraving by Johann Sadeler. Staatsbibliothek zu Berlin—Preussischer Kulturbesitz und Mendelssohn-Archiv Mus. P. Frescobaldi, I, 2, and Mus. P. Lasso, Orlando di, I, 2. Courtesy of the Berlin State Library (Staatsbibliothek zu Berlin).

FIGURE 7.11. Mercury. "Inventor of the lyre." Engraving by Jean le Blond (?) after Annibale Carraci (1757). London, British Museum, Department of Prints and Drawings © The Trustees of the British Museum.

As he filled out his collection in his last months, Bach himself was profoundly aware that he himself was becoming a part of history. He had carefully culled his catalog by burning youthful works, and he constantly reworked and updated many others as he scrupulously assembled his legacy, thanks in part to Westphal. Ten years earlier, in 1778, as he worked with Breitkopf on the publication of the *Heilig* (Wq. 217) he was already looking to his posthumous reputation, explicit that this was a work by which he would be remembered: "It is to be my swan song of this type and thereby serve the purpose that I may not be forgotten too soon after my death." He urged that the print be particularly lavish, on high-quality paper for which he would pay extra.[99] The self-fashioning of the artist, carefully placed in the context of the great family legacy yet clearly claiming a status that would resound into the future, was on full display in the charity concert the aged Bach put on in 1786 for the Armeninstitut in Hamburg, in which he programmed his own works alongside monuments by his father and by Handel that were already classics. This was the famous program that included the Credo from J. S. Bach's B Minor Mass (a piece unknown to Emanuel Bach's Hamburg audience), for which Emanuel composed a special twenty-eight-bar introduction for strings,[100] followed by the two already paradigmatic works of Handel's, the aria "I know That My Redeemer Liveth" and the Hallelujah chorus from *Messiah*.

FIGURE 7.12. Apollo. "Inventor of music." Engraving by Johann Martin Preisler, 1732. Statens Museum fur Kunst, Copenhagen.

In the second half of the concert, the Bach son, Carl Philipp Emanuel, staked his own claim to monumental achievement and posthumous fame with a symphony, his *Magnificat* of 1749, and his famous *Heilig*.[101]

We might also glance at his arrangement of the *Fuga canonica* from his father's *Musical Offering* (BWV 1079), originally composed almost half a century earlier, in a copy set for violin and obbligato keyboard made in Hamburg, perhaps reflecting performance of this music in that very room on whose walls hung the portraits of the participants at its first performance.[102] There were the protagonists—his father in oil and King Frederick II in a pastel drawing—as well as the brilliant witnesses to the event: Emanuel's brother Wilhelm Friedemann in a pastel drawing by Joseph Eichler; Johann Joachim Quantz (in both an engraving by J. F. Schleuen and a drawing by J. H. C. Franke, fig. 7.13); Franz Benda (in a mezzotint by F. M. Schuster, fig. 7.14b), as well as in an engraving, much praised by contemporary collectors, showing him in old age (fig. 7.14a), and his brother Georg (in an engraving by C. G. Geyser); Johann Gottlieb Graun (in oil) and his brother Carl Heinrich Graun (in a mezzotint by Valentin Daniel Preisler). And then a plaster relief, or bust, of Emanuel himself. As the *Fuga canonica* filled Bach's music room of a Hamburg evening, the candlelight would have flickered over not only the faces of the living but also those of the dead: the compelling immediacy of the fiery, complex music would have been pregnant with a past made vivid in the present. But the story of the encounter that engendered that music was to become, thanks to Bach's own efforts, one of the central music-historical anecdotes of the age: first described in economical terms by C. P. E. Bach in the obituary of 1754, it is already imbued there with the aura of legend.[103] It would subsequently be expanded as historical anecdote by Forkel, whose account offers a fully staged scenario of making a hasty entry into the royal music room and groveling before the musical monarch, as a prelude to subsequent contrapuntal heroics before the assembled virtuosi.[104]

* * *

If the collection of portraits in the library—or music room—was a historical-biographical discourse in visual form, then what C. P. E. Bach had accumulated was indeed a biographical history of music. We are reminded again of Sulzer's account of the portrait's magical ability to create the impression, for a moment, that the dead are living among us. If the portrait ruptures the boundary of the past, suddenly reconfiguring a vivid present, the effect of portraiture in the eighteenth-century historical narrative is to momentarily expand chronological succession, to destabilize the sense of historical authority and authorial distance, and to demand a sudden sympathy from the reader: character and feeling supersede event, and it is these qualities that are seen to give rise to the artistic work. Further, the *collection* of portraits in the gallery not only emphasizes a succession of individuals, it creates juxtapositions, encounters, unexpected meetings, according to the accident (or design) of the hanging.

FIGURE 7.13. Johann Joachim Quantz (1697–1773). "Prussian flautist and composer." Drawing by [Johann Heinrich Christian?] Franke in black chalk and india ink with white highlights and wash. 24.5 × 18.5 cm. Staatsbibliothek zu Berlin—Preussischer Kulturbesitz und Mendelssohn-Archiv Mus. P. Quantz, J. J. I, 1. Courtesy of the Berlin State Library (Staatsbibliothek zu Berlin).

FIGURE 7.14. (A, left) Franz Benda, "very old." Engraving by Friedrich Wilhelm Skerl, 1783; SBB. (B, right) Franz Benda as a young man. Mezzotint by Johann Matthias Schuster after Joachim Martin Falbe, 1756. Staatsbibliothek zu Berlin—Preussischer Kulturbesitz und Mendelssohn-Archiv. Mus. P. Benda, Franz I, 1, and Mus. P. Benda Franz, II, 1. Courtesy of the Berlin State Library (Staatsbibliothek zu Berlin).

For C. P. E. Bach, as for his contemporaries, portraits were not merely decorative, nor were they simply the culmination of a lifelong obsession. Crucially for a musician deeply concerned with his own musical lineage and his posthumous reputation, Bach's portrait collection presented a brilliant account, remarkably deep and broad, of the historical context for his own achievements, delineating the past and present of musical culture as he knew it. To read late eighteenth-century music-historiographical projects as compilations of annotations attached to the faces of the past—indeed, as collections of portraits, verbal and visual—is to recognize a conception of history that is less organic, continuous, and event-driven than it is weighted toward the individual actor, the effects of collision and contingency, the subtleties of character, and the concomitant demands of emotional sympathy. Such a history admits not only irony, but also the humor that breeds in anecdotes. Richard Kramer has written of "a certain irony in what might be called [C. P. E.] Bach's long view of history and his place in it."[105] To this might be added a certain sensibility, or sensitivity, that characterizes the imaginative engagement with the past.

FIGURE 7.15. C. P. E. Bach. Engraving by Andreas Stöttrup after a drawing by Stöttrup, c. 1780. 21.5 × 16.5 cm. Staatsbibliothek zu Berlin—Preussischer Kulturbesitz und Mendelssohn-ArchivMus. P. Bach, K. Ph. E. I, 6. Courtesy of the Berlin State Library (Staatsbibliothek zu Berlin).

But perhaps the greater irony has to do with the ephemerality of all this. C. P. E. Bach collected his own works and was an assiduous librarian of his father's. The portrait collection was one of his own most important works. Like many collectors who futilely hope their collections will remain intact, he was keen that his not be dispersed. But the portraits were sold off, disappearing into the collections of some of those who had helped Bach, though some chunks remained intact so that they could once again be brought to light some two hundred years later. Bach's portrait collection and his musical oeuvre shared a kindred fate. His music's standing went into steep critical decline in the nineteenth century, and it is only relatively recently that a complete critical edition of his works has been undertaken. The music's critical demise had everything to do with the same issues that attracted portrait collectors and music historians in the eighteenth century and worried historians in the nineteenth: the absorption in the moment, interest in character often slipping over the edge into caricature, detours akin to anecdote and joke, a lack of obvious cohesion and purpose. Reclaiming the aesthetic of portrait and anecdote in the Bach circle, of faces and the stories told about them, can lure us back into the late eighteenth-century music room, crowded with images of friends and forebears. In this imagined space, we renew and reenact the musical past.

C. P. E. Bach's portrait hangs in this temple of fame and friendship (fig. 7.15). He looks on with, what? Sympathy, amusement, patience? A sense of self-satisfaction? Is he trying to suppress outward signs of the afflictions of old age or is he warming up an anecdote? Is he wondering why his son went to Rome and he never did? Perhaps he is thinking about what to play after dinner or, more likely, what he'll want to hear from you at the clavichord.

You decide.

Acknowledgments

If I were an artist (and my friends at the University of Chicago Press had even more patience and paper than they have already devoted to this project) these thanks would take the form of the faces of those who have accompanied my adventures with C. P. E. Bach's portrait collection. Instead, a set of more mundane but no less grateful annotations will have to do. First, I thank Martina Rebmann, director of the Musikabteilung of the Staatsbibliothek zu Berlin, and Kerstin Wiese, director of the Bach Museum, Leipzig. Three other women, Stefanie Hennecke, Dörte Ohlhorst, and Heike Walk, the best of scholars and even better friends, provided inspiration during repeated research stays in Berlin and, memorably, brought their inimitable style to the formal opening, at the Bach Museum, Leipzig, of the exhibition of the C. P. E. Bach portrait collection. I will always be indebted, too, to the colleague and mentor who was there when I first began asking questions about late eighteenth-century collectors and their music libraries: Lenore Coral of the Cornell University Music Library.

Numerous institutions have generously supported my work on this book. My explorations into art history began with a New Directions Fellowship from the Andrew W. Mellon Foundation, and I conducted much of the archival research on a fellowship from the Alexander von Humboldt Foundation, sponsored by Hermann Danuser. These two fellowships allowed me to work extensively not only in Berlin, but in museums and libraries across Europe. In California I was able to finish writing the book during a luxurious year as a Marta Sutton Weeks Fellow at the Stanford Humanities Center, buoyed by the inspiring company of my fellow Fellows of 2019–20.

This project was also made possible by the Packard Humanities Institute, which helped to collect together all the portraits once I had identified them, publishing them as a pair of appendix volumes to the *Carl Philipp Emanuel Bach: Complete Works* edition. I am grateful to everyone at the edition, including Peter Wollny and Christoph Wolff, but particularly to Paul Corneilson for his editorial expertise during the preparation of the catalog, and for his support since, including generously allowing me to take the musical examples for this book directly from the *Complete Works* edition.

Images for this book have come from far and wide, and librarians, archivists, and collectors in the United States and Europe have responded to my queries and fulfilled my requests with generous interest and expertise. These include, in addition to the Staatsbibliothek zu Berlin, the Herzog August Bibliothek Wolfenbüttel; the Gesellschaft der Musikfreunde in Vienna; the Bildarchiv of the Oesterreichische national Bibliothek; the Kupferstichkabinett, Staatliche Museen zu Berlin; the Bibliothèque royale de Belgique, Cabinet des estampes, Brussels, and the library of the Koningelijk Conservatorium, Brussels; the Klassikstiftung, Weimar; the Department of Prints and Drawings at the British Museum; the National Portrait Gallery, London; the library of the Royal College of Music, London; the New York Public Library; and the Houghton Library, Isham Memorial Library, and Loeb Music Library at Harvard University. Dr. Reimar Lacher at the Gleimhaus, Halberstadt, has been a generous interlocutor, and I am especially grateful to him and to Dr. Ute Pott for their welcome to the Gleimhaus, and to Dr. Peter Prange for hosting me at the Department of Prints and Drawings, Kunsthaus, Hamburg. My research stays in Brussels were transformed by the hospitality of the scholar and organist Jean Ferrard, and in London by the outstanding culinary and conversational gifts of my friends at the Kennington Center for Eighteenth-Century Studies.

Versions of many parts of this book have seen the light in various forms and in various ways. Colleagues who have invited me to give talks based on this material, or who have heard me speak about it, and have given me the best criticism and most inspiring advice include Tom Beghin, Karol Berger, Anna Maria Busse Berger, Francesca Brittan, Scott Burnham, James Q. Davies, Emily Dolan, Roger Grant, Tom Grey, Daniel Grimley, Richard Leppert, Laurenz Lütteken, Nicholas Mathew, Anthony Newcomb, and Elaine Sisman. At Cornell, Leslie Adelson, Malcolm Bilson, Paul Fleming, Peter Uwe Hohendal, Roger Moseley, Neil Saccamano, James Webster, and Neal Zaslaw have been constant sources of expertise and intellectual acuity. I am indebted to the colleagues, including Annegret Fauser, David Schulenberg, and Thomas Donohue, who accepted early versions of various chapters for publication in the *Journal of the American Musicological Society* (parts of chapters 2 and 7), *Early Music* (chapter 3), *Die Tonkunst* (chapter 5), and *The Maestro's Direction: Essays in Honor of Christopher Hogwood* (chapter 4).

All translations from the German started off as mine (unless otherwise noted) but were expertly corrected and deftly transformed by Dietmar Friesenegger. Elizabeth Lyon helped with translations from Latin, Astrid van Oyen with Dutch.

At Cornell, Mat Langlois and Evan Cortens were brilliant research assistants early on; Damien Mahiet a *source d'inspiration*; and without Ji Young Kim I would never have pulled everything together. I am lucky indeed to have the expert assistance of the musicologist Bill Cowdery in the Cornell music library.

I have been truly fortunate to have been able to work with the production team at the University of Chicago Press, and my sincerest thanks go to Alice Bennett, Caterina MacLean, Dylan Montanari, Jill Shimabukuro, and especially Marta Tonegutti for her gracious and effective encouragement.

The ideas and efforts of these colleagues echo in these pages, none with more resonance than those of Richard Kramer, whose remarkable writing on C. P. E. Bach has been a model, and whose thoughtful, generous way of reading (and hearing) both Emanuel Bach and me has made this book better in all sorts of ways, visible and invisible.

No words can say what I owe to David Yearsley, for his creativity, brilliance, musicality, and love—and for sharing with me our magnificent daughters Elizabeth and Cecilia.

At its heart this is a book about friendship, preserved across time and distance, even beyond the grave. It is dedicated to my two dearest friends, one in Ithaca and one in London, neither of whom will see this work in its final form: Nicola Thorold (1965–2016) and Lauren Comly (1965–2014).

Notes

INTRODUCTION

1. Charles Burney, *The Present State of Music in Germany, the Netherlands, and United Provinces*, 2 vols. (London: T. Becket, J. Robson, and G. Robinson, 1773), 2:268–69. Bach surely knew Burney's description of this visit. He owned a copy of the German translation, which included Bach's own biography, commissioned by the translator (and editor), Bach's friend J. J. C. Bode.

2. See R. L. Poole, "The Oxford Music School and the Collection of Portraits Formerly Preserved There," *Musical Antiquary* 4, no. 3 (April 1912): 143–59.

3. See Lorenzo Bianconi, ed., *I ritratti del Museo della Musica di Bologna, da padre Martini al Liceo musicale* (Florence: Leo S. Olschki Editore, 2018), and below, chapter 7.

4. See Roland Kanz's comprehensive study, *Dichter und Denker im Porträt: Spurengänge zur deutschen Porträtkultur des 18. Jahrhunderts* (Munich: Deutscher Kunstverlag, 1993), and Reimar Lacher, "Freundschaftskult und Porträtkult," in *Von Mensch zu Mensch: Porträtkunst und Porträtkultur der Aufklärung*, ed. Reimar Lacher, *Gleimhaus Halberstadt, mit Beiträgen von Helmut Börsch-Supan und Doris Schumacher*, Schriften des Gleimhauses Halberstadt 7 (Göttingen: Wallstein, 2010), exhibition catalog, 41–54.

5. Christian Cay Lorenz Hirschfeld, *Theorie der Gartenkunst*, 5 vols. in 2 (Leipzig: Weidmanns Erben und Reich, 1779–85). Hirschfeld gave detailed accounts of parks such as that at Stowe, with its Temple of Ancient Virtue (its four life-size busts including Homer and Socrates), its Temple of British Worthies with national heroes including Pope, Milton, Shakespeare, Alfred the Great, and Elizabeth I, and its Temple of Friendship, with its ten busts of Lord Cobham's friends.

6. See Elizabeth A. Fay, *Fashioning Faces: The Portraitive Mode in British Romanticism* (Durham: University of New Hampshire Press, 2010), 44.

7. See Marcia Pointon, *Hanging the Head: Portraiture and Social Formation in Eighteenth-Century England* (New Haven, CT: Yale University Press, 1998), and Pointon, *Portrayal and the Search for Identity* (London: Reaktion Books, 2012).

8. Anthony Ashley Cooper, Earl of Shaftesbury, *Second Characters, or The Language of Forms*, ed. Benjamin Rand (Bristol: Thoemmes Press, 1995), 135.

9. Notwithstanding Reynolds's own theoretical writing that still suggested portraiture was a debased genre. See Alison Conway, *Private Interests: Women, Portraiture, and the Visual Culture of the English Novel, 1709–1791* (Toronto: University of Toronto Press, 2001), 16–17.

10. Burney, *Present State*, 2:269–70.

11. "Reading the body, interpreting heads, studying reflections, resisting interpretive strategies, all perform similar functions of portraitive restatement in that they insist on a legibility of the self." Fay, *Fashioning Faces*, 67.

12. Some of the collection, from the holdings of the Berlin State Library, was exhibited at the Bach Museum, Leipzig, in Fall 2011. My reconstruction of the collection is published as a supplement to the C. P. E. Bach *Complete Works* edition. See Annette Richards, ed., *Carl Philipp Emanuel Bach: The Portrait Collection*, 2 vols., *Carl Philipp Emanuel Bach: The Complete Works*, ser. 8, Supplement 4.1, with appendixes by Paul Corneilson (Los Altos, CA: Packard Humanities Institute, 2012).

13. In the pages that follow the portrait inventory there are listed a small collection of silhouettes (126–28) and a collection of drawings by C. P. E. Bach's son, J. S. Bach the younger, as well as a number of works by other artists (131–42). *Verzeichniß des musikalischen Nachlasses des verstorbenen Capellmeisters Carl Philipp Emanuel Bach* (Hamburg: Gortlieb Friedrich Schneibes, 1790). Facsimile reprint, *The Catalog of Carl Philipp Emanuel Bach's Estate: A Facsimile of the Edition by Schneibes, Hamburg, 1790*, annotated and with a preface by Rachel W. Wade (New York: Garland, 1981), xii. Hereafter, NV 1790.

CHAPTER 1

1. Johann Wolfgang von Goethe, "The Collector and His Circle," in *Goethe on Art*, ed. and trans. John Gage (London: Scolar Press, 1980), 65.

2. There may have been a family connection with J. G. Walther's historical-biographical project. Konrad Küster has suggested that J. S. Bach may have helped Walther, his distant relative (and colleague at the Weimar court), making materials available to him from his library of old music and distributing the book from his house in Leipzig. See Konrad Küster, "Bach als Mitarbeiter am 'Walther-Lexikon'?" *Bach-Jahrbuch* 77 (1991): 187–92. See also Kirsten Beisswenger, *Johann Sebastian Bachs Notenbibliothek* (Kassel: Bärenreiter, 1992). For more on music-historical-biographical works in the period, see below, chapter 7.

3. Famous as an organist, Hainlein was also much in demand for his compositions, which included occasional works for Nuremberg citizens, continuo motets and songs, as well as festive choral works and instrumental music (of which little survives today). Walther offered the additional information that Hainlein's keyboard technique was such that he could play the hardest pieces on the organ with little noticeable movement in the fingers and the hand— a technique like that J. S. Bach was famous for. Johann Gottfried Walther, *Musicalisches Lexicon, oder Musicalische Bibliothec* (Leipzig: Wolfgang Deer, 1732), 306–7.

4. Reprinted in Ernst Ludwig Gerber, *Historisch-biographisches Lexikon der Tonkünstler* (Leipzig: Breitkopf, 1792), 2:468–69.

5. See Dieter Lohmeier, ed., *Carl Philipp Emanuel Bach: Musik und Literatur in Norddeutschland; Ausstellung zum 200. Todestag Bachs* (Heide in Holstein: Boyens, 1988), 56; and Annette Richards, "An Enduring Monument: C. P. E. Bach and the Musical Sublime," in *C. P. E. Bach Studies*, ed. Annette Richards (Cambridge: Cambridge University Press, 2006), 149–50.

6. Walther, *Musicalisches Lexicon*, 272. Bach's inventory entry indicates, then, that Bach was in possession of the posthumously issued woodcut of Handl rather than the one Walther

described, which was published with Handl's *Opus musicum* of 1590 with the title "Contrafaktur Des Weltberühmbten MUSICI IACOBI GALLI sonßt Handl gennant."

7. The portrait is listed in Bach's inventory as "*Selle, (Thomas)* Hamburgischer Musik-Director. Von *Dirksen*. 4. In schwarzen Rahmen, unter Glas." NV 1790, 121.

8. Selle's "Canon triginta sex vocibus" was in C. P. E. Bach's library and is listed on page 88 of the *Nachlassverzeichniss*. Bach also owned a leather-bound volume of hymns by Johann Rist, set to music by Selle—either the *Musikalische Fest-Andachten* (Lüneburg, 1655) or the *Sabbahtische Seelenlust* (Lüneburg, 1651). See Ulrich Leisinger, "Die 'Bachsche Auction' von 1789," *Bach-Jahrbuch* 77 (1991): 97–126.

9. NV 1790, 119.

10. Walther, *Musicalisches Lexicon*, 548–49.

11. See Richards, "Enduring Monument," 150–53.

12. Susan Stewart, *On Longing: Narratives of the Miniature, the Gigantic, the Souvenir, the Collection* (Baltimore: Johns Hopkins University Press, 1984), 154.

13. Carl Friedrich Cramer, ed., *Magazin der Musik* 1 (Hamburg: Musicalischen Niederlage, 1783): 963n. See below, chapter 2.

14. Letter from Johanna Maria Bach, Hamburg, March 4, 1789. Ernst Suchalla, ed., *Carl Philipp Emanuel Bach Briefe und Dokumente. Kritische Ausgabe* (Göttingen: Vandenhoeck und Ruprecht, 1994), 934.

15. All page numbers refer to NV 1790.

16. The inventory entry runs "Handel. (G. F). Mezzotint by Faber. Fol. In black frame under glass" (95).

17. On connections between J. S. Bach and the older figures of German music culture represented in the portrait collection, see Robin A. Leaver, "Überlegungen zur 'Bildniss-Sammlung' im Nachlass von C. P. E. Bach," *Bach-Jahrbuch* 93 (2007): 105–38. See also Christoph Wolff, *Johann Sebastian Bach: The Learned Musician* (New York: W. W. Norton, 2000).

18. Gerber, *Lexikon*, 2:186–88.

19. Items 358, 359 and possibly 354 in the "Bachsche Auction" of 1789.

20. Wolff, *Johann Sebastian Bach*, 422. Membership in the Society required presenting a portrait in oil (this is the origin of the famous Haussmann portrait of J. S. Bach); several members' portraits would subsequently be engraved and appear as frontispieces to issues of Mizler's journal, the *Musikalische Bibliothek* (published from 1736 to 1754). Mizler himself appears not to have had his own portrait made, and unlike several other members of his society he was not represented in C. P. E. Bach's collection.

21. Wolff, *Johann Sebastian Bach*, 43 and 58.

22. Along with Mattheson's *Grundlage einer Ehrenpforte* (Hamburg 1740), C. P. E. Bach's library also contained Mattheson's biography of the young Handel. In *Der vollkommene Capellmeister* (Hamburg, 1739) Mattheson referred to J. S. Bach's vocal music and to his status as the age's greatest organist, but in the *Grundlage*, his set of musician biographies and autobiographies, he had been unable to include a biography of J. S. Bach, since Bach had failed to supply one.

23. G. P. Telemann, autobiography, in Johann Mattheson, *Grundlage einer Ehrenpforte*, 362–63.

24. NV 1790, 94.

25. Palestrina, too, continued to be performed in Leipzig during J. S. Bach's tenure there, and performing parts in J. S. Bach's hand survive (copied around 1742), with cornetto, trombone, and basso continuo, of the "Missa sine nomine" from Palestrina's *Liber V. Missarum* (1590).

26. Quite a number of the musicians in the portrait collection were also painters or belonged to families of both painters and musicians. These included the Bachs as well as the Abels, the Grafs, and Nicolas Lanier.

27. C. P. E. Bach and J. F. Agricola, "The World-Famous Organist, Mr. J. S. Bach," reprinted in Hans T. David and Arthur Mendel, eds., *The New Bach Reader: A Life of Johann Sebastian Bach in Letters and Documents*, rev. and enl. Christoph Wolff (New York: W. W. Norton, 1998), 297–307.

28. Charles Burney, *The Present State of Music in Germany, the Netherlands and the United Provinces* (London: T. Becket, J. Robson, and G. Robinson, 1773), 2:274.

29. That there is no separate category for other keyboard players is likely because few experts on other keyboard instruments were not also organists; in the rare cases when he or she did not have a reputation as an organist, a great keyboardist was likely to be classified as a composer. Notably absent among keyboard players in the C. P. E. Bach collection is Johann Jakob Froberger, perhaps because Froberger's music remained unpublished and no portrait of the composer was in circulation.

30. Jacob Paix, *Ein schön nutz und gebreüchlich Orgel Tabulaturbuch*. Forkel's selection is from Paix's intabulation of the Josquin motet "Veni sancte Spiritus." Johann Nikolaus Forkel, *Allgemeine Geschichte der Musik* (Leipzig: Schwickert, 1802), 2:731–32.

31. Listed as item 366 in the catalog of the "Bach Auction" of 1789. See Leisinger, "Bachsche Auction," 102–3, and Leaver, "Überlegungen," 124. Gerber mentions this item in his 1812 entry on Fabricius, giving credence to Leisinger's argument that this was indeed an auction of items from C. P. E. Bach's library: "Eine besondere Lebensbeschreibung, welche ein gewisser Thilonac von ihm herausgegeben hat, soll sich noch unter des Hamburger Bach Nachlasse befunden haben." Gerber, *Neues historisch-biographisches Lexikon*, 2:69.

32. Kuhnau was classified by C. P. E. Bach in his inventory not as an organist but according to his more distinguished role as "Music Director" in Leipzig.

33. Walther, *Musicalisches Lexicon*, 576.

34. [C. P. E. Bach], "Auszug eines Sendschreibens aus———vom 27sten Febr. 1788," in *Allgemeine deutsche Bibliothek*, ed. Friedrich Nicolai (Berlin: Nicolai, 1788), 81, pt. 1, 298–99. English translation based on *The New Bach Reader*, 405. See David Yearsley, *Bach's Feet: The Organ Pedals in European Culture* (Cambridge: Cambridge University Press, 2016), 175.

35. Perhaps surprisingly, J. P. Sweelinck, the "Orpheus of Amsterdam" and teacher of so many German organists in the seventeenth century, was not in C. P. E. Bach's collection, despite the availability of the engraving by Jan Harmensz Muller, made in 1624. Copies of this engraving, according to Gerber, were in the possession of both the famous Sweelinck students Jacob Praetorius and Heinrich Scheidemann, "welches sie Lebenslang in ihrem besten Zimmer vor augen haben mussten" (which for their whole lives they had to keep on view in their best room). Gerber, *Historisch-biographisches Lexikon*, 2:611.

36. These fine prints were likely available in Leipzig, where Pieter Schenck opened a shop in the first decade of the eighteenth century, and where he regularly sold his prints at the fairs; they could have been bought there by J. S. Bach before 1750, but so too could they have been acquired for the collection later by Breitkopf, or in the 1770s by J. S. Bach the Younger.

37. Probably the painting by Mathieu in the Forkel, and then Poelchau, collections. See Annette Richards, ed., *Carl Philipp Emanuel Bach: The Portrait Collection, Carl Philipp Emanuel Bach: The Complete Works*, ser. 8, vol. 4.1 (Los Altos, CA: Packard Humanities Institute, 2012), 1:40.

38. Samuel Cogho was a cellist at the court of Mecklenburg-Strelitz and a painter; he owned a fine collection of engravings. The Bach collection also included a portrait in oils by Cogho of his wife, the soprano Therese Petrini.

39. See below, chapter 5.

40. The portrait was published in 1765 as the frontispiece to the first volume of the *Neue Bibliothek der schönen Wissenschaften und der freien Künste* (Leipzig: Dyck'sche Buchhandlung, 1765), vol. 1, pt. 1.

41. Gerber, *Historisch-biographisches Lexikon der Tonkünstler* (Leipzig: Breitkopf, 1792), 2:793.

42. Jacob Adlung, "Einleitung," *Anleitung zu der musikalischen Gelahrtheit* (Erfurt, 1758), Einleitung, 21.

43. A few other "Schriftsteller" were also framed: Besard (a lutenist), Bona, Bartholinus, Eschstruth (also a composer), Tevo, Till.

44. "*Inventor Intervallorum.*" NV 1790, 117.

45. Nikolaus von Reusner, *Icones sive imagines virorum literis illustrium. . . .* (Strasbourg: Jobin, 1587, 1589, 1590). For more on Reusner's portrait-biography books and the woodcuts from them in the Bach collection, see below, chapter 2.

46. The story is related in Mattheson, *Grundlage*, 356–57. See also Pieter Dirksen, *Heinrich Scheidemann's Keyboard Music: Transmission, Style and Chronology* (Aldershot: Ashgate, 2007), 31.

47. Wolff, *Johann Sebastian Bach*, 26–72.

48. Stockhausen's portrait, engraved by Christian Gottlieb Geyser, was published as the frontispiece to Georg Friedrich Götz's biography, *Leben Herrn Johann Christoph Stockhausens* (Hanau, 1784).

49. BWV 18, 24, 28, 59, and 61.

50. Letter of October 2, 1784, in *The Letters of C. P. E. Bach*, ed. and trans. Stephen L. Clark (New York: Oxford University Press, 1997), 215.

51. Charles Burney wrote that "M. Zachariä, besides being a poet of the first rank, and celebrated for the wit and humour of his mock-heroic poems, is likewise a good practical musician, and an excellent theorist and critic of musical productions." Burney, *Present State . . . Germany, the Netherlands and United Provinces*, 2:334.

52. Brockes was the author of numerous cantata librettos and texts for large-scale choral works, including one of the most famous Passion texts of the era (a copy of the Handel Brockes Passion, in the hand of J. S. and Anna Magdalena Bach, was part of the estate of J. S. Bach).

53. Schubart was the author of two volumes of sacred songs, published in 1733 and 1735.

54. A "Gesang-Buch von J. Rist mit Melod. von Th. Sellins" is listed as item 394 in the "Bachsche Auction" catalog of 1789, as is a "Gesang-Buch von J. Rist mit Melod. von J. Schopp" (item 393 in the catalog). See Leisinger, "Bachsche Auction."

55. The portrait of Bach, originally a very poor likeness, had been slightly improved for the second volume. These were bestsellers, the first volume of *Geistliche Gesänge* attracting 206 subscribers in Hamburg alone.

56. Johann Friedrich Reichardt, *Briefe eines aufmerksamen Reisenden die Musik betreffend* (Frankfurt, 1774), 1:115.

57. Bach set several of Hagedorn's poems, including "Morgen" and "An die Liebe" (music no longer extant), and "Die Alster," and "Harvstehude" (H. 763).

58. Gellert's letters reveal his interest in Bach's settings of his poetry (see especially Suchalla, *C. P. E. Bach Briefe und Dokumente*, 55–57). Bach expressed his own admiration for Gellert in a Stammbuch entry of August 2, 1783, quoting the lines "Wie selig lebt ein mann, der seine Pflichten kennt, / Und seine Pflicht zu thun, aus Menschenliebe brennt!" from Gellert's "Der Menschenfreund," *Moralische Gedichte und Lieder* (Karlsruhe: Schmieder, 1774), 2:3.

59. Denis later published his own poetry in the Ossianic mode under the pseudonym Sined the Bard (*Die Lieder Sineds des Barden*, 1772), gathered together with his Ossian translations in five volumes in 1784 as *Ossians und Sineds Lieder*.

60. Letter of September 26, 1776, in Suchalla, *C. P. E. Bach Briefe und Dokumente*, 607.

61. For more on this friendship circle, and these portraits, see below, chapter 5.

62. See Johan van der Zande, "Orpheus in Berlin: A Reappraisal of Johann Georg Sulzer's Theory of the Polite Arts," *Central European History* 28, no. 2 (1995): 192.

63. The first edition appeared in two volumes (in 1771 and 1774); a second edition was in four volumes 1773–74; and a reprint of this edition appeared before Sulzer's death in 1779; a

third edition, also in four volumes, was issued posthumously in 1786–87 with bibliographies to most of the essays by Friedrich von Blankenburg; a reprint of this edition appeared in 1792–94 (and is the basis for the 1967 facsimile reprint). Sulzer's encyclopedia was a big moneymaker for his publisher, Philipp Erasmus Reich, who created in his Leipzig garden a commemorative monument to Sulzer and to Gellert, another of his best-selling authors. See van der Zande, "Orpheus in Berlin," 178.

64. See Laurenz Lütteken, "Zwischen Ohr und Verstand: Moses Mendelssohn, Johann Philipp Kirnberger und die Begründung des 'reinen Satzes' in der Musik," in *Musik und Ästhetik im Berlin Moses Mendelssohns*, ed. Anselm Gerhard (Tübingen: Max Niemeyer Verlag, 1999), 135–63; and Hartmut Grimm, "Moses Mendelssohns Beitrag zur Berliner Musikästhetik und Carl Philipp Emanuel Bachs Fantasie-Prinzip," in Gerhard, *Musik und Ästhetik*, 165–86.

65. I'll say more about this in chapter 4.

66. Bach's review of Forkel appeared in the *Hamburgischer unpartheyischer Correspondent*, January 9, 1788.

67. A prolific polymath, and a central figure in the study of acoustics, Euler planned to write a complete treatise on all aspects of music, but he realized only part of this: the *Tentamen novae theoriae musicae, ex certissimis harmoniae principiis dilucidae expositae*, written around 1731 (published in St Petersburg, 1739), contained a theory of consonance and modulation, of the "natural 7th chord" (subsequently taken up by the Berlin music theorists), and the most complete system of scales and modes yet published.

68. Leaver, "Überlegungen," 105–38.

69. See Eduard Trautscholdt, "Zur Geschichte des Leipziger Sammelwesens," in *Festschrift Hans Vollmer* (Leipzig: E. A. Seemann, 1957), 217–52. Exhibitions of paintings were a regular feature of the trade fairs, and the main art auctions, too, were timed to take place directly after these fairs. Indeed, many of the Dutch old master paintings in the famous eighteenth-century Leipzig and Dresden art collections were bought by their collectors not on trips abroad, but at the Leipzig fairs. Christoph Wolff and Robin Leaver have both noted how the Bach family found itself in the center of, and with free access to, collecting culture there. See Leaver, "Überlegungen"; Wolff, *Johann Sebastian Bach*, 239; and Roland Kanz, *Dichter und Denker im Portrait: Spurengänge zur deutschen Porträtkultur des 18. Jahrhunderts* (Munich: Deutscher Kunstverlag, 1993). For more on this, see also below, chapter 5.

70. A. F. Oeser to von Hagedorn, undated letter. Quoted in Maria Hübner, "Johann Sebastian Bach d.J.: Ein biographischer Essay," in *Zwischen Empfindsamkeit und Klassizismus: Der Zeichner und Landschaftsmaler Johann Sebastian Bach der Jünger (1748–1778)*, by Anke Fröhlich (Leipzig: Evangelische Verlagsanstalt, 2007), 18. For more on J. S. Bach the younger, see below, chapters 5 and 6.

71. Burney, *Tagebuch*, 3:202. For the brilliant observation that C. P. E. Bach's metaphor here, of a 'great room' fits uncannily well with the portrait gallery he had already assembled, see Reimar F. Lacher, "Carl Philipp Emanuel Bach als Porträtsammler," in *Carl Philipp Emanuel Bach im Spannungsfeld zwischen Tradition und Aufbruch*, ed. Christine Blanken und Wolfram Enßlin, Beiträge der interdisziplinären Tagung anlässlich des 300. Geburtstages von Carl Philipp Emanuel Bach vom 6. bis 8. März 2014 in Leipzig (Hildesheim: Georg Olms, 2016), 351.

72. NV 1790, 104.

73. For more on portrait collections and self-fashioning, see Elizabeth Fay, *Fashioning Faces: The Portraitive Mode in British Romanticism* (Durham: University of New Hampshire Press, 2010).

74. As Roland Kanz has written of the portrait collection assembled by the publisher Philipp Erasmus Reich in Leipzig in the 1770s: "In the publishers' city of Leipzig, . . . [Reich] was a personality, who sought to prove in all his dealings that 'friend of mankind, patriot and world citizen are in fact one.' Cosmopolitanism, literary discourse and cultivated bourgeois exchange

could be held in no more suitable place than in the ambiance of a small private salon, whose walls were filled with a gallery of exemplary cosmopolitans [*Weltweiser*]." Kanz, *Dichter und Denker*, 166.

CHAPTER 2

1. Daniel Chodowiecki, "Steckenpferdreiterei," in *Königlisch Großbrittanischer genealogischer Kalender* (Lauenburg: J. G. Berenberg, 1781).

2. Chodowiecki's series presents a variety of *Liebhaber*—a word that is difficult to translate simply into twenty-first-century English. It often appears as "amateur," in the sense of the opposition of amateur to connoisseur (in German, *Kenner*), but this pair of words has far richer connotations than a simple binary opposition allows for. Widely used in the eighteenth-century literature on collecting, the connotations of *Liebhaber* include afficionado, devotee, enthusiast, connoisseur, *and* amateur.

3. Chodowiecki, "Steckenpferdreiterei," plate 1, *Der Bücher Liebhaber*.

4. Ibid., plate 2, *Der Gemählde Liebhaber*.

5. Ibid., plate 3, *Der Naturalien Liebhaber*.

6. Ibid., plate 4, *Der Kupferstich Liebhaber*.

7. Johann Georg Sulzer, *Allgemeine Theorie der schönen Künste* (Leipzig: Weidmanns Erben und Reich, 1774), 2:641.

8. Johann Caspar Fuessli, *Raisonierendes Verzeichniss der vornehmsten Kupferstecher und ihrer Werke: Zum Gebrauche der Sammler und Liebhaber* (Zurich: Orell, Gessner und Fuessli, 1771), 5–6; quoted in part by Carl Ludwig Junker, "Vorbericht," in *Erste Grundlage zu einer ausgesuchten Sammlung neuer Kupferstiche* (Bern: Typographischen Gesellschaft, 1776), Vorbericht [i]; translation modified from Anne-Marie Link, "Carl Ludwig Junker and the Collecting of Reproductive Prints," *Print Quarterly* 12, no. 4 (1995): 361–74, at 364. Fuessli, and Junker after him, relied on the anonymous German handbook *Abhandlung von Kupferstichen* (Frankfurt: Dodsley, 1768), itself a translation of William Gilpin's *An Essay on Prints; Containing Remarks upon the Principles of Picturesque Beauty, the Different Kinds of Prints, and the Characters of the Most Noted Masters* (London, J. Robson, 1768).

9. See, for example, Johann Georg Meusel, *Teutsches Künstlerlexikon, oder Verzeichnis sehenswürdiger Bibliotheken, Kunst, Münz- und Naturaliencabinette in Teutschland* (Lemgo: Meyersche Buchhandlung, 1778). On eighteenth-century print culture and collecting see Antony Griffiths and Frances Carey, *German Printmaking in the Age of Goethe* (London: British Museum, 1994), and Link, "Carl Ludwig Junker," as well as Roland Kanz's comprehensive study, *Dichter und Denker im Porträt: Spurengänge zur deutschen Porträt Kultur des 18. Jahrhunderts* (Munich: Deutscher Kunstverlag, 1993). For more general information on later eighteenth-century print collecting, and especially on Joseph Haydn's activities as a collector, see Thomas Tolley, *Painting the Cannon's Roar: Music, the Visual Arts and the Rise of an Attentive Public in the Age of Haydn* (Aldershot: Ashgate, 2001).

10. "Und 370 fl.—sind doch auch noch eine Summe für einen ehrlichen Mann." Junker, *Erste Grundlage*, xxvi. As Link notes, 370 Gulden was approximately ten times the annual salary of a tutor, and half a professor's annual income. Link, "Carl Ludwig Junker," 364.

11. "Kunstsachen," *Der Teutsche Merkur*, Zweytes Vierteljahr (1778), 170. Quoted in Link, "Carl Ludwig Junker," 364.

12. "Aus einem Briefe des Hrn. Ernst Ludewig [*sic*] Gerber, Fürstlich Schwarzburgischem Hoforganisten und Cammermusicus zu Sondershausen, den 30 August 1783," in Carl Friedrich Cramer, ed., *Magazin der Musik* 1 (Hamburg: Musicalischen Niederlage, 1783): 962–63.

13. Ibid., 963–64.

14. Bause was in his post when C. P. E. Bach's son, J. S. Bach the Younger, studied at the Leipzig Kunstakademie. He engraved at least three of J. S. Bach the Younger's works, including the *Mary Magdalena* that the grieving C. P. E. Bach sent to Forkel (and others) as a memento after his son's death (fig. 6.3 below). See below, chapter 6, and Anke Fröhlich, *Zwischen Empfindsamkeit und Klassizismus: Der Zeichner und Landschaftsmaler Johann Sebastian Bach der Jüngere (1748–1778)* (Leipzig: Evangelische Verlagsanstalt, 2007), 18–19, 31–32, 38.

15. Gerber, "Aus einem Briefe," 965.

16. Hans Adolf Freiherr von Eschstruth, "Nachrichten von Marmor-Säulen, Büsten, Gips-Abdrücken, Kupferstichen und Schattenrissen verschidner [sic] Tonkünstler," in *Musikalische Bibliothek*, ed. Hans Adolf Friedrich von Eschstruth (Marpurg: Krieger, 1784; reprint Hildesheim: Olms, 1977), 1:123–30, at 130.

17. Ernst Ludwig Gerber, *Historisch-biographisches Lexikon der Tonkünstler* (Leipzig: Breitkopf, 1790), 1:83.

18. Gerber, "Anhang, welcher Nachrichten von Bildnissen, Büsten und Statüen berühmter Tonlehrer und Tonkünstler, nebst einigen dazu nöthigen Vorerrinerungen . . . enthält," *Historisch-biographisches Lexikon* (Leipzig: Breitkopf, 1792), 2:viii.

19. Ibid., vii.

20. Sigmund Jacob Apin, *Anleitung wie man die Bildnisse berühmter und gelehrter Männer mit Nutzen sammlen und denen dagegen gemachten Einwendungen gründlich begegnen soll* (Nuremberg: Adam Jonathan Felßbecker, 1728). See Elizabeth M. Hajós, "Sigmund Jakob Apins Handbuch für den Sammler von Bildnissstichen: Ein Beitrag zu der Geschichte des Sammelwesens im 1. Viertel des 18. Jahrhunderts," *Philobiblon* 13 (1969): 3–26. See also Eckhard Schinkel, "Sammeln, Ordnen und Studieren: Sozialgeschichtliche Aspekte zur Verwendung von Graphik und Porträts im 18. Jahrhundert," in *Porträt 1: Der Herrscher. Graphische Bildnisse des 16.-19. Jahrhunderts aus dem Porträtarchiv Diepenbroick* (Münster: Westfälisches Landesmuseum für Kunst und Kulturgeschichte, 1977), 47–66.

21. Apin, *Anleitung*, 20.

22. Apin, *Anleitung*, 20. Emphasis in quotations from Apin is original throughout.

23. Apin, *Anleitung*, 20, 29n.

24. Apin, *Anleitung*, 20, 36–37. This is exactly what one sees on the portraits in the Berlin State Library, especially those from the Poelchau collection.

25. Apin, *Anleitung*, 59–60.

26. Apin, *Anleitung*, 63–64.

27. In a typically useful detail, Apin mentions that the volume the index is written in should have plenty of empty pages so that additions can easily be indexed in the correct place.

28. Apin, *Anleitung*, 49.

29. Letter of February 24, 1775, in *The Letters of C. P. E. Bach*, ed. and trans. Stephen L. Clark (New York: Oxford University Press, 1997), 78. Schröter's portrait was not, in fact, published in Mizler's *Bibliothek*.

30. Letter of April 15, 1775, Clark, *Letters*, 79; translation modified.

31. Letter of December 26, 1775, Clark, *Letters*, 90.

32. Letter of January 17, 1776, Clark, *Letters*, 91–92.

33. Letter of October 9, 1784, Clark, *Letters*, 216.

34. Letter of April 15, 1785, Clark, *Letters*, 227.

35. Johann Nikolaus Forkel, *Ueber Johann Sebastian Bachs Leben, Kunst und Kunstwerke: Für patriotische Verehrer echter musikalischer Kunst* (Leipzig: Hoffmeister und Kühnel, 1802).

36. Letter to Forkel, April 20, 1774, Clark, *Letters*, 54. The pastel portrait of J. S. Bach mentioned here was not in Bach's collection by the time of the preparation of NV 1790, which lists only

the oil painting by Haussmann. According to family tradition in the Meinungen branch of the Bach family, this pastel is the portrait now known as the "Meinungen pastel," by Bach's distant cousin Gottlieb Friedrich Bach (1714–85), the musician and painter at the Meinungen court, and was exchanged by C. P. E. Bach for the same artist's pastel of his father, Johann Ludwig Bach, listed in NV 1790 as "Bach, (Joh. Ludw.) Meinungischer Kapellmeister. Mit trocknen Farben von Ludw. Bach, seinem Sohne" (NV 1790, 95–96). See Werner Neumann, *Bilddokumente zur Lebensgeschichte Johann Sebastian Bachs* (Kassel: Bärenreiter, 1979), 397; Karl Geiringer, *The Bach Family: Seven Generations of Creative Genius* (New York: Oxford University Press, 1954), 448–49; Annette Richards, *Carl Philipp Emanuel Bach: The Portrait Collection, Carl Philipp Emanuel Bach: The Complete Works*, ser. 8, vol. 4.1. (Los Altos, CA: Packard Humanities Institute, 2012), 42.

37. Letter to Forkel, April 20, 1774, Clark, *Letters*, 54. Bach wrote in the account of the family genealogy he sent to Forkel in 1774 that both Gottlieb Friedrich Bach and his son Johann Philipp were excellent portrait painters, and that the latter "visited me last summer, and painted my portrait, catching the likeness excellently." The latter portrait was the basis for the engraving mentioned further on in the same letter, which would eventually be published in Lavater's *Physiognomische Fragmente zur Beförderung der Menschenkenntnis und Menschenliebe* (Leipzig: Weidmanns Erben und Reich, 1775–78). See below, chapters 3 and 4.

38. Letter to Forkel on May 13, 1786, in Clark, *Letters*, 247. The drawing of Martini is now lost. The letter also mentions what it would cost to have the same artist copy the collection's drawings (also by J. S. Bach the Younger) of Mingotti (spelled "Mignotti" by Bach) and Buffardin: "However, since you want to know, for future purposes, what such a drawing costs: I must say that I gave 4 Lübisch marks for it. Buffardin and Mignotti are much larger and more trouble. He won't [copy] them for less than a ducat. Expensive things!" (Translation modified.) See also Anke Fröhlich, *Zwischen Empfindsamkeit und Klassizismus: Der Zeichner und Landschaftsmaler Johann Sebastian Bach der Jüngere (1748–1778)* (Leipzig: Bach-Archiv, 2007), 164–65. For more on J. S. Bach the younger and portrait drawings, see below, chapter 5.

39. The collection Westphal created was bought after his death by Fétis, who eventually sold it to the libraries at the Royal Conservatory and the Royal Library in Brussels. The Wotquenne catalog of C. P. E. Bach's works was based on the former Westphal holdings in Brussels. See below, chapter 7, and Ulrich Leisinger and Peter Wollny, *Die Bach-Quellen der Bibliotheken in Brüssel: Katalog*; Leipziger Beiträge zur Bach-Forschung 2 (Hildesheim: Olms, 1997), esp. 25–73.

40. Letter of March 5, 1787, Clark, *Letters*, 259.

41. Letter of May 8, 1787, Clark, *Letters*, 262.

42. Letter of May 8, 1787, Clark, *Letters*, 262 (translation modified).

43. Clark, *Letters*, 263.

44. Letter of August 4, 1787, in Clark, *Letters*, 267.

45. According to the 1790 inventory both the Engel and Kellner portraits remained unframed. The Saint-Huberty portrait, however, is listed there as framed, suggesting that, as with one of the two Engel prints, Westphal did Bach what he thought was the honor of sending the portrait already framed, not knowing Bach's preference at this late stage for receiving prints unframed.

46. Letter of October 25, 1787. "*Richtern aus Strasburg, Schmidten 1642 aus Magdeburg, Schmidten Sächsischer Kapellmeister u. Caspar Kerle wünschte ich mir, wenn sie zu haben wären.*" Ernst Suchalla, ed., *Carl Philipp Emanuel Bach Briefe und Dokumente: Kritische Ausgabe* (Göttingen: Vandenhoeck und Ruprecht, 1994), 1237, and Clark, *Letters*, 273.

47. As Marcia Pointon notes, by then "the dynamics of collecting were determined more by a notion of plenitude, by a desire to fill in all the gaps." See her *Hanging the Head: Portraiture and Social Formation in Eighteenth-Century England* (New Haven, CT: Yale University Press, 1993), 58.

48. Most of the items in the folder, Bc, 34.734 H.P., relate to Westphal's portrait collecting and his efforts to supply corrections and emendations to Gerber. The document in question,

Bc, 34.734 H.P. no. 25, is reprinted in facsimile in Leisinger and Wollny, *Bach-Quellen der Biblio-theken in Brüssel*, 157.

49. NV 1790, 106.

50. "*Pancirolus, (Guido)*, Schriftsteller. 4" (NV 1790, 116); "*Passerius, (Joh. Bapt.)* Musikus und Schriftsteller. Schwarze Kunst von *Haid. Fol.*" (NV 1790, 116).

51. It seems that C. P. E. Bach relied on Walther's entry in his identification of the figure in the portrait. Gerber, perhaps conflating the two figures, cites a discussion of the music of the Etruscans in Giovanni Battista Passeri's *Picturae Etruscorum in Vasculis* (Rome: Zempel, 1770), 2:73.

52. NV 1790, 104.

53. The source for all the octavo woodcuts was likely Nikolaus von Reusner's *Icones sive imagines virorum literis illustrium*. . . . (Strasbourg: Jobin, 1587, 1589, 1590, etc.), whose images were relatively crude. That they were to be found in Reusner is confirmed in Gerber's inventory of portrait prints.

54. Letter of July 21, 1788, Clark, *Letters*, 282.

55. Waxes of this sort were made from plaster life masks and could be painted and adorned with hair to achieve lifelike, if creepy, versions of the original. Goethe gives a humorous account of this in his novella "Der Sammler und die Seinigen," translated as "The Collector and His Circle," in *Goethe on Art*, ed. and trans. John Gage (London: Scolar Press, 1980), 36–37: "An artist visited us and proposed making gypsum casts of the family members which he would then form in wax and tint in natural colors. As a sample he showed us the wax bust of his young assistant. It proved his talent, and my father decided to have the job done. It was successful. The artist painstakingly and realistically made a likeness of head and hands. A wig and a damask dressing gown were sacrificed for the phantom, and in this attire the wax replica of my dear old father sits today behind a curtain. I did not have the courage to show it to you" (127). The pantalon was a large hammered dulcimer, invented by Noelli's teacher Pantaleon Hebenstreit.

56. NV 1790, 115.

57. Letter to Westphal, July 21, 1788, Clark, *Letters*, 282.

58. Letter to Westphal, July 29, 1788, Clark, *Letters*, 283.

59. Hermann Schmid, "'Das Geschäft mit dem Nachlaß von C. Ph. E. Bach': Neue Dokumente zur Westphal-Sammlung des Conservatoire royal de musique und der Bibliothèque royale de Belgique in Brussel," in *Carl Philipp Emanuel Bach und die europäische Musikkultur des mittleren 18. Jahrhunderts: Bericht über das internationale Symposium der Joachim Jungius-Gesellschaft der Wissenschaften Hamburg, 29. September-2. Oktober 1988*, ed. Hans Joachim Marx (Göttingen: Vandenhoeck und Ruprecht, 1990), 488.

60. Nikolaus von Reusner, *Contrafacturbuch: Ware und lebendige Bildnussen* [sic] *etlicher weitberumbten u. hochgelehrten Männer in Teutschland* (Strasbourg: Jobin, 1587); Reusner, *Icones sive imagines virorum literis illustrium*. I am especially indebted here to Kanz, *Dichter und Denker*, 46–56; see also Pointon, *Hanging the Head*, 62–65.

61. See Griffiths and Carey, *German Printmaking*, 10–28.

62. The woodcuts in Bach's collection that were in the 1587 volume of Reusner portrayed Mariangelo Accorso, Alardus Amstelredamus, Nicolaus Cisnerus, Johannes Cochlaeus, Desiderius Erasmus, Conrad Gesner, Helius Eobanus Hessus, Wolfgang Musculus, Nikolaus Reusner, Beatus Rhenanus, Paul Schalichius, and Wilhelm Xylander. Corresponding to the 1589 set were the portraits of Leo Baptista Alberti, Andrea Alciati, Pietro Bembo, Filippo Buonaccorsi Callimachus, Cristoforo Marcello, Étienne Dolet, Marsilio Ficino, Girolamo Fracastoro, Lorenzo di Medici, Giovanni Pico della Mirandola, Giovanni Pontano, Angelo Poliziano, Ptolemy, Baptista Siculus, Stephanus Kis (Szegedinus), Leonardo da Vinci, and Theodor Zwinger. The sheer number of these suggests that C. P. E. Bach owned the complete volumes they came from; this in turn

might explain why some of these men, especially those for whom C. P. E. Bach's contemporaries could find little or no connection to music, were in the collection at all.

63. See below, chapters 3 and 7.

64. See Maria Hübner, "Johann Sebastian Bach d.J.: Ein biographischer Essay," in Fröhlich, *Zwischen Empfindsamkeit und Klassizismus*, 15.

65. I'll return to these in chapter 3. That the latter was in the collection when its catalog was printed in 1790 but had remained unframed (unlike the other three) is a further indication that it was a late addition to the collection.

66. Probably the "Gesang-Buch von J. Rist mit Melod. von J. Schopp," listed as item 394 in the 1789 "Bachsche Auction." See Ulrich Leisinger, "Die 'Bachsche Auction' von 1789," *Bach Jahrbuch* 77 (1991): 97–126. Schop's portrait was also printed on the title page of his *Geistlicher Concerten* (Hamburg, 1644).

67. The image of Rist listed in the 1790 inventory, with the engraver's name "Streuheld," must have been the engraving by Franz Steürhelt (1651) published as the frontispiece to Rist's *Sabbathische Seelenlust* (Lüneburg, 1651), a book that was also in C. P. E. Bach's library, listed in the 1789 auction catalog as item 394, "Gesang-Buch von J. Rist mit Melod. von Th. Sellins" (music by Thomas Selle). The frontispiece of the *Himmlischer Lieder* showed both Schop and also Rist (but not by Steürhelt); once the strip showing Schop had been cut off, Rist would have been left: this may have been the source of the duplicate sent to Forkel in 1786.

68. Given his acquaintance with both the artist and the portrait subject, Bach could have obtained this portrait directly from either Kniep or Ebeling. See below, chapter 5.

69. Georg Gottfried Küster, preface (unpaginated) to Martin Friedrich Seidel, *Bilder-sammlung, in welcher hundert gröstentheils in der Mark Brandenburg gebohrne, allerseits aber um dieselbe wohlverdiente Männer vorgestellet werden, mit beygefügter Erläuterung, in welcher Derselben merkwürdigste Lebens-Umstände und Schriften erzehlet werden, von George Gottfried Küster* (Berlin: Verlag des Buchladens bey der Real-Schule, 1751), 2. Quoted in Kanz, *Dichter und Denker*, 50.

70. See Werner Muensterberger, *Collecting: An Unruly Passion: Psychological Perspectives* (Princeton, NJ: Princeton University Press, 1994), and Susan Pearce, *On Collecting: An Investigation into Collecting in the European Tradition* (London: Routledge, 1995).

71. Renata Schellenberg, "The Self and Other Things: Goethe the Collector," *Publications of the English Goethe Society*, 81, no. 3 (2012): 171.

72. Schellenberg, "Self and Other Things," 171.

73. Friedmar Apel, ed., *Johann Wolfgang von Goethe: Ästhetische Schriften. Johann Wolfgang von Goethe Sämtliche Werke. Briefe, Tagebücher und Gespräche*, part 1, vol. 18 (Frankfurt am Main: Deutscher Klassiker Verlag, 1998), 1287. See also Goethe's novella *Der Sammler und die Seinigen* (cited in note 56), written in collaboration with Friedrich Schiller and first published in *Propyläen*, vol. 2 (1799). See Johannes Grave, "Ideal and History: Johann Wolfgang Goethe's Collection of Prints and Drawings," *Artibus et Historiae* 27, no. 53 (2006): 175–86; Renata Schellenberg, "The Self and Other Things: Goethe the Collector," *Publications of the English Goethe Society* 81, no. 3 (2012): 166–77.

CHAPTER 3

1. Ernst Ludwig Gerber, *Neues historisch-biographisches Lexikon* (Leipzig: Kühnel, 1813), 3:58. This painting was the copy Haussmann made in 1748 of the portrait he had painted in 1746. In the early nineteenth century it was bought by members of the family of Walter Jenke, who owned it until the early 1950s. In 1953 it was bought by William H. Scheide of Princeton, New Jersey, who bequeathed it to the Bach Archiv, Leipzig. It returned to Leipzig in 2015.

2. Johann Georg Sulzer, *Allgemeine Theorie der schönen Künste* (Leipzig: Weidmanns Erben und Reich, 1774), 2:919.

3. On the relation between libraries and portrait collections see Marcia Pointon, *Hanging the Head: Portraiture and Social Formation in Eighteenth-Century England* (New Haven, CT: Yale University Press, 1993), and Roland Kanz, *Dichter und Denker im Portrait: Spurengänge zur deutschen Porträtkultur des 18. Jahrhunderts* (Munich: Deutscher Kunstverlag, 1993).

4. Only a copy in the hand of his daughter Anna Carolina Philippina exists, but it has late-life annotations by C. P. E. Bach. See Christoph Wolff, "C. P. E. Bach and the History of Music," *Notes* 71, no. 2 (2014): 199–200.

5. C. P. E. Bach and J. F. Agricola, Obituary for J. S. Bach, 1750, published 1754. In *The New Bach Reader: A Life of Johann Sebastian Bach in Letters and Documents*, ed. Hans T. David and Arthur Mendel, revised and enlarged by Christoph Wolff (New York: W. W. Norton, 1998), 298.

6. As Christoph Wolff has summarized it, "If anyone deserves primary credit for keeping memorable objects and important information pertaining to the Bach family together and saving them for posterity, it is he." Wolff, "C. P. E. Bach and the History of Music," 200 and 203.

7. For more on the family portraits, and on the images of Emanuel Bach and his own family, see Annette Richards, ed., *Carl Philipp Emanuel Bach: The Portrait Collection, Carl Philipp Emanuel Bach: The Complete Works*, ser. 8, vols. 4.1 and 4.2 (Los Altos, CA: Packard Humanities Institute, 2012), and the appendixes to those volumes, ed. Paul Corneilson.

8. *The Letters of C. P. E. Bach*, ed. and trans. Stephen L. Clark (New York: Oxford University Press, 1997), 113.

9. See Clark, *Letters*, 245 (translation modified), and Ernst Suchalla, ed., *C. P. E. Bach Briefe und Dokumente* (Göttingen: Vandenhoeck und Ruprecht, 1994), 1140. In the Bach genealogy made in 1776 and sent to Forkel, C. P. E. Bach wrote under the entry for Johann Ludwig that "The son [Gottlieb Friedrich Bach] of the Meinungen Kapellmeister [Johann Ludwig Bach] still lives there, as court organist and court painter. His son [Johann Philipp] is his assistant in both capacities. Father and son are outstanding portrait painters. (The latter visited and painted me last Summer, excellently capturing my likeness.)" Suchalla, ed., *Carl Philipp Emanuel Bach Briefe und Dokumente*, 616. The portrait exists today in at least two copies. The portrait from which Lips made his engraving appears to have been made from a pastel signed J. C. Löhr, likely also copied from the Johann Philipp Bach pastel. See Paul Corneilson, introduction to Appendix B, in Richards, *Portrait Collection*, 210–11.

10. Manfred Hermann Schmid, "'Das Geschäft mit dem Nachlaß von C. Ph. E. Bach': Neue Dokumente zur Westphal-Sammlung des Conservatoire Royal de musique und der Bibliothèque royale de Belgique in Brussel," in Hans Joachim Marx, ed., *Carl Philipp Emanuel Bach und die europäische Musikkultur* (Göttingen: Vandenhoeck und Ruprecht, 1990), 488. See also Corneilson, introduction to appendix B, in Richards, *Portrait Collection*, 214.

11. See Richard Kramer, *Unfinished Music* (Oxford: Oxford University Press, 2008), especially chap. 2, "Carl Philipp Emanuel Bach and the Aesthetics of Patricide." See also David Ferris, "Plates for Sale: C. P. E. Bach and the Story of *Die Kunst der Fuge*," in Annette Richards, ed., *C. P. E. Bach Studies* (Cambridge: Cambridge University Press, 2006), 202–20.

12. Kramer, *Unfinished Music*, 37, Christoph Wolff, "C. P. E. Bach and the History of Music," 203, and Robert Marshall, "Father and Sons: Confronting a Uniquely Daunting Paternal Legacy," in *J. S. Bach and His Sons*, ed. Mary Oleskiewicz (Urbana: University of Illinois Press, 2017), 1–23.

13. The fragment was reproduced by Johann Friedrich Reichardt in his *Briefe eines aufmerksamen Reisenden die Musik betreffend* (Frankfurt, 1776), 2:22; see Kramer, *Unfinished Music*, 26–27, and Suchalla, ed., *Carl Philipp Emanuel Bach Briefe und Dokumente*, 405.

14. David Schulenberg notes the similarities between these two pieces in *The Instrumental Music of Carl Philipp Emanuel Bach* (Ann Arbor: UMI Research Press, 1984), 13, and refers also to

Erich Herbert Beurmann, *Die Klaviersonaten Carl Philipp Emanuel Bachs* (PhD diss., Georg-August Universität, Göttingen, 1952), 36–37. On learning by copying and emulation, see Matthew Hall, "Copying Bach: Compositional Emulation and Originality in Apprenticeships with J. S. Bach, 1720–1750" (PhD diss., Cornell University, 2019).

15. For more on Bach's burning "a ream" of his old works, see Ulrich Leisinger and Peter Wollny, "'Altes Zeug von mir': Carl Philipp Emanuel Bachs kompositorisches Schaffen vor 1740," *Bach-Jahrbuch*, 79 (1993): 127–204.

16. The piece is published in Annette Richards and David Yearsley, eds., *Carl Philipp Emanuel Bach: Organ Works, Carl Philipp Emanuel Bach: The Complete Works*, ser. 1, vol. 9 (Los Altos, CA: Packard Humanities Institute, 2008).

17. See John Butt, *Bach: Mass in B Minor* (Cambridge: Cambridge University Press, 1991), 19–20, and Butt, "Bach's Mass in B Minor: Considerations of Its Early Performance and Use," *Journal of Musicology* 9 (1991): 110–24. I'll return to C. P. E. Bach's engagement with the B Minor Mass late in life in chapter 7.

18. Richard Brilliant, *Portraiture* (Cambridge, MA: Harvard University Press, 1991), 7.

19. I discuss this at greater length in chapter 7.

20. Gerber, *Historisch-biographisches Lexikon* (1790), 1:283.

21. The caption to the woodcut of Dolet published in Nikolaus Reusner, *Icones sive imagines virorum literis illustrium* (Strasbourg: Jobin, 1587), concludes: "Musica turba dolet." This must have been the image owned by Bach, whose catalog entry simply offers the information: "*Doletus, (Steph.) Es heißt von seinem Tode: Musica turba dolet*" (*Nachlassverzeichniss*, 101). Reusner's information appears to be somewhat garbled: on the way to his death Dolet was said to have composed the punning lines "*Non dolet ipse Dolet, sed pia turba dolet.*" (It is not Dolet who grieves, but a pious crowd.) Gerber did not include Dolet in the first edition of his *Lexikon*; he appears only in the *Neues Lexikon*, 1:914–15. By then Gerber had thoroughly studied the inventory of Bach's collection, published in NV 1790.

22. Gerber, *Historisch-biographisches Lexikon*, 1:431–32, and *Neues Lexikon*, 2:173.

23. As Gerber pointed out, the author's first name had not, at first, widely circulated in Germany. Gerber, *Neues Lexikon*, 1:526–27.

24. Thomas Browne, *Religio Medici* (1645), 130.

25. "*Fordyce, (Miss)* Lautenistinn. Schwarze Kunst. 4. In goldenen Rahmen unter Glas." NV 1790, 103.

26. Gerber, *Historisch-biographisches Lexikon*, 1:424.

27. Indeed, the lute was old-fashioned by the second half of the eighteenth century.

28. "*Bastardella, (Lucret. Angujari, genant)* eine Sopranistinn. Von *Corbutt*. Gr. 8. In schwarzen Rahmen, unter Glas." NV 1790, 96.

29. The couple were based in Parma; the caricature puns on da Colla's name and that of a famous glue made in the city, "Colla da Parma."

30. The painting depicts Anne Bastard, née Worsley, who had married William Bastard of Kitley in 1754. See David Mannings, *Sir Joshua Reynolds: A Complete Catalogue of His Paintings* (New Haven, CT: Yale University Press, 2000), 2:79.

31. Some of these portraits are reproduced in this volume as follows: Caecilia, fig. 5.1; Benda, fig. 5.7; Huberty, fig. 2.8; Koch, fig. 5.8a; Mara, fig. 5.12; Mingotti, fig. 5.2; Müller, fig. 7.7. The paintings of Cuzzoni and Anna Magdalena Bach are lost, as is the caricature of Turcotti.

32. For Annibali, see fig. 2.15; Concialini, fig. 7.4; and Bedeschi, fig. 7.3. The caricatures of Reginelli and Bernacchi are lost.

33. "Giovannini, vorgegebner Graf St. Germain, componist und violinist. Von Thönert," NV 1790, 104.

34. Gerber, *Historisch-biographisches Lexikon*, 1:510.

35. "Mein Leser," front matter to *Sammlung verschiedener und auserlesener Oden zu welchen von den berühmtesten Meistern in der Musik eigene Melodeyen verfertiget worden*, vol. 4 (Halle, 1743).

36. See David Yearsley, *Sex, Death, and Minuets: Anna Magdalena Bach and Her Musical Notebooks* (Chicago: University of Chicago Press, 2019), 187–88. The Breitkopf catalog of 1762 also lists eight sonatas by Giovannini, now lost. See Ludwig Finscher, "Giovannini, de," in *MGG Online*, ed. Laurenz Lütteken (Kassel, Stuttgart, New York, 2016ff.; first published 2002, online publication 2016).

37. Ludwig Finscher, "Saint Germain, Graf von," in *MGG Online*.

38. Letter to Horace Mann, December 9, 1745. In W. S. Lewis et al., eds., *The Yale Edition of Horace Walpole's Correspondence* (New Haven, CT: Yale University Press, 1955), 19:181–82.

39. *Mémoires inédits de Madame la Comtesse de Genlis sur le dixhuitième siècle et la révolution francaise depuis 1756 jusqu'à nos jours* (Paris, 1825), 1:107.

40. Charles Burney, *A General History of Music from the Earliest Ages to the Present Period* (London, 1789), 4:452.

41. Gerber lists this mysterious figure as "Giovannini . . .—also played a role as the putative Count St. Germain." Gerber, *Neues Lexikon*, 2:332.

42. J. H. Calmeyer, "The Count of Saint Germain or Giovannini: A Case of Mistaken Identity," *Music and Letters* 48, no. 1 (January 1967): 4–16.

43. NV 1790, 124.

44. *Raccolta di XXIV Caricature / Disegnate colla penne dell Celebre / Cavalliere Piet. Leon. Ghezzi / Conservati nell Gabinetto di / Sua Maestà il Re di / Polonia Elett: di / Sassonia. / Matth: Oesterreich / Sculpsit | Dresdae / Nell Anno / MDCCL* and *Raccolta / de vari disegni / dell Cavalliero Pietro Leone Ghezzi / Romano / è di / Giovann Battista Internari / Romano / e di alcuni altri maestri / Incise in rame / da / Matteo Oesterreich / Hamgourghese / Potsdam 1766.*

45. The same print (without the number XIX) appeared in the second edition of the *Raccolta* (1766) as plate 4; in this volume the index gives a fuller account: "Il Signior _ Annibali, in Vesta di Cammera, Virtuoso di Sua Maestá il Ré di Polonia. Elettore di Sassonia." A different Ghezzi/Oesterreich caricature of Annibali, in which Annibali is formally dressed and is standing, was made in 1751 and bears the inscription "Virtuoso di Camera / Di Sua Maestà di Polonia Elettore di Sassonia / Il Disegno si conserva nell Reggio Gabinetto."

46. Clarke, *Letters*, 247.

47. The more detailed inscription runs: "Domenico con suo fratello Bresciani. Il primo, che é di Faccià suona mirabilmente il Colascioncino à due corde, e l'altro che é di Schiena, l'accompagnava con la Chitarra. Furono nel Mese di Aprile 1765; nell Palazze à Sans-souci, dove Sua Maestà il Ré di Prussia li intese ambedue à Sonare."

48. The drawing of the two brothers this engraving is based on was in the collection of the Saxon Count Brühl; an earlier version of the print appeared as plate 15 in *Recueil / de / Quelques Desseins . . . par | Matthieu Oesterreich / à Dresde, / . . . 1752.* See Giancarlo Rostirolla, *Il "mondo novo" musicale di Pier Leone Ghezzi* (Milan: Accademia nazionale di Santa Cecilia, 2001), 220. Burney recounts hearing street musicians in Naples playing the instrument in *The Present State of Music in France and Italy* (London: T. Becket, 1771), 297–98.

49. Ulrike Kollmar, *Gottlob Harrer (1703–1755), Kapellmeister des Grafen Heinrich von Brühl am sächsisch-polnischen Hof und Thomaskantor in Leipzig: Mit einem Werkverzeichnis und einem Katalog der Notenbibliothek Harrers*. Ständige Konferenz Mitteldeutsche Barockmusik 12 (Beeskow: Ortus Musikverlag, 2006), 41–43.

50. Kollmar, *Gottlob Harrer*, 43.

51. See Rostirolla, *Il "mondo novo" musicale*, 181–82 and 379–80.

52. Kollmar, *Gottlob Harrer*, 104–17. Harrer was even responsible for claiming rooms for himself

in the cantor's lodgings from J. S. Bach's widow, Anna Magdalena Bach, before the customary widow's grace period of a half year ("Gnadenhalbjahr") was up. Kollmar, *Gottlob Harrer*, 117.

53. That the question of identity was important is borne out by the information E. F. Chladni supplied in 1795 for Gerber's *Lexikon*: Chladni had clearly checked the volume's table of contents and explained that the violinist was named "Haar." "Beyträge zu dem Gerberschen Tonkünstler-Lexikon," in Heinrich Christoph Koch, *Journal der Tonkunst* (1795), 2:201.

54. Charles Burney, *The Present State of Music in Germany, the Netherlands, and United Provinces* (London: T. Becket, J. Robson, G. Robinson, 1773), 2:269.

55. Intervening publications were the *6 Leichte* ("Easy") *Sonaten*, Wq. 53, of 1766 and the *6 Sonates à l'usage des Dames*, Wq. 54, of 1770. Christopher Hogwood notes that the words "Erste Sammlung" were added to the title page only shortly before publication, suggesting that the notion that the volume was to be the first of a series may have come to Bach relatively late.

56. Burney, *Present State of Music in Germany, the Netherlands, and United Provinces*, 2:271.

57. Burney's overall assessment of Bach, we recall, was that he was "the best player in point of expression," whose works were more difficult to "*express* than to *execute*," a judgment borne out by the other works, with their detailed expression markings for the clavichord, published alongside this one in *Kenner und Liebhaber* I. Burney, *Present State of Music in Germany, the Netherlands, and United Provinces*, 2:270, 2:266 (Burney's emphasis).

58. See Peter Wollny, introduction to *Carl Philipp Emanuel Bach: Miscellaneous Keyboard Works II, Carl Philipp Emanuel Bach: The Complete Works*, ser. 1, vol. 8.2 (Los Altos, CA: Packard Humanities Institute, 2005), xviii: "A solfeggio thus served a pedagogical goal. . . . When the term was used to refer to instrumental music, it had approximately the meaning of 'etude,' a term not yet current during Bach's lifetime. The pieces were thus meant primarily to develop technical facility and accuracy."

59. Anthologized in the nineteenth century and repeatedly since, this solfeggio has been part of the training of countless piano students, making it (perhaps ironically) one of C. P. E. Bach's best-known works.

60. Burney, *Present State of Music in Germany, the Netherlands, and United Provinces*, 2:272.

61. While we have no conclusive evidence that Bach had a large-scale multivolume project in mind when he published the first volume for *Kenner und Liebhaber*, his recent *Clavierstücke mit veränderten Reprisen* ran to three volumes, and the publication of *Accompanied Sonatas*, begun in 1776, had also run to three sets. If there was no definite plan for a series in 1779, Bach would certainly have understood the possibility that future volumes might follow the first volume for *Kenner und Liebhaber*.

62. Arthur Bahr and Alexandra Gillespie, "Medieval English Manuscripts: Form, Aesthetics, and the Literary Text," *Chaucer Review* 47, no. 7 (2013): 358–59.

63. Bahr and Gillespie, "Medieval English Manuscripts," 359.

CHAPTER 4

1. Letter of August 9, 1777, in *The Letters of C. P. E. Bach*, ed. and trans. Stephen L. Clark (New York: Oxford University Press, 1997), 113 (translation modified). The German runs: "Und mein Lavatorisch Portrait, welches nach allgemeiner Beurtheilung, nichts weniger als getroffen ist u. mehr einen schlafenden als wachenden gleicht, haben Sie gesehen? Der gute Lavater raisonirt so bündig und gewiß, ohngeacht, was ich kenne u. gesehen habe, blos 2 Stück ziemlich getroffen sind, nehmlich Friedrich und Rameau." Ernst Suchalla, ed., *Carl Philipp Emanuel Bach Briefe und Dokumente: Kritische Ausgabe* (Göttingen: Vandenhoeck und Ruprecht, 1994), 647. "*Getroffen*"

is hard to translate, though crucial to these questions of likeness and characterization. Clark uses "characterized."

2. Johann Caspar Lavater, *Physiognomische Fragmente zur Beförderung der Menschenkenntnis und Menschenliebe* (Leipzig: Weidmanns Erben und Reich, 1775–78; reprint Hildesheim: Weidmann, 2002), 3:200.

3. Ibid.

4. Ibid.

5. Ibid.

6. Ibid. The translation of this last section is Paul Corneilson's, in Annette Richards, ed., *Carl Philipp Emanuel Bach: The Portrait Collection, Carl Philipp Emanuel Bach: The Complete Works*, ser. 8, vol. 4.1 (Los Altos, CA: Packard Humanities Institute, 2012), appendix B, 211.

7. Ibid. As if to echo and reinforce the dynamic inspiration so vigorously conveyed in Jomelli's portrait, Lavater includes at this point in the text a reduced outline version of the masterful Van Dyck portrait of an inspired Hendrik Liberti (an engraving of which was in the Bach collection; see fig. 1.12 above), with the comment, "What a ripe, voluptuous, yearning Physiognomy!"

8. See Barbara Maria Stafford, "From Brilliant Ideas to Fitful Thoughts: Conjecturing the Unseen in Late Eighteenth-Century Art," *Zeitschrift für Kunstgeschichte* 48 (Fall 1985): 329–64; and her *Body Criticism: Imaging the Unseen in Enlightenment Art and Medicine* (Boston: MIT Press, 1991).

9. Some 22,065 sheets are preserved today in the Austrian National Library. About 1,500 further leaves from Lavater's holdings are to be found at the Central Library in Zurich.

10. Karin Althaus, "Die Physiognomik ist ein neues Auge: Zum Portät in der Sammlung Lavater" (PhD diss., University of Basel, 2010), 7 and 9.

11. On the widespread acceptance of Lavater's theories in the later eighteenth century and throughout the nineteenth, see Joan K. Stemmler, "The Physiognomical Portraits of Johann Caspar Lavater," in *Art Bulletin* 75, no. 1 (March 1993): 151–68. For further studies on Lavater, see especially Gerda Mraz, "Musikerportraits in der Sammlung Lavater," in *Studies in Music History Presented to H. C. Robbins Landon on His Seventieth Birthday*, ed. Otto Biba and David Wyn Jones (London: Thames and Hudson, 1996), 165–76; Richard T. Gray, *About Face: German Physiognomic Thought from Lavater to Auschwitz* (Detroit: Wayne State University Press, 2004); Melissa Percival and Graeme Tytler, eds., *Physiognomy in Profile: Lavater's Impact on European Culture* (Newark: University of Delaware Press, 2005); Claudia Schmölders, ed., *Der exzentrische Blick: Gespräch über Physiognomik* (Berlin: Akademie Verlag, 1996); Ellis Shookman, ed., *The Faces of Physiognomy: Interdisciplinary Approaches to Johann Caspar Lavater* (Columbia, SC: Camden House, 1993).

12. See especially Georg Christoph Lichtenberg's *Über Physiognomik, wider der Physiognomen* (Göttingen, 1778). Lichtenberg hilariously satirized Lavater in his famous physiognomical fragment on pigtails—a spoof that devastatingly mimicked Lavater's pompous, almost incoherent, style while lambasting his readings. See Ernst Gombrich, "On Physiognomic Perception," in *Meditations on a Hobby Horse and Other Essays on the Theory of Art* (London: Phaidon, 1963), 45–55.

13. For more on Lavater and Kayser, see Ursula Caflisch-Schnetzler, "Genie und Individuum: Die Beziehung zwischen Philipp Christoph Kayser und Johann Caspar Lavater, gespiegelt am Genie-Gedanken der *Physiognomischen Fragmente*," in *Philipp Christoph Kayser (1755–1823): Komponist, Schriftsteller, Pädagoge, Jugendfreund Goethes*, ed. Gabriele Busch-Salmen (Hildesheim: Olms, 2007), 117–38.

14. Bach's engraving of Rameau was credited to Johann Georg Sturm, after Jean Jacques Caffieri's 1760 painting; the one published in Lavater was an almost identical engraving by Augustin de Saint Aubin, after the same painting and issued by the same publisher (Joulain);

the only significant difference was the addition of Rameau's death date (September 12, 1764) to the engraving issued by Sturm.

15. Lavater, *Physiognomische Fragmente* (Leipzig: Weidmanns Erben und Reich, 1775), 1:266.

16. See Eduard von der Hellen, *Goethes Anteil an Lavaters Physiognomischen Fragmenten* (Frankfurt am Main: Rütten & Loening, 1888), 110-112. See also Evelyn K. Moore, "Goethe and Lavater: A Specular Friendship," in *The Enlightened Eye: Goethe and Visual Culture*, ed. Evelyn K. Moore and Patricia Anna Simpson (Leiden: Brill, 2007), 165–91; and Mary Helen Dupree, "What Goethe Heard: Special Section on Hearing and Listening in the Long Eighteenth Century," in *Goethe Yearbook* 25 (2018): 6.

17. Lavater, *Physiognomische Fragmente*, 3:195. As C. P. E. Bach noted, Lavater expresses himself with great certainty; disarmingly, though, Lavater confesses here that although he in fact knows very little about music, his own real-life observations of musicians and musician portraits confirm his theory: "Is this really so? How dare I decide, since I know so few musicians, and don't even understand the slightest thing about music? This much I can say though, that what I have seen in nature and portrait, up to now, appears to confirm my intuitions on this." Lavater, *Physiognomische Fragmente*, 3:193.

18. Hinting at the limitations of the *Physiognomische Fragmente*'s reliance on portraiture, Lavater admitted he had not yet completed his study of musicians' ears, partly because he was working from engraved portraits in which, for the most part, the ear is not drawn clearly enough (or is often hidden by hair or a wig). Lavater, *Physiognomische Fragmente*, 3:127, 3:198.

19. Lavater, *Physiognomische Fragmente*, 3:195.

20. Carl Ludwig Junker, "Charakteristische Vorstellung des einzelnen Menschen Porträt," in *Betrachtungen über Mahlerey, Ton- und Bildhauerkunst* (Basel: Karl August Serini, 1778), 33.

21. Junker, "Charakteristische Vorstellung," 24.

22. Junker, "Charakteristische Vorstellung," 31.

23. The subtext here is that, countering the traditional critique of the genre, portraiture is more than simple imitation, and an art that does not necessarily pander to the desires of the sitter.

24. Junker, "Charakteristische Vorstellung," 67.

25. Junker, "Charakteristische Vorstellung," 88; emphasis mine.

26. "Karl Avison's Versuch über den musikalischen Ausdruck: Aus dem Englischen übersetzt, . . ." in *Musikalisch-kritische Bibliothek*, ed. Johann Nikolaus Forkel (Gotha, 1778), 2:142–65. C. P. E. Bach knew and admired Forkel's *Musikalisch-kritische Bibliothek* and owned all three volumes.

27. Johann Georg Sulzer, *Allgemeine Theorie der schönen Künste* (Leipzig: Weidmanns Erben und Reich, 1774), s.v. "Mahlerey" (Redende Künste; Musik), 2:739. Translation adapted from *Aesthetics and the Art of Musical Composition in the German Enlightenment: Selected Writings of Johann Georg Sulzer and Heinrich Christoph Koch*, ed. and trans. Thomas Christensen and Nancy Kovaleff Baker (Cambridge: Cambridge University Press, 1996), 89–90.

28. Ibid. Sulzer goes on to register the typical anxieties of the age with regard to the problem of language and the indeterminacy of instrumental music, borrowing from the debates played out in the 1750s in Marpurg's *Historisch-kritische Beyträge* and perhaps at his own dinner table: strikingly effective musical painting is really possible only "when music is accompanied by poetry, by which the painting whose effect is sensed by the ear also presents itself to our imagination."

29. François Couperin, preface to *Pièces de clavecin*, book 1 (1713). Translation from Darrell Berg, "C. P. E. Bach's Character Pieces and His Friendship Circle," in *C. P. E. Bach Studies*, ed. Stephen L. Clark (Oxford: Clarendon Press, 1988), 18. Darrell Berg's essay is still the standard work on C. P. E. Bach's character pieces, and I am indebted to her here, though my interest ranges beyond the questions of identity and character that are her main focus, to the problem of time. I presented an early version of parts of this chapter as "The Poetry of the Moment:

C. P. E. Bach and the Musical Portrait" at the American Musicological Society meeting in Washington, DC, in November 2005, and as "Picturing the Moment in Sound: C. P. E. Bach and the Musical Portrait," Peter Le Huray Memorial Keynote Lecture, at the Annual Meeting of the Royal Musical Association in Nottingham, England, in July 2006. Some similar ideas, and readings of the pieces discussed below are to be found in the essay published soon afterward by Joshua Walden, "Composing Character in Musical Portraits: Carl Philipp Emanuel Bach and L'Aly Rupalich," *Musical Quarterly* 91 (Fall 2008): 379–411.

30. F. W. Marpurg, *Historisch-kritische Beyträge zur Aufnahme der Musik* (Berlin: G. A. Lange, 1754), 1:32ff.

31. Marpurg, *Historisch-kritische Beyträge*, 1:32ff. The English translation is from Charles Batteux, *A Course of the Belles Lettres, or The Principles of Literature . . . by Mr. Miller* (London, 1761), 1:181. There was enormous interest in Batteux in 1750s Berlin: the German translation by Ramler, first published in 1756–58, was swiftly followed by an expanded second edition, and a third.

32. Christian Gottfried Krause (XYZ, pseud.), "Vermischte Gedanken, welche dem Verfasser der Beyträge zugeschicket worden," in Marpurg, *Historisch-kritische Beyträge* (Berlin, 1756): 2:214.

33. Krause, "Vermischte Gedanken, von dem Verfasser der musikalischen Poesie," in Marpurg, *Historisch-kritische Beyträge*, vol. 3, no. 6 (Berlin, 1758), 533. Several of Marpurg's and Krause's colleagues heeded their call: character pieces appeared in numerous Berlin anthologies in the late 1750s and early 1760s by composers who included C. P. E. Bach, Marpurg, C. F. C. Fasch, J. P. Kirnberger, C. Nichelmann, C. F. Schale, and J. O. Uhde. See Bernhard R. Appel, "Charakterstück," in *MGG*, 2nd ed., ed. Ludwig Finscher (Kassel: Bärenreiter, 1995-), Sachteil, vol. 2, cols. 636–42. See also Arnfried Edler, "Das Charakterstück Carl Philipp Emanuel Bachs und die französische Tradition," in *Aufklärungen 2. Studien zur deutsch-franzözischen Musikgeschichte im 18. Jahrhundert: Einflüsse und Wirkungen*, ed. Wolfgang Birtel and Christoph-Hellmut Mahling (Heidelberg: Winter, 1986), 219–35.

34. Krause, "Vermischte Gedanken, von dem Verfasser der musikalischen Poesie," 534.

35. Krause, "Vermischte Gedanken, von dem Verfasser der musikalischen Poesie," 536.

36. Contemporary critics used a considerable range of terms for this kind of painting, now normally termed "genre" painting, including *petits sujets galants*, and *petits sujets naïfs*. See Colin B. Bailey, "Das Genre in der französischen Malerei des 18. Jahrhunderts: Ein Überlick," in *Meisterwerke der Französischen Genremalerei im Zeitalter von Watteau, Chardin und Fragonard*, ed. Colin B. Bailey, Philip Conisbee, and Thomas W. Gaehtgens (Berlin: DuMont, 2004), 2–39.

37. See Christoph Martin Vogtherr, "Frédéric II de Prusse et sa collection de peintures françaises: Thèmes et perspectives de recherche," in *Poussin, Watteau, Chardin, David . . . : Peintures françaises dans les collections allemandes XVIIe-XVIIIe siècles* (Paris: Galeries Nationales du Grand Palais, 2005), exhibition catalog, 89–96.

38. "[Chardin] chooses the simplest, most naïve subjects. . . . He knows how to capture attitudes and characters. . . . It is this, in my opinion, that makes his paintings so popular." Pierre-Jean Mariette, *Abécédario*, 1749. Quoted in Pierre Rosenberg, *Chardin, 1699–1779* (Bloomington: Indiana University Press, 1979), Cleveland Museum of Art, exhibition catalog, 81.

39. Abbé Jean-Bernard le Blanc, *Observations sur les ouvrages de M. M. de l'Académie de peinture et de sculpture* (Paris, 1753), 23–25. Translation in Rosenberg, *Chardin*, 82.

40. Ibid., 47–50.

41. René Demoris, "La nature morte chez Chardin," *Revue d'esthétique* 4 (1969): 369, 377–78, 383–84. Translation from Rosenberg, *Chardin*, 95–96. See also Norman Bryson, *Word and Image: French Painters of the Ancien Régime* (Cambridge: Cambridge University Press, 1981); Bryson, "Chardin and the Text of Still Life," *Critical Inquiry* 15 (1989): 227–52; Thomas Crow, *Painters and Public Life in 18th-Century Paris* (New Haven, CT: Yale University Press, 1985);

and Michael Baxandall, *Shadows and Enlightenment* (New Haven, CT: Yale University Press, 1995).

42. See Christian Ludwig von Hagedorn, *Lettre à un amateur de la peinture* (Dresden: George Conrad Walther, 1755), 24–26. The inclusion of a self-portrait of the artist, as if to sign for the whole series, was not unprecedented. Just a few years earlier, in 1749 Hogarth had issued an engraving of his self-portrait painted in 1745 to function as the frontispiece to the bound collections of his prints. Goya would do the same with the publication of the *Caprichos* (1799). Hogarth and Goya were thinking in terms of publication, however, while Rotari was staging the actual visit to the gallery. I should also mention here the work of the Austrian sculptor Franz Xaver Messerschmidt (1736–83), whose extraordinary series of "character heads," most likely self-portraits, explores the grotesque transformations of the face under the influence of varying emotions. While Messerschmidt's work was little known outside Vienna and would not have been familiar to C. P. E. Bach, it may well have been known to Haydn. See Annette Richards, "Haydn's London Trios and the Rhetoric of the Grotesque," in *Haydn and the Performance of Rhetoric*, ed. Tom Beghin and Sander Goldberg (Chicago: University of Chicago Press, 2007), 278–79.

43. Gregor J. M. Weber, "Die Gemälde Pietro Graf Rotaris für den Sächsischen Hof," in *Pietro Graf Rotari in Dresden*, ed. Gregor J. M. Weber (Emsdetten: Imorde, 1999), 32. See also exhibition catalog for *Ceci n'est pas un portrait: Figures de fantaisie de Murillo, Fragonard, Tiepolo . . .* Musée des Augustins, Toulouse, November 21, 2015—March 6, 2016.

44. Weber, *Pietro Graf Rotari in Dresden*, 43–45. Le Brun was also an important source for Lavater, whose first plate in the *Physiognomische Fragmente* showed a collection of heads taken from his work. See Ross Woodrow, "Lavater and the Drawing Manual," in *Physiognomy in Profile: Lavater's Impact on European Culture*, ed. Melissa Percival and Graeme Tytler (Newark: University of Delaware Press, 2005), 71–93, and Deanna Petheridge and Ludmilla Jordanova, *The Quick and the Dead: Artists and Anatomy* (London: Hayward Gallery and Arts Council of Great Britain, 1997), exhibition catalog, 66. Le Brun's ideas were based in the notion that physical and facial expressions reflected the inner state—they were essentially physiognomical. One of the later Italian editions of Le Brun was dedicated to Rotari.

45. Weber, *Pietro Graf Rotari in Dresden*, 44.

46. Weber, *Pietro Graf Rotari in Dresden*, 46. For more on absorption see Michael Fried, *Absorption and Theatricality: Painting and Beholder in the Age of Diderot* (Chicago: University of Chicago Press, 1980).

47. The print was made between 1726 and 1731. The engraver has reversed the original image, so that Rebel appears to be writing with his left hand while the right hand plays; in the original drawing it is clear that Rebel is right-handed. The engraving is based on a portrait in charcoal and red chalk by Jean Antoine Watteau (1684–1721), made about 1710 and held at the Musée National Magnin in Dijon.

48. On the early eighteenth-century Parisian salon pastime of sketching literary portraits extempore, which spread to London in midcentury, see Benedetta Craveri, *The Age of Conversation*, trans. Teresa Waugh (New York: New York Review of Books, 2005), and Elizabeth Fay, *Fashioning Faces: The Portraitive Mode in British Romanticism* (Durham: University of New Hampshire Press, 2010), 35: "As elites found pleasure in creating verbal or visual sketches of each other for private or public circulation, a new consciousness arose concerning personality, especially its quirks and indiscretions, and surprises beneath the decorous surface."

49. As Peter Wollny has pointed out, Bach included other short single-movement pieces under this designation in his catalogs of his works—both the 1772 *Clavierwerkverzeichniss* and the 1790 *Nachlassverzeichniss*—not confining his use of *petites pièces* to pieces with titles. See Peter Wollny, ed., *Carl Philipp Emanuel Bach: Miscellaneous Keyboard Works II*, Carl Philipp Emanuel Bach: The Complete Works ser. 1, vol. 8.2 (Los Altos, CA: Packard Humanities Institute, 2005),

xv; and Christopher Hogwood, ed., *Carl Philipp Emanuel Bach: 23 Pièces characteristiques* (Oxford: Oxford University Press, 1989), introduction. Also useful is Ingeborg Allihn, "Die Pièces caractéristiques des C. P. E. Bach—ein Modell für die Gesprächskultur in der zweiten Hälfte des 18. Jahrhunderts," in *Carl Philipp Emanuel Bach—Musik für Europa*, ed. Hans-Günter Ottenberg (Frankfurt/Oder: Konzerthalle C. P. E. Bach, 1998), 94–107. Tom Beghin also addresses the question of "character" and "caricature" in the liner notes to his 2002 CD, *C. P. E. Bach: Pièces de caractère* (Eufoda 1347). For a wider consideration of "characteristic" music see Richard Will, *The Characteristic Symphony in the Age of Haydn and Beethoven* (Cambridge: Cambridge University Press, 2001).

50. "Ueber die Gemeinnützigkeit der Musik," *Ephemeriden der Menschheit* 6 (June 1784): 648. Translation from Berg, "C. P. E. Bach's Character Pieces," 7.

51. The suggestion is made by both Hogwood and Wollny.

52. See Johanna Geyer-Kordesch, *Pietismus, Medizin und Aufklärung in Preußen im 18. Jahrhundert: Das Leben und Werk Georg Enst Stahls* (Tübingen: Niemeyer, 2000), esp. 180–200.

53. See Berg, "C. P. E. Bach's Character Pieces," 7.

54. Darrell Berg hears Gleim as "urbane and slightly hypochondriacal" ("C. P. E. Bach's Character Pieces," 25). "This deceptively gentle piece," she writes, "has a piquant harmonic style unlike that of any of Bach's other works" (12). There is a "harmonic cloudiness" to it: the first four couplets all share a harmonic style characterized by "simple underlying harmony garnished with a surface containing many pungent unresolved dissonances" (12).

55. Berg, "C. P. E. Bach's Character Pieces," 12.

56. See Peter Wollny, ed., *Carl Philipp Emanuel Bach: Miscellaneous Keyboard Works II*, *Carl Philipp Emanuel Bach: The Complete Works*, ser. 1, vol. 8.2 (Los Altos, CA: Packard Humanities Institute, 2005), introduction.

57. Joshua Walden has suggested that this piece might be understood as a self-portrait of the composer or a portrait of a member of the Bach family, in the act of composition; though David Schulenberg argues that "the piece illustrates none of the devices associated with the arts of composition in Bach's circle." See Walden, "Composing Character," and David Schulenberg, *The Music of Carl Philipp Emanuel Bach* (Rochester, NY: University of Rochester Press, 2014), 135. Darrell Berg has surmised that "L'Aly Rupalich" may have been a cryptic reference to Karl Wilhelm Ramler (see her "Bach's Character Pieces," 31). In the preface to his edition of the Character Pieces, Christopher Hogwood notes the alternative title "La Bach" and draws attention to the possible Turkishness of the name and its characterization.

58. One could cite Haydn as a close second in this.

59. Bach left only one direct clue to the interpretation of his titles, explaining, according to C. F. Cramer, that "La Pott" was a musical description of the man's gait ("der Gang des Mannes"); from the fine traces of emotion registered in the face, we are presented here with character expressed on the large scale in the motions of the whole body. See C. F. Cramer, *Magazin der Musik* 1, nos. 9–10 (September-October 1783): 1179. See also Wollny, *Carl Philipp Emanuel Bach*, xvi.

60. Johann Georg Sulzer, *Allgemeine Theorie der schönen Künste* (Leipzig: Weidmanns Erben und Reich, 1774), 2:919.

61. Sulzer, *Allgemeine Theorie*, 919.

62. Sulzer, *Allgemeine Theorie*, 919.

63. Sulzer, *Allgemeine Theorie*, 918–19.

64. Lavater, *Von der Physiognomik*, First Section (Leipzig: Weidmanns Erben und Reich, 1772), 54–55.

65. Lavater, *Von der Physiognomik*, 68–69.

66. Letter from Matthias Claudius to H. W. von Gerstenberg, Hamburg, July 5, 1768; Suchalla, *Briefe*, 149. This exchange over the character piece, and characterization, between Claudius,

Bach, and Gerstenberg is discussed at length in Tobias Plebuch, "Dark Fantasies and the Dawn of the Self: Gerstenberg's Monologues for C. P. E. Bach's C-Minor Fantasia," in *C. P. E. Bach Studies*, ed. Annette Richards (Cambridge: Cambridge University Press, 2006), 25–66; see also Eugene Helm, "The Hamlet Fantasy and the Literary Element in C. P. E. Bach's Music," *Musical Quarterly* 58 (1972): 277–96; Laurenz Lütteken, *Das Monologische als Denkform in der Musik zwischen 1760 und 1785* (Tübingen: Niemeyer, 1998); and Annette Richards, *The Free Fantasia and the Musical Picturesque* (Cambridge: Cambridge University Press, 2001).

67. Letter from Gerstenberg to Bach, late September 1773; Clark, *Letters*, 39 (and Suchalla, *Briefe*, 322–35). Translation modified from Clark.

68. Ibid., 39–40.

69. Clark, *Letters*, 40–41.

70. Letter of October 21, 1773, in Clark, *Letters*, 41–42.

71. Ibid.

CHAPTER 5

1. "Caecilia, Sancta, schön gezeichnet von Kniep. Fol. In goldenen Rahmen, unter Glas." NV 1790, 98.

2. Charles Burney, *The Present State of Music in Germany, the Netherlands, and United Provinces* (London: T. Becket, J. Robson, G. Robinson, 1773), 2:272.

3. Burney, *Present State of Music*, 2:271. Burney reported that C. P. E. Bach expressed distaste for the contemporary taste for the comic in music, dismissing, for example, the music of Baldassare Galuppi.

4. Johann Georg Sulzer, *Allgemeine Theorie der schönen Künste* (Leipzig: Weidmanns Erben und Reich, 1774), s.v. "Zeichnung; Handzeichnung," 2:1284.

5. F. J. L. Meyer, *Skizzen zu einem Gemälde von Hamburg: Von dem Verfasser der Darstellungen aus Italien* (Hamburg: Nestler, 1801), 3:301. Quoted in Anke Fröhlich, *Zwischen Empfindsamkeit und Klassizismus: Der Zeichner und Landschaftsmaler Johann Sebastian Bach der Jünger (1748–1778)* (Leipzig: Evangelische Verlagsanstalt/Bach-Archiv, 2007), 34.

6. See above, chapter 4.

7. The drawing previously identified as that of Buffardin (D-B Mus. P. Buffardin III, 1) has recently been shown to represent not Buffardin but Johann Gotthilf Ziegler. J. S. Bach's portrait of Buffardin is D-B Mus. P. Buffardin I, 1. See Kristina Funk-Kunath, "Spurensuche: Ein unbekanntes Porträt von Pierre Gabriel Buffardin," in *Bach-Jahrbuch* 104 (2018): 225–34.

8. See Maria Hübner, "Johann Sebastian Bach d.j.: Ein biographischer Essay," in Fröhlich, *Zwischen Empfindsamkeit und Klassizismus*, 13–32.

9. The *Nachlassverzeichniss* lists drawings by Adam Friedrich Oeser, Abraham Bloemaert, Jacopo da Palma, the Dresden history painter and director of the Academy Giovanni Battista Casanova, the Frankfurt landscape painter Franz Schütz, and the Berlin painter Bernhard Rode, as well as many works by J. S. Bach.

10. Meyer, *Skizzen*, 305–6. Leading German artists represented in Meyer's album included Angelika Kaufmann, Adam Friedrich Oeser, Johann Heinrich Wilhelm Tischbein, Johann Heinrich Lips, Johann Friedrich Bause, Daniel Chodowiecki, and Christian Heinrich Kniep. J. S. Bach the Younger, who was twelve years Friedrich Johann Lorenz's senior, was also represented in the collection.

11. Ibid., 306–7. Meyer's album, and the room in which it was kept, constituted a shrine to friendship, like Voltaire's "chambre de coeur" (chamber of the heart), hung with carefully arranged portraits of friends, each with its own inscription beneath, which had been made public

in 1781 in an engraving of Voltaire's deathbed by François-Denis. For more on this see Roland Kanz, *Dichter und Denker im Portrait: Spurengänge zur deutschen Porträtkultur des 18. Jahrhunderts* (Munich: Deutscher Kunstverlag, 1993), 124.

12. The visit to Hamburg is described in *Vor hundert Jahren: Elise von der Reckes Reisen durch Deutschland, 1784–86, nach dem Tagebuche ihrer Begleiterin Sophie Becker*, ed. G. Karo and M. Geyer (Stuttgart: Spemann, n.d.), 203 and 207. For an early nineteenth-century engraving of Elisa von der Recke's Dresden salon and portrait collection, see Reimar F. Lacher, "Carl Philipp Emanuel Bach als Porträtsammler," in *Carl Philipp Emanuel Bach im Spannungsfeld zwischen Tradition und Aufbruch*, ed. Christine Blanken and Wolfram Enßlin (Hildersheim: Olms, 2016).

13. F. J. L. Meyer, *Darstellungen aus Italien* (Berlin: Voss, 1792), 155.

14. Meyer, *Darstellungen*, 156.

15. Meyer, *Darstellungen*, 156–57.

16. *The Letters of C. P. E. Bach*, ed. and trans. Stephen L. Clark (New York: Oxford University Press, 1997), 218 (translation modified).

17. Ernst Suchalla, ed., *C. P. E. Bach Briefe und Dokumente* (Göttingen: Vandenhoeck und Ruprecht, 1994), 2:1069; Clark, *Letters*, 225. Bach appears not to have received these drawings, for neither Eschenburg's nor the Reinagles' appears in the estate catalog.

18. As Reimar Lacher reminds us, Bach usually asked for portraits from the musicians themselves—expecting them to find an artist—rather than himself directly commissioning the artist. See Reimar F. Lacher, "Carl Philipp Emanuel Bach als Porträtsammler," 345.

19. Carl Ludwig Junker, "Charakteristische Vorstellung des einzelnen Menschen Porträt," *Betrachtungen über Mahlerey, Ton- und Bildhauerkunst* (Basel: Karl August Serini, 1778), 31.

20. Kanz, *Dichter und Denker*, 54.

21. Kanz, *Dichter und Denker*, 54.

22. Kanz, *Dichter und Denker*. The invitation is similar to the moment in Laurence Sterne's *Tristram Shandy* when the reader (presumed to be male) is presented with a blank page and invited to draw the Widow Wadman from his imagination: Chapter 38: "To conceive this right,—call for pen and ink—here's paper ready to your hand.—Sit down, Sir, paint her to your own mind—as like your mistress as you can—as unlike your wife as your conscience will let you—'tis all one to me—please put your fancy in it" (Laurence Sterne, *The Life and Opinions of Tristram Shandy, Gentleman* [London: D. Lynch, 1761], 2:565–66).

23. On Gleim and his Freundschaftstempel see Kanz, "Porträtgalerie und Freundschaftstempel," in *Dichter und Denker*, 121ff. See also Diana Stört, *Johann Wilhelm Ludwig Gleim und die gesellige Sammlungspraxis im 18. Jahrhundert* (Hamburg: Kovac, 2010); Reimar Lacher, *Von Mensch zu Mensch: Porträtkunst und Porträtkultur der Aufklärung* (Göttingen: Wallstein, 2010); Ute Pott, ed., *Das Jahrhundert der Freundschaft: Johann Wilhelm Ludwig Gleim und seine Zeitgenossen* (Göttingen: Wallstein, 2004); Horst Scholke, *Der Freundschaftstempel im Gleimhaus zu Halberstadt: Porträts des 18. Jahrhunderts*. Bestandskatalog (Halberstadt: Gleimhaus, 2000).

24. Scholke, *Freundschaftstempel*, 157–58.

25. Scholke, *Freundschaftstempel*, 44. Quoted by Scholke (though Scholke deletes the bit about kissing) from Carl Schüddekopf, ed., *Briefwechsel zwischen Gleim und Ramler* (Tübingen 1906–7), 1:342–43. Scholke suggests that this portrait may have been the basis for the Kauke engraving of 1759 (the print Bach owned).

26. Scholke, *Freundschaftstempel*, 44.

27. Scholke, *Freundschaftstempel*, 46.

28. Heinrich Düntzer and Ferdinand Gottfried von Herder, *Von und an Herder: Ungedruckte Briefe aus Herders Nachlaß* (Leipzig: Dyk'sche Buchhandlung, 1861), 1:113. Quoted in Gerlinde Wappler, "Freundschaft und Musik: Gleims Musikerfreunde Carl Philipp Emanuel Bach und

Johann Friedrich Reichardt," in *Das Jahrhundert der Freundschaft*, ed. Ute Pott (Göttingen: Wallstein, 2004), 73.

29. Letter from Gleim to Johann Peter Uz (August 29, 1751), in Suchalla, *C. P. E. Bach Briefe und Dokumente*, 59. See also Wappler, "Freundschaft und Musik," 72.

30. Oddly, though, there is no trace in the Gleimhaus collection of any letters from Bach among about ten thousand letters from about four hundred different people, although letters certainly passed between them.

31. Quoted in Scholke, *Freundschaftstempel*, 51.

32. It was on this trip that Graff met his future wife, Sulzer's daughter.

33. Quoted in Kanz, *Dichter und Denker*, 158.

34. Various portraits from the Reich gallery appeared as frontispieces to the *Neue Bibliothek der schönen Wissenschaften und der freyen Künste*, ed. Christian Felix Weisse.

35. See Lacher, "Carl Philipp Emanuel Bach als Porträtsammler," 341.

36. *Hamburg unpartheyische Correspondent* 1783, no. 25 (February 12, 1783): 7. In Barbara Wiermann, ed., *C. P. E. Bach: Dokumente zu Leben und Wirken aus der Zeitgenössischen Hamburgischen Presse (1767–1790)* (Hildesheim: Olms, 2000), 104. See also Leta Miller, "C. P. E. Bach and Friedrich Ludwig Dülon: Composition and Improvisation in Late 18th-Century Germany," *Early Music* 23 (1995): 65–80, and John A. Rice, "The Blind Dülon and His Magic Flute," *Music and Letters* 71 (1990): 25–51.

37. Bach's inventory entry runs: "*Dulon, (Friedlieb Lud.) ein blinder Flötenist. Gezeichnet von Karstens. 8. In schwarzen Rahmen, unter Glas.*" *Nachlassverzeichniss*, 101. The autobiographical account is in C. M. Wieland, ed., *Dülons des blinden Flötenspielers Leben und Meynungen von ihm selbst bearbeitet* (Zurich, 1807–8), 1:319–21, 326ff.

38. Wieland, *Dülons des blinden Flötenspielers Leben*, 319.

39. Wieland, *Dülons des blinden Flötenspielers Leben*, 320.

40. Wieland, *Dülons des blinden Flötenspielers Leben*, 321. The discrepancy between the catalog's description of the portrait as a drawing and Dülon's referring to a "painting" throughout his account may be because Dülon, being blind, had not seen the picture himself. Or the drawing may have been done in colored chalks (pastels)—a medium sometimes referred to as drawn, sometimes as painted (see below regarding Paradis).

41. The identification of the artist is made by Lacher in "Carl Philipp Emanuel Bach als Porträtsammler," 348–49. The drawing was eventually acquired by the collector Georg Poelchau and entered the Berlin State Library with his other holdings.

42. Carl Ludwig Fernow, *Carstens: Leben und Werke*, ed. and enl. Herman Riegel (Hanover: Carl Rümpler, 1867), 69. See Lacher, "Carl Philipp Emanuel Bach als Porträtsammler," 348.

43. Carl Friedrich Cramer, ed., *Magazin der Musik* (Hamburg: Musicalischen Niederlage, 1783; reprint Hildesheim: Olms, 1971), 1:508; in response to an article in the *Unpartheyisches Schreiben über den gegenwärtigen Zustand des deutschen Theaters* (1783). See Wiermann, *C. P. E. Bach: Dokumente*, 109.

44. On the identification of "Hardrich" as Herterich, see Lacher, "Carl Philipp Emanuel Bach als Porträtsammler," 347.

45. Madame Benda was a popular subject for Hamburg artists; a drawing of her by Bach's friend Andreas Stöttrup, dating from 1782, is in the collection of the Hamburg Kunsthalle (Inv. Nr. 24275).

46. Letter to Breitkopf, May 13, 1780. Clark, *Letters*, 161.

47. See above, chapter 3.

48. Ernst Ludwig Gerber, *Historisch-biographisches Lexikon der Tonkünstler* (Leipzig: Breitkopf, 1790), 1:820–21.

49. C. F. D. Schubart, *Ideen zu einer Ästhetik der Tonkunst* (Stuttgart: Scheible, 1839), 69–70.

50. *Hamburg unpartheyische Correspondent* 1775, no. 20 (February 4, 1775): 4, in Wiermann, *C. P. E. Bach: Dokumente*, 88.

51. NV 1790, 125.

52. See Lacher, 347.

53. Information on Walter comes from *Dansk biografisk Leksikon*, 3rd ed. (Copenhagen: Gyldendal, 1984), 16:237–38, and Bertil van Boer, *Historical Dictionary of Music of the Classical Period* (Lanham, MD: Scarecrow, 2012), 592.

54. Walter went on to Italy and to Bologna, where in 1776 he met, and perhaps took lessons from, Padre Martini. In 1778 Angelo Crescimbeni made an impressive oil painting of him (which survives there today) for Padre Martini's collection. See Lorenzo Bianconi et al., *I Ritratti del Museo della Musica di Bologna* (Florence: Leo S. Olschki Editore, 2018), 473–76.

55. A similar claim can be made about Bach's small collection of silhouettes, listed after the portrait collection in the catalog of his estate. My point here, though, is that while printed silhouettes, like engravings, were already in circulation, drawings had to specially commissioned, by either the sitter or the collector.

56. Inventoried in NV 1790, 122.

57. [Becker], *Vor hundert Jahren*, 208. Performers at the concert included Stamitz and Minna Brandes, who played a harpsichord concerto.

58. NV 1790, 116. The artist was probably N. Schubart, who settled in Hamburg about 1786 and made a reputation there as a miniature painter as well as a portraitist in oils and pastels. See Tobias Biehler, *Über Miniaturmalereien: Mit Angaben vieler Künstler und Hofbibliotheken* (Vienna: Zamarski und Dittmarsch, 1861), 80.

59. See Manfred Schmid, "Das Geschäft mit dem Nachlaß von C. Ph. E. Bach: Neue Dokumente zur Westphal-Sammlung des Conservatoire Royal de Musique und der Bibliothèque royale de Belgique in Brüssel," in *C. P. E. Bach und die europäische Musikkultur des mittleren 18. Jahrhunderts*, ed. Hans Joachim Marx (Göttingen: Vandenhoeck und Ruprecht, 1990), 524. In a set of draft pages for a catalog for his own portrait collection, now in the library of the Koninklijk Conservatorium, Brussels, Westphal noted that the portrait was in pastels (colored chalk), "NB: not drawn, but painted in pastels by Schubart" ("nicht gezeichnet, sondern in Pastell gemahlt von Schubart"). Westphal uses the word "painted" (*gemahlt*), but pastels are largely classified in this collection as drawings.

60. Cramer, *Magazin der Musik*, 1:662.

61. C. N. Schnittger, *Erinnerungen eines alten Schleswigers* (1904), 278.

62. Cramer, *Magazin der Musik*, 1:663n.

63. Cramer, *Magazin der Musik*, 1:663n.

64. Schnittger, *Erinnerungen*, 137.

65. But finally, and perhaps of greatest interest to the collector and archivist, he eventually made a great project of publishing the history of the city of Schleswig (updating the chronicle of Heldauer from 1603), collecting all the materials he could find on the city and state, amassing a library of about one thousand volumes, along with a collection of coins, a mineral collection, and a collection of copperplate engravings. So well known was he that any person of standing passing through Schleswig would pay him a visit. Schnittger, *Erinnerungen*, 137–39.

66. NV 1790, 108. The drawing is to be found today in the Berlin State Library; an annotation on the back identifies the sitter as "Jurgensen Instrumentenmacher in Hollstein" and continues, "Aus der [unreadable word] Sammlung," where the unreadable word must be "Bachschen." The library's card catalog erroneously transcribes this as "Aus der Sammlung Hollstein."

67. On Jens Juel and Kniep, see Georg Striehl, *Der Zeichner Christoph Heinrich Kniep (1755–1825)* (Hildesheim: Olms, 1998), 32. Striehl appears not to have known of the drawing of Jürgensen, nor of Kniep's connection to C. P. E. Bach. He dates Kniep's drawing of Saint Cecilia to "before

1782"; given Kniep's close contact with the Bach circle, and the presence of his work in the Bach collection, I would suggest that we can more closely date the drawing to Kniep's stay in Hamburg, 1778–1780, likely toward the end of that period. Kniep left the city during the later part of 1780. The face of the female figure at the keyboard is strikingly similar to the beautifully drawn face of an unnamed woman Kniep entered into the *Stammbuch* of the Norwegian Jakob Hersleb in Berlin on December 24, 1780. Striehl suggests that this drawing represents an ideal female beauty, but it could surely have been based on a woman both Kniep and Hersleb had met in Hamburg, perhaps a female musician (Hersleb was in Hamburg in November of that year, when Klopstock wrote an entry into his Stammbuch [Striehl, 3]). The drawing is reproduced in Striehl, *Der Zeichner Christoph Heinrich Kniep*, 33.

68. C. F. C. Haller, "Christoph Heinrich Kniep, Zeichner und Professor an der Königlischen Akademie der schönen Künste in Neapel," *Kunst-Blatt: Morgenblatt für gebildete Stände* (Stuttgart, 1825), 6:261; quoted in Striehl, *Der Zeichner Christoph Heinrich Kniep*, 2.

69. Kniep's portrait of Ebeling, engraved by Chodowiecki, was a late addition to Bach's collection.

70. Striehl, *Zeichner Christoph Heinrich Kniep*, 357. The portrait of Meyer is reproduced in Striehl, 31.

71. Engraved portraits of both would appear on the frontispiece of their joint *Geistliche Gesänge*, 1780 and 1781, W. 197 and W. 198. The miniature Bach portraits on both frontispieces are rather poor, though an improved version was issued for the 1781 volume, but Stöttrup's excellent drawing of Bach (in all his portly late-life presence), on which they were based, was engraved and issued separately (see fig. 7.15).

72. "*Mara, (Mad. Elis.)* Sängerinn. Gezeichnet von *L. A. Abel*. Kl. 4. In schwarzen Rahmen, mit goldenem Stäbchen unter Glas" (NV 1790, 111); "*Abel, (Leopold August)* Violinist in Ludwigslust. Von ihm selbst gezeichnet. Gr. 4. In schwarzen Rahmen mit goldenem Stäbchen unter Glas" (NV 1790, 92–93).

73. See Josef Sittard, *Geschichte des Musik- und Concertwesens in Hamburg vom 14. Jahrhunderts bis auf die Gegenwart* (Altona: Reher, 1890), 157.

74. The Mara portrait, like many others from Bach's collection, was eventually acquired by Georg Poelchau; on this one Poelchau wrote not his usual annotation "aus der Bachschen Sammlung," but "gezeichnet . . . für die Bachsche Sammlung"—an indication that Poelchau understood that portrait drawings like these were indeed made specifically for Bach's collection.

75. "*Abel (Carl Fried.)*, Violdigambist in London. Gezeichnet von *E. H. Abel*, 1786. Gr. 4. In schwarzen Rahmen mit goldenem Stäbchen, unter Glas" (NV 1790, 93).

76. Clark, *Letters*, 19.

77. The prices were marked into Westphal's copy of NV 1790 (now preserved in Brussels), which was the basis for the facsimile reprint edited by Rachel Wade.

78. "*Fisher, Dt. Mus.* In Miniatur. In goldenen Rahmen, unter Glas." NV 1790, 103. A clue to the identity of Dr. Fisher is given by Gerber, again relying heavily on the Bach inventory: "Fisher——" (as in NV 1790, no first name given), "Doktor der Musik aus Oxford." Gerber, *Lexikon Historisch-biographisches* 1 (1790), col. 418.

79. Sittard, *Geschichte*, 135.

80. [Becker], *Vor hundert Jahren*, 207.

CHAPTER 6

1. *Hamburgischer unpartheyischer Correspondent*, 1788, no. 49 (Tuesday, March 25, 1788): 2ff. Van Swieten was a great admirer of C. P. E. Bach and had commissioned from him, in

1773, the six string symphonies, Wq. 182, encouraging Bach to write "without restraint [and] without regard for the difficulties that would inevitably arise in performance." J. F. Reichardt's autobiography in *Allgemeine musikalische Zeitung* 16, no. 2 (January 12, 1814): 29. Bach dedicated the third *Kenner und Liebhaber* collection (1781) to van Swieten.

2. Letter to Johann Gottlob Immanuel Breitkopf, Hamburg, May 3, 1788, in *The Letters of C. P. E. Bach*, ed. and trans. Stephen L. Clark (New York: Oxford University Press, 1997), 281.

3. Laurence Sterne, *The Life and Opinions of Tristram Shandy, Gentleman* (London: D. Lynch, 1761), 4:128.

4. Sterne, *Tristram Shandy*, 129.

5. Sterne, *Tristram Shandy*, 134.

6. For the classic treatment of sensibility, see John Mullan, *Sentiment and Sociability: The Language of Feeling in the Eighteenth Century* (Oxford: Clarendon Press, 1988); G. J. Barker-Benfield, *The Culture of Sensibility: Sex and Society in Eighteenth-Century Britain* (Chicago: University of Chicago Press, 1992); Robert Markley, "Sensibility as Performance: Shaftesbury, Sterne, and the Theatrics of Virtue," in *The New 18th Century: Theory, Politics, English Literature*, ed. Felicity Nussbaum and Laura Brown (New York: Methuen, 1987), 201–30. See also Deirdre Lynch, "Personal Effects and Sentimental Fictions," in *The Secret Life of Things: Animals, Objects and It-Narratives in Eighteenth-Century England*, ed. Mark Blackwell (Lewisburg, PA: Bucknell University Press, 2007), 63–91.

7. David Fairer, "Sentimental Translation in Mackenzie and Sterne," in *Translating Life: Studies in Transpositional Aesthetics*, ed. Alistair Stead and Shirley Chew (Liverpool: Liverpool University Press, 1999), 164–65.

8. Samuel Johnson, *Dictionary of the English Language* (1755), s.v. "Object."

9. Johnson citing Isaac Newton. Johnson, *Dictionary*, s.v. "Sensorium."

10. Laurence Sterne, *The Life and Opinions of Tristram Shandy, Gentleman* (London: T. Becket and P. A. Dehondt, 1762), 45. For the reminder about Corporal Trim's hat, I'm grateful to my colleague Neil Saccamano; and for Johnson's definition of "Object," to Nicholas Mathew.

11. I won't rehearse here my own efforts, and those of other scholars, to grapple with the F-sharp Minor Fantasia and its play of sincerity and irony, or critical distance. See my chapter "Solitude and the Clavichord Cult," in *The Free Fantasia and the Musical Picturesque* (Cambridge: Cambridge University Press, 2003), esp. 176–82; for a richer account, see Richard Kramer, "Diderot's *Paradoxe* and C. P. E. Bach's *Empfindungen*," in *C. P. E. Bach Studies*, ed. Annette Richards, 6–24, and Richard Kramer, *Unfinished Music* (Oxford: Oxford University Press, 2008).

12. From 1779 to 1787 Bach published six collections *für Kenner und Liebhaber*. The first contains six sonatas; the second and third alternate between rondos and sonatas (three of each); in the fourth collection three rondos alternate with two sonatas, and the volume concludes with two free fantasias. Collections five and six each contain two sonatas, two rondos, and two fantasias; in the fifth collection they are ordered as in the fourth, the two fantasias concluding the volume; in the sixth, the order runs Rondo I, Sonata I, Fantasia I, Rondo II, Sonata II, Fantasia II.

13. See C. P. E. Bach, *Versuch über die wahre Art das Clavier zu spielen*, Part I (Berlin, 1753), 123–24; Part II (Berlin, 1762), 325–41; D. G. Türk, *Klavierschule, oder Anweisung zum Klavierspielen für Lehrer und Lernende* (Leipzig, 1789).

14. Carl Friedrich Cramer, *Magazin der Musik* 1, no. 2 (December 7, 1783): 1241. On rondos and fashion, see Malcolm S. Cole, "The Vogue of the Instrumental Rondo in the Late Eighteenth Century," *Journal of the American Musicological Society* 22, no. 3 (1969): 425–55, and Matthew Head, "Fantasy in the Instrumental Music of C. P. E. Bach" (PhD diss., Yale University, 1995), chap. 4, "Rondos: Fashion and Fantasy."

15. Indeed, Johann Friedrich Reichardt concurred that fashionable composers of the 1780s produced "almost nothing other than rondos. . . . When it comes to the huge idiocy of greed for money and applause, or the desire to please the critics in the daily newspapers and the

journals, then every spark of truth and freedom in their work is extinguished." Johann Friedrich Reichardt, *Musikalisches Kunstmagazin* (1782), reprinted in *Magazin der Musik* 1, no. 1 (1783): 37.

16. See chapter 4 above.

17. For more on irony, see Richards, "Solitude and the Clavichord Cult," and Kramer, "Diderot's *Paradoxe* and C. P. E. Bach's *Empfindungen*."

18. Johann Friedrich Reichardt, *Briefe eines aufmerksamen Reisenden die Musik betreffend*, 2 vols. (Frankfurt, 1774–76), 2:ii.

19. Reichardt, *Briefe*, 21.

20. See Head, "Fantasy in the Instrumental Music of C. P. E. Bach."

21. Cramer, *Magazin der Musik* 1, no. 2 (1783): 1238–55.

22. Ibid., 1246.

23. Ibid., 1249.

24. Ibid.

25. Ibid.

26. Ibid.

27. Ibid.

28. See Richards, *Free Fantasia and the Musical Picturesque*, 153–55, Kramer, "Diderot's *Paradoxe*," esp. 20–24, and Elaine Sisman, "Music and the Labyrinth of Melody: Traditions and Paradoxes in C. P. E. Bach and Beethoven," in *Oxford Handbook of Disability Studies*, ed. Blake Howe, Stephanie Jensen-Moulton, Neil Lerner, and Joseph Straus (Oxford: Oxford University Press, 2015), 590–617.

29. See Peter Wollny, introduction to *Carl Philipp Emanuel Bach: The Complete Works*, ser. 1, vol. 8.1 (Los Altos, CA: Packard Humanities Institute, 2006), xvi-xvii.

30. Translation from Wollny, ibid.

31. *Vor hundert Jahren: Elise von der Reckes Reisen durch Deutschland, 1784–86, nach dem Tagebuche ihrer Begleiterin Sophie Becker*, ed. G. Karo and M. Geyer (Stuttgart: Spemann, n.d.), 201. The distinction between "compositions" and "improvisations" perhaps implies sonatas and rondos on the one hand and free fantasias on the other. That Bach should have played the rondos on the clavichord and his improvisations on the piano further muddies the notion that the rondo was generally associated with the piano and the free fantasia with the clavichord.

32. *Vor hundert Jahren*, 210. Grotthus would appear in Hamburg, and they would meet up with him two days later on November 4.

33. *Vor hundert Jahren*, 204–5. The story is rehearsed and the texts given in full in Anselm Gerhard, "Carl Philipp Emanuel Bach und die 'Programmusik': Ein unbekannter Reisebericht und der 'Beweis, dass man auch klagende Rondeaux machen könne,'" in *Die Verbreitung der Werke Carl Philipp Emanuel Bachs in Ostmitteleuropa im 18. und 19. Jahrhundert*, ed. Ulrich Leisinger and Hans-Günther Ottenberg (Frankfurt an der Oder: Mess- und Veranstaltungs, 2002), 411–35.

34. The review is reprinted in full in Barbara Wiermann, ed. *C. P. E. Bach: Dokumente zu Leben und Wirken aus der Zeitgenössischen Hamburgischen Presse (1767–1790)* (Hildesheim: Olms, 2000), here at 258–59. Wiermann discusses Leister's possible authorship on 35–36.

35. Ibid. Leister makes sure to point out that, as the titles to the *Kenner und Liebhaber* volumes suggest, this rondo is to be played on a fortepiano.

36. Heinrich Poos, "Carl Philipp Emanuel Bachs Rondo a-Moll aus der 'Zweiten Sammlung . . . für Kenner und Liebhaber': Protokoll einer Annäherung," in *Carl Philipp Emanuel Bach: Beiträge zu Leben und Werk*, ed. Heinrich Poos (Mainz, 1993), 119–70. On the idea of C. P. E. Bach's fantasies as *tombeaux* for family members, see Peter Schleuning, *Die freie Fantasie: Ein Beitrag zur Erforschung der klassischen Klaviermusik* (Göppingen: A. Kümmerle, 1973).

37. Gerhard, "Carl Philipp Emanuel Bach und die 'Programmusik,'" 423.

38. 1778: rondos in C major, Wq. 56/1, D major, Wq. 56/3, and A minor, Wq. 56/5 (all published

in *Kenner und Liebhaber* II, 1780); 1779: rondos in E major, Wq. 57/1, and A minor, Wq. 57/5 (both published in *Kenner und Liebhaber* III, 1781); rondo in B-flat major, Wq. 58/5 (published in *Kenner und Liebhaber* IV, 1783), and rondo in G major, Wq. 59/2 (published in *Kenner und Liebhaber* V, 1785); 1780: rondo in G major, Wq. 57/3 (published in *Kenner und Liebhaber* III, 1781); 1781: rondo in E major, Wq. 58/3 (published in *Kenner und Liebhaber* IV, 1783), and the *Abschied* rondo, Wq. 66. The three remaining rondos were composed in 1784: rondo in C minor, Wq. 59/4 (published in *Kenner und Liebhaber* V, 1785); 1785: rondo in D minor, Wq. 61/4 (published in *Kenner und Liebhaber* VI, 1787); and 1786: rondo in E-flat major, Wq. 61/1 (published in *Kenner und Liebhaber* VI, 1787).

39. Letter to Breitkopf, October 9, 1778; Clark, *Letters*, 126.

40. The obelisk is made explicit in the engraved version of the drawing made by Carl Wilhelm Grießmann. These and other images of C. P. E Bach's family can be seen in Paul Corneilson, ed., appendix B to Annette Richards, ed., *Carl Philipp Emanuel Bach: The Portrait Collection, Carl Philipp Emanuel Bach: The Complete Works*, ser. 8, vol. 4.1 (Los Altos, CA: Packard Humanities Institute, 2012), 211.

41. Ibid., 131.

42. Ernst Ludwig Gerber, *Historisch-biographisches Lexikon der Tonkünstler*, vol. 2 (Leipzig: Breitkopf, 1792), Anhang, Vorerinnerung, VII.

43. Clark, *Letters*, 136.

44. Clark, *Letters*, 135–36.

45. Clark, *Letters*, 135.

46. Clark, *Letters*, 135.

47. Cramer, *Magazin der Musik*, 1242–43.

48. Cramer, *Magazin der Musik*, 1243.

49. Cramer, review of Reichardt, *Musikalisches Kunstmagazin*, in *Magazin der Musik* 1, no. 1 (1783), 36n. The context is a discussion of the contemporary fad for rondos.

50. Ibid., 35n.

51. Ibid., 36n.

CHAPTER 7

1. Johann Georg Sulzer, *Allgemeine Theorie der schönen Künste* (Leipzig: Weidmanns Erben und Reich, 1774), 2:919. On the dramatic change across the eighteenth century in the fortunes of the portrait among the hierarchies of the visual arts, see Marcia Pointon, *Hanging the Head: Portraiture and Social Formation in 18th-Century England* (New Haven, CT: Yale University Press, 1993).

2. Sulzer, *Allgemeine Theorie*, 2:919.

3. Sulzer, *Allgemeine Theorie*, 2:919.

4. Sigmond Jacob Apin, *Anleitung wie man die Bildnisse berühmter und gelehrter Männer mit Nutzen sammlen und denen dagegen gemachten Einwendungen gründlich begegnen soll* (Nuremberg: Adam Jonathan Felßecker, 1728), 59–60.

5. See above, chapter 2.

6. Ernst Ludwig Gerber, "Vorerinnerung," *Historisch-biographisches Lexikon der Tonkünstler* (Leipzig: Breitkopf, 1790), 1:vi.

7. Gerber, *Historisch-biographisches Lexikon*, 2:277.

8. Gerber, *Historisch-biographisches Lexikon*, 2:172.

9. NV 1790, 126.

10. Gerber, *Historisch-biographisches Lexikon*, 2:860.

11. Gerber, *Neues historisch-biographisches Lexikon der Tonkünstler* (Leipzig: Kühnel, 1814), 4:658.

12. Either Bach took a special interest in Eschstruth, or Eschstruth's enthusiasm for the composer led him to supply him with portraits for his collection: the NV 1790 lists three images of Bach's young admirer: a now-lost painting in oils by an unnamed artist, an engraving in octavo by Ch. G. Geyser after Specht, and a silhouette.

13. Gerber appears not to have known, at this point, about J. J. H. Westphal's collection—although he certainly would by the time he published the second edition of the *Lexikon*, for which Westphal supplied a great deal of new material and corrections.

14. Gerber, *Historisch-biographisches Lexikon* (1792), 2:iii.

15. The collection survives today in Bologna and is beautifully documented in Lorenzo Bianconi, ed., *I Ritratti del Museo della Musica di Bologna, da padre Martini al Liceo musicale* (Florence: Leo S. Olschki Editore, 2018).

16. Angelo Mazza, "'Al Maggior Ornamento di Cotesta Insigne Libreria Musicale': L'Iconoteca di Padre Giambattista Martini nel Convento di San Francesco," in Bianconi, *I Ritratti*, 7.

17. Ibid., 5. As we learn from Mazza's study of the Martini correspondence, whereas about forty of the letters written from 1735 to 1772 contain portrait requests or allusions to portraiture, in the eleven years from 1773 1784, no fewer than 250 do so.

18. Johann Gottlob August Kläbe, *Neues gelehrtes Dresden oder Nachrichten von jetzt lebenden Dresdner Gelehrten, Schriftstellern, Künstlern, Bibliotheken- und Kunstsammlern* (Leipzig: Voss, 1796), 170–71.

19. Gerber, *Historisch-biographisches Lexikon*, 2:671. Gerber quotes Reichardt here; see J. F. Reichardt, *Briefe eines aufmerksamen Reisenden die Musik betreffend* (1776), 2:121. For more on Transchel as C. P. E. Bach's agent in Dresden from 1783 to 1787, see Hans Günter Ottenberg, "Wer waren Carl Philipp Emanuel Bachs Pränumeranten? Überlegungen zur sozialen Schichtung des elbastädtischen Musik-publikums um 1780," in *"Critica Musica": Studien zum 17. und 18. Jahrhundert. Festschrift Hans Joachim Marx zum 65. Geburtstag*, ed. Nicole Ristow, Wolfgang Sandberger, and Dorothea Schröder (Stuttgart: Metzler, 2001), 233–46.

20. Gerber, *Historisch-biographisches Lexikon* (1792), 2:671–72.

21. Given the extraordinary completeness of his collection, Gerber suggests that other portrait enthusiasts (*Liebhaber*) might simply use his catalog—the supplement to the *Lexikon*—to catalog their own, making a red mark beside items they owned.

22. Gerber, *Historisch-biographisches Lexikon* (1792), viii.

23. Gerber, *Historisch-biographisches Lexikon* (1790), appendix, 1:83.

24. A copy of the *Nachlassverzeichniss* with the prices listed is extant in the Westphal collection in Brussels, with Westphal's annotation: "NB: The prices noted here [*die beygeschribenen Preise*] are those for which the portraits were sold, or should have been sold." See Manfred Hermann Schmid, "'Das Geschäft mit dem Nachlaß von C. Ph. E. Bach,'" in *Carl Philipp Emanuel Bach und die europäische Musikkultur des mittleren 18. Jahrhunderts*, ed. Hans Joachim Marx (Göttingen: Vandenhoeck und Ruprecht, 1990), 482. See also *The Catalog of Carl Philipp Emanuel Bach's Estate: A Facsimile of the Edition by Schneibes, Hamburg, 1790*, ed. Rachel W. Wade (New York: Garland, 1981), xii.

25. Letter to J. J. H. Westphal, July 28, 1797, in Schmid, "Das Geschäft mit dem Nachlaß von C. Ph. E. Bach," 515.

26. Ibid., 514.

27. Letter to Westphal, May 24, 1797, ibid.

28. Letter to J. J. H. Westphal, October 17, 1797, ibid., 516. There is a separate essay to be written on the role of daughters in assisting with their fathers' collections and the gendered aspects of collecting practices in this period. To some extent this is thematized, though discreetly, in Goethe's novella "The Collector and His Circle."

29. BC 34.734 H. P. is a folder containing many loose sheets. Most of them seem to be part of the project to collect portraits—or to list, in the manner of Gerber, extant portraits—and to provide additional information to Gerber for the second edition of his *Lexikon*.

30. BC 34.734 H. P. No. 98.

31. The terminology can be confusing here: pastels are usually classified as drawings, made with colored chalks or "dry colors," but with their soft colors they can sometimes be designated paintings. See above, chapter 5, for the case of the portrait of Dülon, listed in Bach's inventory as "Gezeichnet" but described by Dülon himself as having been painted.

32. "Aus der Bachischen befinden sich in meiner Sammlung: Telemann, G. F. in Gips von Gibbons; . . . Noelly, in Gips . . . , Noelly . . . in Wachs, von Sirl, Bach, C. P. E. in Gips von Schubart." BC 34.734 H. P. No. 100.

33. Schmid, "Das Geschäft mit dem Nachlaß von C. Ph. E. Bach," 518. See above, chapter 2. None of these items has yet been found. They may later have been sold to Fétis along with the rest of Westphal's library, but there is now no trace of them, or of the rest of Westphal's portrait collection, at the Brussels Conservatory or the Royal Library in Brussels.

34. Wundemann noted that there was also a fine catalog of the complete collection. Johann Christian Friedrich Wundemann, *Mecklenburg in Hinsicht auf Kultur, Kunst und Geschmack* (Schwerin, 1803), 2:12.

35. See Ulrich Leisinger and Peter Wollny, *Die Bach-Quellen der Bibliotheken in Brüssel: Katalog* (Hildesheim: Olms, 1997), 74. On Westphal's library, see 25–74; on Fétis and the Westphal collection, see 85–89 and Ernst Suchalla, ed., *Carl Philipp Emanuel Bach im Spiegel seiner Zeit: Die Dokumentensammlung Johann Jacob Heinrich Westphals* (Hildesheim: Olms, 1993).

36. Letter from A. C. P. Bach to Westphal, October 17, 1797, in Schmid, "Das Geschäft mit dem Nachlaß von C. Ph. E. Bach," 516.

37. Gerber, "Fortgesetztes Verzeichniß der Gemälde und Zeichnungen," *Neues historisch-biographisches Lexikon*, 4:735–43.

38. Ibid. The drawing of Palestrina is listed there as "Palestrina (Giov. Piet. Alois.), Päpstlicher Kapellmeister. Gezeichnet in Italien. Gr. 4. In schwarzen Rahmen, unter Glas." NV 1790, 115.

39. The Bach collection contained a (now lost) caricature of Bernacchi, but this was an engraving by Oesterreich.

40. "Chladni's Selbstbiographie," in *Caecilia, eine Zeitschrift für die musikalische Welt* 6 (1827): 305–6.

41. Wilhelm Bernhardt, *Dr. Ernst Chladni der Akustiker: Eine Biographie und geschichtliche Darstellung seiner Entdeckungen* (Wittenberg: Franz Mohr's Buchhandlung, 1856), 98.

42. Letter to Breitkopf, September 21, 1787, in *Carl Philipp Emanuel Bach: Briefe und Dokumente*, ed. Ernst Suchalla (Göttingen: Vandenhoeck und Ruprecht, 1994), 1695.

43. Gerber, *Neues historisch-biographisches Lexikon*, 4:735. See above, chapter 3.

44. "Fünf Briefe von Joh. Nic. Forkel an Carl Friedr. Zelter," *Allgemeine musikalische Zeitung* 9, no. 39 (September 30, 1874): 610.

45. See *Verzeichniß der von dem verstorbenen Doctor und Musikdirector Forkel in Göttingen nachgelassenen Bücher und Musikalien* (Göttingen: F. C. Huth, 1819).

46. Letter from Westphal to the Schwerin "Zahl-Kommisair" Henk, June 30, 1819 (A-Wgm, Briefsammlung), quoted in Leisinger and Wollny, *Bach-Quellen*, 74.

47. Item 4768 on page 563 of the catalog of Fétis's library is entered as "Sammlung von Bildnissen verschiedner Tonkünstler und musikalischer Schriftsteller. 2 vols., in fol." This must refer to either a two-volume catalog of the collection or two large albums into which the prints and drawings had been pasted (I think more likely a catalog, given the extent of the collection)—most likely these catalog entries describe volumes that entered the Fétis library with the Westphal

collection (rather than a collection of portraits built later by Fétis). The two volumes appear to have been long lost, and my research in the Royal Library and in the library of the Brussels conservatory has drawn a blank.

48. See Klaus Engler, "Georg Poelchau und seine Musikaliensammlung" (PhD diss., Universität Tübingen, 1970), and Paul Kast, *Die Bach-Handschriften der Berliner Staatsbibliothek* (Trossingen: Hohner, 1958).

49. Shelfmarks are Mus. Ms. theor. Kat. 62, and again in HB VII, Kat Ms. 131.

50. See Richard Schaal, *Die Tonkünstler-Portraits der Wiener Musiksammlung von Aloys Fuchs* (Wilhelmshaven: Heinrichshofen's Verlag, 1970).

51. The shelfmark is HB VII, Mus. Ms. Theor. Kat 319.

52. Bach's entry for this drawing runs: "*Concialini, (Carlo)* Königl. Preußischer Sopranist. Gezeichnet von *Stranz.* Gr. *Fol.* In goldenen Rahmen, unter Glas," NV 1790, 100.

53. Unpublished manuscript, "Archiv der musikalischen Kunst, zur Beförderung eines gründlichen Studiums derselben zusammengestellt von Georg Pölchau" (Archive of the art of music, for the advancement of a rigorous study of the same assembled by Georg Pölchau), reprinted in Engler, "Georg Poelchau und seine Musikaliensammlung," 3.

54. Ibid.

55. Ibid., 5.

56. Ibid., 6.

57. Ibid.

58. Pointon, *Hanging the Head,* 59.

59. Pointon, *Hanging the Head,* 59.

60. "Granger's system proved effective in the marketplace; it also had major implications for portraiture as a mechanism for shaping the past and making sense of the present." Pointon, *Hanging the Head,* 60.

61. *Plutarch's Lives in Six Volumes, Translated from the Greek, with Explanatory and Critical Notes, from Davier and others, to Which Is Prefixed "The life of Plutarch," Written by Mr. Dryden* (Edinburgh: A. Donaldson and Reid, 1763), 4:231–32.

62. See also Hugh Blair, *Lectures on Rhetoric and Belles Lettres* (London: W. Strahan, T. Cadell, and W. Creech, Edinburgh, 1783). Blair praises Tacitus as "eminent for his knowledge of the human heart . . . sentimental and refined in a high degree" (2: 270). I borrow heavily here from Mark Phillips, *Society and Sentiment: Genres of Historical Writing in Britain, 1740–1820* (Princeton, NJ: Princeton University Press, 2000).

63. Sir John Hawkins, preface to *A General History of the Science and Practice of Music* (London: T. Payne and Son, 1776), 1:5–6.

64. Arthur Murphy, *The Works of Cornelius Tacitus with an Essay on His Life and Genius* (1793), 1:lxv; quoted in Phillips, *Society and Sentiment,* 144.

65. Hugh Blair, *Lectures on Rhetoric and Belles Lettres,* 287. See Phillips, *Society and Sentiment,* chap. 1, "David Hume and the Vocabularies of British Historiography," esp. 42–44.

66. George Thomson, *The Spirit of General History, in a Series of Lectures from the Eighth to the Eighteenth Century,* 2nd ed. (London, 1792), iii-iv. Quoted in Phillips, *Society and Sentiment,* 18.

67. Crucial information on C. P. E. Bach's library was provided in the Hamburg auction catalog of 1789, which, as Ulrich Leisinger has shown, contained a substantial portion of his collection of books and music. Later collectors, including Gerber, referred to this auction as the "Bachsche Auction." See Ulrich Leisinger, "Die 'Bachsche Auction' von 1789," *Bach-Jahrbuch* 77 (1991): 97–126.

68. This volume was not among the books sold at the "Bachsche Auction" of 1789, but it was clearly a reference tool Bach used. Given its importance for the curation and organization

of the portrait collection, I think it likely that Bach's daughter, Anna Carolina Philippina, who was her father's assistant and collaborator, kept the *Lexicon* in her possession along with the rest of the portrait collection.

69. Three volumes are listed in the catalog of the "Bachsche Auction" (1, 3, and 4), though C. P. E. Bach surely had volume 2 as well, if not the later fifth volume to complete the run.

70. Information, though less directly historical and biographical, was also to be gleaned from Reichardt's *Musikalisches Kunstmagazin*, its first four issues listed in the 1789 auction. Cramer's *Magazin der Music* was another such publication surely known to Bach, though not listed in the auction.

71. Junker pays homage to the genre's inherent instability of tone—as well as the variety of its contents: "Finally, by dint of the term '*Almanach*' we are guilty of binding ourselves mainly to two principals, namely to the *diversity* of the material and to the humor of its presentation. We commit ourselves to both; only one does not forget that there is also serious *humor*." [Carl Ludwig Junker], "Vorbericht," *Musikalische und Künstler Almanach auf das Jahr 1783* (Kosmopolis); emphasis in the original. Published anonymously, Junker's almanachs have sometimes been ascribed, erroneously, to J. F. Reichardt.

72. The contents of Junker's music almanachs mirrored the mixture of topics that filled the enormously popular literary almanachs of the age. In the 1783 Göttingen *Taschenbuch* (edited by Georg Christoph Lichtenberg), for example, there were essays on William Herschel's telescope and his most recent astronomical discoveries, topographical and ethnographic descriptions of the Kingdom of Java; an essay on the classification of various gases; an account of European voyages of discovery to the South Seas; a comparative study of age at first marriage in a small Swedish town (concluding that women can still hope to get married for the first time at past forty, while men have little hope of doing so); new inventions and other curiosities, from theories of the lunar cycle to a thermometer invented by Josiah Wedgwood to withstand extremely high temperatures; improvements to gunpowder; a new English "whirling table"; experiments with electricity; a table comparing coin weights from city to city; an international comparison of mile measurements; a comparison of volume measurements. For more on almanachs and their culture see Gerhard Sauder, "Almanach-Kultur und Empfindsamkeit," in *Literarische Leitmedien: Almanach und Taschenbuch im kulturwissenschaftlichen Kontext*, ed. Paul Gerhard Klussmann and York-Gothart Mix (Wiesbaden: Harrassowitz, 1998), 16–30; York-Gothart Mix, "Der Literaturfreund als Kalendernarr: Die Almanachkultur und ihr Publikum," in *Almanach und Taschenbuch Kultur des 18. and 19. Jahrhunderts*, ed. York-Gothart Mix (Wiesbaden: Harrassowitz, 1996), 77–88. and Heinrich W. Schwab, "Musikbeilagen in Almanachen und Taschenbüchern," in *Almanach und Taschenbuch Kultur des 18. and 19. Jahrhunderts*, ed. York-Gothart Mix, 167–201. See also Matt Erlin, *Necessary Luxuries: Books, Literature, and the Culture of Consumption in Germany, 1770–1815* (Ithaca, NY: Cornell University Press, 2014).

73. [Junker], "Vorbericht," *Musikalischer Almanach auf das Jahr 1782* (Alethinopel), iii.

74. [Junker], "Vorbericht," *Musikalischer Almanach auf das Jahr 1782* (Alethinopel), 2.

75. The Forkel and Junker almanachs were sold in lots together by year in the 1789 auction.

76. Forkel's almanachs both plot out music's history and report on the contemporary state of the art, collecting information and inviting contributions from readers, constantly open to amendment and addition. A decade later Gerber would follow this same model for his *Lexikon*, inviting correction and contribution of the sort soon readily supplied by fellow collector-historians such as Westphal and Chladni.

77. Forkel, *Musikalischer Almanach für Deutschland auf das Jahr 1783* (Leipzig: Schwickertschen Verlag, 1782), 126–27.

78. Forkel is scrupulous with his sources: the Steffani biography is cited as a reprint from

the *Hamburgischer unpartheyischer Correspondent*, 1764; the information on Pergolesi is largely drawn from Hawkins.

79. "Ueber eine Sonate aus Carl Phil. Emanuel Bachs Dritter Sammlung für Kenner und Liebhaber in F moll . . . ," Forkel, *Musikalischer Almanach für Deutschland auf das Jahr 1784* (Leipzig: Schwickertschen Verlag, 1783), 22–38.

80. Essential reading on Burney and the conjunction of travel writing and history in his work is Vanessa Agnew, *Enlightenment Orpheus: The Power of Music in Other Worlds* (Oxford: Oxford University Press, 2008).

81. Amid the very long list of names of Englishmen (and women) who had subscribed to Burney's project are a number of distinguished continentals, including Bach and Ebeling in Hamburg, Hiller in Leipzig, Marpurg and Nicolai in Berlin, Jomelli and Piccinni in Naples, Metastasio, and Rousseau.

82. See, for example, Warren Dwight Allen, *Philosophies of Music History* (1939; reprint Dover, 1962): in a section whose subtitle runs "Modern Music Historiography Begins in England," Allen describes the projects of Burney and Hawkins as "the first and most ambitious narrative histories ever attempted in English," which "stand near the top of every bibliography of music history, and have been the models for all of our narrative histories since that time" (76).

83. For Forkel's review of Hawkins see Johann Nikolaus Forkel, *Musikalisch-kritische Bibliothek* (Gotha: Ettinger, 1778), 2:160–229; his review of Burney appeared in *Musikalisch-kritische Bibliothek* (Gotha: Ettinger, 1779), 2:117–91. Bach's review of Forkel appeared in the *Hamburgischer unpartheyischer Correspondent* (January 9, 1788), reprinted in Forkel, *Allgemeine Geschichte der Musik*, ed. Othmar Wessely (Leipzig, 1788; Graz, 1967), 1:xvii.

84. This despite the publisher's claim that "the whole of the original text has been printed in its integrity": *A General History of the Science and Practice of Music, by Sir John Hawkins. A New Edition . . .* (London: J. Alfred Novello, 1853), xii. Mark Phillips reminds us that "Perhaps the greatest challenge to historical mimesis in this period, however, came from the desire to represent experience as well as action, and the many narrative experiments that register this ambition stand among the most interesting histories of this time. They also stand, it should be added, among the most neglected, since they do not conform to our conception of what historians should be about in a neo-classical age." Phillips, *Society and Sentiment*, 23.

85. See Ian Spink, "Hunt, Arabella," *Grove Music Online* (2001), http://www.oxfordmusiconline .com/subscriber/article/grove/music/13571 (accessed September 9, 2019).

86. Burney, *A General History of Music from the Earliest Ages to the Present Period* (London, 1776), 1:4–5.

87. Burney, *General History of Music*, Preface, xvii, xviii.

88. Friedrich Wilhelm Marpurg [Simon Metaphrastes, pseud.], ed., *Legende einiger Musik-Heiligen: Ein Nachtrag zu den musikalischen Almanachen und Taschenbüchern jetziger Zeit* (Cologne: Peter Hammern, 1786), 74–76.

89. Marpurg, *Legende einiger Musik-Heiligen*, 71–73.

90. Johann Nikolaus Forkel, *Musikalischer Almanach für Deutschland auf das Jahr 1783* (Leipzig: Schwickert, 1782; reprint, Hildesheim: Georg Olms, 1974), 159–60.

91. Paul Fleming, "The Perfect Story: Anecdote and Exemplarity in Linnaeus and Blumenberg," *Thesis Eleven* 104, no. 1 (2011): 75. See also Rudolf Schäfer, *Die Anekdote: Theorie, Analyse, Didaktik* (Munich: Oldenbourg, 1982); Joel Fineman, "The History of the Anecdote: Fiction and Fiction," in *The New Historicism*, ed. Harold Aram Veeser (New York: Routledge 1989), 49–76; Volker Weber, *Anekdote: Die andere Geschichte. Erscheinungsformen der Anekdote in der deutschen Literatur, Geschichtsschreibung und Philosophie* (Tübingen: Stauffenburg, 1993); Sonja Hilzinger, *Anekdotisches Erzählen im Zeitalter der Aufklärung: Zum Struktur- und Funktionswandel der Gattung Anekdote in Historiographie, Publizistik und Literatur des 18. Jahrhunderts* (Stuttgart: Metzler, 1997).

92. Fleming, "Perfect Story," 75.

93. Elizabeth A. Fay, *Fashioning Faces: The Portraitive Mode in British Romanticism* (Durham: University of New Hampshire Press, 2010), 40.

94. Fay, *Fashioning Faces*, 44.

95. Fay, *Fashioning Faces*, 44.

96. Gerber, *Historisches-Biographiches Lexikon*, 2:762.

97. NV 1790, 114. Bach also owned silhouettes of Christian Friedrich Müller and "his wife" Carolina Fredrika (NV 1790, 127). Further information on both T. C. Walter and Carolina Müller is to be found in the *Dansk biografisk Leksikon*, 18:237–38 and 18:230–33. See also Bertil van Boer, *Historical Dictionary of Music of the Classical Period* (Lanham, MD: Scarecrow Press, 2012), 592 (on T. C. Walter) and 258 (on Carolina Halle).

98. *Bach-Dokumente III: Dokumente zum Nachwirken Johann Sebastian Bachs, 1750–1800*, ed. Hans-Joachim Schulze (Kassel: Bärenreiter, 1972), no. 666; *The New Bach Reader*, ed. Hans T. David and Arthur Mendel, rev. and enl. Christoph Wolff (New York: W. W. Norton, 1999), 302. In a letter to Johann Nikolaus Forkel of January 13, 1775, C. P. E. Bach listed Reincken as among the organists his father had admired and studied (*geliebt u. studiert*); *Bach-Dokumente III*, no. 803; *New Bach Reader*, 398. Reincken's extraordinary age is an important factor in this much-repeated anecdote about the handing down of a venerable tradition and derives from Johann Mattheson's claim in *Grundlage einer Ehrenpforte* that the composer was born in 1623. Recent research suggests that the correct birthdate was 1643—putting Reincken at a less mythic, though still impressive, seventy-seven years of age when this encounter with J. S. Bach took place. See Ulf Grapenthin, "Reincken, Johann Adam," in *Grove Music Online*.

99. Letter to Breitkopf, September 16, 1778, in *The Letters of C. P. E. Bach*, ed. and trans. Stephen L. Clark (New York: Oxford University Press, 1997), 128.

100. This fragment is listed in NV 1790, 66, "Einleitung zu Joh. Sebast. Bachs Credo."

101. See above, chapter 2, and Annette Richards, "An Enduring Monument: C. P. E. Bach and the Musical Sublime," in *C. P. E. Bach Studies*, ed. Annette Richards (Cambridge: Cambridge University Press, 2006), 149–72, and Annette Richards, "The Charitable Handel," in *The Power of Musick*, ed. Anorthe Kremers and Wolfgang Sandberger, Göttinger Händel Beiträge 15 (Göttingen: Vandenhoeck und Ruprecht, 2014), 87–108. See also Christoph Wolff, "C. P. E. Bach and the History of Music," *Notes* 71, no. 2 (2014): 197–218.

102. The score, in C. P. E. Bach's hand, is housed in the Staatsbibliothek zu Berlin, Mus. ms. Bach P 218. A copy of parts made from it exists in the hand of C. P. E. Bach's chief Hamburg copyist Johann Heinrich Michel, Mus. ms. St. 430. See Christoph Wolff, *Kritischer Bericht: Canons, Musikalisches Opfer. Johann Sebastian Bach: Neue Ausgabe sämtlicher Werke*, ser. 8, vol. 1 (Kassel: Bärenreiter, 1976), 83. The arrangement is discussed in David Yearsley, "C. P. E. Bach and the Living Traditions of Learned Counterpoint," in *C. P. E. Bach Studies*, ed. Annette Richards (Cambridge: Cambridge University Press, 2006), 194–95.

103. *Bach-Dokumente III*, no. 3; *New Bach Reader*, 302.

104. Johann Nikolaus Forkel, *Ueber Johann Sebastian Bachs Leben, Kunst und Kunstwerke: Für patriotische Verehrer echter musikalischer Kunst* (Leipzig: Hoffmeister und Kühnel, 1802), 9–10. Forkel recounts the story as having been told to him by Wilhelm Friedemann Bach. See David Yearsley, *Bach and the Meanings of Counterpoint* (Cambridge: Cambridge University Press, 2002), esp. 128–30. See also Mary Oleskiewicz, "Keyboards, Music Rooms, and the Bach Family at the Court of Frederick the Great," in *J. S. Bach and His Sons*, ed. Mary Oleskiewicz (Urbana: University of Illinois Press, 2017), 24–82.

105. Richard Kramer, *Unfinished Music* (New York: Oxford University Press, 2008), 103.

Bibliography

PRIMARY SOURCES

Abhandlung von Kupferstichen. Frankfurt: Dodsley, 1768.

Adlung, Jacob. *Anleitung zu der musikalischen Gelahrtheit*. Erfurt: J. D. Jungnicol, 1758.

Apin, Sigmund Jacob. *Anleitung wie man die Bildnisse berühmter und gelehrter Männer mit Nutzen sammlen und denen dagegen gemachten Einwendungen gründlich begegnen soll*. Nuremberg: Adam Jonathan Felßecker, 1728.

Avison, Charles. *Essay on Musical Expression*. 3rd ed. London: L. Davis, 1753.

Bach, Carl Philipp Emanuel. *Autobiography* [with] *Verzeichniß des musikalischen Nachlasses*. Annotations in English and German by William S. Newman. Buren: Frits Knuf, 1991.

———. *Briefe und Dokumente: Kritische Gesamtausgabe*. Edited by Ernst Suchalla. Göttingen: Vandenhoek und Ruprecht, 1994.

———. *Essay on the True Art of Playing Keyboard Instruments*. Edited and translated by William J. Mitchell. New York: W. W. Norton, 1949.

———. *The Letters of C. P. E. Bach*. Edited and translated by Stephen L. Clark. New York: Oxford University Press, 1997.

———. *Versuch über die wahre Art das Clavier zu spielen*. Part 1, Berlin: Henning, 1753; Part 2, Berlin: Georg Ludewig Winter, 1762. Facsimile edition, edited by Lothar Hoffmann-Erbrecht, Leipzig: Breitkopf und Härtel, 1969.

———. *Verzeichniß des musikalischen Nachlasses des verstorbenen Capellmeisters Carl Philipp Emanuel* Bach. Hamburg: Gottlieb Friedrich Schneibes, 1790. Reprint, *The Catalog of Carl Philipp Emanuel Bach's Estate: A Facsimile of the Edition by Schneibes, Hamburg, 1790*. Annotated and with a preface by Rachel W. Wade. New York: Garland, 1981.

Baron, Ernst Gottlieb. *Historische, theoretische, und praktische Untersuchung des Instruments des Lauten*. Nuremberg: J. F. Rudiger, 1727.

Bartholin, Caspar. *De tibiis veterum, et earum antique usu*. Rome: B. Carrara, 1677.

Batteux, Charles. *A Course of the Belles Lettres, or The Principles of Literature*. Translated . . . by Mr. Miller. 4 vols. London: B. Law, 1761.

[Becker, Sophie.] *Vor hundert Jahren: Elise von der Reckes Reisen durch Deutschland, 1784–86, nach dem Tagebuche ihrer Begleiterin Sophie Becker.* Edited by G. Karo and M. Geyer. Stuttgart: Spemann, n.d.

Blair, Hugh. *Lectures on Rhetoric and Belles Lettres.* 3 vols. Dublin: Messrs. Whitestone, Colles, Burnet, Moncrieffe, Gilbert [and nine others], 1783.

Boissard, Jean Jacques. *Bibliotheca chalcographica.* 9 vols. Frankfurt: Ammonius, 1650–64.

———. *Icones virorum illustrium.* 4 vols. Frankfurt: T. de Bry, 1597–99.

Bromley, Henry. *A Catalogue of Engraved British Portraits from Egbert the Great to the Present Time. Consisting of the Effigies of Persons in Every Walk of Human Life . . .* London: T. Payne, 1793.

Brown, John. *A Dissertation on the Rise, Union, and Power, the Progressions, Separations, and Corruptions, of Poetry and Music.* London: L. Davis and C. Reymers, 1763.

Browne, Thomas. *Religio Medici.* 2nd ed. London: Andrew Crooke, 1645.

Burney, Charles. *An Account of the Musical Performances in Westminster Abbey in Commemoration of Handel.* London, 1785.

———. *Carl Burney's der Musik Doctors Tagebuch seiner Musikalischen Reisen.* Translated by C. D. Ebeling and J. J. C. Bode. 3 vols. Hamburg: Bode, 1773.

———. *A General History of Music from the Earliest Ages to the Present Period.* 4 vols. London, 1776–89.

———. *The Present State of Music in France and Italy.* London: T. Becket, 1771.

———. *The Present State of Music in Germany, the Netherlands, and United Provinces.* 2 vols. London: T. Becket, J. Robson, and G. Robinson, 1773.

Calvör, Caspar. *De musica ac sigillatim de ecclesiastica, eoque spectantibus organis.* Leipzig, 1702.

Chladni, Ernst. "Chladni's Selbstbiographie." *Caecilia, eine Zeitschrift für die musikalische Welt* 6 (1827): 297–308.

Chodowiecki, Daniel. "Steckenpferdreiterei." *Königlisch Großbrittanischer genealogischer Kalender.* Lauenburg: J. G. Berenberg, 1781.

Couperin, François. *Premier livre de pièces de clavecin.* Paris, 1713.

Cramer, Carl Friedrich, ed. *Magazin der Musik.* 2 vols. Hamburg: Musicalischen Niederlage, 1783. Reprint, Hildesheim: Olms, 1971.

Denis, Michael [Sined the Bard, pseud.]. *Die Lieder Sineds des Barden.* Vienna, 1772.

———. *Ossians und Sineds Lieder.* 5 vols. Vienna, 1784.

Diderot, Denis. *Diderot on Art.* 2 vols. Vol. 1, *The Salon of 1765 and Notes on Painting;* vol. 2, *The Salon of 1767.* Edited and translated by John Goodman, with an introduction by Thomas Crow. New Haven, CT: Yale University Press, 1995.

Engel, Johann Jacob. *Ideen zu einer Mimik.* Berlin: Mylius, 1785.

———. *Über die musikalische Malerei* (1780). Berlin: Mylius, 1802.

Eschstruth, Hans Adolf Friedrich von, ed. *Musikalische Bibliothek.* 2 vols. Marpurg: Krieger, 1784 and 1785. Reprint Hildesheim: Olms, 1977.

Fabricius, Werner. *Unterricht, wie man ein neu Orgelwerk, obs gut und beständig sey, nach allen stücken, in- und auswendig examiniren, und so viel möglich probiren soll.* Frankfurt, 1756.

Forkel, Johann Nikolaus. *Allgemeine Geschichte der Musik.* 2 vols. Leipzig: Schwickert, 1788–1801. Reprint, Othmar Wessely. Graz: Akademische Druck und Verlagesanstalt, 1967.

———. *Allgemeine Literatur der Musik.* Leipzig: Schwickert, 1792. Reprint, Hildesheim: Georg Olms, 1962.

———. "Fünf Briefe von Joh. Nic. Forkel an Carl Friedr. Zelter." *Allgemeine musikalische Zeitung* 9, no. 39 (September 30, 1874): 610.

———. *Johann Sebastian Bach: His Life, Art, and Work.* Translated with notes and appendixes by Charles Sanford Terry. London: Constable, 1920. Reprint, New York: Vienna House, 1974.

———. *Musikalisch-kritische Bibliothek.* 3 vols. Gotha: Carl Wilhelm Ettinger, 1778–79. Reprint, Hildesheim: Olms, 1964.

———. *Musikalischer Almanach für Deutschland auf das Jahr 1783.* Leipzig: Schwickert, 1782. Reprint, Hildesheim: Olms, 1974.

———. *Musikalischer Almanach für Deutschland auf das Jahr 1784.* Leipzig: Schwickertschen Verlag, 1783.

———. *Ueber Johann Sebastian Bachs Leben, Kunst und Kunstwerke: Für patriotische Verehrer echter musikalischer Kunst.* Leipzig: Hoffmeister und Kühnel, 1802.

———. *Verzeichniß der von dem verstorbenen Doctor und Musikdirector Forkel in Göttingen nachgelassenen Bücher und Musikalien.* Göttingen: F. C. Huth, 1819.

Fuessli, Johann Caspar. *Raisonierendes Verzeichniss der vornehmsten Kupferstecher und ihrer Werke: Zum Gebrauche der Sammler und Liebhaber.* Zurich: Orell, Gessner und Fuessli, 1771.

Geier, Martin. *Kurtze Beschreibung des (Tit.) Herrn Heinrich Schützens: Chur-fürstl. sächs. ältern Capellmeisters geführten müheseeligen Lebens-Lauff.* Reprint, Kassel: Bärenreiter, 1972.

Gellert, Christian Fürchtegott. *Geistliche Oden und Lieder.* Leipzig: Weidmann, 1757.

Gerber, Ernst Ludwig. *Historisch-biographisches Lexikon der Tonkünstler, welches Nachrichten von dem Leben und Werken musikalischer Schriftsteller, berühmter Componisten, Sänger, Meister auf Instrumenten, Dilettanten, Orgel- und Instrumentenmacher, enthält.* 2 vols. Leipzig: Breitkopf, 1790, 1792.

———. *Neues historisch-biographisches Lexikon der Tonkünstler, welches Nachrichten von dem Leben und den Werken musikalischer Schriftsteller, berühmter Komponisten, Sänger, Meister auf Instrumenten, kunstvoller Dilettanten, Musikverleger, auch Orgel- und Instrumentenmacher, älterer und neuerer Zeit, aus allen Nationen enthält.* 4 vols. Leipzig: Kühnel, 1812–14.

Ghezzi, Pier Leone. *Raccolta de vari disegni dell Cavalliero Pietro Leone Ghezzi Romano è di Giovanni Battista Internari Romano e di alcuni altri maestri. Incise in rame da Matteo Oesterreich Hamgourghese.* Potsdam, 1766.

———. *Raccolta di XXIV caricature disegnate colla penne dell celebre cavalliere Piet. Leon. Ghezzi Conservati nell Gabinetto di sua maestà il re di Polonia Elett: Di Sassonia. Matth: Oesterreich Sculpsit.* Dresden, 1750.

Gilpin, William. *An Essay on Prints: Containing Remarks upon the Principles of Picturesque Beauty, the Different Kinds of Prints, and the Characters of the Most Noted Masters.* London: J. Robson, 1768.

Goethe, Johann Wolfgang von. *Goethes Werke: Hamburger Ausgabe in 14 Bände.* Munich: C. H. Beck, 1981.

———. "Der Sammler und die Seinigen." *Propyläen* 2, no. 11 (1799). Translated as "The Collector and His Circle" by John Gage in *Goethe on Art*, 31–72. London: Scolar Press, 1980.

Götz, Georg Friedrich. *Leben Herrn Johann Christoph Stockhausens.* Hanau, 1784.

Gräfe, Johann Friedrich. *Sammlung verschiedener und auserlesener Oden.* Halle, 1741.

Granger, James. *A Biographical History of England, from Egbert the Great to the Revolution: Consisting of Characters Disposed in Different Classes, and Adapted to a Methodical Catalogue of Engraved British Heads: Intended as an Essay towards Reducing Our Biography to System, and a Help to the Knowledge of Portraits: Interspersed with a Variety of Anecdotes, and Memoirs of a Great Number of Persons, Not to Be Found in Any Other Biographical Work.* London: T. Davies, 1769.

Hagedorn, Christian Ludwig von. *Betrachtungen über die Malerey.* Leipzig: Johann Wendler, 1762.

———. *Lettre à un amateur de la peinture.* Dresden: George Conrad Walther, 1755.

Hagedorn, Friedrich von. *Moralische Gedichte.* Hamburg: J. C. Bohn, 1750.

Haid, Johann Jakob, and Jakob Brucker. *Bildersal heutiges Tages lebender und durch Gelahrtheit berühmter Schriftsteller.* Augsburg: Haid, 1741–55.

Haller, F. C. "Christoph Heinrich Kniep, Zeichner und Professor an der königlichen Akademie der schönen Künste in Neapel." *Kunst-Blatt: Morgenblatt für gebildete Stände* 6. Stuttgart, 1825.

Hawkins, Sir John. *A General History of the Science and Practice of Music*. 5 vols. London: T. Payne, 1776.

———. *A General History of the Science and Practice of Music, by Sir John Hawkins. A New Edition with the Author's Posthumous Notes*. London: J. Alfred Novello, 1853.

Hirschfeld, Christian Cay Lorenz. *Theorie der Gartenkunst*, 5 vols in 2. Leipzig: Weidmanns Erben und Reich, 1779–85.

Hogarth, William. *The Analysis of Beauty: Written with a View of Fixing the Fluctuating Ideas of Taste*. London: J. Reeves, 1753.

Johnson, Samuel. *Dictionary of the English Language*. London, 1755.

Junker, Carl Ludwig. *Betrachtungen über Mahlerey, Ton- und Bildhauerkunst*. Basel: Karl August Serini, 1778.

———. *Erste Grundlage zu einer ausgesuchten Sammlung neuer Kupferstiche*. Bern: Typographischen Gesellschaft, 1776.

———. *Musikalische und Künstler Almanach auf das Jahr 1783*. Kosmopolis, 1783[?].

———. *Zwanzig Componisten: Eine Skizze*. Bern: Typographischen Gesellschaft, 1776.

Kellner, Johann Christoph. *Orgel-Stücke von verschiedner Art*, Op. 14. Kassel, 1787.

Kläbe, Johann Gottlob August. *Neues gelehrtes Dresden oder Nachrichten von jetzt lebenden Dresdner Gelehrten, Schriftstellern, Künstlern, Bibliotheken- und Kunstsammlern*. Leipzig: Voss, 1796.

Koch, Heinrich Christoph, ed. *Journal der Tonkunst*. Erfurt: Georg Adam Keyser, 1795.

———. *Musikalisches Lexikon*. Frankfurt am Main: August Hermann dem Jüngern, 1802. Reprint, Hildesheim: Georg Olms, 1985.

Krause, Christian Gottfried [pseud. XYZ]. "Vermischte Gedanken, welche dem Verfasser der Beyträge zugeschickt worden." In Marpurg, *Historische Kritische Beyträge zur Aufnahme der Musik* 2, no. 3 (1756): 181–224.

Kremberg, Jakob. *Musicalische Gemüths-Ergötzung oder Arien*. Dresden, 1689.

———. *Von der musikalischen Poesie*. Berlin: J. F. Voss, 1752.

[Krüger, Andreas Ludwig.] *Première partie des antiquités dans la collection de sa majesté le roi de Prusse à Sans-Souci. Contenant douze planches d'après les plus beaux bustes, demi-bustes, et thermes dessinées et gravées par Krüger à Potsdam*. Berlin: Bernstiel, 1769.

Kuhnau, Johann. *Neue Clavierübung*. Leipzig: Johann Kuhnau, 1689.

Küster, Georg Gottfried. Preface (unpaginated) to Martin Friedrich Seidel, *Bilder-sammlung, in welcher hundert größtentheils in der Mark Brandenburg gebohrne, allerseits aber um dieselbe wohlverdiente Männer vorgestellet werden, mit beygefügter Erläuterung, in welcher Derselben merkwürdigste Lebens-Umstände und Schriften erzehlet werden, von George Gottfried Küster*. Berlin, 1751.

Lavater, Johann Caspar, *Essai sur la physiognomie, destiné à faire connoître l'homme et le faire aimer*. The Hague: Jacques van Karnebeek et J. van Cleef, 1781–1803.

———. *Essays on Physiognomy, Designed to Promote the Knowledge and the Love of Mankind*. London: John Murray, 1789–98.

———. *Physiognomische Fragmente zur Beförderung der Menschenkenntnis und Menschenliebe*. 4 vols. Leipzig: Weidmanns Erben und Reich, 1775–78. Reprint, Hildesheim: Weidmann, 2002.

———. *Von der Physiognomik*. Leipzig: Weidmanns Erben und Reich, 1772.

Le Blanc, Abbé Jean-Bernard. *Observations sur les ouvrages de M.M. de l'Académie de peinture et de sculpture*. Paris, 1753.

Le Brun, Charles. *Conférence sur l'expression générale et particulière des passions*. Amsterdam: Picart, 1713.

Lichtenberg, Georg Christoph. *Handlungen des Lebens. Erklärungen zu 72 Monatskupfern von Daniel Chodowiecki*. Stuttgart: Deutsche Verlags-Anstalt, 1971.

———. *Lichtenberg's Commentaries on Hogarth's Engravings.* Translated and with an introduction by Innes and Gustav Herdan. London: Cresset Press, 1966.

———. *Über Physiognomik; wider der Physiognomen: Zu Beförderung der Menschenliebe und Menschenkenntniß.* Göttingen: Johann Christian Dieterich, 1778.

Marpurg, Friedrich Wilhelm. *Abhandlung von der Fuge nach den Grundsätzen und Exempeln der besten deutschen und ausländischen Meister entworfen.* 2 vols. Berlin: A. Haude und J. S. Spener, 1753–54. Reprint, New York: Georg Olms, 1970.

———. *Des critischen Musicus an der Spree.* Berlin: A. Haude und J. C. Spener, 1750. Reprint, New York: Georg Olms, 1970.

———. *Historisch-kritische Beyträge zur Aufnahme der Musik.* 5 vols. Berlin: G. A. Lange, 1754–78. Reprint, New York: Georg Olms, 1970.

———. [Simon Metaphrastes, pseud.], ed. *Legende einiger Musik-Heiligen: Ein Nachtrag zu den musikalischen Almanachen und Taschenbüchern jetziger Zeit.* Cologne: Peter Hammern, 1786.

Martini, Giambattista. *Storia della musica.* Bologna, 1757–81.

Mattheson, Johann. *Grundlage einer Ehrenpforte.* Hamburg: Verlegung des Verfassers, 1740.

Mendelssohn, Moses. *Gesammelte Schriften.* Vol. 1, *Schriften zur Philosophie und Ästhetik.* Berlin: Akademie-Verlag, 1929.

———. *Philosophical Writings.* Translated and edited by Daniel O. Dahlstrom. Cambridge: Cambridge University Press, 1997.

———. "Versuch, eine vollkommen gleichschwebende Temperatur durch die Construktion zu finden." In *Historisch-kritische Beyträge*, ed. Friedrich Wilhelm Marpurg, vol. 2. Berlin: G. A. Lange, 1761.

Merulo, Claudio. *Ricercari da cantare.* Venice, 1607.

Meusel, Johann Georg. *Teutsches Künstlerlexikon, oder Verzeichnis sehenswürdiger Bibliotheken, Kunst, Münz- und Naturaliencabinette in Teutschland.* Lemgo: Meyersche Buchhandlung, 1778.

Meyer, F. J. L. *Darstellungen aus Italien.* Berlin: Voss, 1792.

———. *Skizzen zu einem Gemälde von Hamburg: Von dem Verfasser der Darstellungen aus Italien.* 4 vols. Hamburg: Nestler, 1801.

Mizler, Lorenz Christoph. *Musikalische Bibliothek.* 4 vols. Leipzig, 1736–54.

Murphy, Arthur. *The Works of Cornelius Tacitus, with an Essay on His Life and Genius, Notes, Supplements, &c.* 8 vols. London: Green and Chaplin, 1811.

Neue Bibliothek der schönen Wissenschaften und der freien Künste. Leipzig: Dyck'sche Buchhandlung, 1765.

Nicolai, Friedrich, ed. *Allgemeine deutsche Bibliothek.* Berlin: Nicolai, 1788.

Paix, Jacob. *Ein schön Nutz- und Gebreüchlich Orgel Tabulaturbuch.* Lauingen, 1583.

Passeri, Giovanni Battista. *Picturae Etruscorum in Vasculis.* 3 vols. Rome: Zempel, 1767–75.

Plutarch. *Plutarch's Lives, in Six Volumes, Translated from the Greek with Explanatory and Critical Notes from Davier and Others, to Which Is Prefixed "The life of Plutarch," Written by Mr. Dryden* ... Edinburgh: Donaldson and Reid, 1763.

Praetorius, Michael. *Syntagma Musicum* (1615–19). Facsimile reprint, ed. Wilibald Gurlitt. 3 vols. Kassel: Bärenreiter, 1958.

———. *The "Syntagma Musicum" of Michael Praetorius*, vol. 2, *De Organographia: First and Second Parts, Plus All Forty-Two Original Woodcut Illustrations from "Theatrum Instrumentorum."* 3rd ed. New York: Da Capo Press, 1980.

———. *The "Syntagma Musicum" of Michael Praetorius*, vol. 3, *an Annotated Translation*, edited by Hans Lampl and Margaret Boudreaux. [S.l.]: American Choral Directors Association, 2001.

Reichardt, Johann Friedrich. *Briefe eines aufmerksamen Reisenden die Musik betreffend.* 2 vols. Frankfurt, 1774–76.

————. *Musikalisches Kunstmagazin*. Berlin: Verlage des Verfassers, 1782–91. Reprint, Hildesheim: Georg Olms, 1969.

————. "Noch ein Bruchstück aus J. F. Reichardts Autobiographie." *Allegemeine musikalische Zeitung* 16, no. 2 (January 12, 1814): 21–34.

Reusner, Nikolaus von. *Contrafacturbuch: Ware und lebendige Bildnussen etlicher weitberumbten u. hochgelehrten Männer in Teutschland*. Strasbourg: Jobin, 1587.

————. *Icones, sive Imagines virorum literis illustrium: Quorum fide et doctrina religionis et bonarum literarum studia, nostra patrumque memoria, in Germania praesertim, in integrum sunt restituta. Additis eorundem elogiis diversorum auctorum*. Strasbourg: Jobin, 1587, 1589, 1590.

Rist, Johann. *Musikalische Fest-Andachten*. Lüneburg, 1655.

————. *Sabbahtische Seelenlust*. Lüneburg, 1651.

Scheidt, Samuel. *Tabulatura nova*. 1624.

Schmid, Bernhard the Elder. *Zwey Bücher einer neuen künstlichen Tabulatur . . . allen Organisten und angehenden Instrumentisten zu nutz*. Strasbourg: Jobin, 1577.

Schubart, Christian Friedrich Daniel. *Ideen zu einer Ästhetik der Tonkunst*. Stuttgart: Scheible, 1839.

Schüddekopf, Carl, ed. *Briefwechsel zwischen Gleim und Ramler*. 2 vols. Tübingen: Litterarischer Verein in Stuttgart, 1906–7.

Seidel, Martin Friedrich. *Bilder-sammlung, in welcher hundert gröstentheils in der Mark Brandenburg gebohrne, allerseits aber um dieselbe wohlverdiente Männer vorgestellet werden, mit beygefügter Erläuterung, in welcher Derselben merkwürdigste Lebens-Umstände und Schriften erzehlet werden, von George Gottfried Küster*. Berlin: Verlag des Buchladens bey der Real-Schule, 1751.

Sterne, Laurence. *The Life and Opinions of Tristram Shandy*. 9 vols. London: Anne Ward, 1759; London: D. Lynch, 1761; London: T. Becket and P. A. Dehondt, 1762. Translated by Johann Joachim Bode as *Tristram Schandis Leben und Meynungen*. Hamburg: Bode, 1774.

————. *A Sentimental Journey through France and Italy by Mr. Yorick*. 1768. Edited with an introduction by Ian Jack. Oxford: Oxford University Press, 1968. Translated by Johann Joachim Bode as *Yoricks empfindsame Reise*. 2nd ed. Hamburg: Johann Hinrich Cramer, 1769.

Sturm, Christoph Christian. *Betrachtungen über die Werke Gottes im Reiche der Natur und der Vorsehung auf alle Tage des Jahres*. Halle, 1772–76.

Thomson, George. *The Spirit of General History, in a Series of Lectures from the Eighth to the Eighteenth Century; Wherein Is Given a View of the Progress of Society, in Manners and Legislation, during That Period*. 2nd ed. London: B. Law and Son, and F. Jollie, Carlisle, 1792.

Türk, D. G. *Klavierschule, oder Anweisung zum Klavierspielen für Lehrer und Lernende*. Leipzig, 1789.

"Ueber die Gemeinnützigkeit der Musik." *Ephemeriden der Menschheit* 6 (June 1784): 641–61.

Vallet, Nicolas. *Paradisus musicus testudinis*. Amsterdam, 1618.

Van Dyck, Antony. *Icones principum, virorum doctorum, pictorum chalcographorum statuariorum nec non amatorum pictoriae artis numero centum ab Antonio van Dyck pictore ad vivum expressae ejusque sumptibus aeri incisae*. Antwerp: Gillis Hendricx, 1645.

Vasari, Giorgio. *Le vite de' più eccellenti architetti, pittori, et scultori italiani, da Cimabue insino a' tempi nostri* (Florence, 1550), edited by Luciano Bellosi and Aldo Rossi. Turin: Giulio Einaudi, 1986.

Vetter, Daniel. *Musicalische Kirch- und Hauss-Ergötzlichkeit*. Leipzig: Rumpff, 1709–13.

Walther, Johann Gottfried. *Musicalisches Lexikon, oder Musicalische Bibliothek*. Leipzig: Wolfgang Deer, 1732.

Wieland, C. M., ed. *Dülons des blinden Flötenspielers Leben und Meynungen von ihm selbst bearbeitet*. 2 vols. Zurich, 1807–8.

Wundemann, Johann Christian Friedrich. *Mecklenburg in Hinsicht auf Kultur, Kunst und Geschmack*. Vol. 2. Schwerin, 1803.

SECONDARY SOURCES

Agnew, Vanessa. *Enlightenment Orpheus: The Power of Music in Other Worlds*. Oxford: Oxford University Press, 2008.

Allen, Warren Dwight. *Philosophies of Music History*. 1939. Reprint, New York: Dover, 1962.

Allihn, Ingeborg. "Die Pièces caractéristiques des C. P. E. Bach—ein Modell für die Gesprächs-kultur in der zweiten Hälfte des 18. Jahrhunderts." In *Carl Philipp Emanuel Bach: Musik für Europa*. Bericht über das internationale Symposium vom 8. März bis 12. März 1994 in Frankfurt (Oder), edited by Hans-Günter Ottenberg, 94–107. Frankfurt (Oder): Konzerthalle C. P. E. Bach, 1998.

Althaus, Karin. "Die Physiognomik ist ein neues Auge: Zum Porträt in der Sammlung Lavater." PhD diss., University of Basel, 2010.

Apel, Friedmar, ed. *Johann Wolfgang von Goethe: Ästhetische Schriften. Johann Wolfgang von Goethe Sämtliche Werke. Briefe, Tagebücher und Gespräche*, part 1, vol. 18. Frankfurt am Main: Deutscher Klassiker Verlag, 1998.

Appadurai, Arjun, ed. *The Social Life of Things: Commodities in Cultural Perspective*. Cambridge: Cambridge University Press, 1986.

Appel, Bernhard R. "Charakterstück." In *Die Musik in Geschichte und Gegenwart*, edited by Ludwig Finscher. 2nd ed. Kassel: Bärenreiter, 1995-.

Aspden, Suzanne. "Fam'd Handel Breathing, tho' Transformed to Stone": The Composer as Monument." *Journal of the American Musicological Society* 55, no. 1 (2005): 39–90.

Attfield, Judy. *Wild Things: The Material Culture of Everyday Life*. Oxford: Berg, 2010.

Bahr, Arthur, and Alexandra Gillespie. "Medieval English Manuscripts: Form, Aesthetics, and the Literary Text." *Chaucer Review* 47, no. 7 (2013): 358–59.

Bailey, Colin B. "Das Genre in der französischen Malerei des 18. Jahrhunderts: Ein Überlick." In *Meisterwerke der Französischen Genremalerei im Zeitalter von Watteau, Chardin und Frago-nard*, edited by Colin B. Bailey, Philip Conisbee, and Thomas W. Gaehtgens, 2–39. Berlin: DuMont, 2004.

Barker-Benfield, G. J. *The Culture of Sensibility: Sex and Society in Eighteenth-Century Britain*. Chicago: University of Chicago Press, 1992.

Baudrillard, Jean. *The System of Objects*. Translated by James Benedict. London: Verso, 1997.

Baxandall, Michael. *Patterns of Intention: On the Historical Explanation of Pictures*. New Haven, CT: Yale University Press, 1985.

———. *Shadows and Enlightenment*. New Haven, CT: Yale University Press, 1995.

Beer, Axel. "Musikzeitschriften." In *Von Almanach bis Zeitung: Ein Handbuch der Medien in Deutschland, 1700–1800*, edited by Ernst Fischer, Wilhelm Haefs, and York-Gothart Mix, 233–47. Munich: C. H. Beck, 1999.

Beisswenger, Kirsten. *Johann Sebastian Bachs Notenbibliothek*. Kassel: Bärenreiter, 1992.

Berg, Darrell. "C. P. E. Bach's Character Pieces and His Friendship Circle." In *C. P. E. Bach Studies*, edited by Stephen L. Clark, 1–32. Oxford: Clarendon Press, 1988.

Bergquist, Stephen A. "Composer Portrait Prints." In *The Routledge Companion to Music and Visual Culture*, ed. Tim Shephard and Anne Leonard. New York: Routledge, 2013.

Bernhardt, Wilhelm. *Dr. Ernst Chladni der Akustiker: Eine Biographie und geschichtliche Darstellung seiner Entdeckungen*. Wittenberg: Franz Mohr's Buchhandlung, 1856.

Beurmann, Erich Herbert. "Die Klaviersonaten Carl Philipp Emanuel Bachs." Ph.D. diss., Georg-August Universität, Göttingen, 1952.

Bianconi, Lorenzo, ed. *I ritratti del Museo della Musica di Bologna, da padre Martini al Liceo musicale*. With contributions by Maria Cristina Casali Pedrielli, Giovanna Degli Esposti, Angelo Mazza, Nicola Usula, and Alfredo Vitolo. Florence: Leo S. Olschki Editore, 2018.

Biehahn, Erik. *Kunstwerke der deutschen Staatsbibliothek*. Berlin: Henschelverlag, 1961.

Biehler, Tobias. *Über Miniaturmalereien: Mit Angaben vieler Künstler und Hofbibliotheken*. Vienna: Zamarski und Dittmarsch, 1861.

Blackwell, Mark, ed. *The Secret Life of Things: Animals, Objects, and It-Narratives in Eighteenth-Century England*. Lewisburg, PA: Bucknell University Press, 2007.

Boer, Bertil van. *Historical Dictionary of Music of the Classical Period*. Lanham, MD: Scarecrow Press, 2012.

Brilliant, Richard. *Portraiture*. Cambridge, MA: Harvard University Press, 1991.

Brown, Bill. *Other Things*. Chicago: University of Chicago Press, 2015.

Bryson, Norman. "Chardin and the Text of Still Life." *Critical Inquiry* 15 (1989): 227–52.

———. *Word and Image: French Painters of the Ancien Régime*. Cambridge: Cambridge University Press, 1981.

Bryson, Norman, Michael Ann Holly, and Keith Moxey, eds. *Visual Culture: Images and Interpretations*. Middletown, CT: Wesleyan University Press, 1994.

Busch-Salmen, Gabriele, ed. *Philipp Christoph Kayser (1755–1823): Komponist, Schriftsteller, Pädagoge, Jugendfreund Goethes*. Hildesheim: Olms, 2007.

Butt, John. "Bach's Mass in B Minor: Considerations of Its Early Performance and Use." *Journal of Musicology* 9 (1991): 110–24.

———. *Bach: Mass in B Minor*. Cambridge: Cambridge University Press, 1991.

Caflisch-Schnetzler, Ursula. "Genie und Individuum: Die Beziehung zwischen Philipp Christoph Kayser und Johann Caspar Lavater, gespiegelt am Genie-Gedanken der *Physiognomischen Fragmente*." In *Philipp Christoph Kayser (1755–1823): Komponist, Schriftsteller, Pädagoge, Jugendfreund Goethes*, edited by Gabriele Busch-Salmen, 117–38. Hildesheim: Olms, 2007.

Calmeyer, J. H. "The Count of Saint Germain or Giovannini: A Case of Mistaken Identity." *Music and Letters* 48, no. 1 (January 1967): 4–16.

Carl Philipp Emanuel Bach: Musik und Literatur in Norddeutschland; Ausstellung zum 200. Todestag Bachs. Heide in Holstein: Westholsteinische Verlagsanstalt Boyens, 1988.

Ceci n'est pas un portrait: Figures de fantaisie de Murillo, Fragonard, Tiepolo. . . . Musée des Augustins, Toulouse, November 21, 2015—March 6, 2016. Exhibition catalog.

Christensen, Thomas, and Nancy Kovaleff Baker, eds. and trans. *Aesthetics and the Art of Musical Composition in the German Enlightenment: Selected Writings of Johann Georg Sulzer and Heinrich Christoph Koch*. Cambridge: Cambridge University Press, 1996.

Clark, Stephen L., ed. and trans. *The Letters of C. P. E. Bach*. New York: Oxford University Press, 1997.

Cole, Malcolm S. "The Vogue of the Instrumental Rondo in the Late Eighteenth Century." *Journal of the American Musicological Society* 22, no. 3 (1969): 425–55.

Craveri, Benedetta. *The Age of Conversation*. Translated by Teresa Waugh. New York: New York Review of Books, 2005.

Crow, Thomas. *Painters and Public Life in 18th-Century Paris*. New Haven, CT: Yale University Press, 1985.

Czerwenka-Papdopoulos, Karoline. *Typologie des Musikerporträts in Malerei und Grafik: Das Bildnis des Musikers ab der Renaissance bis zum Klassizismus*. 2 vols. Vienna: Österreichische Akademie der Wissenschaften, 2007.

Dansk biografisk Leksikon. 3rd ed. 16 vols. Copenhagen: Gyldendal, 1979–84.

David, Hans T., and Arthur Mendel, eds. *The New Bach Reader: A Life of Johann Sebastian Bach in Letters and Documents*. Revised and enlarged by Christoph Wolff. New York: W. W. Norton, 1998.

Davison, Alan. "The Face of a Musical Genius: Thomas Hardy's Portrait of Joseph Haydn." *Eighteenth-Century Music* 6, no. 2 (2009): 209–27.

Demoris, René. "La nature morte chez Chardin." *Revue d'esthétique* 4 (1969): 363–85.

Dirksen, Pieter. *Heinrich Scheidemann's Keyboard Music: Transmission, Style, and Chronology.* Aldershot: Ashgate, 2007.

Düntzer, Heinrich, and Ferdinand Gottfried von Herder. *Von und an Herder: Ungedruckte Briefe aus Herders Nachlaß.* Vol. 1. Leipzig: Dyk'sche Buchhandlung, 1861.

Dupree, Mary Helen. "What Goethe Heard: Special Section on Hearing and Listening in the Long Eighteenth Century." *Goethe Yearbook* 25 (2018): 3–10.

Edler, Arnfried. "Das Charakterstück Carl Philipp Emanuel Bachs und die französische Tradition." In *Aufklärungen 2. Studien zur deutsch-französischen Musikgeschichte im 18. Jahrhundert: Einflüsse und Wirkungen,* edited by Wolfgang Birtel and Christoph-Hellmut Mahling. Heidelberg: Winter, 1986.

Eger, Elizabeth, ed. *Bluestockings Displayed: Portraiture, Performance, and Patronage, 1730–1830.* Cambridge: Cambridge University Press, 2013.

Eisen, Cliff. "Authenticity and Likeness in Mozart Portraiture." In *Late Eighteenth-Century Music and Visual Culture,* edited by Cliff Eisen and Alan Davison. Turnhout, Belgium: Brepols, 2017.

Eisen, Cliff, and Alan Davison, eds. *Late Eighteenth-Century Music and Visual Culture.* Turnhout, Belgium: Brepols, 2017.

Elliott, Kamilla. *Portraiture and British Gothic Fiction: The Rise of Picture Identification, 1764–1835.* Baltimore: Johns Hopkins University Press, 2012.

Engler, Klaus. *Georg Poelchau und seine Musikaliensammlung: Ein Beitrag zur Überlieferung Bachscher Musik in der ersten Hälfte des 19. Jahrhunderts.* PhD diss., University of Tübingen, 1970.

"Er ist Original!": Carl Philipp Emanuel Bach: Ausstellung in Berlin zum 200. Todestag des Komponisten, 14 Dezember 1988 bis 11. Februar 1989. Wiesbaden: Ludwig Reichert, 1988.

Erlin, Matt. *Necessary Luxuries: Books, Literature, and the Culture of Consumption in Germany, 1770–1815.* Ithaca, NY: Cornell University Press, 2014.

Fairer, David. "Sentimental Translation in Mackenzie and Sterne." In *Translating Life: Studies in Transpositional Aesthetics,* edited by Alistair Stead and Shirley Chew, 161–80. Liverpool: Liverpool University Press, 1999.

Fay, Elizabeth. *Fashioning Faces: The Portraitive Mode in British Romanticism.* Durham: University of New Hampshire Press, 2010.

Fernow, Carl Ludwig. *Carstens: Leben und Werke.* Edited and enlarged by Herman Riegel. Hannover: Carl Rümpler, 1867.

Ferris, David. "Plates for Sale: C. P. E. Bach and the Story of *Die Kunst der Fuge.*" In *C. P. E. Bach Studies,* edited by Annette Richards, 202–20. Cambridge: Cambridge University Press, 2006.

Fineman, Joel. "The History of the Anecdote: Fiction and Fiction." In *The New Historicism,* edited by Harold Aram Veeser, 49–76. New York: Routledge, 1989.

Finscher, Ludwig. "Giovannini, de." In *MGG Online,* edited by Laurenz Lütteken. Bärenreiter, Metzler, RILM, 2016–. Article first published 2002. Article published online 2016. Accessed March 19, 2020. https://www-mgg-online-com.proxy.library.cornell.edu/mgg/stable/24999.

———. "Saint Germain, Graf von." In *MGG Online,* edited by Laurenz Lütteken. Bärenreiter, Metzler, RILM, 2016–. Article first published 2005. Article published online 2016. Accessed March 19, 2020. https://www-mgg-online-com.proxy.library.cornell.edu/mgg/stable/52632.

Fleming, Paul. "The Perfect Story: Anecdote and Exemplarity in Linnaeus and Blumenberg." *Thesis Eleven* 104, no. 1 (2011): 72–86.

Fried, Michael. *Absorption and Theatricality: Painting and Beholder in the Age of Diderot.* Chicago: University of Chicago Press, 1980.

Fröhlich, Anke. *Zwischen Empfindsamkeit und Klassizismus: Der Zeichner und Landschaftsmaler Johann Sebastian Bach der Jünger (1748–1778).* Leipzig: Evangelische Verlagsanstalt/Bach-Archiv, 2007.

Funk-Kunath, Kristina. "Spurensuche: Ein unbekanntes Porträt von Pierre Gabriel Buffardin." *Bach-Jahrbuch* 104 (2018): 225–34.

Gage, John. *Goethe on Art*. London: Scolar Press, 1980.

Geiringer, Karl. *The Bach Family: Seven Generations of Creative Genius*. New York: Oxford University Press, 1954.

Gerhard, Anselm. "Carl Philipp Emanuel Bach und die 'Programmusik': Ein unbekannter Reisebericht und der 'Beweis, dass man auch klagende Rondeaux machen könne.'" In *Die Verbreitung der Werke Carl Philipp Emanuel Bachs in Ostmitteleuropa im 18. und 19. Jahrhundert*, edited by Ulrich Leisinger and Hans-Günther Ottenberg, 411–35. Frankfurt (Oder): Mess- und Veranstaltungs, 2002.

——, ed. *Musik und Ästhetik im Berlin Moses Mendelssohns*. Tübingen: Max Niemeyer Verlag, 1999.

Geyer-Kordesch, Johanna. *Pietismus, Medizin und Aufklärung in Preußen im 18. Jahrhundert: Das Leben und Werk Georg Enst Stahls*. Tübingen: Niemeyer, 2000.

Gombrich, Ernst. "On Physiognomic Perception." In *Meditations on a Hobby Horse and Other Essays on the Theory of Art*, 45–55. London: Phaidon, 1963.

Grapenthin, Ulf. "Reincken, Johann Adam." In *Grove Music Online*. http://www.oxfordmusiconline.com/subscriber/article/grove/music/23126. Accessed December 1, 2020.

Grave, Johannes. "Ideal and History: Johann Wolfgang Goethe's Collection of Prints and Drawings." *Artibus et Historiae* 27, no. 53 (2006): 175–86.

Gray, Richard T. *About Face: German Physiognomic Thought from Lavater to Auschwitz*. Detroit: Wayne State University Press, 2004.

Griffiths, Antony, and Frances Carey. *German Printmaking in the Age of Goethe*. London: British Museum, 1994.

Grimm, Hartmut. "Moses Mendelssohns Beitrag zur Berliner Musikästhetik und Carl Philipp Emanuel Bachs Fantasie-Prinzip." In *Musik und Ästhetik im Berlin Moses Mendelssohns*, edited by Anselm Gerhard, 165–86. Tübingen: Max Niemeyer Verlag, 1999.

Hajós, Elizabeth M. "Sigmund Jakob Apins Handbuch für den Sammler von Bildnissstichen: Ein Beitrag zu der Geschichte des Sammelwesens im 1. Viertel des 18. Jahrhunderts." *Philobiblon* 13 (1969): 3–26.

Head, Matthew. "Fantasy in the Instrumental Music of C. P. E. Bach." PhD diss., Yale University, 1995.

Heartz, Daniel. *Artists and Musicians: Portrait Studies from the Rococo to the Revolution*. Edited by Beverly Wilcox, with contributing studies by Paul Corneilson and John A. Rice. Ann Arbor, MI: Steglein, 2014.

Helm, Eugene. "The 'Hamlet' Fantasy and the Literary Element in C. P. E. Bach's Music." *Musical Quarterly* 58, no. 2 (April 1972): 277–96.

Hilzinger, Sonja. *Anekdotisches Erzählen im Zeitalter der Aufklärung: Zum Struktur- und Funktionswandel der Gattung Anekdote in Historiographie, Publizistik und Literatur des 18. Jahrhunderts*. Stuttgart: Metzler, 1997.

Hogwood, Christopher, ed. *Carl Philipp Emanuel Bach: 23 Pièces Characteristiques*. Oxford: Oxford University Press, 1989.

Holman, Peter. *Life after Death: The Viola da Gamba in Britain from Purcell to Dolmetsch*. Woodbridge, Suffolk: Boydell Press, 2010.

Hortschansky, Klaus, Siegfried Kessemeier, and Laurenz Lütteken. *Musiker der Renaissance und des Frühbarock: Grafische Bildnisse aus dem Porträtarchiv Diepenbroick*. Münster: Landschaftsverband Westfalen-Lippe, 1987.

Hübner, Maria. "Johann Sebastian Bach d.J.: Ein biographischer Essay." In *Zwischen Empfindsamkeit und Klassizismus: Der Zeichner und Landschaftsmaler Johann Sebastian Bach der Jünger (1748–1778)*, edited by Anke Fröhlich, 13–32. Leipzig: Evangelische Verlagsanstalt/Bach-Archiv, 2007.

Jedlicka, Gotthard. "Vom privaten und öffentlichen Sammeln." In *Der Sammler und die Seinigen: Sechs beiträge über das Sammeln. Karl Ströher zum 75. Geburtstag*, 21–28. Cologne: Galerie der Spiegel, 1966.

Jordanova, Ludmilla. *Defining Features: Scientific and Medical Portraits, 1660–2000.* London: Reaktion, 2000.

Kanz, Roland. *Dichter und Denker im Portrait: Spurengänge zur deutschen Porträtkultur des 18. Jahrhunderts.* Munich: Deutscher Kunstverlag, 1993.

Kast, Paul. *Die Bach-Handschriften der Berliner Staatsbibliothek.* Trossingen: Hohner, 1958.

Kollmar, Ulrike. *Gottlob Harrer (1703–1755), Kapellmeister des Grafen Heinrich von Brühl am sächsisch-polnischen Hof und Thomaskantor in Leipzig: Mit einem Werkverzeichnis und einem Katalog der Notenbibliothek Harrers.* Ständige Konferenz Mitteldeutsche Barockmusik 12. Beeskow: Ortus Musikverlag, 2006.

Kramer, Richard. *Cherubino's Leap: In Search of the Enlightenment Moment.* Chicago: University of Chicago Press, 2016.

———. "Diderot's *Paradoxe* and C. P. E. Bach's *Empfindungen*." In *C. P. E. Bach Studies*, edited by Annette Richards, 6–24. Cambridge: Cambridge University Press, 2006.

———. *Unfinished Music.* Oxford: Oxford University Press, 2008.

Küster, Konrad. "Bach als Mitarbeiter am 'Walther-Lexikon'?" *Bach-Jahrbuch* 77 (1991): 187–92.

Lacher, Reimar, ed. "Carl Philipp Emanuel Bach als Porträtsammler." In *Carl Philipp Emanuel Bach im Spannungsfeld zwischen Tradition und Aufbruch: Beiträge der interdisziplinären Tagung anlässlich des 300. Geburtstages von Carl Philipp Emanuel Bach vom 6. bis 8. März 2014 in Leipzig*, edited by Christine Blanken and Wolfram Enßlin, 339–51. Hildesheim: Olms, 2016.

———. *Von Mensch zu Mensch: Porträtkunst und Porträtkultur der Aufklärung. Gleimhaus Halberstadt, mit Beiträgen von Helmut Börsch-Supan und Doris Schumacher.* Schriften des Gleimhauses Halberstadt 7. Göttingen: Wallstein, 2010. Exhibition catalog.

Lamb, Jonathan. *The Evolution of Sympathy in the Long Eighteenth Century.* London: Pickering and Chatto, 2009.

———. *The Things Things Say.* Princeton, NJ: Princeton University Press, 2011.

Leaver, Robin A. "Überlegungen zur 'Bildniss-Sammlung' im Nachlass von C. P. E. Bach." *Bach-Jahrbuch* 93 (2007): 105–38.

Leisinger, Ulrich. "Die 'Bachsche Auction' von 1789." *Bach-Jahrbuch* 77 (1991): 97–126.

Leisinger, Ulrich, and Hans Günter Ottenberg, eds. *Die Verbreitung der Werke Carl Philipp Emanuel Bachs in Ostmitteleuropa im 18. und 19. Jahrhundert: Bericht über das internationale Symposium vom 12. bis 16. März 1998 in Frankfurt (Oder), Zagan, and Zielona Gora.* Frankfurt (Oder): Konzerthalle Carl Philipp Emanuel Bach, 2002.

Leisinger, Ulrich, and Peter Wollny. "'Altes Zeug von mir': Carl Philipp Emanuel Bachs kompositorisches Schaffen vor 1740." *Bach-Jahrbuch* 79 (1993): 127–204.

———. *Die Bach-Quellen der Bibliotheken in Brüssel: Katalog; mit einer Darstellung von Überlieferungsgeschichte und Bedeutung der Sammlungen Westphal, Fétis und Wagener.* Leipziger Beiträge zur Bach-Forschung 2. Hildesheim: Olms, 1997.

Leppert, Richard D. *Music and Image: Domesticity, Ideology, and Socio-cultural Formation in Eighteenth-Century England.* Cambridge: Cambridge University Press, 1988.

Lewis, W. S., et al., eds. *The Yale Edition of Horace Walpole's Correspondence.* New Haven, CT: Yale University Press, 1955.

Link, Anne-Marie. "Carl Ludwig Junker and the Collecting of Reproductive Prints." *Print Quarterly* 12, no. 4 (1995): 361–74.

Lohmeier, Dieter, ed. *Carl Philipp Emanuel Bach: Musik und Literatur in Norddeutschland; Ausstellung zum 200. Todestag Bachs.* Heide in Holstein: Boyens, 1988.

Lowerre, Kathryn. "Beauty, Talent, Virtue and Charm: Portraits of Two of Handel's Sopranos." *Imago Musicae* 9–12 (1992–95): 205–44.

Lütteken, Laurenz. "Zwischen Ohr und Verstand: Moses Mendelssohn, Johann Philipp Kirnberger und die Begründung des 'reinen Satzes' in der Musik." In *Musik und Ästhetik im Berlin Moses Mendelssohns*, edited by Anselm Gerhard, 135–63. Tübingen: Max Niemeyer Verlag, 1999.

Lynch, Deidre. "Personal Effects and Sentimental Fictions." In *The Secret Life of Things: Animals, Objects, and It-Narratives in Eighteenth-Century England*, edited by Mark Blackwell, 63–91. Lewisburg, PA: Bucknell University Press, 2007.

Mannings, David. *Sir Joshua Reynolds: A Complete Catalogue of His Paintings*. New Haven, CT: Yale University Press, 2000.

Markley, Robert. "Sensibility as Performance: Shaftesbury, Sterne, and the Theatrics of Virtue." In *The New 18th Century: Theory, Politics, English Literature*, edited by Felicity Nussbaum and Laura Brown, 201–30. New York: Methuen, 1987.

Marshall, Robert. "Father and Sons: Confronting a Uniquely Daunting Paternal Legacy." In *J. S. Bach and His Sons*, edited by Mary Oleskiewicz, 1–23. Urbana: University of Illinois Press, 2017.

Marx, Hans Joachim, ed. *Carl Philipp Emanuel Bach und die europäische Musikkultur des mittleren 18. Jahrhunderts: Bericht über das internationale Symposium der Joachim Jungius-Gesellschaft der Wissenschaften Hamburg, 29. September-2. Oktober 1988*. Göttingen: Vandenhoeck und Ruprecht, 1990.

Miesner, Heinrich. *Philipp Emanuel Bach in Hamburg: Beiträge zu seiner Biographie und zur Musikgeschichte seiner Zeit*. Leipzig: Breitkopf und Härtel, 1929.

Miller, Leta. "C. P. E. Bach and Friedrich Ludwig Dülon: Composition and Improvisation in Late 18th-Century Germany." *Early Music* 23 (1995): 65–80.

Mitchell, W. J. T. *Picture Theory: Essays on Verbal and Visual Representation*. Chicago: University of Chicago Press, 1995.

———. *What Do Pictures Want? The Lives and Loves of Images*. Chicago: University of Chicago Press, 2013.

Mix, York-Gothart. *Die deutschen Musen-Almanache des 18. Jahrhunderts*. Munich: C. H. Beck, 1987.

———, ed. *Kalender? Ey, wie viel Kalender! Literarische Almanache zwischen Rokoko und Klassizismus*. Herzog August Bibliothek Wolfenbüttel, June 15—November 5, 1986. Exhibition catalog.

———. "Der Literaturfreund als Kalendernarr: Die Almanachkultur und ihr Publikum." In *Almanach- und Taschenbuchkultur des 18. und 19. Jahrhunderts*, Wolfenbütteler Forschungen 69, edited by York-Gothart Mix, 77–88. Wiesbaden: Harrassowitz, 1996.

Moore, Evelyn K. "Goethe and Lavater: A Specular Friendship." In *The Enlightened Eye: Goethe and Visual Culture*, edited by Evelyn K. Moore and Patricia Anna Simpson, 165–91. Leiden: Brill, 2007.

Mortzfeld, Peter. *Die Porträtsammlung des Herzog August Bibliothek Wolfenbüttel*. 50 vols. Munich: K. G. Saur, 1986–2008.

Mraz, Gerda. "Musikerportraits in der Sammlung Lavater." In *Studies in Music History Presented to H. C. Robbins Landon on His Seventieth Birthday*, edited by Otto Biba and David Wyn Jones, 165–76. London: Thames and Hudson, 1996.

Muensterberger, Werner. *Collecting: An Unruly Passion; Psychological Perspectives*. Princeton, NJ: Princeton University Press, 1994.

Mullan, John. *Sentiment and Sociability: The Language of Feeling in the Eighteenth Century*. Oxford: Clarendon Press, 1988.

Neumann, Werner. *Bilddokumente zur Lebensgeschichte Johann Sebastian Bachs*. Kassel: Bärenreiter, 1979.

Oleskiewicz, Mary. "Keyboards, Music Rooms, and the Bach Family at the Court of Frederick the Great." In *J. S. Bach and His Sons*, edited by Mary Oleskiewicz, 24–82. Urbana: University of Illinois Press, 2017.

Ottenberg, Hans Günter. *Carl Philipp Emanuel Bach: Music für Europa*. Bericht über das internationale Symposium . . . 1994. Frankfurt (Oder): Konzerthalle "Carl Phillip Emanuel Bach," 1998.

———, ed., *Carl Philipp Emanuel Bach: Spurensuche: Leben und Werk in Selbszeugnissen und Dokumenten seiner Zeitgenossen.* Leipzig: E. A. Seemann, 1994.

———, ed. *Carl Philipp Emanuel Bach.* Leipzig: Philipp Reclam jun., 1982. Translated by Philip J. Whitmore as *C. P. E. Bach.* Oxford: Oxford University Press, 1987.

———. *Der critische Musicus an der Spree: Berliner Musikschrifttum von 1748 bis 1799: Eine Dokumentation.* Leipzig: Reclam, 1984.

———. *Kultur- und Musiktransfer im 18. Jahrhundert: Das Beispiel C. P. E. Bach in Musikkultureller Vernetzung Polen-Deutschland-Frankreich: Bericht über das Internationale Symposium . . . 2009 in Frankfurt (Oder) und Wrocław.* 1. Aufl. Frankfurt (Oder): Musikgesellschaft Carl Philipp Emanuel Bach, 2011.

———. "Wer waren Carl Philipp Emanuel Bachs Pränumeranten? Überlegungen zur sozialen Schichtung des elbastädtischen Musik-publikums um 1780." In *"Critica Musica": Studien zum 17. und 18. Jahrhundert. Festschrift Hans Joachim Marx zum 65. Geburtstag,* edited by Nicole Ristow, Wolfgang Sandberger, and Dorothea Schröder, 233–46. Stuttgart: Metzler, 2001.

Ottenberg, Hans Günter, and Ulrich Leisinger, ed. *Carl Philipp Emanuel Bach und die europäische Musikkultur des mittleren 18. Jahrhundert: Bericht über das Internationale Symposium der Joachim Jungius-Gesllschaft des Wissenschaften Hamburg, September 29-October 2, 1988.* Hamburg: Vandenhoeck und Ruprecht, 1990.]

———. *Carl Philipp Emanuel Bach, Musik zwischen West und Ost: Bericht über das internationale Symposium . . . 1998 in Frankfurt (Oder), Żagań und Zielona Góra [im Rahmen der 33. Frankfurter Festtage der Musik an der Konzerthalle "Carl Philipp Emanuel Bach" in Frankfurt (Oder).* Frankfurt (Oder): Konzerthalle "Carl Philipp Emanuel Bach," 2000.

———. *Carl Philipp Emanuel Bach als Lehrer: Die Verbreitung der Musik Carl Philipp Emanuel Bachs in England und Skandinavien. Bericht über das international Symposium . . . 2001, im Rahmen der 36. Frankfurter Festtage der Musik und der X. Internationalen Musik-Begegnungen "Ost-West" Zielona Gora.* Frankfurt (Oder): Musikgesllschaft Carl Philipp Emanuel Bach, 2005.

Pearce, Susan M. *Museums, Objects, and Collections: A Cultural Study.* Washington, DC: Smithsonian Institution Press, 1993.

———. *On Collecting: An Investigation into Collecting in the European Tradition.* London: Routledge, 1995.

Percival, Melissa, and Graeme Tytler. *Physiognomy in Profile: Lavater's Impact on European Culture.* Newark: University of Delaware Press, 2005.

Petheridge, Deanna, and Ludmilla Jordanova. *The Quick and the Dead: Artists and Anatomy.* London: Hayward Gallery and Arts Council of Great Britain, 1997. Exhibition catalog.

Phillips, Mark Salber. *Society and Sentiment: Genres of Historical Writing in Britain, 1740–1820.* Princeton, NJ: Princeton University Press, 2000.

Plebuch, Tobias. "Dark Fantasies and the Dawn of the Self: Gerstenberg's Monologues for C. P. E. Bach's C-Minor Sonata." In *C. P. E. Bach Studies,* edited by Annette Richards, 25–66. Cambridge: Cambridge University Press, 2006.

Pointon, Marcia. *Hanging the Head: Portraiture and Social Formation in Eighteenth-Century England.* New Haven, CT: Yale University Press, 1993.

———. *Portrayal and the Search for Identity.* London: Reaktion Books, 2012.

Pomian, Krzystof. *Collectors and Curiosities: Paris and Venice, 1500–1800.* Translated by Elizabeth Wiles-Portier. Cambridge: Polity Press, 1990.

Poos, Heinrich. *Carl Philipp Emanuel Bach: Beiträge zu Leben und Werk.* Mainz: Schott, 1993.

———. "Carl Philipp Emanuel Bachs Rondo a-Moll aus der 'Zweiten Sammlung . . . für Kenner und Liebhaber': Protokoll einer Annäherung." In *Carl Philipp Emanuel Bach: Beiträge zu Leben und Werk,* edited by Heinrich Poos, 119–70. Mainz: Schott, 1993.

Pott, Ute, ed. *Das Jahrhundert der Freundschaft: Johann Wilhelm Ludwig Gleim und seine Zeitgenossen.* Göttingen: Wallstein, 2004.

Rampe, Siegbert. *Carl Philipp Emanuel Bach und seine Zeit.* Laaber: Laaber Verlag, 2014.

Rice, John A. "The Blind Dülon and His Magic Flute." *Music and Letters* 71 (1990): 25–51.

Richards, Annette, ed. *C. P. E. Bach Studies.* Cambridge: Cambridge University Press, 2006.

———, ed. *Carl Philipp Emanuel Bach: The Portrait Collection. Carl Philipp Emanuel Bach: The Complete Works*, ser. 8, vol. 4.1. Los Altos, CA: Packard Humanities Institute, 2012.

———. "The Charitable Handel." In *The Power of Musick*, Göttinger Händel Beiträge 15, edited by Anorthe Kremers and Wolfgang Sandberger, 87–108. Göttingen: Vandenhoeck und Ruprecht, 2014.

———. "An Enduring Monument: C. P. E. Bach and the Musical Sublime." In *C. P. E. Bach Studies*, edited by Annette Richards, 149–72. Cambridge: Cambridge University Press, 2006.

———. *The Free Fantasia and the Musical Picturesque.* Cambridge: Cambridge University Press, 2003.

———. "Haydn's London Trios and the Rhetoric of the Grotesque." In *Haydn and the Performance of Rhetoric*, edited by Tom Beghin and Sander Goldberg (Chicago: University of Chicago Press, 2007), 251–80.

Richards, Annette, and David Yearsley, eds. *Carl Philipp Emanuel Bach: Organ Works. Carl Philipp Emanuel Bach: The Complete Works*, ser. 1, vol. 9. Los Altos: Packard Humanities Institute, 2008.

Rosenberg, Pierre. *Chardin, 1699–1779.* Cleveland: Cleveland Museum of Art, in cooperation with Indiana University Press, 1979. Exhibition catalog.

Rostirolla, Giancarlo. *Il "mondo novo musicale" di Pier Leone Ghezzi.* Milan: Accademia nazionale di Santa Cecilia, 2001.

Rovee, Christopher. *Imagining the Gallery: The Social Body of British Romanticism.* Stanford, CA: Stanford University Press, 2006.

Salmen, Walter, and Gabriele Busch-Salmen. *Musiker im Porträt.* 5 vols. Munich: C. H. Bach, 1982–84.

Sauder, Gerhard. "Almanach-Kultur und Empfindsamkeit." In *Literarischer Leitmedien: Almanach und Taschenbuch im kulturwissenschaftlichen Kontext*, Mainzer Studien zur Buchwissenschaft 4, edited by Paul Gerhard Klussmann and York-Gothart Mix, 16–30. Wiesbaden: Harrassowitz, 1998.

Schaal, Richard. *Die Tonkünstler-Portraits der Wiener Musiksammlung von Aloys Fuchs.* Wilhelmshaven: Heinrichshofens Verlag, 1970.

Schäfer, Rudolf. *Die Anekdote: Theorie, Analyse, Didaktik.* Munich: R. Oldenbourg, 1982.

Scheide, William H. "Johann Sebastian Bachs Sammlung von Kantaten seines Vetters Johann Ludwig Bach." *Bach-Jahrbuch* 46 (1959): 52–94.

Schellenberg, Renata. "The Self and Other Things: Goethe the Collector." *Publications of the English Goethe Society* 81, no. 3 (2012): 166–77.

Shephard, Tim, and Anne Leonard, eds. *The Routledge Companion to Music and Visual Culture.* New York: Routledge, 2013.

Schinkel, Eckhard. "Sammeln, Ordnen und Studieren: Sozialgeschichtliche Aspekte zur Verwendung von Graphik und Porträts im 18. Jahrhundert." In *Porträt 1: Der Herrscher. Graphische Bildnisse des 16.–19. Jahrhunderts aus dem Porträtarchiv Diepenbroick*, 47–66. Münster: Westfälisches Landesmuseum für Kunst und Kulturgeschichte, 1977. Exhibition catalog.

Schleuning, Peter. *Die freie Fantasie: Ein Beitrag zur Erforschung der klassischen Klaviermusik.* Göppingen: A. Kümmerle, 1973.

Schmid, Manfred Hermann. "'Das Geschäft mit dem Nachlaß von C. Ph. E. Bach': Neue Dokumente zur Westphal-Sammlung des Conservatoire royal de musique und der Bibliothèque royale de Belgique in Brüssel." In *Carl Philipp Emanuel Bach und die europäische Musikkultur des mittleren 18. Jahrhunderts. Bericht über das internationale Symposium der Joachim Jungius-*

Gesellschaft der Wissenschaften Hamburg, September 29–October 2, 1988, edited by Hans Joachim Marx, 473–528. Göttingen: Vandenhoeck und Ruprecht, 1990.

Schmölders, Claudia, ed. *Der exzentrische Blick: Gespräch über Physiognomik*. Berlin: Akademie Verlag, 1996.

Schnittger, C. N. *Errinerungen eines alten Schleswigers*. With annotations and an appendix by Heinrich Philippsen. Schleswig: Ibbeken, 1904.

Scholke, Horst. *Der Freundschaftstempel im Gleimhaus zu Halberstadt: Porträts des 18. Jahrhunderts*. Bestandskatalog. Leipzig: E. A. Seemann, 2000.

Schulenberg, David. *The Instrumental Music of Carl Philipp Emanuel Bach*. Ann Arbor, MI: UMI Research Press, 1984.

———. *The Music of Carl Philipp Emanuel Bach*. Rochester, NY: University of Rochester Press, 2014.

Schulze, Hans-Joachim, ed. *Bach-Dokumente III: Dokumente zum Nachwirken Johann Sebastian Bachs, 1750–1800*. Kassel: Bärenreiter, 1972.

Schwab, Heinrich W. "Musikbeilagen in Almanachen und Taschenbüchern." In *Almanach- und Taschenbuchkultur des 18. und 19. Jahrhunderts*, Wolfenbütteler Forschungen 69, edited by York-Gothart Mix, 167–201. Wiesbaden: Harrassowitz, 1996.

Sheehan, James. "From Princely Collections to Public Museums: Toward a History of the German Art Museum." In *Rediscovery History: Culture, Politics and the Psyche*, edited by Michael Roth. Stanford, CA: Stanford University Press, 1994.

Shookman, Ellis, ed. *The Faces of Physiognomy: Interdisciplinary Approaches to Johann Caspar Lavater*. Columbia, SC: Camden House, 1993.

Sisman, Elaine. "Music and the Labyrinth of Melody: Traditions and Paradoxes in C. P. E. Bach and Beethoven." In *Oxford Handbook of Disability Studies*, edited by Blake Howe, Stephanie Jensen-Moulton, Neil Lerner, and Joseph Straus, 590–617. Oxford: Oxford University Press, 2015.

Sittard, Josef. *Geschichte des Musik- und Concertwesens in Hamburg vom 14. Jahrhunderts bis auf die Gegenwart*. Leipzig: Reher, 1890.

Smith, David R. "Irony and Civility: Notes on the Convergence of Genre and Portraiture in 17th-Century Dutch Painting." *Art Bulletin* 69, no. 3 (September 1987): 407–30.

Sontag, Susan. "Notes on Camp." In *Against Interpretation*. New York: Farrar, Straus and Giroux, 1964.

Spink, Ian. "Hunt, Arabella." In Grove Music Online. http://www.oxfordmusiconline.com /subscriber/article/grove/music/13571. Accessed September 9, 2020.

Stafford, Barbara Maria. *Body Criticism: Imaging the Unseen in Enlightenment Art and Medicine*. Cambridge, MA: MIT Press, 1991.

———. "From Brilliant Ideas to Fitful Thoughts: Conjecturing the Unseen in Late Eighteenth-Century Art." *Zeitschrift für Kunstgeschichte* 48 (Fall 1985): 329–63.

Stemmler, Joan K. "The Physiognomical Portraits of Johann Caspar Lavater." *Art Bulletin* 75, no. 1 (March 1993): 151–68.

Stewart, Susan. *On Longing: Narratives of the Miniature, the Gigantic, the Souvenir, the Collection*. Baltimore: Johns Hopkins University Press, 1984.

Stört, Diana. *Johann Wilhelm Ludwig Gleim und die gesellige Sammlungspraxis im 18. Jahrhundert*. Hamburg: Kovac, 2010.

Striehl, Georg. *Der Zeichner Christoph Heinrich Kniep (1755–1825)*. Hildesheim: Olms, 1998.

Suchalla, Ernst, ed. *Carl Philipp Emanuel Bach: Briefe und Dokumente. Kritische Ausgabe*. Göttingen: Vandenhoeck und Ruprecht, 1994.

———. *Carl Philipp Emanuel Bach im Spiegel seiner Zeit: Die Dokummentensammlung Johann Jacob Heinrich Westphals*. Hildesheim: Olms, 1993.

Sulzer, Johann Georg. *Allgemeine Theorie der schönen Künste.* Vol. 2. Leipzig: Weidmanns Erben und Reich, 1774.

Tolley, Thomas. *Painting the Cannon's Roar: Music, the Visual Arts, and the Rise of an Attentive Public in the Age of Haydn.* Aldershot, UK: Ashgate, 2001.

Trautscholdt, Eduard. "Zur Geschichte des Leipziger Sammelwesens." In *Festschrift Hans Vollmer,* edited by Magdalena George, 217–52. Leipzig: E. A. Seemann, 1957.

Van der Zande, Johan. "Orpheus in Berlin: A Reappraisal of Johann Georg Sulzer's Theory of the Polite Arts." *Central European History* 28, no. 2 (1995): 175–208.

Vogtherr, Christoph Martin. "Frédéric II de Prusse et sa collection de peintures françaises: Thèmes et perspectives de recherche." In *Poussin, Watteau, Chardin, David . . . : Peintures françaises dans les collections allemandes XVIIe-XVIIIe siècles,* 89–96. Galeries nationales du Grand Palais, Paris, 2005. Exhibition catalog.

Von der Hellen, Eduard. *Goethes Anteil an Lavaters Physiognomischen Fragmenten.* Frankfurt am Main: Rütten & Loening, 1888.

Walden, Joshua. "Composing Character in Musical Portraits: Carl Philipp Emanuel Bach and L'Aly Rupalich." *Musical Quarterly* 91 (Fall 2008): 379–411.

———. *Musical Portraits: The Composition of Identity in Contemporary and Experimental Music.* New York: Oxford University Press, 2018.

Wappler, Gerlinde. "Freundschaft und Musik: Gleims Musikerfreunde Carl Philipp Emanuel Bach und Johann Friedrich Reichardt." In *Das Jahrhundert der Freundschaft,* edited by Ute Pott, 71–78. Göttingen: Wallstein, 2004.

Weber, Gregor J. M. "Die Gemälde Pietro Graf Rotaris für den Sächsischen Hof." In *Pietro Graf Rotari in Dresden: Ein italienischer Maler am Hof König Augusts III. Bestandskatalog, anläßlich der Ausstellung im Spemperbau 9. November 1999—9. Januar 2000,* edited by Gregor J. M. Weber, 17–53. Emsdetten: Imorde, 1999.

Weber, Volker. *Anekdote: Die andere Geschichte. Erscheinungsformen der Anekdote in der deutschen Literatur, Geschichtsschreibung und Philosophie.* Tübingen: Stauffenburg, 1993.

West, Shearer. *Portraiture.* Oxford: Oxford University Press, 2004.

White, Hayden. *Metahistory: The Historical Imagination in Nineteenth-Century Europe.* Baltimore: Johns Hopkins University Press, 1973.

Wiermann, Barbara, ed. *C. P. E. Bach: Dokumente zu Leben und Wirken aus der Zeitgenössischen Hamburgischen Presse (1767–1790).* Hildesheim: Olms, 2000.

Will, Richard. *The Characteristic Symphony in the Age of Haydn and Beethoven.* Cambridge: Cambridge University Press, 2001.

Wolff, Christoph. "C. P. E. Bach and the History of Music." *Notes* 71, no. 2 (2014): 197–218.

———. *Johann Sebastian Bach: The Learned Musician.* New York: W. W. Norton, 2000.

———, ed. *Kanons; Musikalisches Opfer: Kritischer Bericht.* Johann Sebastian Bach: Neue Ausgabe sämtlicher Werke, ser. 8, vol. 1. Kassel: Bärenreiter, 1976.

Wollny, Peter, ed. *Carl Philipp Emanuel Bach: Miscellaneous Keyboard Works II,* Carl Philipp Emanuel Bach: The Complete Works, ser. 1, vol. 8.2. Los Altos: Packard Humanities Institute, 2005.

Woodall, Joanna. *Portraiture: Facing the Subject.* Manchester: Manchester University Press, 1997.

Woodrow, Ross. "Lavater and the Drawing Manual." In *Physiognomy in Profile: Lavater's Impact on European Culture,* edited by Melissa Percival and Graeme Tytler. Newark: University of Delaware Press, 2005.

Yearsley, David. *Bach and the Meanings of Counterpoint.* Cambridge: Cambridge University Press, 2002.

———. *Bach's Feet: The Organ Pedals in European Culture.* Cambridge: Cambridge University Press, 2012.

———. "C. P. E. Bach and the Living Traditions of Learned Counterpoint." In *C. P. E. Bach Studies*, edited by Annette Richards, 173–201. Cambridge: Cambridge University Press, 2006.

———. *Sex, Death, and Minuets: Anna Magdalena Bach and Her Musical Notebooks*. Chicago: University of Chicago Press, 2019.

Index